D0518069

# Ten Southeast
# ASIAN TRIBES
*from five countries*

*THAILAND BURMA*

*VIETNAM LAOS PHILIPPINES*

# DAVID HOWARD

# www.tribalartasia.com

# DEDICATION

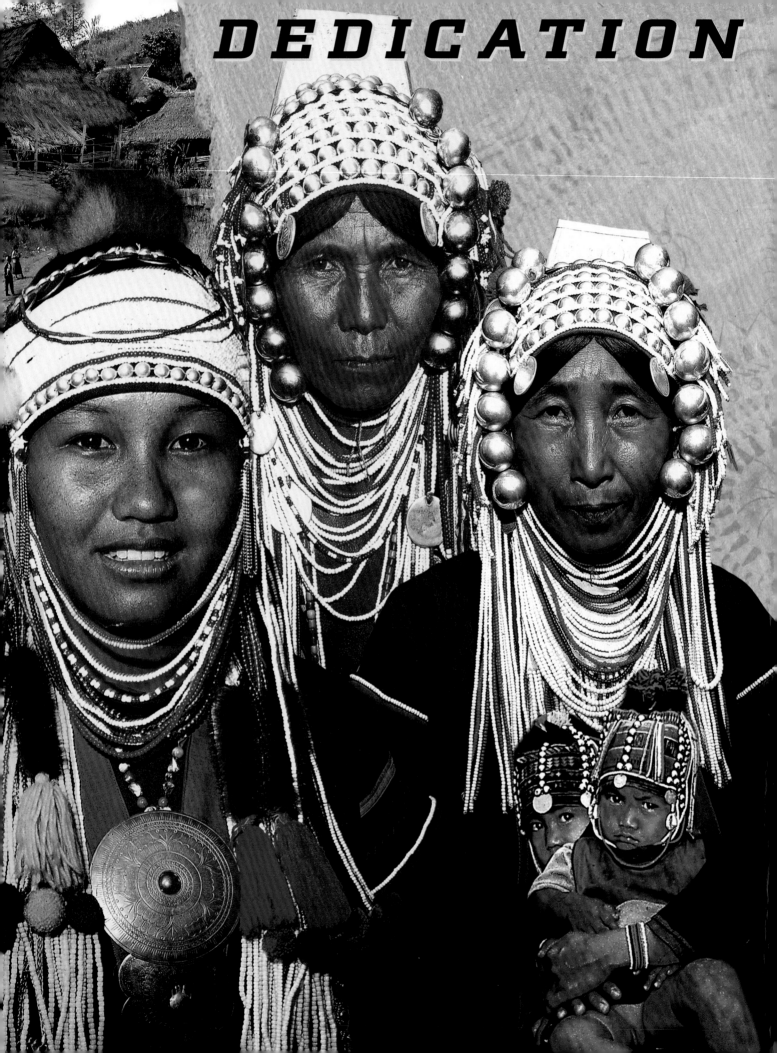

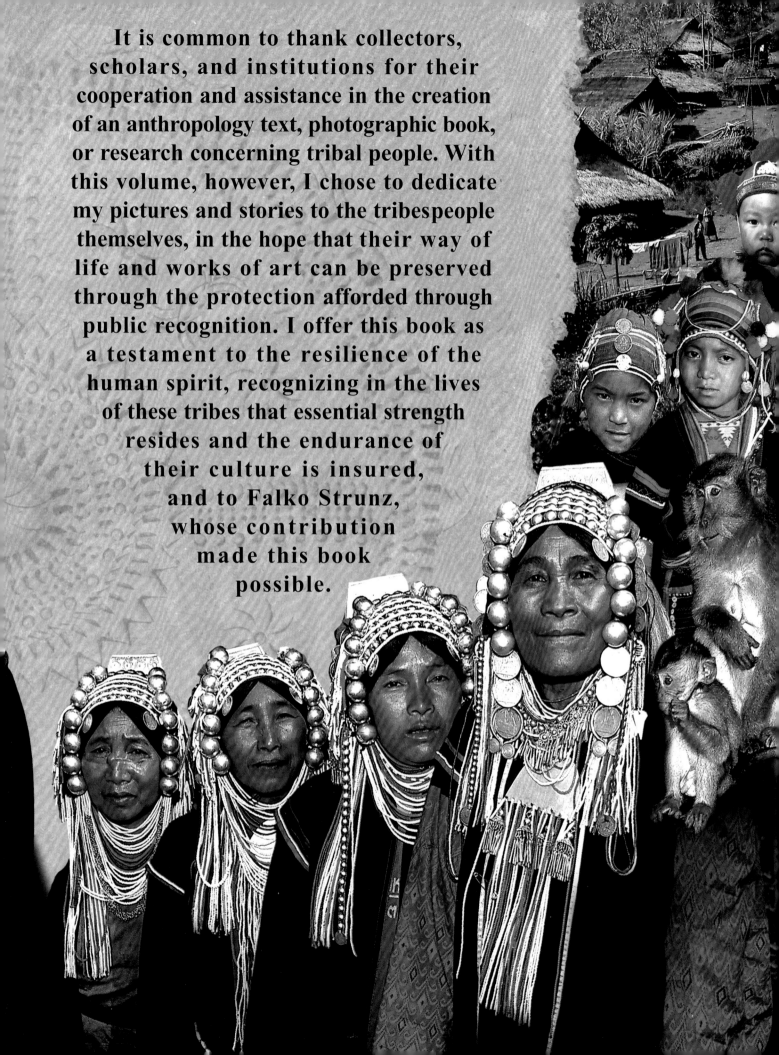

It is common to thank collectors, scholars, and institutions for their cooperation and assistance in the creation of an anthropology text, photographic book, or research concerning tribal people. With this volume, however, I chose to dedicate my pictures and stories to the tribespeople themselves, in the hope that their way of life and works of art can be preserved through the protection afforded through public recognition. I offer this book as a testament to the resilience of the human spirit, recognizing in the lives of these tribes that essential strength resides and the endurance of their culture is insured, and to Falko Strunz, whose contribution made this book possible.

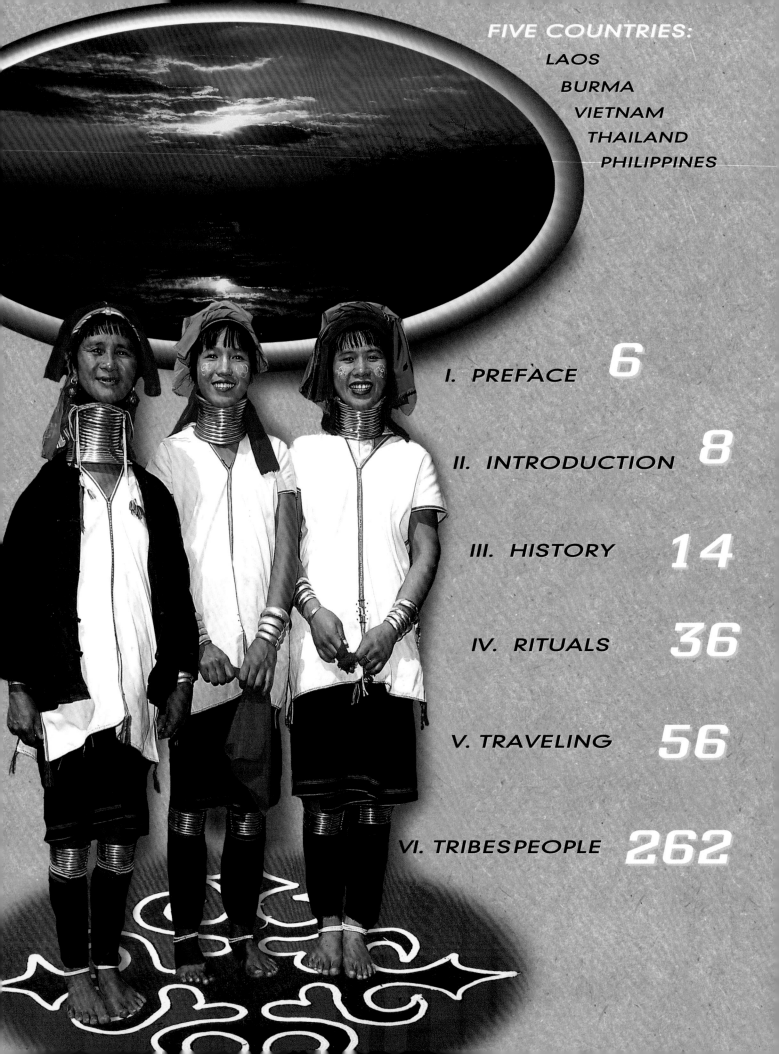

FIVE COUNTRIES:
LAOS
BURMA
VIETNAM
THAILAND
PHILIPPINES

# CONTENTS

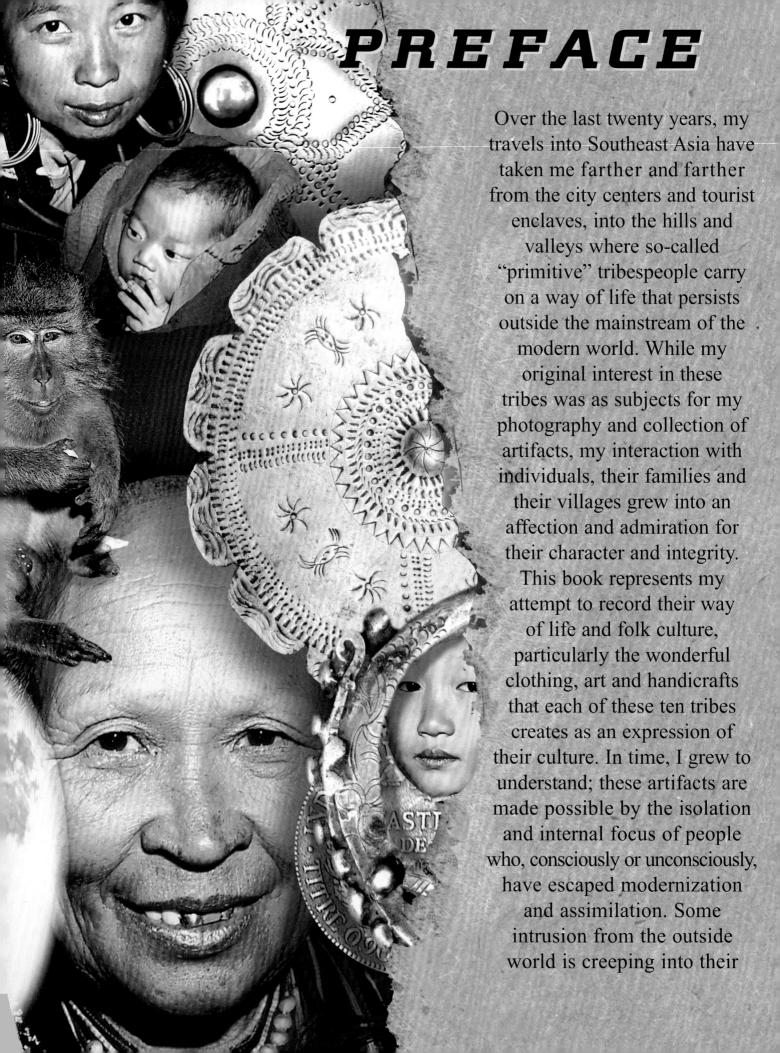

# PREFACE

Over the last twenty years, my travels into Southeast Asia have taken me farther and farther from the city centers and tourist enclaves, into the hills and valleys where so-called "primitive" tribespeople carry on a way of life that persists outside the mainstream of the modern world. While my original interest in these tribes was as subjects for my photography and collection of artifacts, my interaction with individuals, their families and their villages grew into an affection and admiration for their character and integrity. This book represents my attempt to record their way of life and folk culture, particularly the wonderful clothing, art and handicrafts that each of these ten tribes creates as an expression of their culture. In time, I grew to understand; these artifacts are made possible by the isolation and internal focus of people who, consciously or unconsciously, have escaped modernization and assimilation. Some intrusion from the outside world is creeping into their

lives. In some villages new trucks are parked alongside old carts. The practice of fitting neck coils on Padaung women has become less frequent, as it had not market value, but some girls are beginning to wear the brass coils around their necks again because the practice has become a tourist attraction. Embroidery and needlework were done by hand in the past; now, however, the tribes have discovered sewing machines. Fabric printed in ready-made patterns, available in all the markets, saves time and work that would otherwise be spent creating the images by hand. Plastic beads have begun to replace the seeds that must be laboriously dyed and drilled for use in headdress. The traditional style of clothing is mostly retained by older people, but as the villages become more accessible, T-shirts and jeans are common. Looking closely at these examples of tribal handicraft and folk art, the ancient tradition of tribal art, while strong, still however, shines through a modern influence.

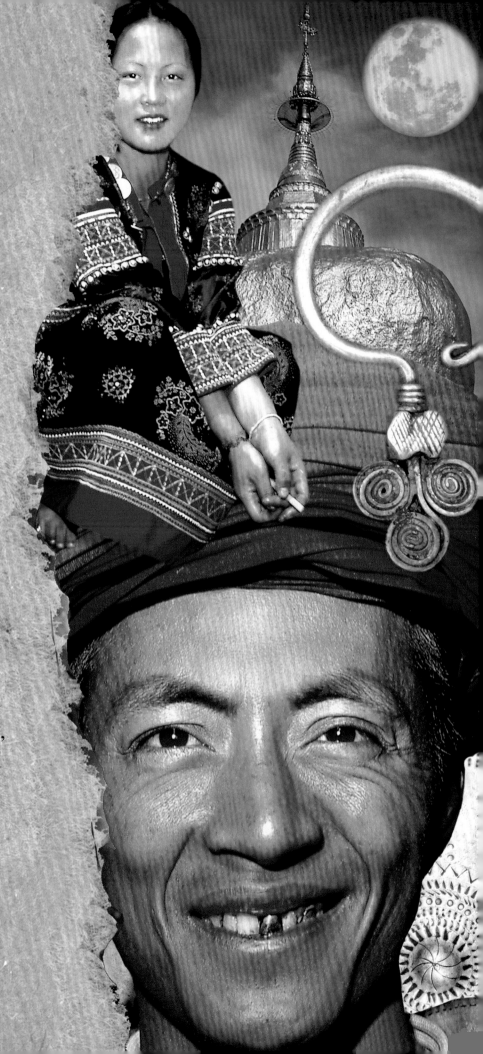

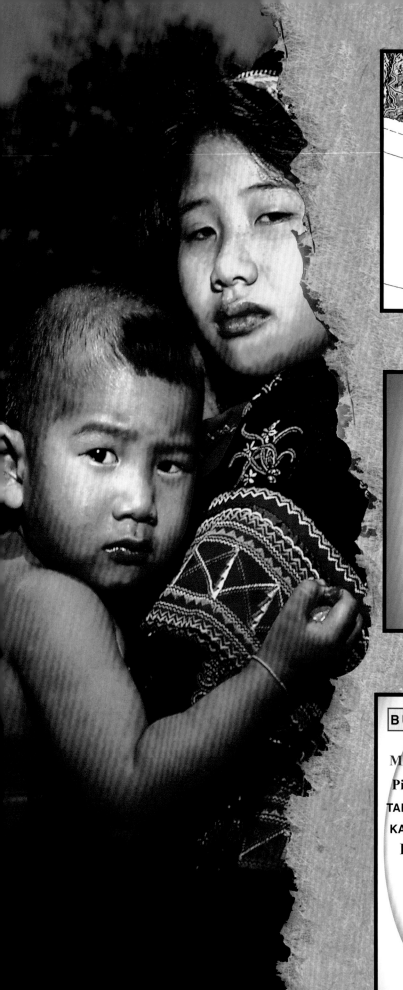

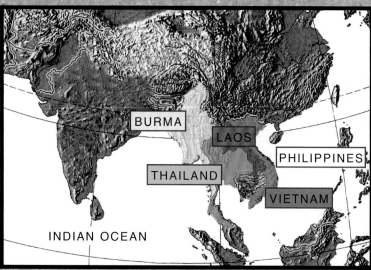

BURMA

LAOS

PHILIPPINES

THAILAND

VIETNAM

INDIAN OCEAN

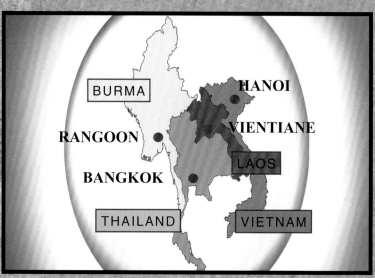

BURMA

HANOI

RANGOON

VIENTIANE

LAOS

BANGKOK

THAILAND

VIETNAM

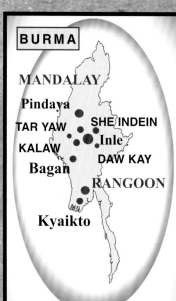

BURMA

MANDALAY

Pindaya

TAR YAW    SHE INDEIN

KALAW    Inle

Bagan    DAW KAY

RANGOON

Kyaikto

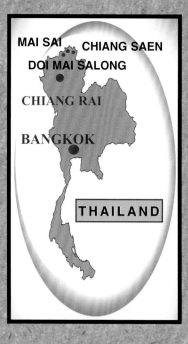

MAI SAI    CHIANG SAEN

DOI MAI SALONG

CHIANG RAI

BANGKOK

THAILAND

# INTRODUCTION

The tribes pictured in this book live in remote regions of Southeast Asia: Vietnam, Laos, Thailand, Myanmar (formerly Burma), and the Philippines. But it is not possible to locate tribes that were in some of these regions only decades ago because centuries of endless tribal migratory cycles never cease and will always remain in progress. Many from south China migrated to destinations depending on the tribe's agrarian economy.

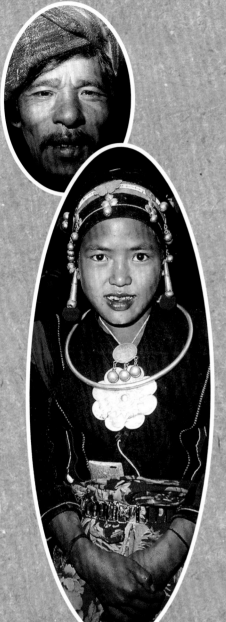

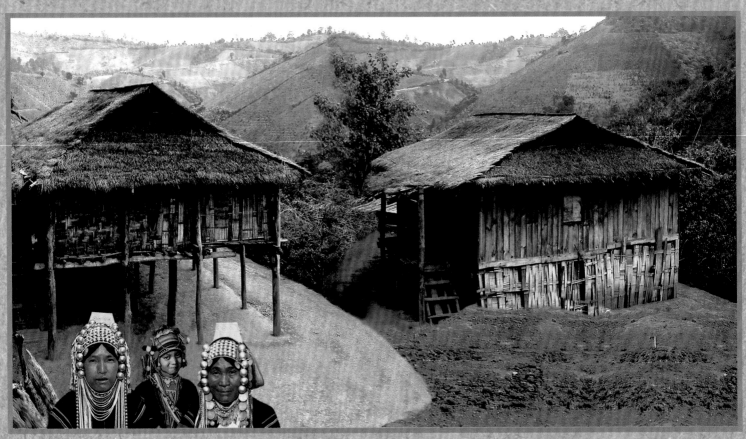

Akha: Thailand        Isolated tribal huts in a remote mountain region: Burma

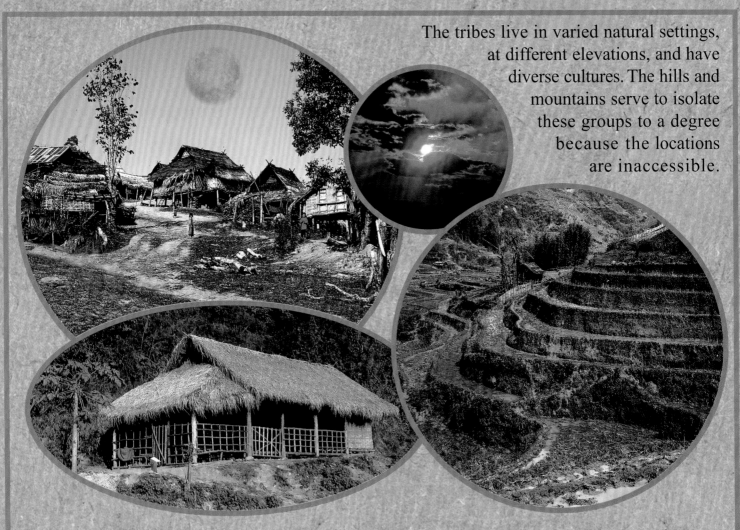

The tribes live in varied natural settings, at different elevations, and have diverse cultures. The hills and mountains serve to isolate these groups to a degree because the locations are inaccessible.

Akha village moonrise: Laos        Tribal hut: Laos        Sunrise: Laos        Rice terrace: Vietnam

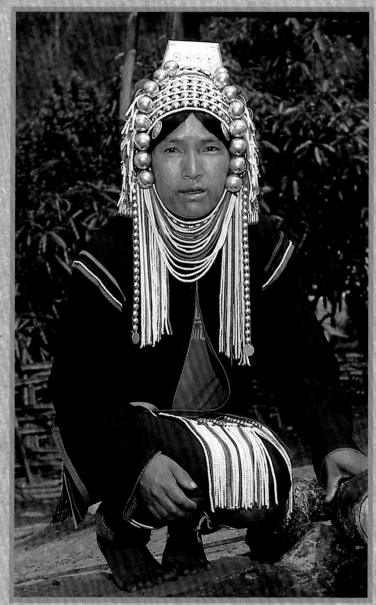

Akha female collecting fire wood: Thailand

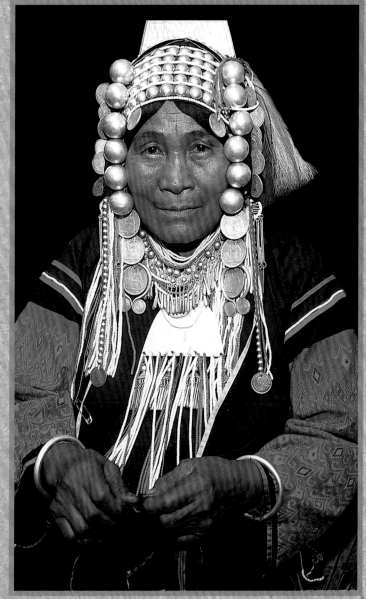

Akha female sowing: Thailand

This isolation has enabled the tribes to maintain political autonomy, and has kept their cultures and traditions relatively intact, although signs of change are unmistakable. Today, these tribespeople easily move back and forth to the largest cities, as far as Rangoon, Vientiane, and even Bangkok without the luxury of a passport or visa.

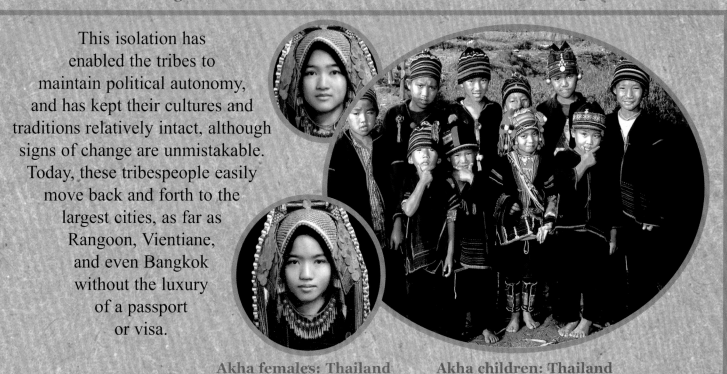

Akha females: Thailand

Akha children: Thailand

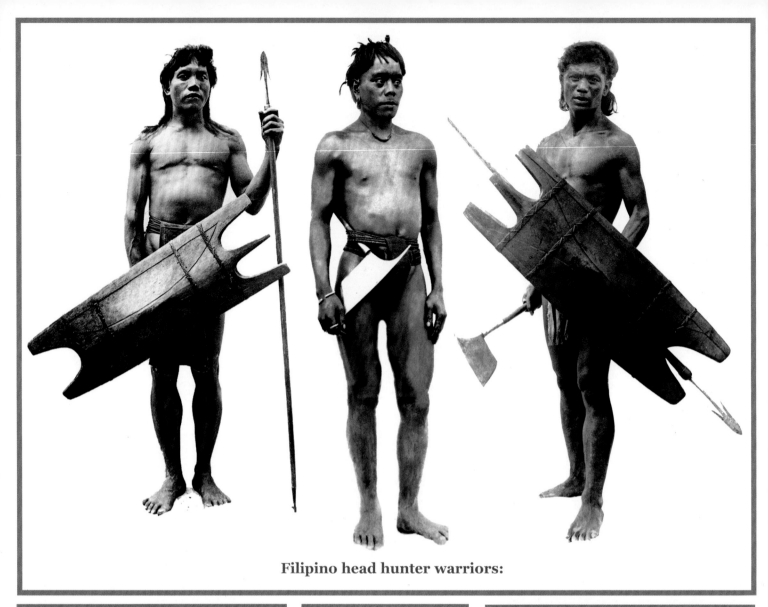

**Filipino head hunter warriors:**

Their persistence in maintaining a vibrant traditional village culture is clearly a matter of choice and a point of pride. But most tribespeople are not literate or modern in the Western sense. The Yao and Lantien are exceptions because they do keep books, but transmission of knowledge and

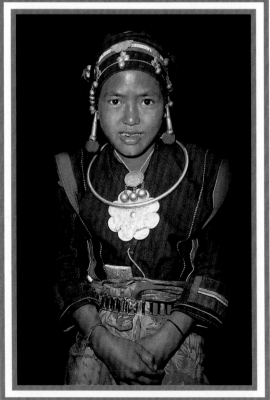

**Akha female: Laos**

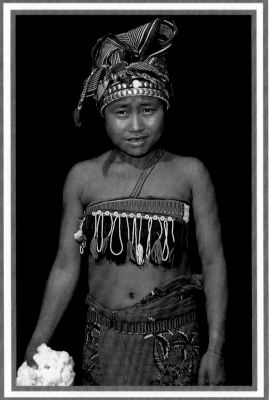

**Akha female: Laos**

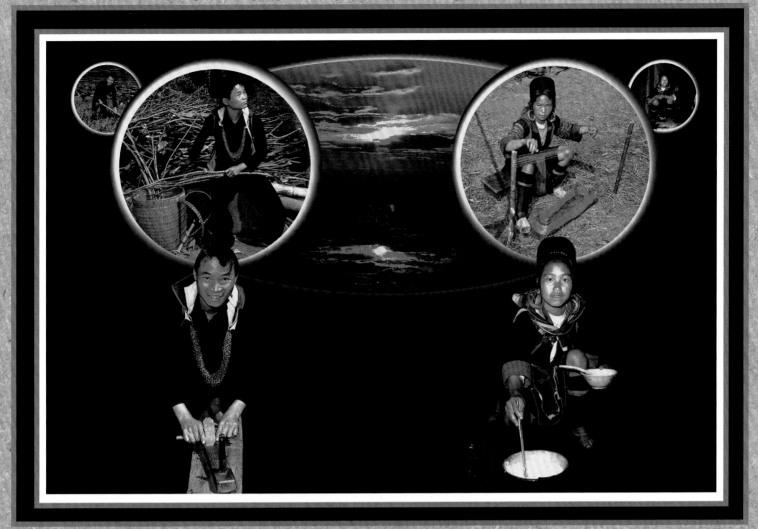

**Black Hmong male and female**
**cooking, gardening, weaving, and woodworking at dawn: Vietnam**

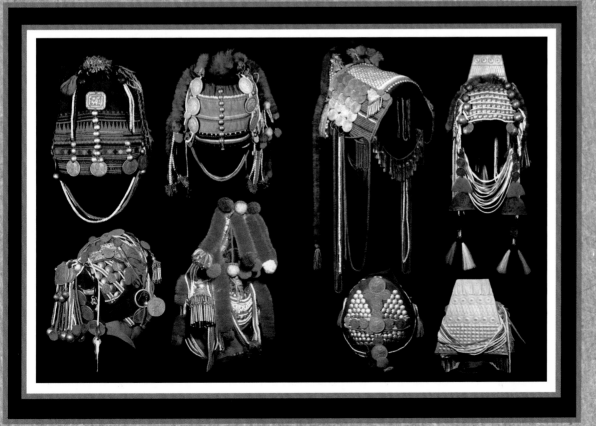

codes of conduct are generally accomplished by oral tradition, folk art, and in the case of the Hmong, by the very iconography embroidered into their clothing. In a very real sense, these Asian tribes wear and display their culture, a point I sought to graphically illustrate in the photographs that follow.

**Akha female's headdress      Top left pair for children:      Laos and Thailand**

The majority of the Akha tribe remain in Yunnan province, in China where they originated. Over the course of several centuries, however, groups of Akha migrated into Laos, Vietnam, and Thailand via Burma (Lewis & Lewis, 1984). Akha settlements are generally below the crest of ridges, on steep terrain between 3500 and 4000 feet in elevation. The Akha are swidden (slash and burn) farmers, a crop culture that encourages nomadic movement (Lebar, Hickey, & Musgrave, 1964). The Akha have no written history, but a powerful tradition of legends and rituals connects them to their ancient past. As in many Asian tribal cultures, ancestors are venerated as the source of all life and knowledge. The Akha

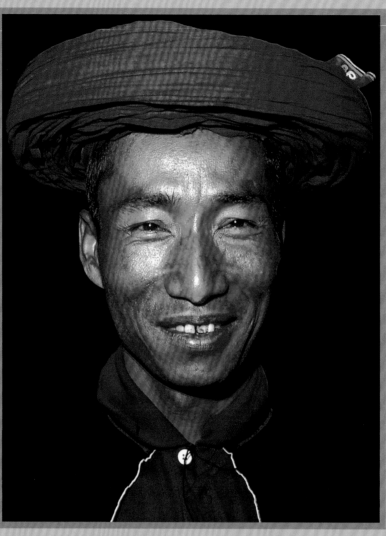

**Akha tribesman: Laos**

tribespeople, although scattered throughout China, Burma, Thailand and Laos, are in considerable agreement about their genealogies and migratory routes, an impressive consensus considering the lack of a written language (Lewis & Lewis, 1984). The "Akha Way" described in this book embraces every aspect of Akha life. Akha mythology and traditions provide a continuity that tribe members are expected to maintain. Their deity, an all-powerful spirit, possesses the qualities and memories of the ancestors and is intimately involved with the daily life of the Akha (Lewis & Lewis, 1984). Thus, the Akha Way places great emphasis on ancestor worship and ancestral spirits. Some spirits reside

**Black Hmong female: Vietnam**

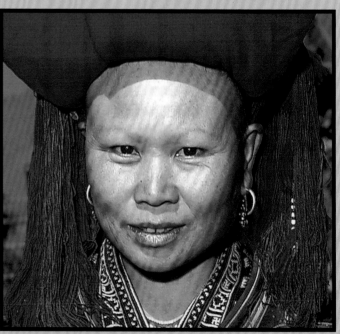

**Red Zao female: Vietnam**

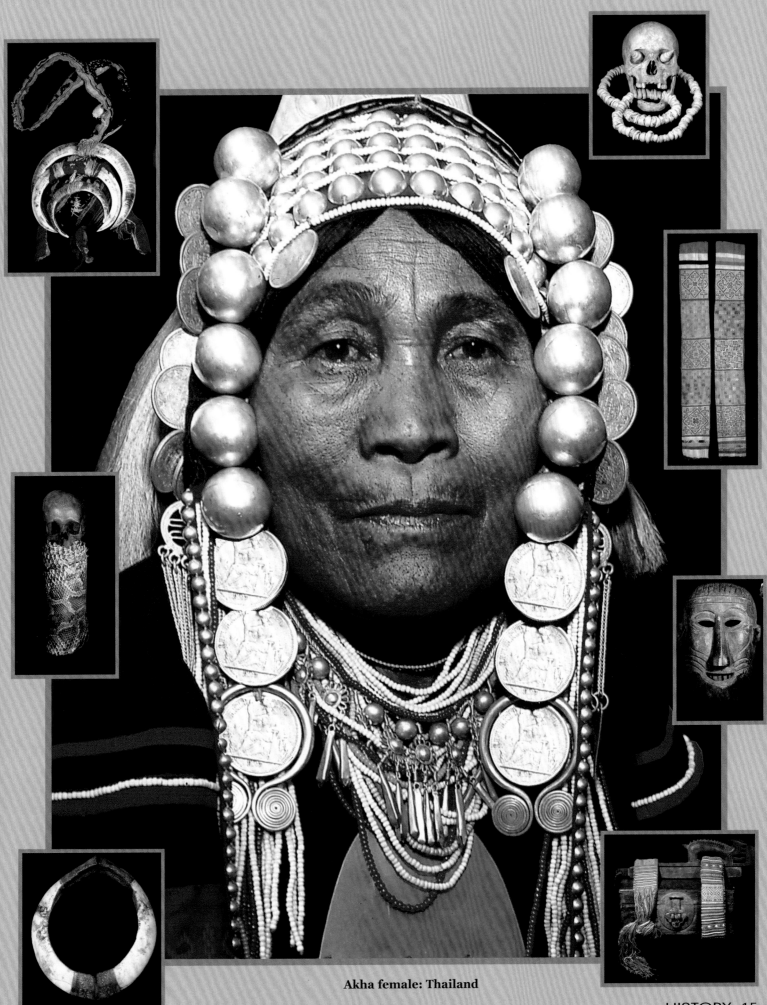

**Akha female: Thailand**

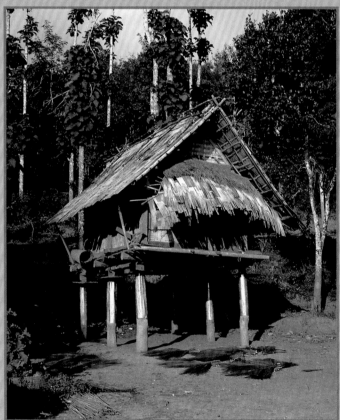

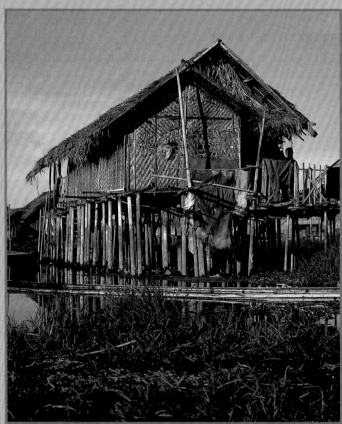

Tribal huts: Laos, Burma, Philippines, and Vietnam    (inset) Akha Spirit Gate

in familiar objects; some are malevolent while others are guardian spirits of the house (Lebar, Hickey, & Musgrave, 1964). Wooden gateways are installed at the upper and lower ends of the village to keep spirits and people separate. Male and female figures are placed at the main gate to indicate that the realm of humans is within the gate. Each Akha house also has an ancestral altar, which is key to ritual ceremonies, recorded in this book, that concern ancestor worship.

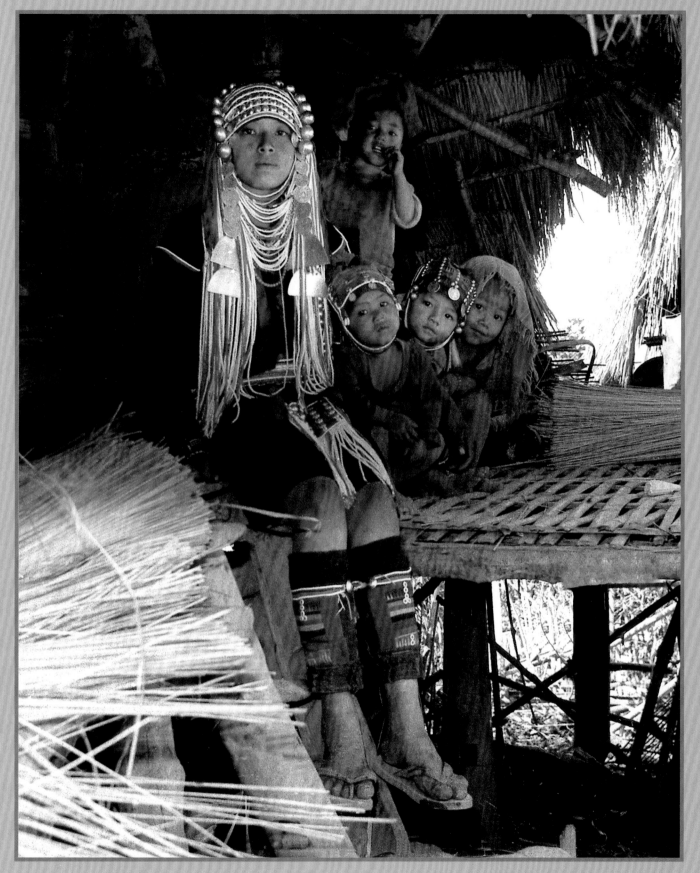

An Akha mother with her four children in their home: Thailand

The several Hmong tribes are differentiated by variations in their clothing color and pattern. The Flower Hmong dress in brightly colored garb that is woven and embroidered in intricate patterns, while the Black Hmong wear indigo-dyed hemp clothing of a more somber cast. The Hmong emigrated from central China, and possibly beyond central Asia, to Yunnan, Laos, Thailand, Vietnam, and Burma. Hmong legend holds that their original home was an "icy land," perhaps north China or even Mongolia (Diran, 1999).

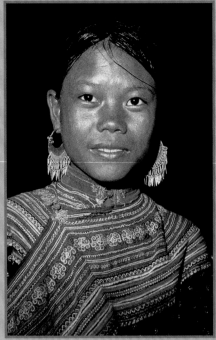

Flower Hmong: Vietnam

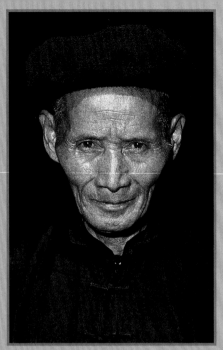

Flower Hmong: Vietnam

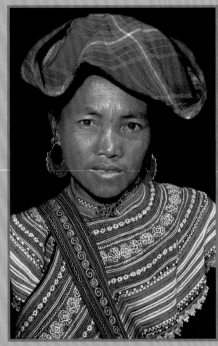

Flower Hmong: Vietnam

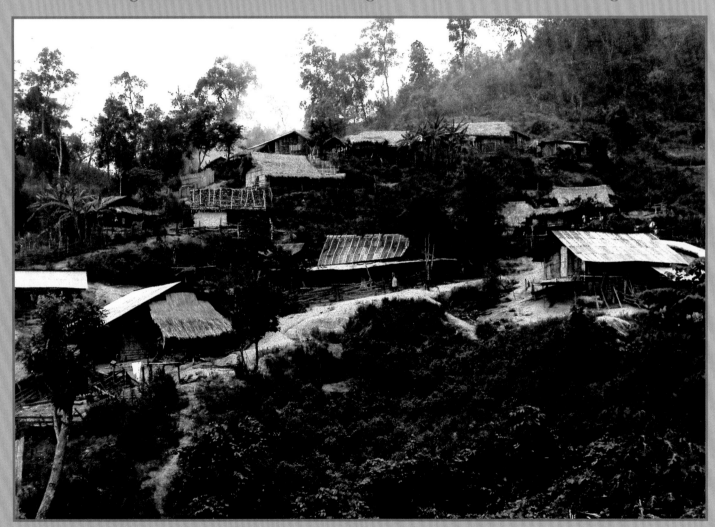

Hmong village: Thailand          (inset below): **Five ceremonial Yao shaman's dagger rattles**

During the 18th and 19th centuries they waged a protracted armed conflict with the dominant Han Chinese. Fleeing the repeated attempts by the Chinese to subjugate them, the Hmong dispersed (1984). The Hmong maintain ancestral altars in their homes. Shamans use ceremonial rattles when they put themselves in trances to communicate with the spirit world, for example, to deal with illness or contact the dead. Paper "spirit money" is burned as an offering, and

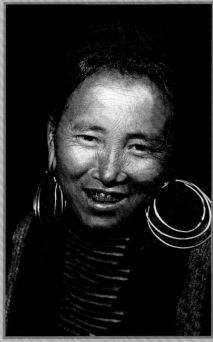

Black Hmong: Vietnam

Black Hmong: Vietnam

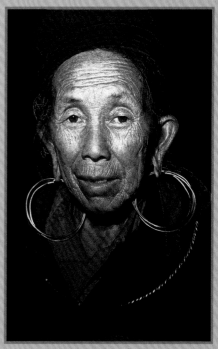

Black Hmong: Vietnam

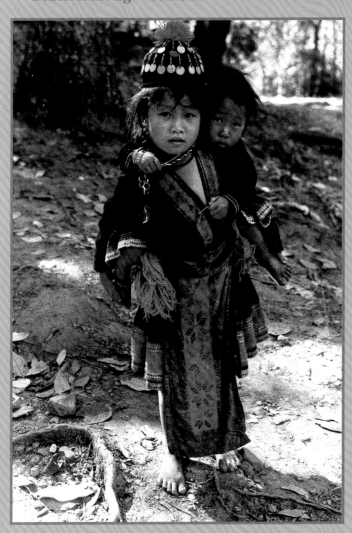

Hmong children lost in Thailand

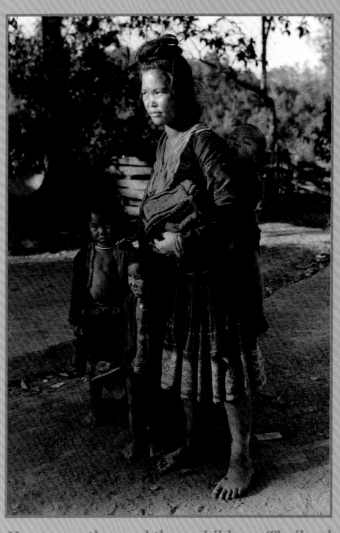

Hmong mother and three children: Thailand

divining sticks are used to ascertain the outcome of the struggle between the shaman and evil forces. The Hmong tribes all have respected village elders, but within the family, the eldest male has unlimited authority over the other members of the family. Within the clan, each person has obligations to the others members of his or her clan (Lewis & Lewis, 1984). But the larger tribe is a single people who recognize their kindred spirits and common origins.

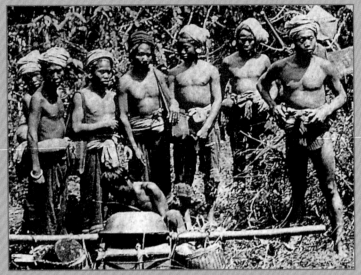
Hunting on the Mekong river banks: Laos

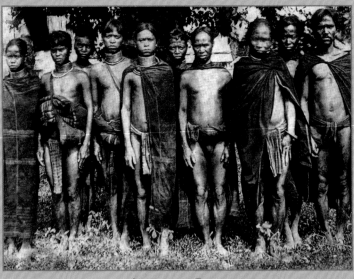
Attapeu: Laos

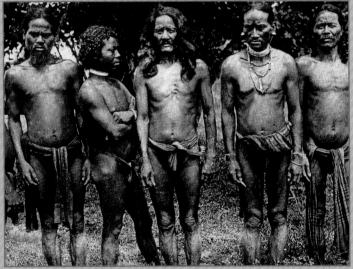
Bassac: Laos

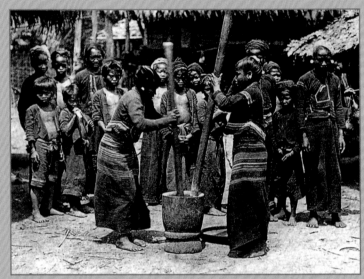
Village rice pounding: Laos

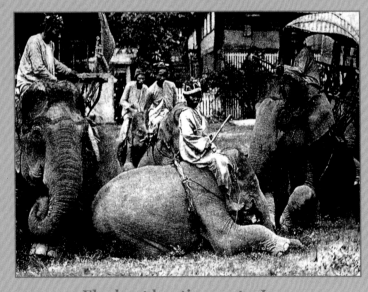
Elephant hunting party: Laos

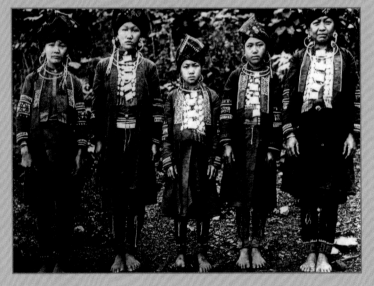
Ko-Po-Sang: Laos

The Yao call themselves the "Mein." They have a primitive written tradition that is unique among Asian tribal people that dates back several centuries. The Mein, like the Hmong and Akha, most likely originated in the south of China two millennia ago. One migration legend is that Mein ancestors crossed the sea in the 14th century, but it is known that they migrated into Thailand around the middle of the 19th century (Lewis & Lewis, 1984). Yao settlers from the late 18th and early 19th

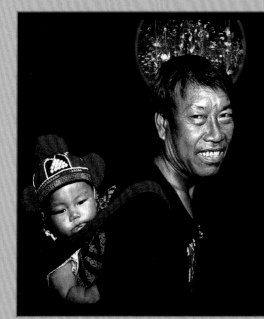

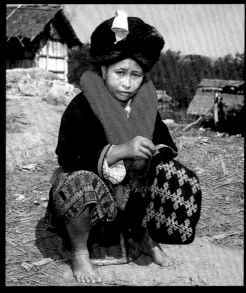

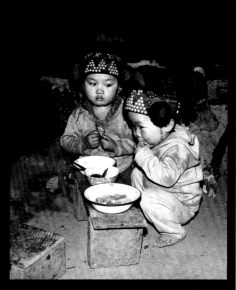

**Yao tribesman and child**    **Yao seamstress: Laos**    **Yao children: Thailand**

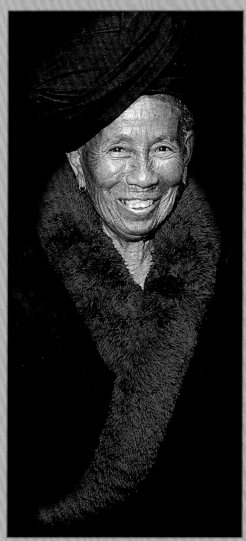

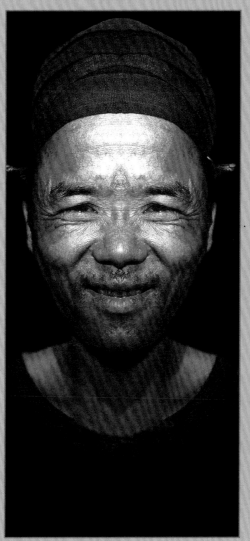

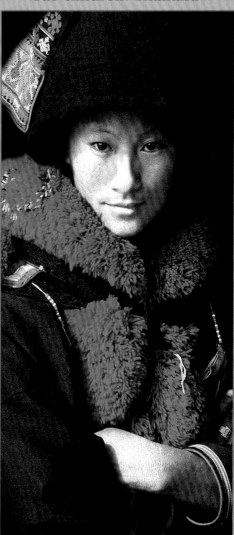

**Yao woman: Thailand**    **Yao tribesman: Laos**    **Yao female: Thailand**

century came from Yunnan and Vietnam. The Yao in Laos moved to Thailand to stay, or to emigrate as refugees to the West. Their population has stabilized in the last two decades, with some of the tribe having returned from Thailand (Pourret, 2002). The Yao practice a religion that is a blend of the 14th century Taoist system and a more primitive animist belief in spirits and ancestors. Their most important rituals require the display of the Taoist pantheon; comprising a celestial hierarchy of the

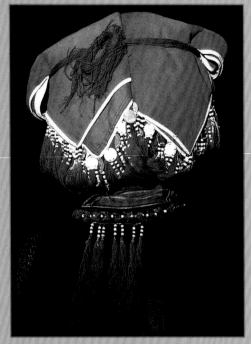

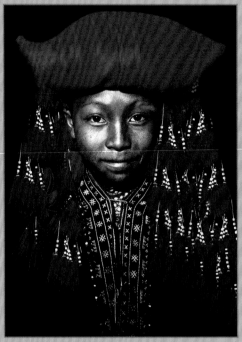

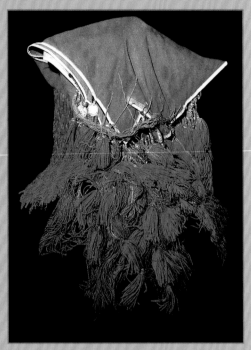

A Red Zao female's headdress     Red Zao tribeswoman: Vietnam     Red Zao female's headdress

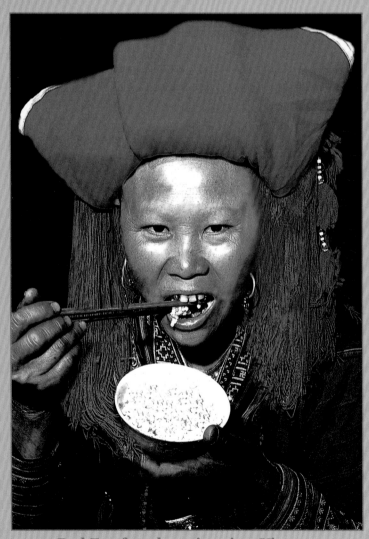

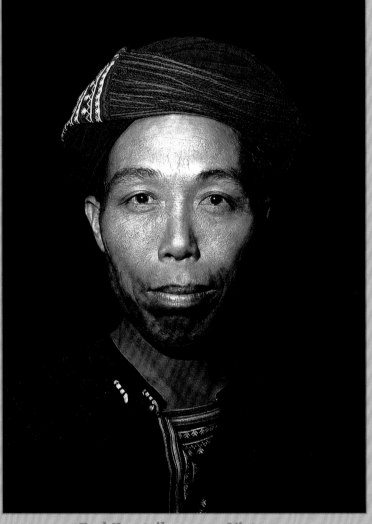

Red Zao female eating rice: Vietnam        Red Zao tribesman: Vietnam

supreme functionaries (Lewis & Lewis, 1984). There are 17 pictures in a set plus a long scroll known as the "Dragon Bridge of the Great Tao." Livestock, money, and goods are also required for Taoist rituals in order to properly carry out spiritual obligations. The Yao headman is responsible for the general welfare of the villagers; he maintains security, directs rituals, celebrations, and presides over tribal meetings. He acts as a mediator, suggesting alternative resolutions to conflicts,

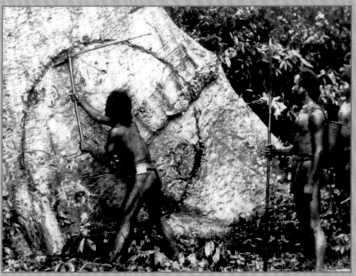
Tribal designs on trees: 19th century Thailand

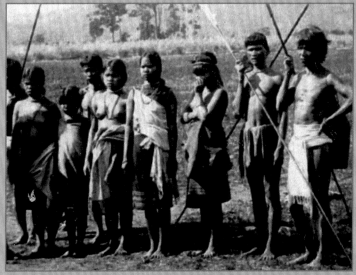
Tribal hunting party: 19th century Thailand

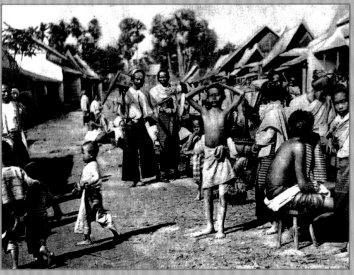
Chiang Mai's 19th century market: Thailand

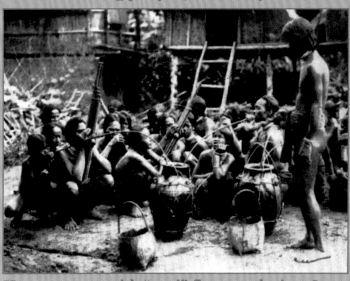
Hmong party with "qeej" flutes and wine: Laos

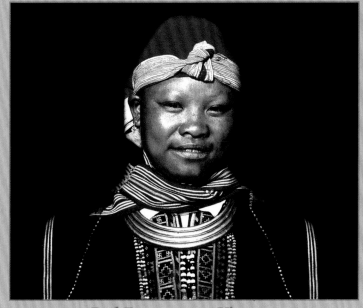
Red Zao woman: Vietnam

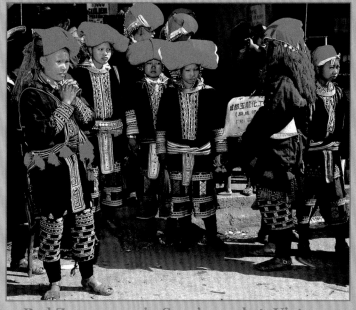
Red Zao woman in Sapa's market: Vietnam

rather than as a judge to resolve disputes (Lewis & Lewis, 1984). The Red Zao reside in remote areas of north Vietnam; their culture centered in the Hoang Lien Son Valley. The Red Zao, so designated because of their bright tribal apparel, believe in a "Divine Eye," an attribute of deceased ancestors who see all of existence. Ancestors are omnipresent and omnipotent, living as enlightened, blissful beings. The tribal origins of the Red Zao probably lie in South China,

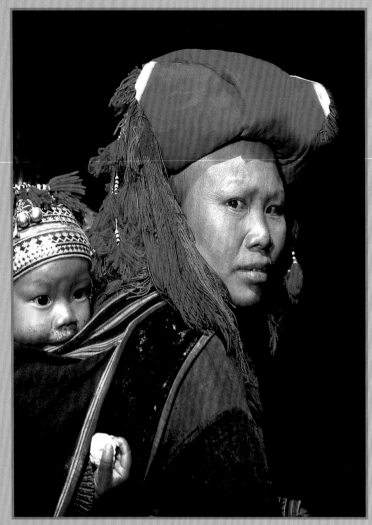
Red Zao mother and child: Vietnam

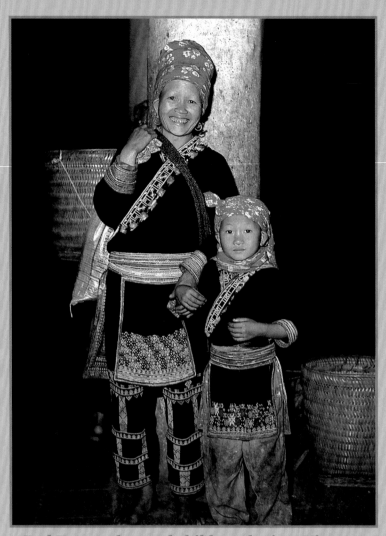
Red Zao mother and child marketing: Vietnam

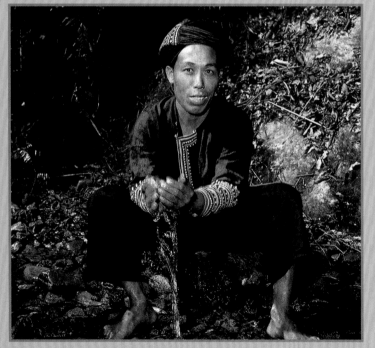
Red Zao tribesman washing in a river

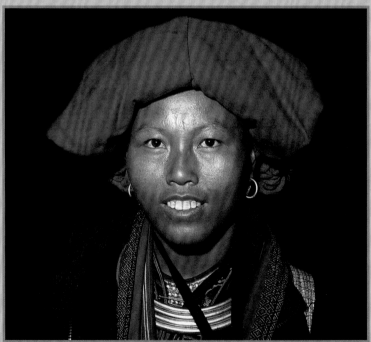
Red Zao female: Sapa Vietnam

but because of their relative isolation, and the conflicts of the Vietnam War era, they have remained in obscurity until recently. Red Zao tribal rituals comprise a combination of animism, ancestor worship, and ceremonies for life events such as the naming of children. Their food sources come from a combination of subsistence agriculture, hunting and gathering, and a newly emerging, but still small, market for artifacts and clothing. The Red Zao settled in remote areas that lack

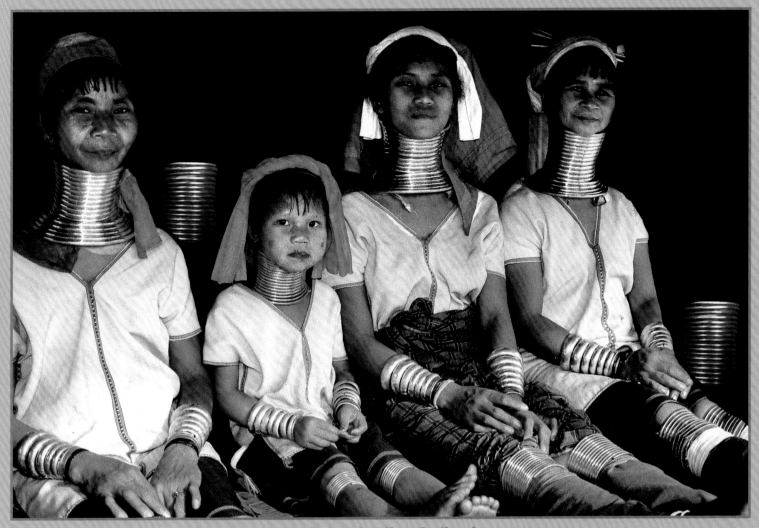

Padaung family: Thailand

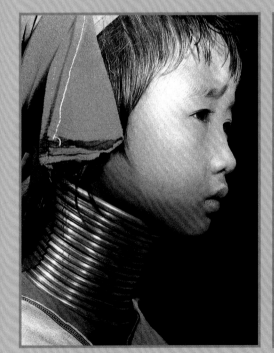

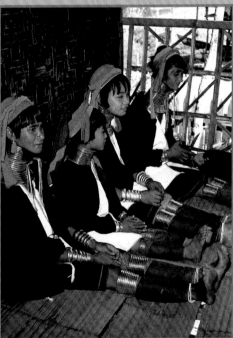

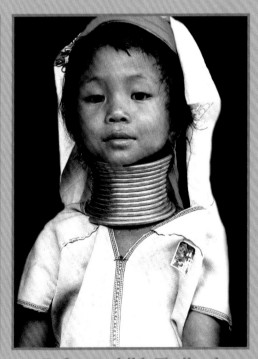

Padaung child: Burma          Padaung family: Burma          Padaung child: Thailand

electricity and running water, and although virtually isolated from globalization and modern society, their contact with tourists and the AIDS epidemic indicates the Red Zao, too, are threatened by encroaching civilization. The Padaung (Long Neck) tribe however, could possibly be exempt from the Red Zao's dilemma as the Padaung, perhaps deliberately, escaped the confines of civilization into the hills of the Shan State in Burma. Many have converted to Catholicism over the last century, but the old religion persists (Diran, 1999).

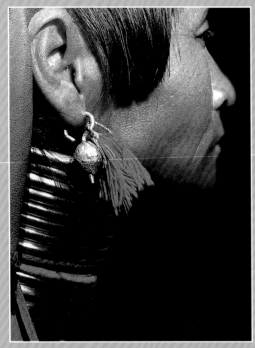

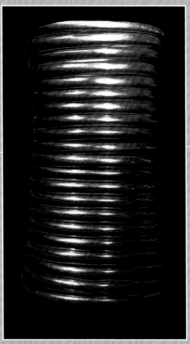

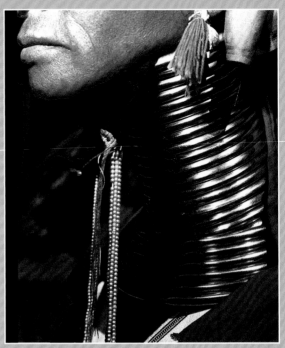

Padaung female and neck coil

Padaung brass neck coil

Padaung woman's neck coil

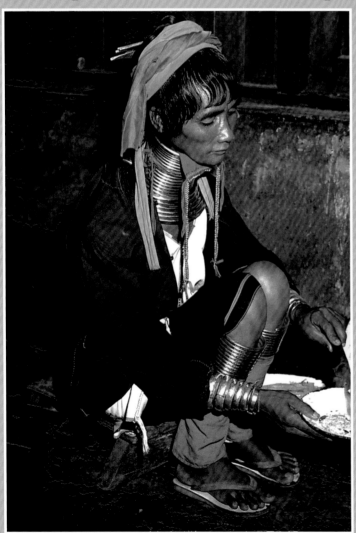

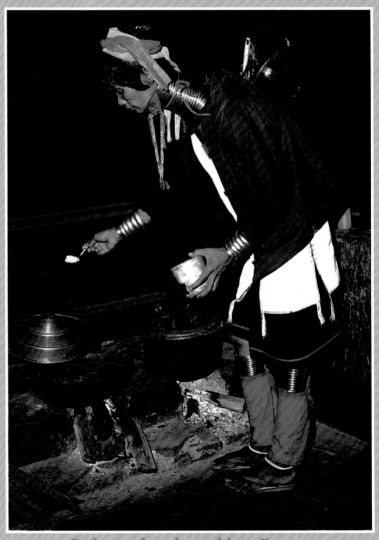

Padaung female eating: Burma

Padaung female cooking: Burma

Padaung women are known for wearing brass neck rings for their entire lives and some even begin the practice before their sixth birthday! New coils are added yearly until the girl marries. Although the longneck custom has given the tribe its common nickname and has been widely photographed and discussed in the West, the Padaung also possess a vital and colorful tribal culture similar to that of their counterparts in the mountains of other Southeast Asian countries. The present restrictions on travel and political activity by the Myanmar (Burmese)

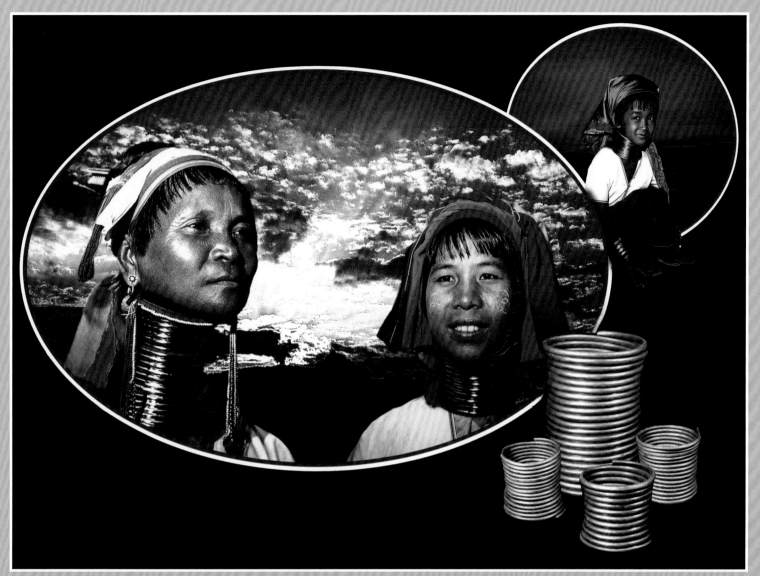

Three generations of Padaung wearing brass neck coils: Burma

Padaung brass bracelets

Padaung leg coils

Padaung brass leg coils

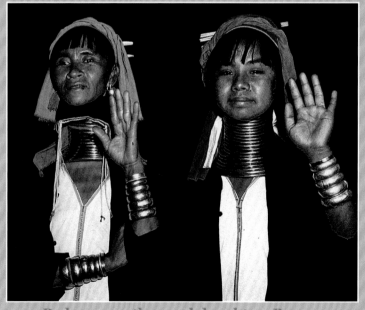

Padaung mother and daughter: Burma

regime will hopefully preserve this vanishing culture from the inroads of modern civilization, at least for the coming few years. Their metalwork and millenery skills still appear to be devoted almost entirely to the internal activities of the tribe, although persistent curiosity (and misunderstanding) about Padaung customs and the tribe's unique and unusual tradition of wearing brass neck rings for beauty and social status has brought droves of Western travelers to their villages in recent years.

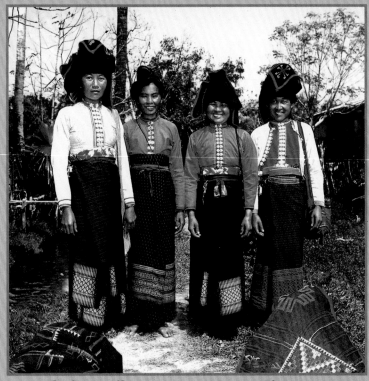

Thai Lu tribeswomen: Muang Sing Laos

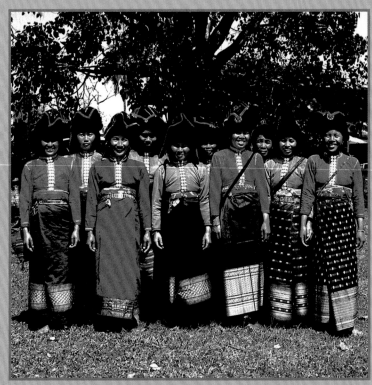

Ten Thai Lu women: Laos

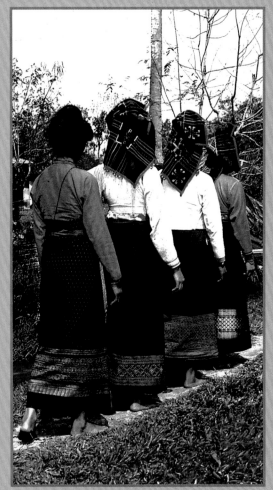

Four Thai Lu woman: Laos

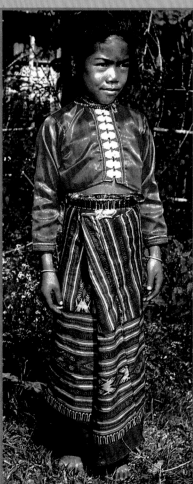

Thai Lu girl

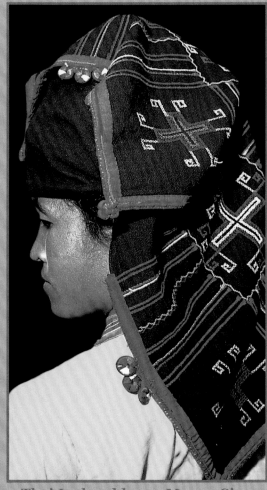

Thai Lu headdress: Muang Sing

The Thai Lu originated in southern Yunnan and emigrated to Laos, Burma, and Thailand over the last two centuries. The Lu are primarily Buddhist, but also believe in various spirits and divinities; there is no developed ancestor cult as such. Among the Thai Lu, Buddhist monks use charms and talismans to counteract illness (Lebar, Hickey, & Musgrave, 1964). Traditional Lu society embraces communal elements but the family and household influence remains strongest. The father, as head

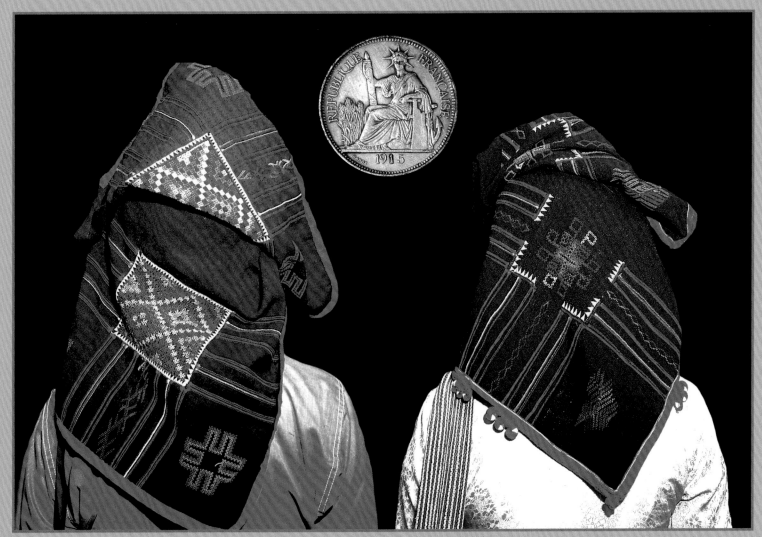
Thai Lu headdress and an old French franc tribal hairpin: Laos

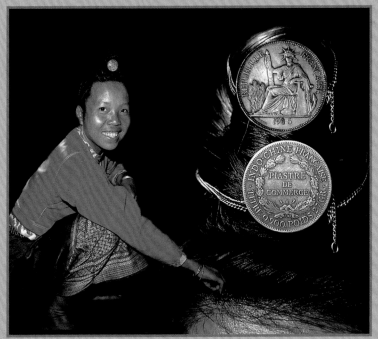
Thai Lu's most prized possession: coin hair pins

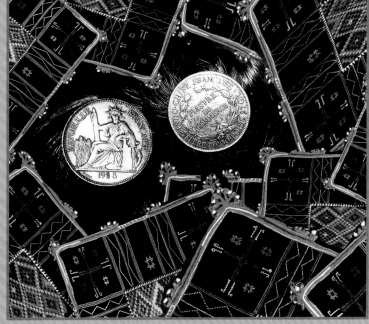
Thai Lu textile headdress and old coins: Laos

of the household, holds all the domestic power and runs family affairs. The Buddhist monks perform tasks which are clearly animist or superstitious in nature, and many village structures and artifacts are well outside the Buddhist tradition. Like the Akha and other tribes, the Lu erect sacred posts, gates, and doorways around their village temple so villagers can receive the blessings of deities and separate the world inside the sacred circle of the village from the external world beyond their experience.

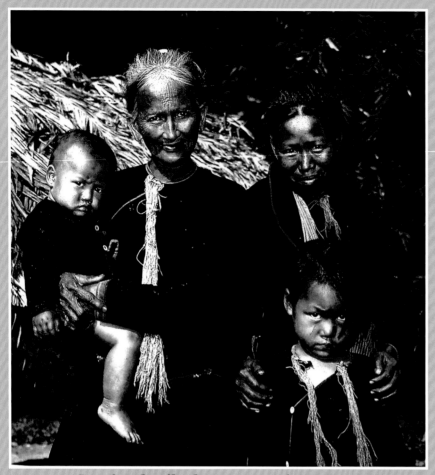

Lantien family three generations; Laos

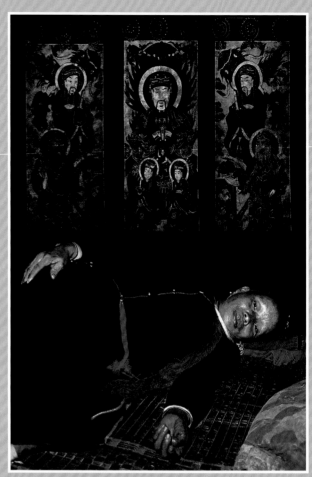

Lantien woman during Taoist ritual

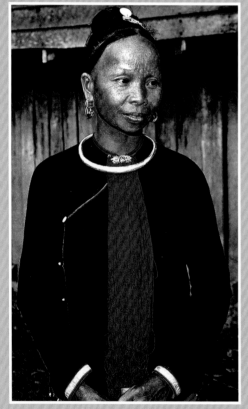

Lantien female: Laos

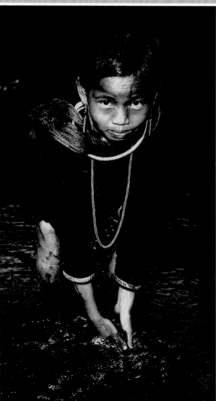

Lantien child river washing

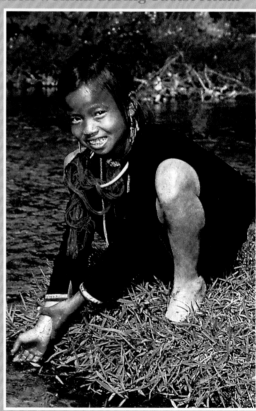

Lantien girl bathing: Laos

The Lantien migrated into Laos centuries ago, perhaps from China, as many other tribes have done. They, too, practice a religious tradition known as "The Way," which acknowledges ancestors as gods and the concept of a living force within all things, animate or inanimate. This blend of reverence for ancestors and animistic philosophy also has elements of Taoism,

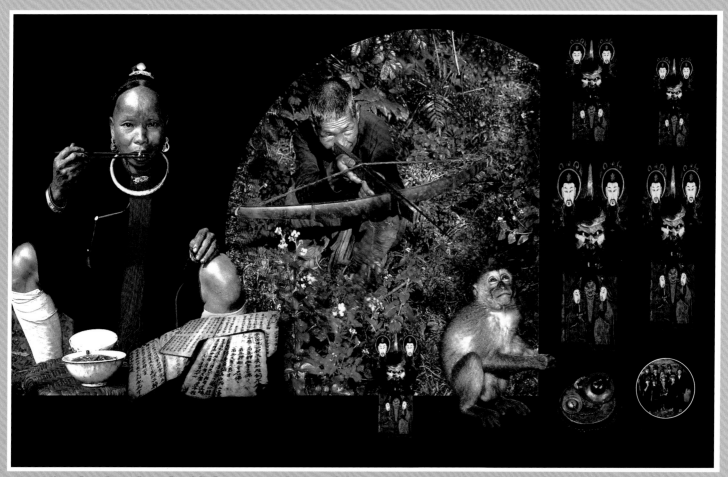

Lantien husband and wife hunt monkeys with crossbows, eat, and practice Taoist rituals: Laos

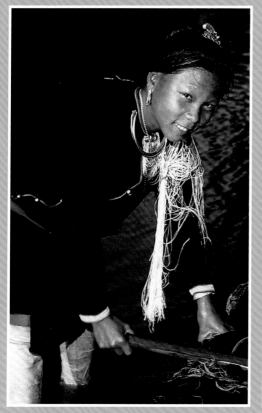

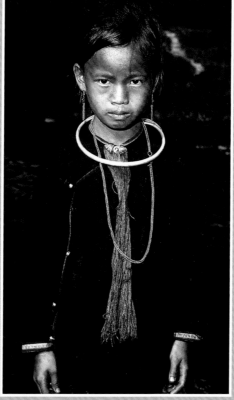

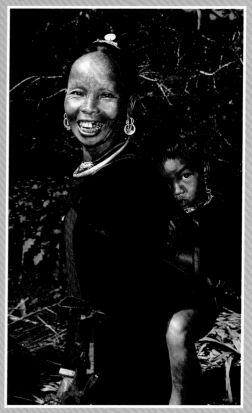

Lantien woman river washing          Lantien child: Laos          Lantien mother and child

modified into the Way, or path that informs the whole of nature and human existence. For the Lantien, as for other Asian tribes practicing variations on traditional Chinese Taoism, the essence of wisdom is for the human being to live and create artifacts that reflect the natural order of the Way; a cosmic river of existence that shapes every aspect of our worldly existence.

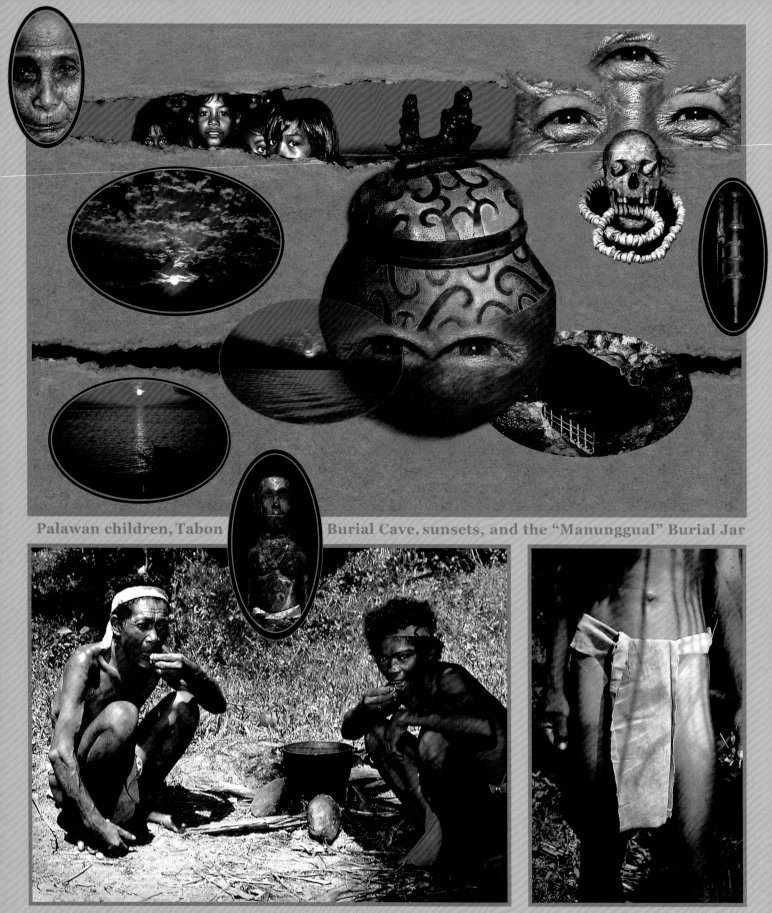

Palawan children, Tabon Burial Cave, sunsets, and the "Manunggual" Burial Jar

Palawan tribesmen eating (inset): Palawan tribal deity: "Tao Tao"   Palawan tribemen's loincloth

The Palawan tribe inhabit Palawan island: the third largest of seven thousand islands, and most southern, in the Filipino archipelago. The tribe believes "the Weaver," who is also referred to as "Ampu the Master," is responsible for "weaving" the world and creating humanity. The religion is animist for the most part, and upholds Ampu as the supreme deity. Although Ampu is a protective presence, He is always invisible to the people on earth.

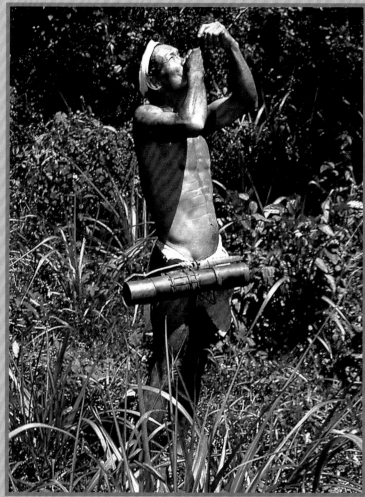

Tribesman hunting with a bamboo blowgun

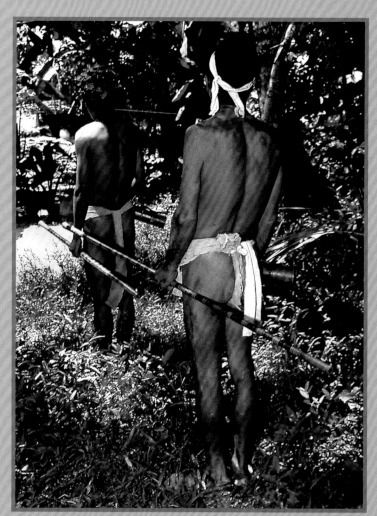

Palawan blowgun and poison dart hunt

Inland mountains on Palawan Island Philippines

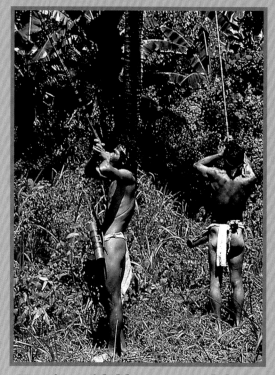

Hunting with blowguns and darts

A benevolent deity known as "Diwata" resides in a space between Ampu's home and Earth, and acts as a mediator between earth and heaven. Other deities in the Palawan pantheon are either benevolent or malevolent. The tribe's shaman establishes relationships between people and these deities through rituals that require six kinds of prayer speeches to dead and living ancestors, while medicinal plants and religious ceremonies are used to cure anxiety and illness.

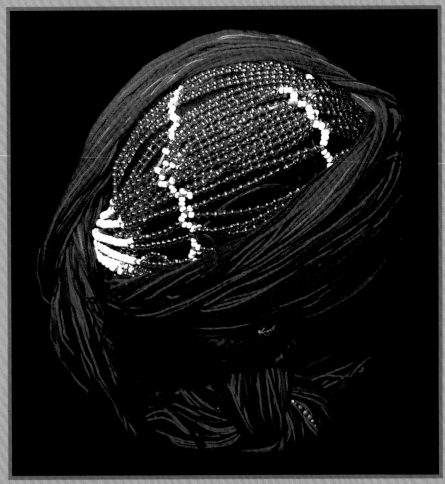

Palaung female's traditional tribal headdress: Burma

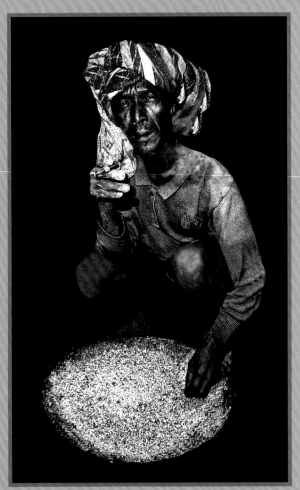

Palaung tribesman sifting rice

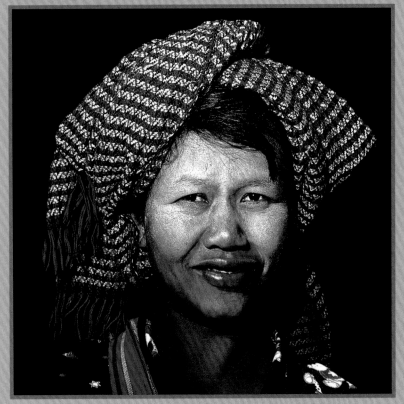

Palaung with powered face and headdress

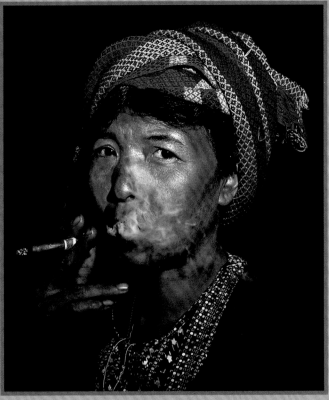

Palaung female smoking a "cheroot"

The Palaung are descended from the Mon-Khmer and live in the mountains of the Shan State in Burma. Their settlements are on isolated barren hilltops or ridges between hills. Rice and tea are their cash and food crops, because opium poppies do not grow well at the altitude where the Palaung settled villages (Lebar, Hickey, & Musgrave, 1964). The tribe practices traditional Animist rituals, but some Palaung revere transvestite gay "Nat" mediums. "Nat Worship" is a mixture of

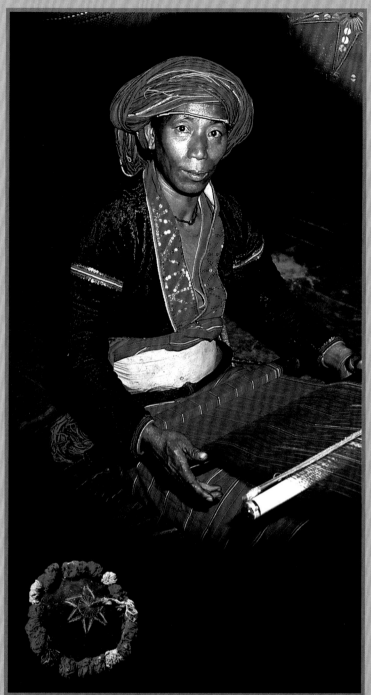

Palaung female weaving: Burma

Palaung female: Tar Yaw village Burma

Palaung traditional tribal headdress and shoulder bag: Burma

Buddhism and Animism that embraces a pantheon of thirty-seven Nat Gods. Although few, some Palaung are pure Buddhists, because towns near their villages promote monasteries, but in a modified, individualized system, the tribe still surely trusts more in their ancient belief that each Palaung has two personal guardian spirits and a variety of other spirit guardians, who protect every aspect and need within their surrounding environment (Diran, 1999).

# CUSTOM RITUAL

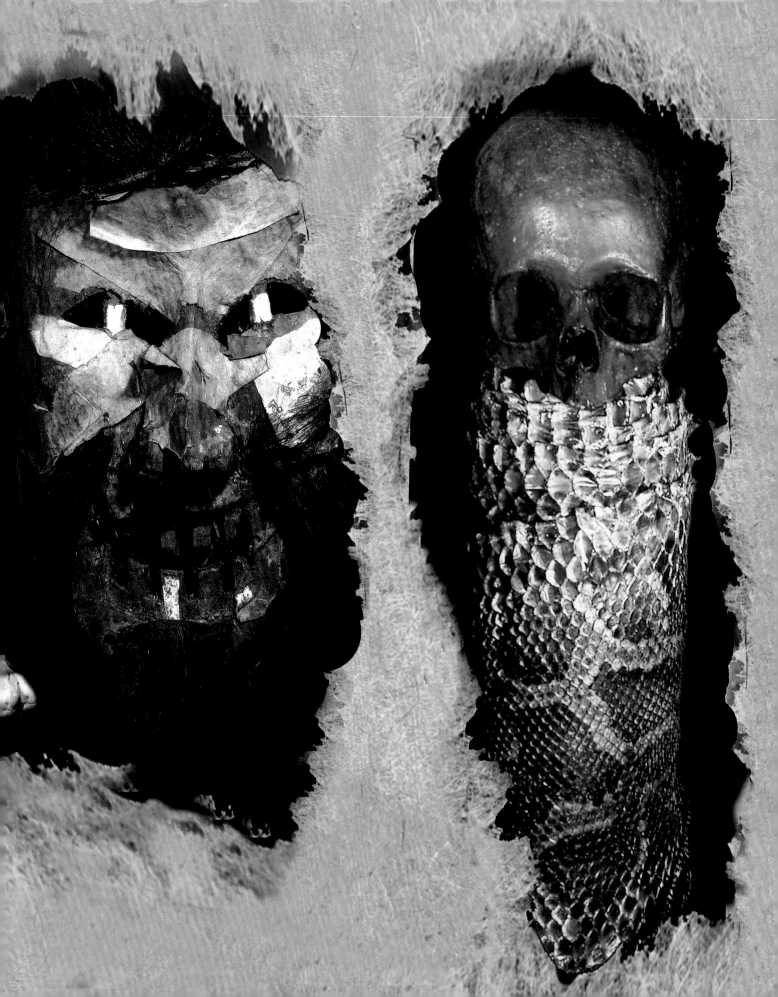

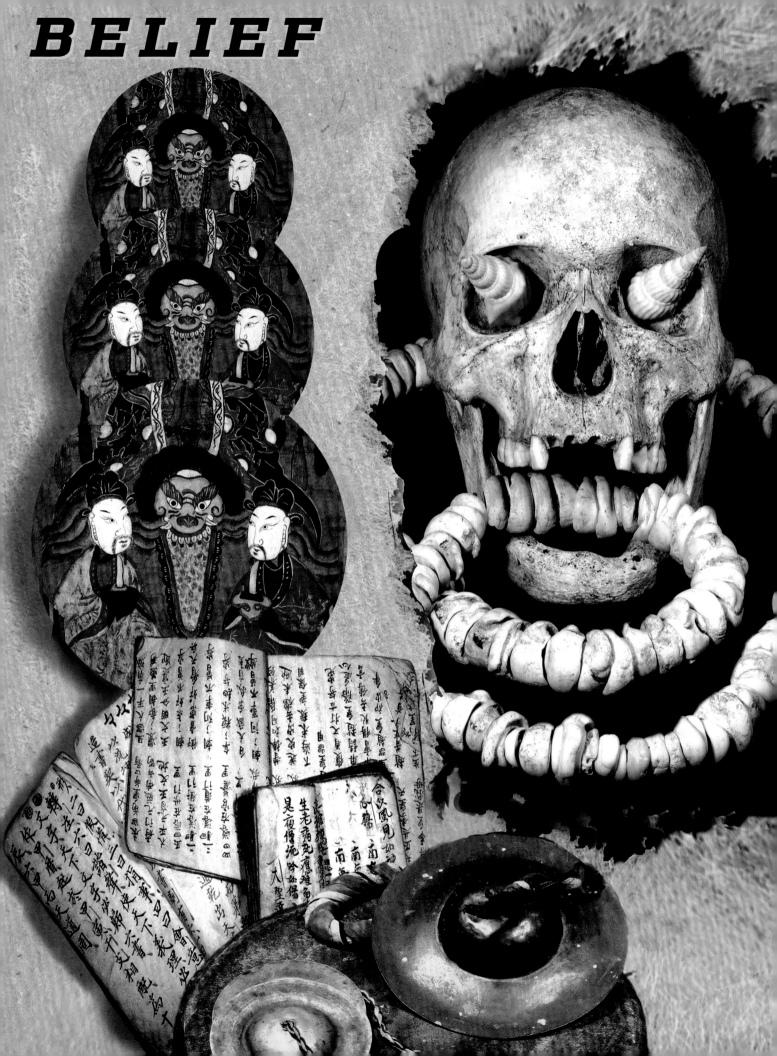

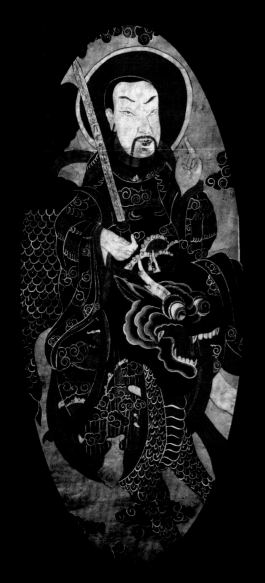

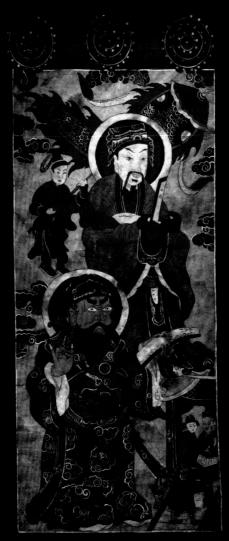

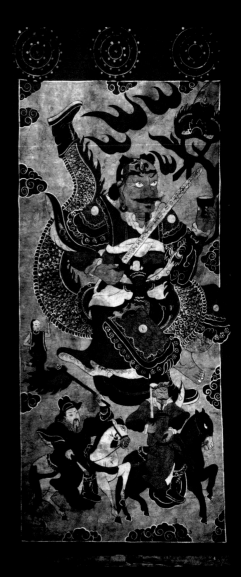

**Yao "Hoi Fan Ton" sacred "Mien Fang" ceremonial scrolls**

"Mien Fang" sacred scrolls are believed to possess the authority and power of the spiritual creators of the ancient Yao religion known as the "Way." These scrolls may have derivations of Buddhist, Taoist, and Animist stories and characters, but their special value lies in their retention of the power of dead ancestors rather than theological import.

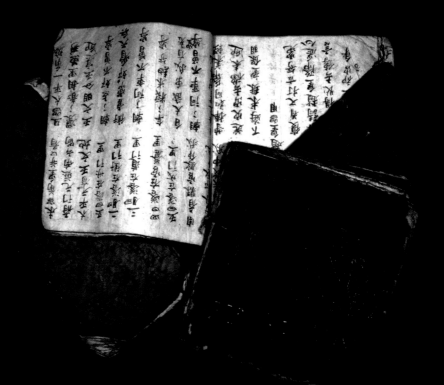

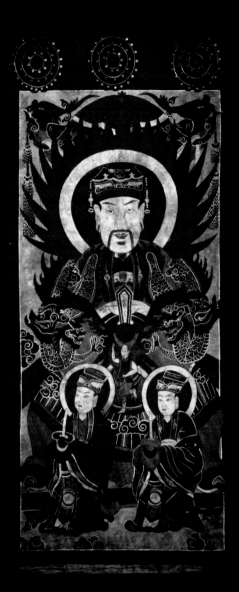

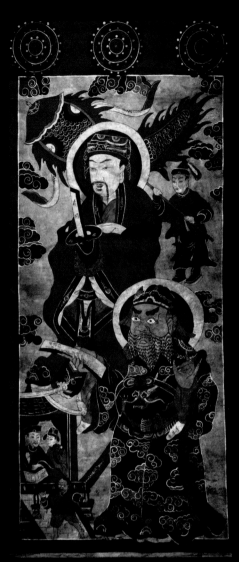

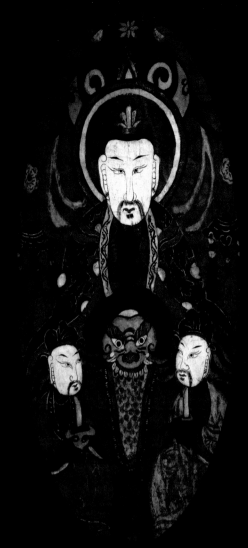

**(below):** **Sacred Yao ritual "Koi Tan" handwritten books**

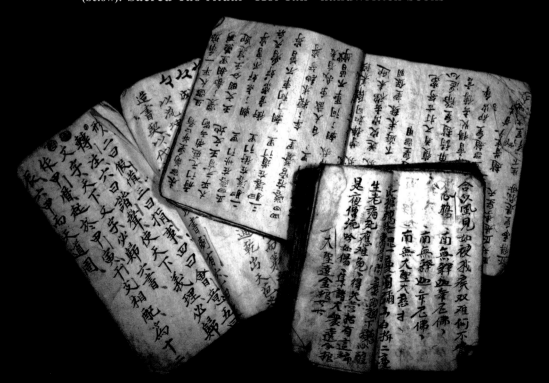

The Taoist pantheon of sacred paintings are displayed during important Yao tribal rituals. Each picture has a specific position and meaning within the display. The scrolls with "Three Stars," on the top represent the most important deities and hang in the center. The names of the gods, the artist, and date recorded on the back give the paintings' sense of sacred power.

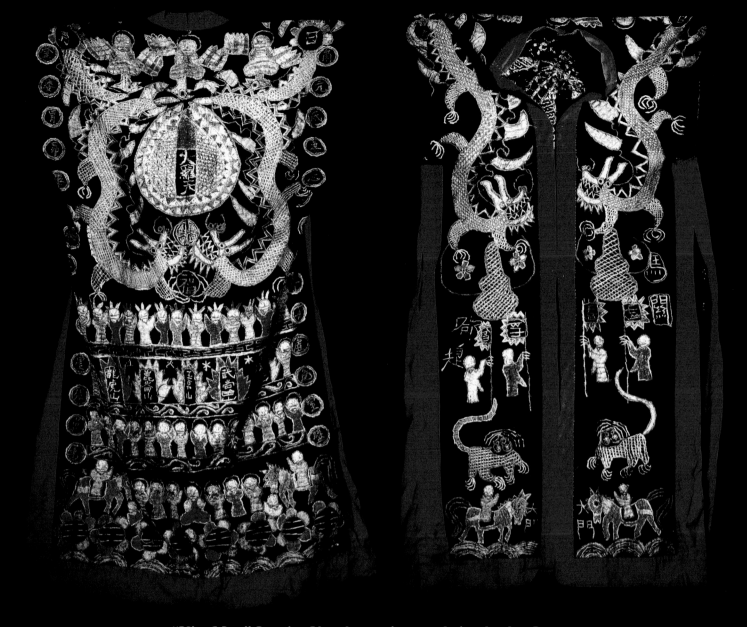

**"Kim Mun" Lantien Yao shaman's sacred ritual robe: Laos**

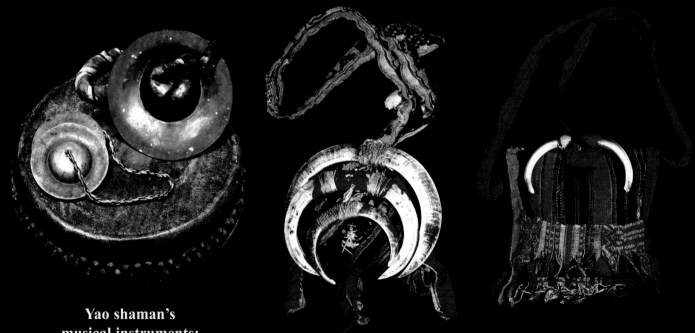

**Yao shaman's
musical instruments:
drum and symbols**

**"Quan Chet" Yao shaman's sacred talisman bags: Vietnam**

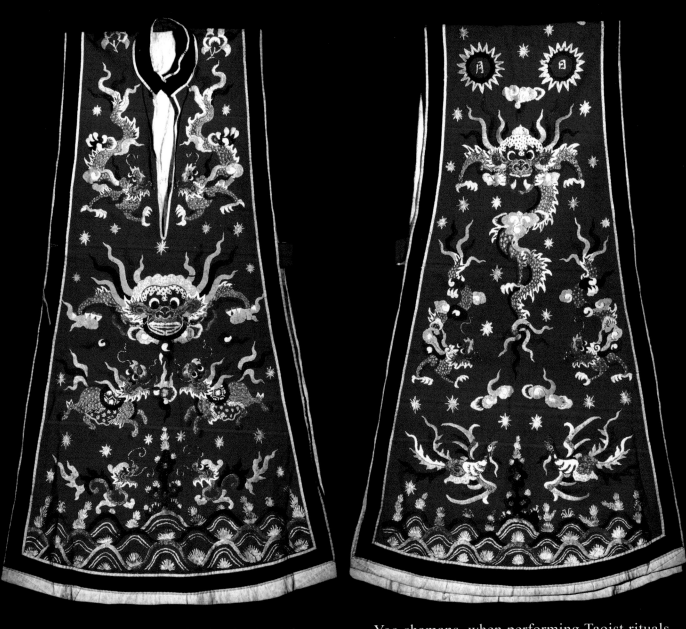

**"Mien Quan Chet" shaman's ritual robe: Vietnam**

Yao shamans, when performing Taoist rituals, garb themselves in "Lei" robes that are made of cotton and decorated on the front with silk embroidered dragon figures. The back flaps depict saints, gods, the Seven Stars, and the abode of the "Three Pure Ones." When performing ceremonies they uses a variety of ritual objects that include a crown, mask, and a set of sacred scrolls.

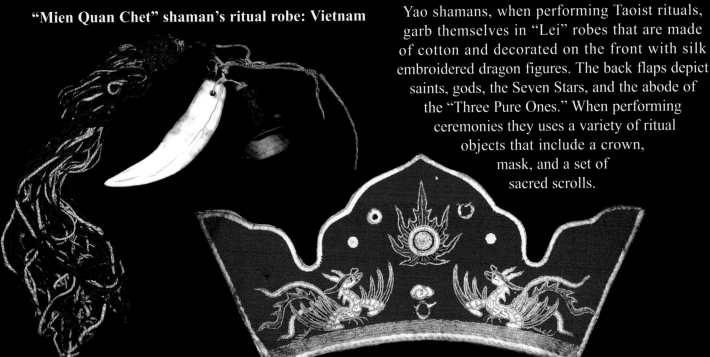

**Loatian "Fam Tsing" ceremonial Yao crown, tiger tooth, and bell**

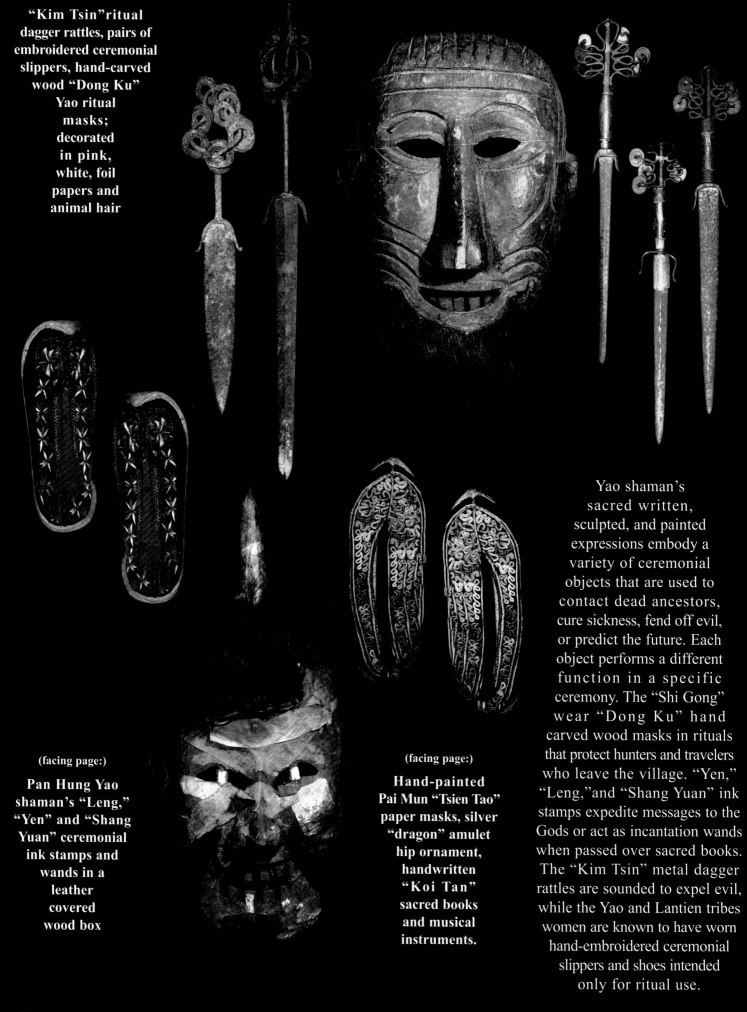

"Kim Tsin" ritual dagger rattles, pairs of embroidered ceremonial slippers, hand-carved wood "Dong Ku" Yao ritual masks; decorated in pink, white, foil papers and animal hair

(facing page:)

Pan Hung Yao shaman's "Leng," "Yen" and "Shang Yuan" ceremonial ink stamps and wands in a leather covered wood box

(facing page:)

Hand-painted Pai Mun "Tsien Tao" paper masks, silver "dragon" amulet hip ornament, handwritten "Koi Tan" sacred books and musical instruments.

Yao shaman's sacred written, sculpted, and painted expressions embody a variety of ceremonial objects that are used to contact dead ancestors, cure sickness, fend off evil, or predict the future. Each object performs a different function in a specific ceremony. The "Shi Gong" wear "Dong Ku" hand carved wood masks in rituals that protect hunters and travelers who leave the village. "Yen," "Leng," and "Shang Yuan" ink stamps expedite messages to the Gods or act as incantation wands when passed over sacred books. The "Kim Tsin" metal dagger rattles are sounded to expel evil, while the Yao and Lantien tribes women are known to have worn hand-embroidered ceremonial slippers and shoes intended only for ritual use.

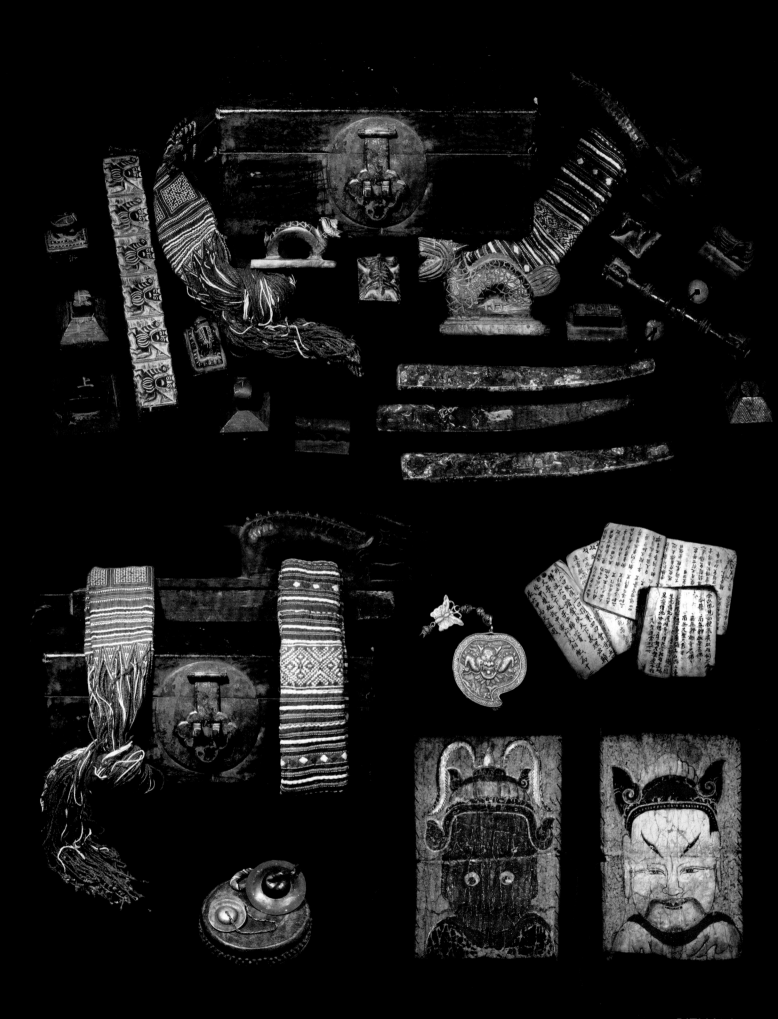

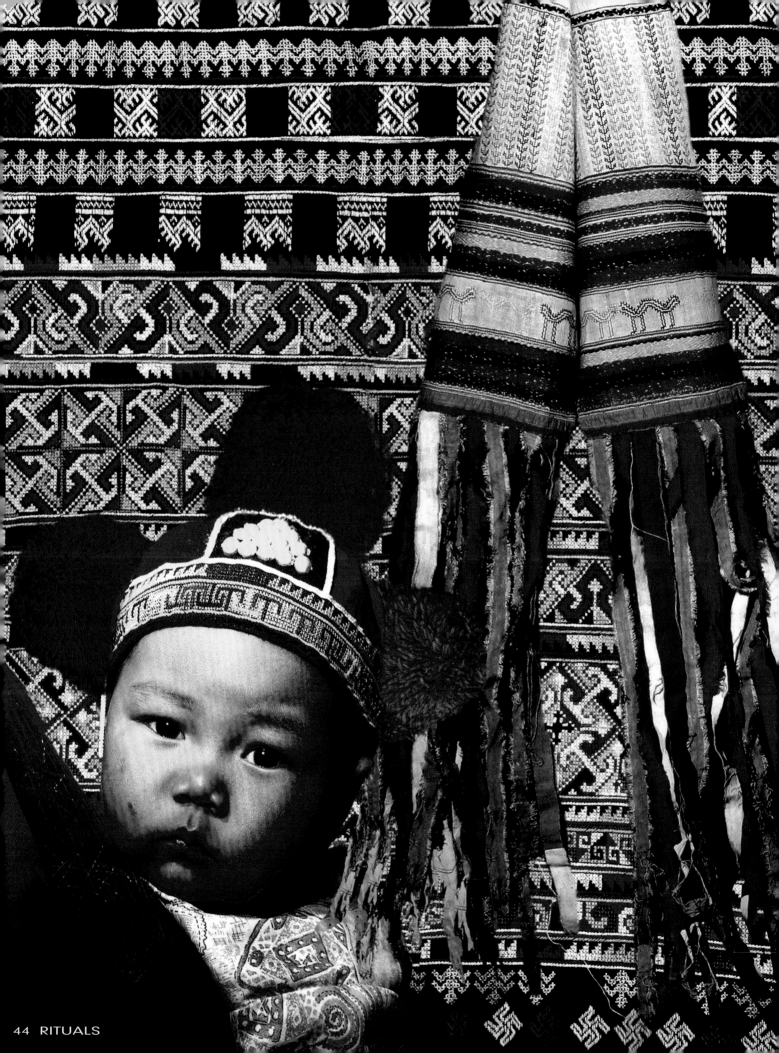

The Iu Mien Yao tribe, in Thailand and Laos, make hats for their children and babies. The caps feature red pom-poms and symbols that include birds, animals, plants, trees, and conceptual iconography. These Yao hats are purely practical and have no ritual intent. The Dao Gong shaman's ritual garments, on the other hand, from the Kim Mun Lantien tribe in northern Laos, also include iconographic images of animals and celestial bodies, but those ritual garments are only intended for ceremonial use.

**"Iu Mien"**
**Yao embroidered**
**children's hats with**
**red pom-poms:**
**Laos and**
**Thailand**

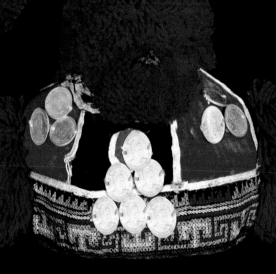

(facing page:)

**"Kim Mun" Lantien**
**"Dan Gong" shaman's**
**sacred ritual turban: Laos**

**Yao female's pants**
**(background)**
**Thailand**

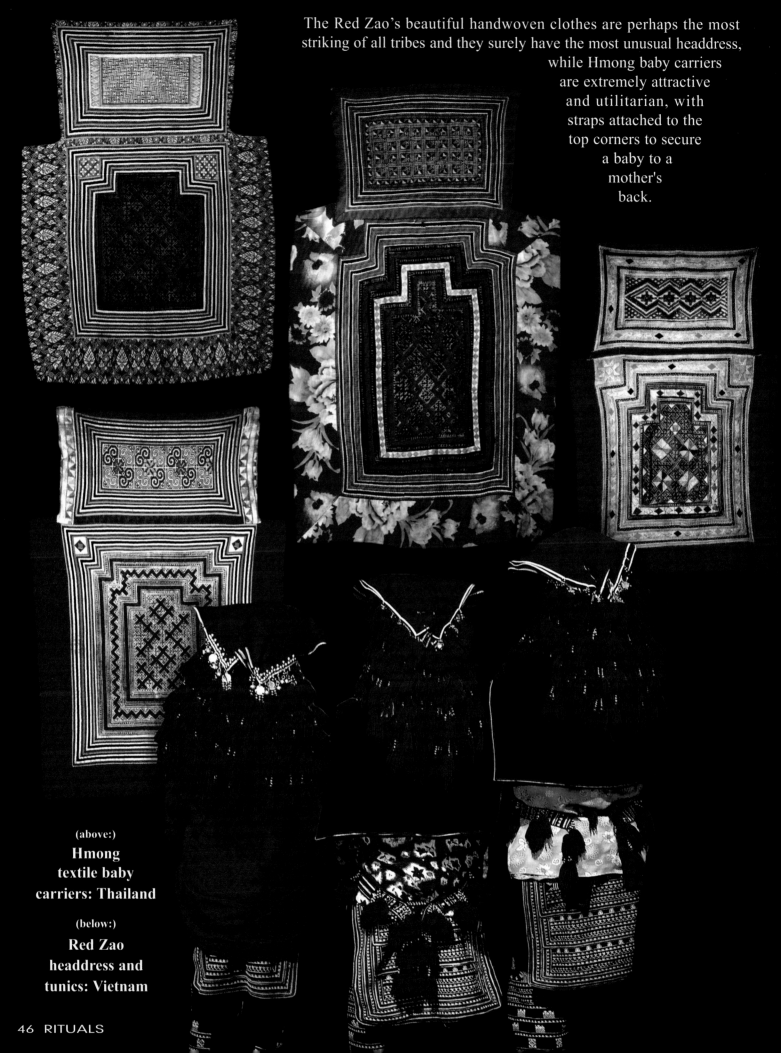

The Red Zao's beautiful handwoven clothes are perhaps the most striking of all tribes and they surely have the most unusual headdress, while Hmong baby carriers are extremely attractive and utilitarian, with straps attached to the top corners to secure a baby to a mother's back.

(above:)
**Hmong textile baby carriers: Thailand**

(below:)
**Red Zao headdress and tunics: Vietnam**

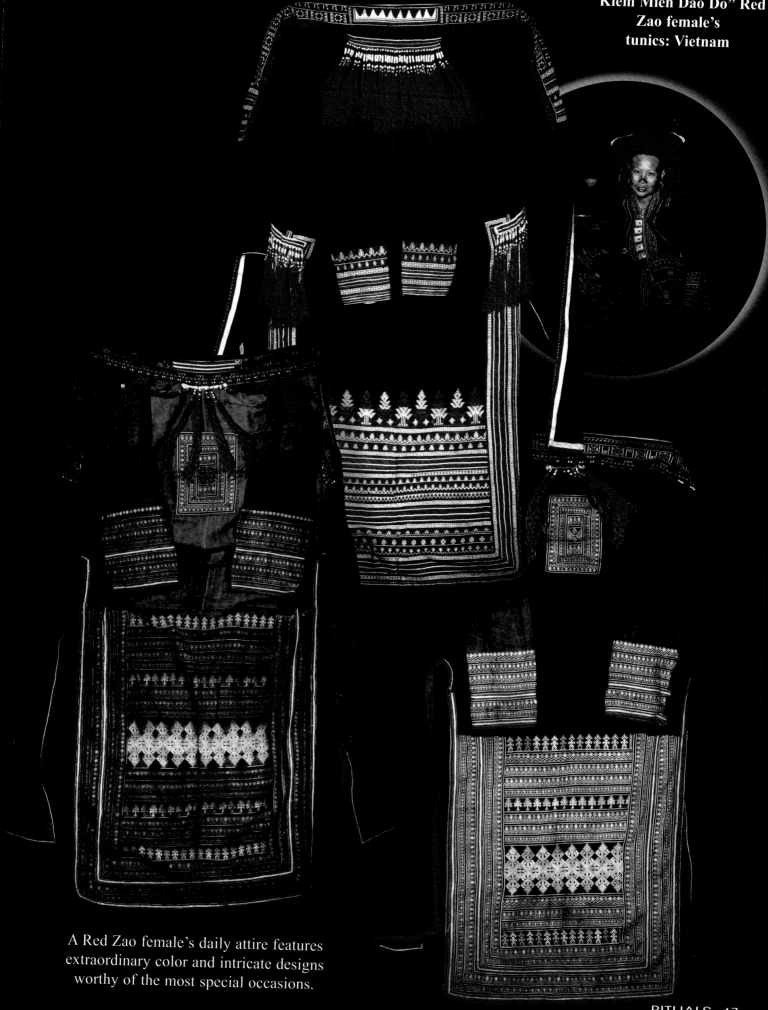

A Red Zao female's daily attire features extraordinary color and intricate designs worthy of the most special occasions.

Lantien tribal ornaments are frequently made from silver wire and 19th-century French francs and Indian rupees.

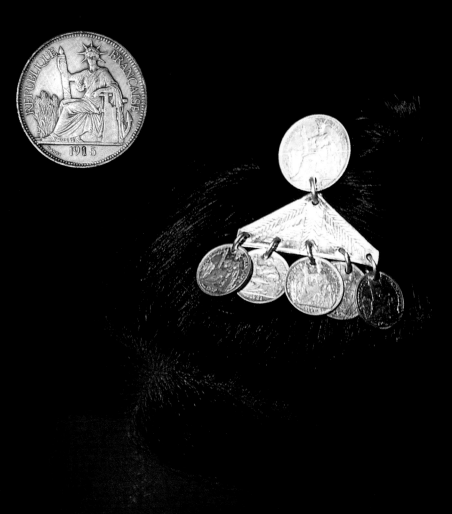

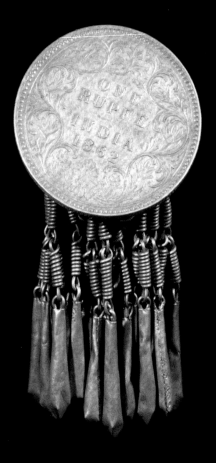

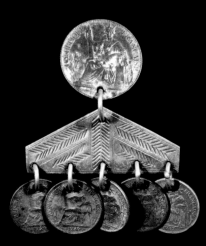

Other Lantien objects consist of round or rectangular silver pendants, hair pins, and buckles.

"Thai Lu" French franc and India rupee coin hairpins, "Tiem Wan" silver Lantien choker, and "Kim Mun" collar clasp: Laos

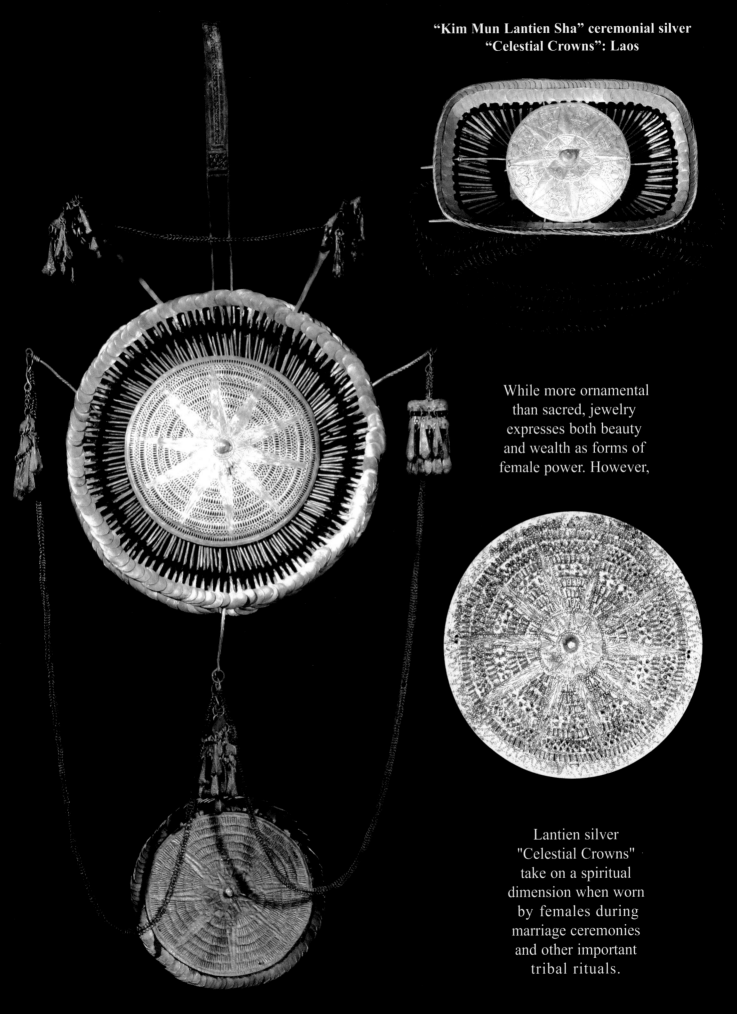

While more ornamental
than sacred, jewelry
expresses both beauty
and wealth as forms of
female power. However,

Lantien silver
"Celestial Crowns"
take on a spiritual
dimension when worn
by females during
marriage ceremonies
and other important
tribal rituals.

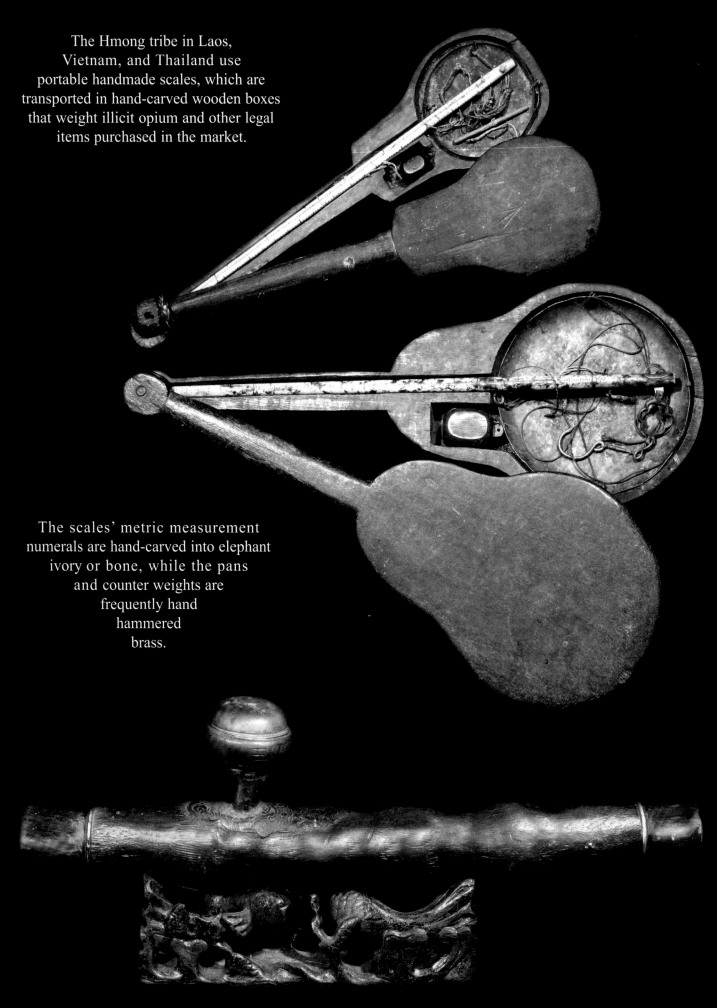

The Hmong tribe in Laos,
Vietnam, and Thailand use
portable handmade scales, which are
transported in hand-carved wooden boxes
that weight illicit opium and other legal
items purchased in the market.

The scales' metric measurement
numerals are hand-carved into elephant
ivory or bone, while the pans
and counter weights are
frequently hand
hammered
brass.

**"Lok Tho Tiem" silver "dragon" bracelets: Thailand, Laos, and Vietnam**

**Twisted silver "Phami Akha" bracelets: Thailand**

The tribes practice an ornate but practical style of metal work.

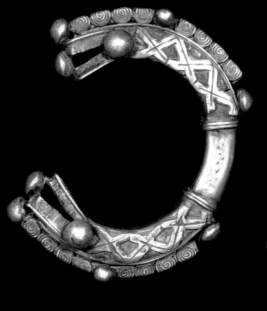

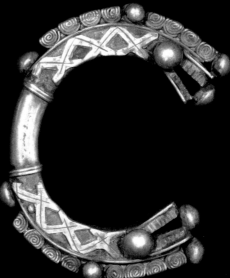

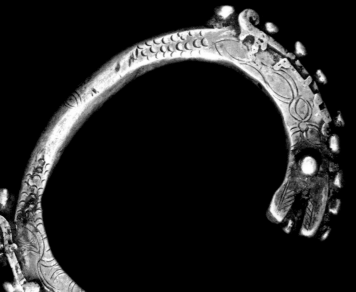

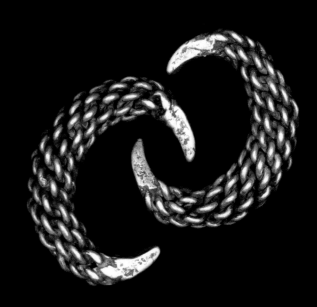

Silver tribal bracelets, in a variety of plain and engraved designs, are worn by both men and women.

**(facing page)**

**Handmade Chinese "Mun and Mien" Yao: opium scales**

**Hmong opium pipe on a hand-carved wood stand: Laos**

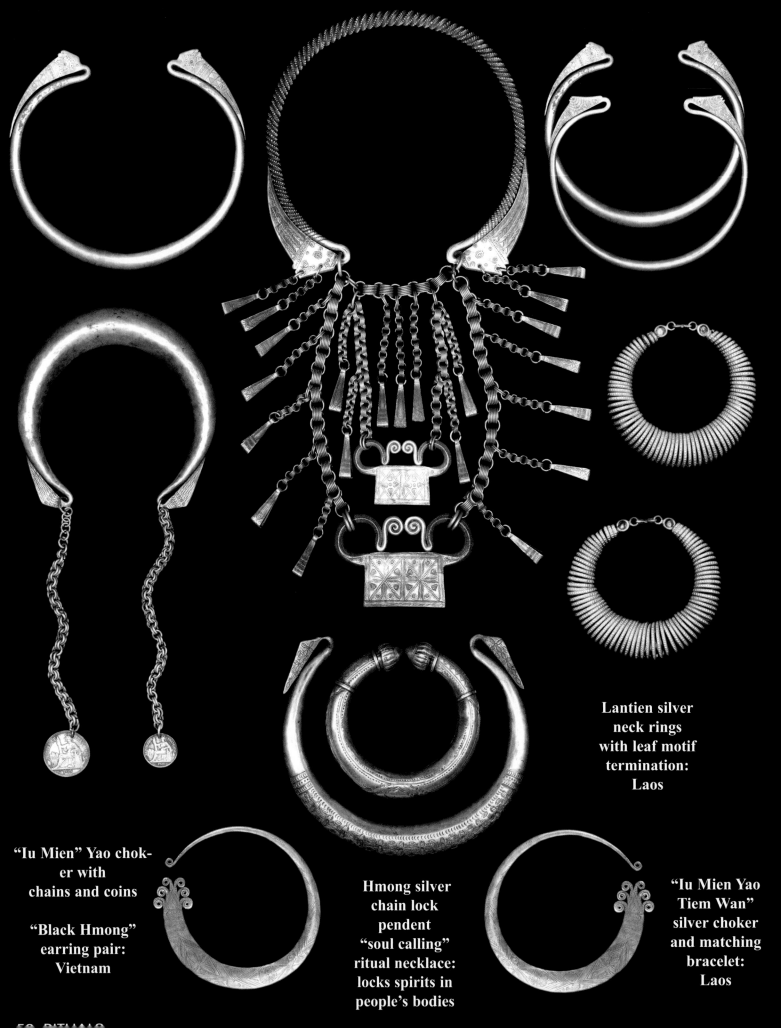

"Iu Mien" Yao choker with chains and coins

"Black Hmong" earring pair: Vietnam

Lantien silver neck rings with leaf motif termination: Laos

Hmong silver chain lock pendent "soul calling" ritual necklace: locks spirits in people's bodies

"Iu Mien Yao Tiem Wan" silver choker and matching bracelet: Laos

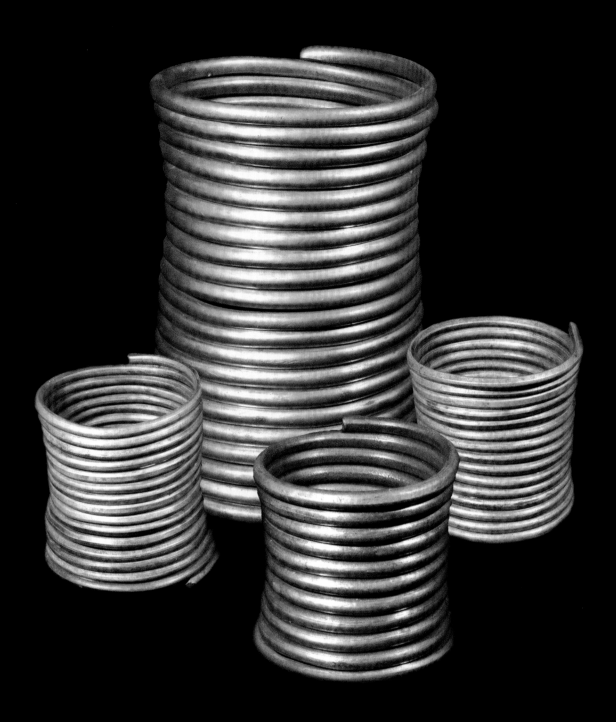

**Padaung neck, knee, and ankle coiled brass jewelry: Burma**

Perhaps the most striking cultural characteristic common to all Asian
tribes is the breathtaking beauty in their art, clothes, headdress, and
jewelry. These tribes create stunning embroidered clothing and
jewelry while learning skills at an early age. Silver and brass
jewelry is ubiquitous in the form of earrings, coins, pendants,
bracelets, anklets, neck rings, and hair ornaments.

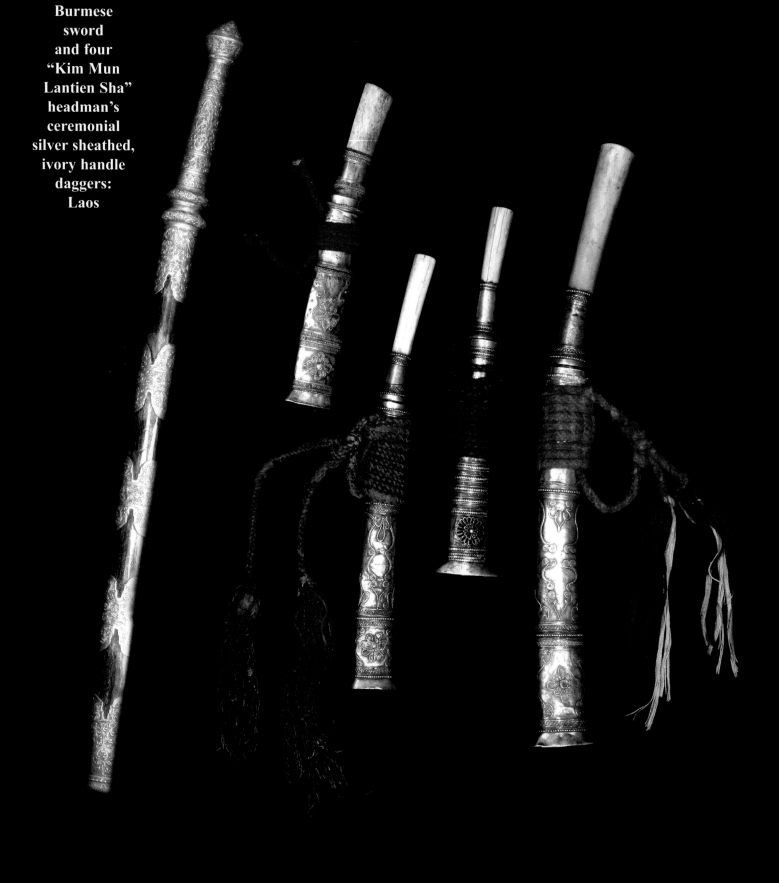

**Burmese sword and four "Kim Mun Lantien Sha" headman's ceremonial silver sheathed, ivory handle daggers: Laos**

Tribal knives and swords are ornate objects worked in silver, ivory, horn, and wood. Silver-sheathed, ivory or bone-handled knives, scabbards, and swords that are handsome implements and status symbols of an upper class nobleman no longer

**Four Laotian wood
sheathed tribal swords, a
Thai Yao bamboo-sheathed long
knife, and a Vietnamese bone
and brass handle, wood
sheathed, tribal sword**

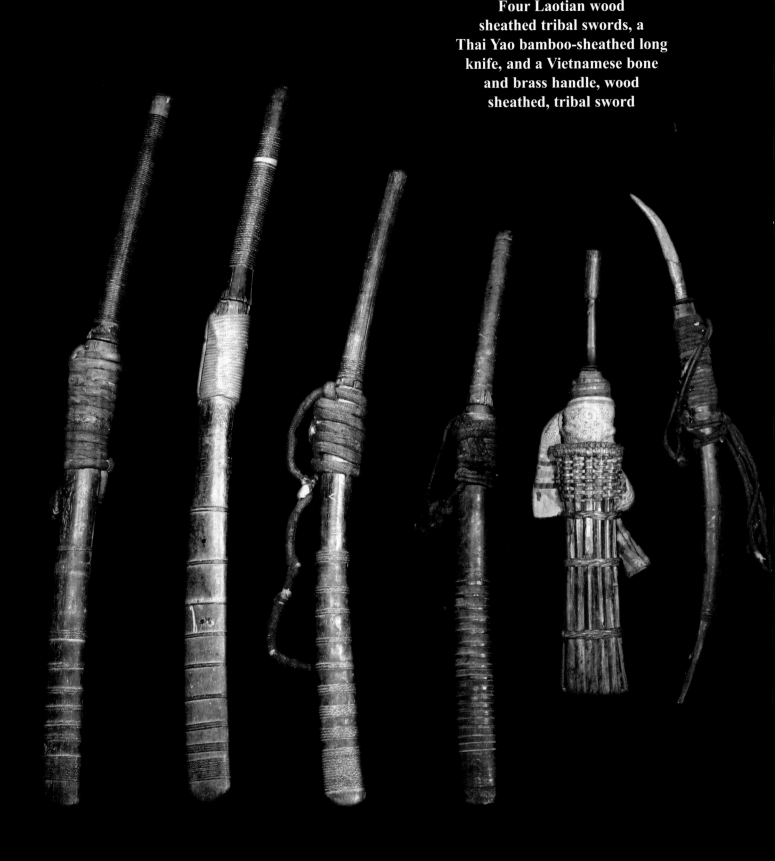

have martial usage. Wooden-sheathed, wood-handle weapons, used by the lower
class laborers, unlike the ornamental silver status swords, are practical tools that
are owned by villagers and used, even to this day, as weapons if necessary.

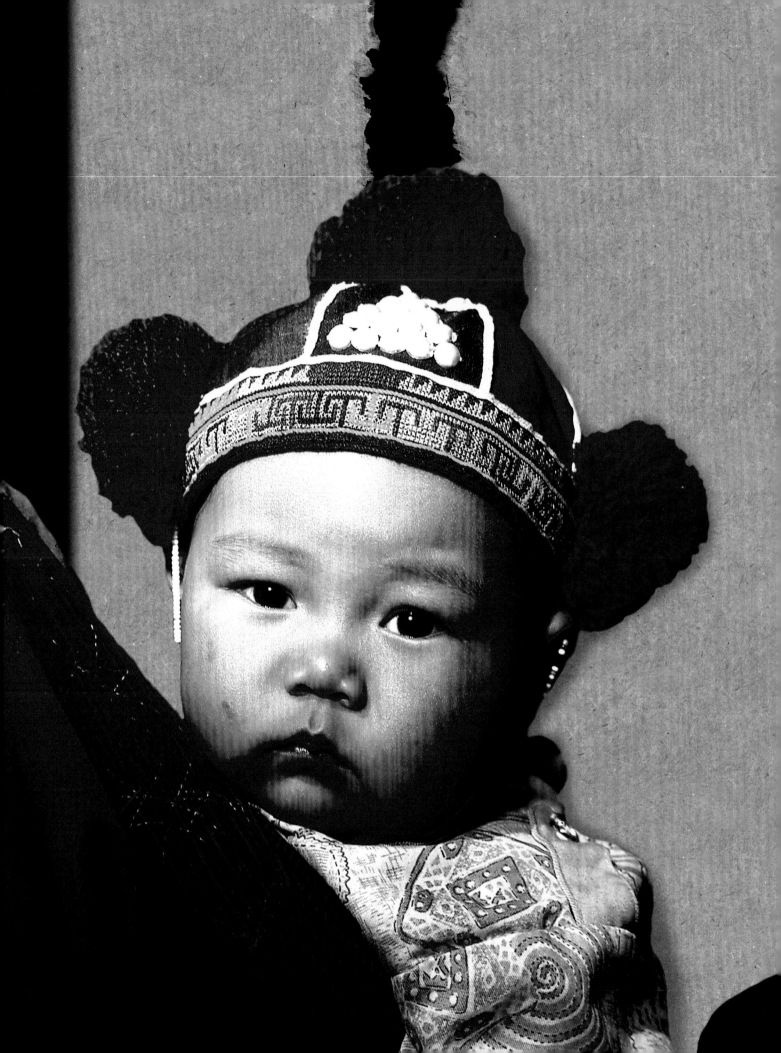

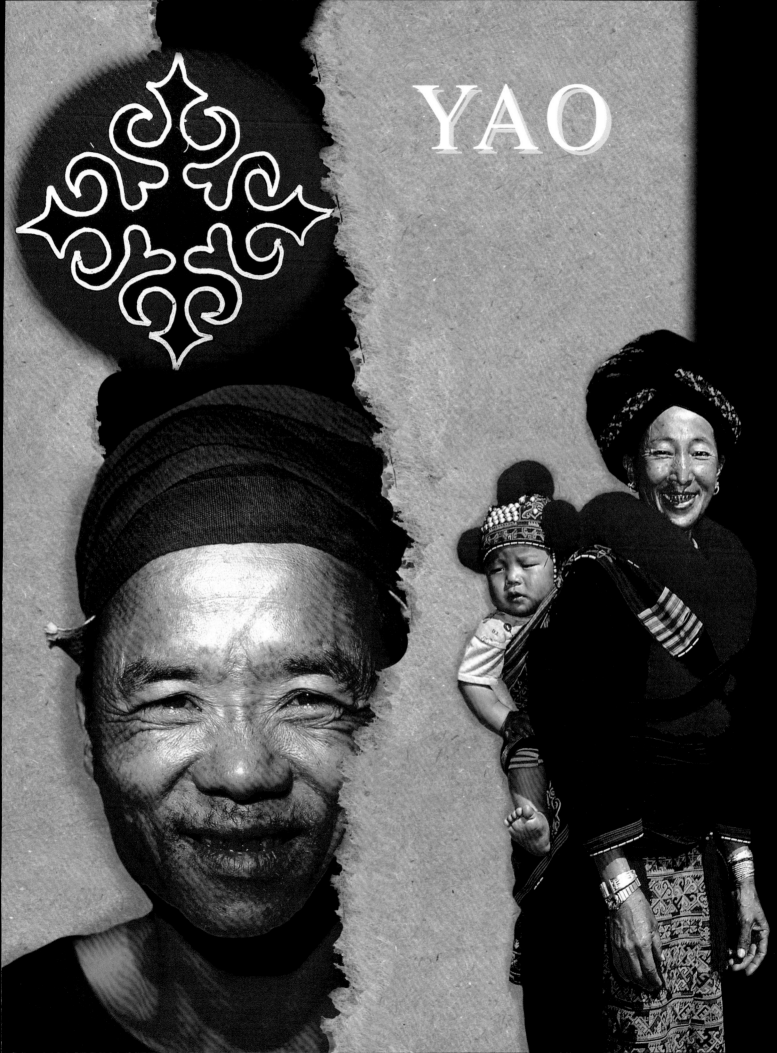

YAO

**"Im Mien Man Den" Yao silver earrings**

**"Kim Mun Lantien Sha / Shanzi" status symbol hip ornament: silver pendants on chains, bear tooth, tiger claws, coins, and amulet containers: Vietnam**

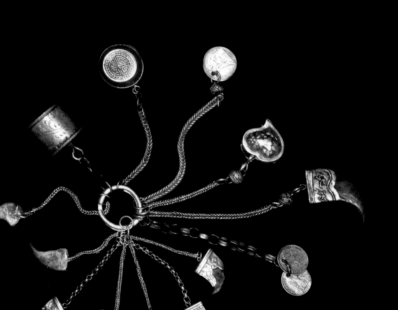

Before leaving the three block Laotian town of "Muang Sing," I noticed whitewashed plastered posters on many walls in several local guest houses that advised travelers:

" #1) DO NOT BUY HEIRLOOM ANTIQUES FROM THE NATIVES. #2) DO NOT SMOKE OPIUM WITH THE NATIVES. #3) DO NOT HAVE SEX WITH THE NATIVES. #4) DO NOT WALK IN THE JUNGLE WHERE THE "SPIRITS" RESIDE OR ENTER THROUGH THE NATIVE "SPIRIT GATES" THAT LEAD TO VILLAGES. IF YOU WANT TO HELP THE TRIBES PLEASE RESPECT THESE FOUR SIMPLE RULES! "

Unfortunately, before I had a chance to read any one of those informative public notices, I had already violated each and every one of the four listed prescribed covenants. That's how it all began. Well maybe... maybe I am getting a little a head of myself...

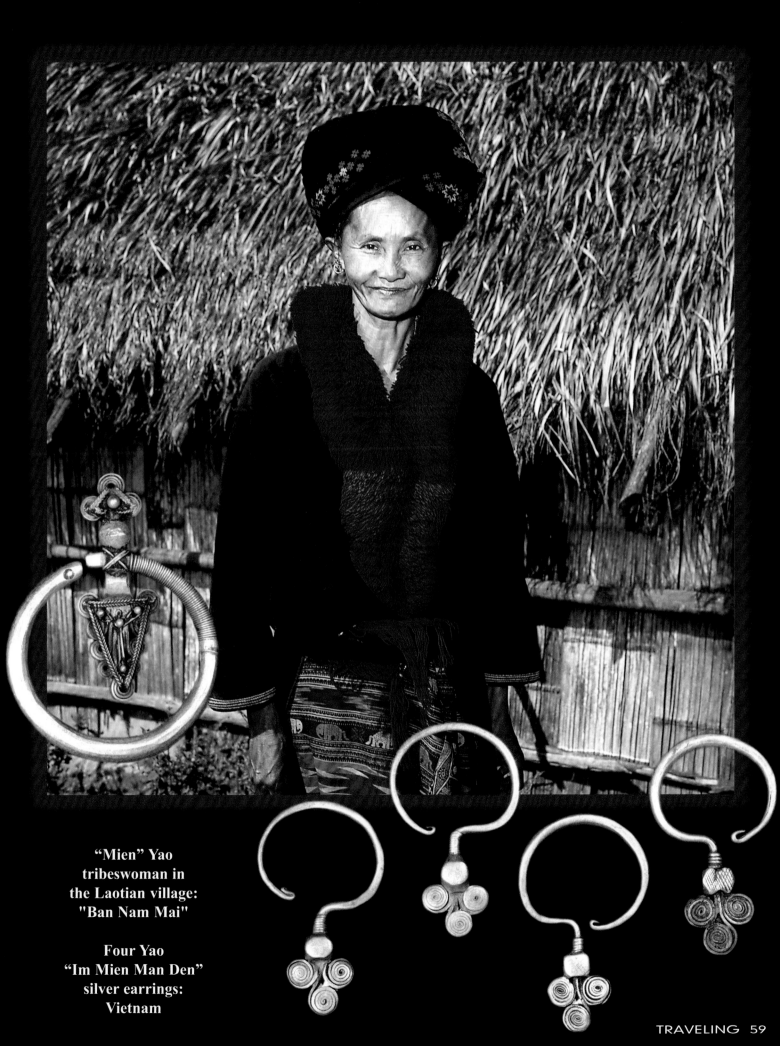

"Mien" Yao
tribeswoman in
the Laotian village:
"Ban Nam Mai"

Four Yao
"Im Mien Man Den"
silver earrings:
Vietnam

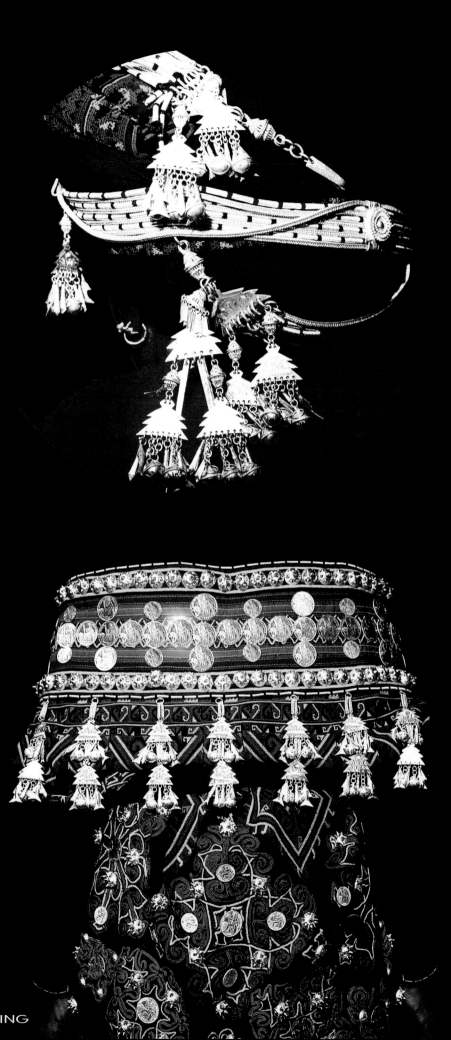

My expedition to five Southeast Asian countries and ten primitive tribes began when I left my San Francisco home on a twenty-three hour flight to Vientiane, the capital city of Laos. At the Vientiane airport I took a chance on a Lao Aviation pilot's tantalizing promise! For a "special price" he could make an "unscheduled stop" on a dirt landing field, a road, only a mile from the Chinese boarder in northern Laos. I accepted his offer, paid a modest bribe, and soon was within striking distance of my first tribe. After the eight-seater plane touched down in predawn darkness I traveled over deep rutted roads in the back of a "doysan" open bed truck to reach a trekking path that led to the Yao village: "Ban Nam Mai." I was convinced to return to this ramshackle enclave, which lacks both plumbing and electricity, only after receiving an invitation from "Moowong Hy," a woman I previously met, who was to be wed in the village that day. I had already planned to leave Laos after hearing unbelievable stories from three German backpackers who spoke of an encounter with the "Padaung" (Long Neck) tribe in the remote Burmese village of "Daw Kay." They told tall tales of old women and young girls who stretched their necks, more than a foot long, after wrapping ever-expanding concentric brass coils around their throats for decades! Could it be true? I had to check it out, but before leaving Laos I had the rare pleasure of seeing Moowong dress in the finest "Mien" Yao wedding garb that exists on earth!

She truly was an unforgettable sight!

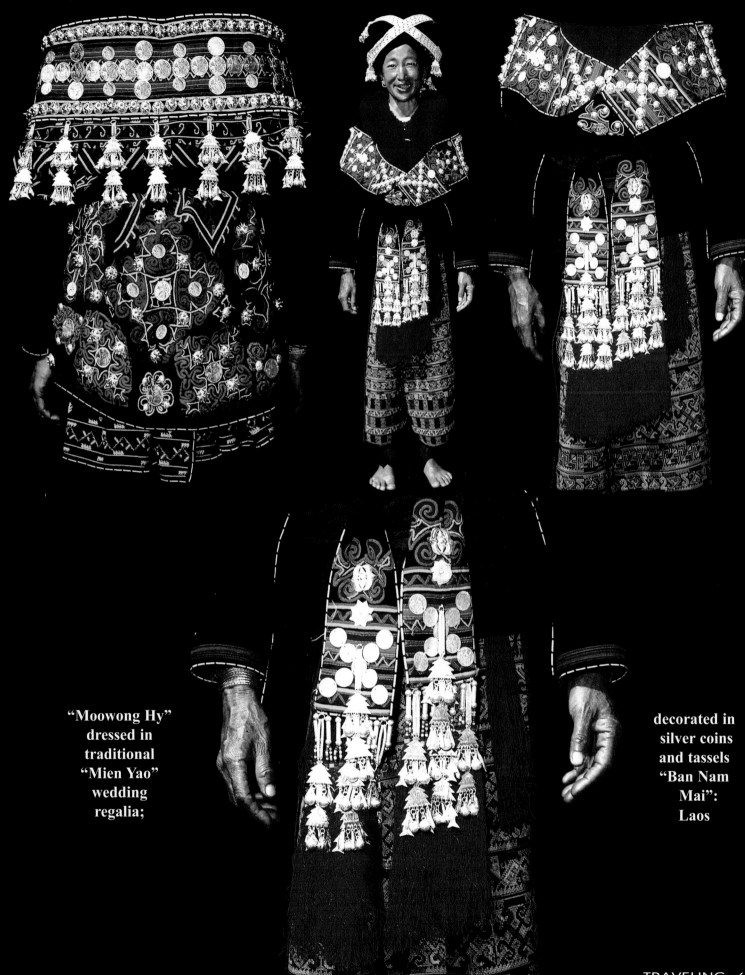

"Moowong Hy" dressed in traditional "Mien Yao" wedding regalia;

decorated in silver coins and tassels "Ban Nam Mai": Laos

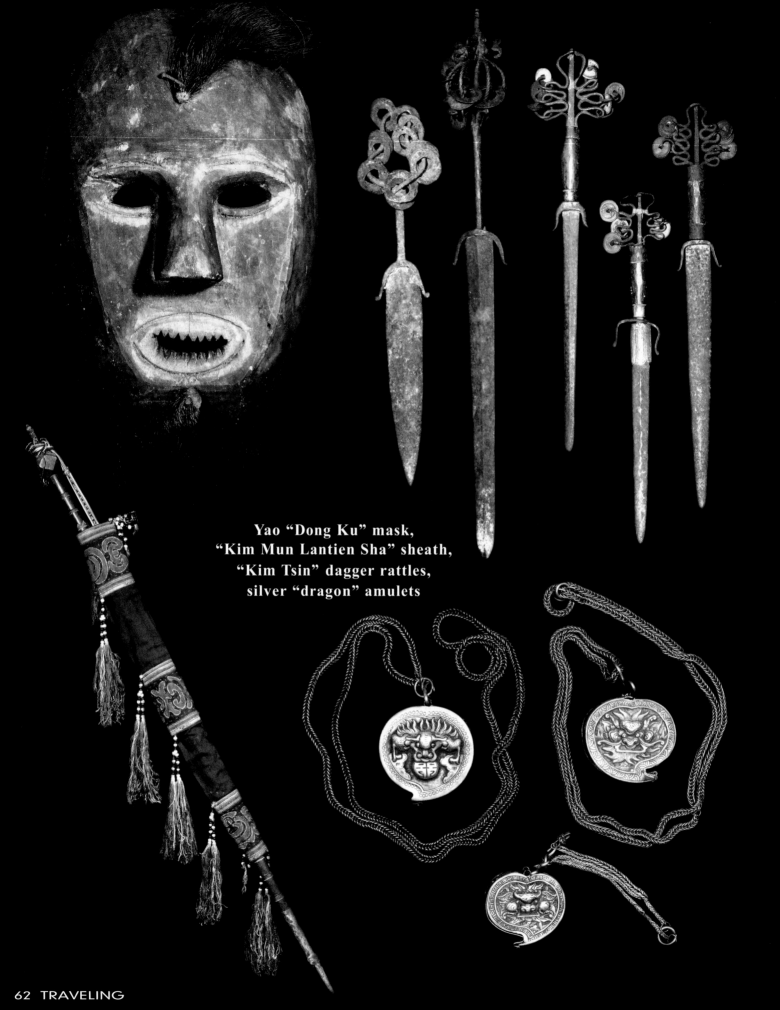

Yao "Dong Ku" mask,
"Kim Mun Lantien Sha" sheath,
"Kim Tsin" dagger rattles,
silver "dragon" amulets

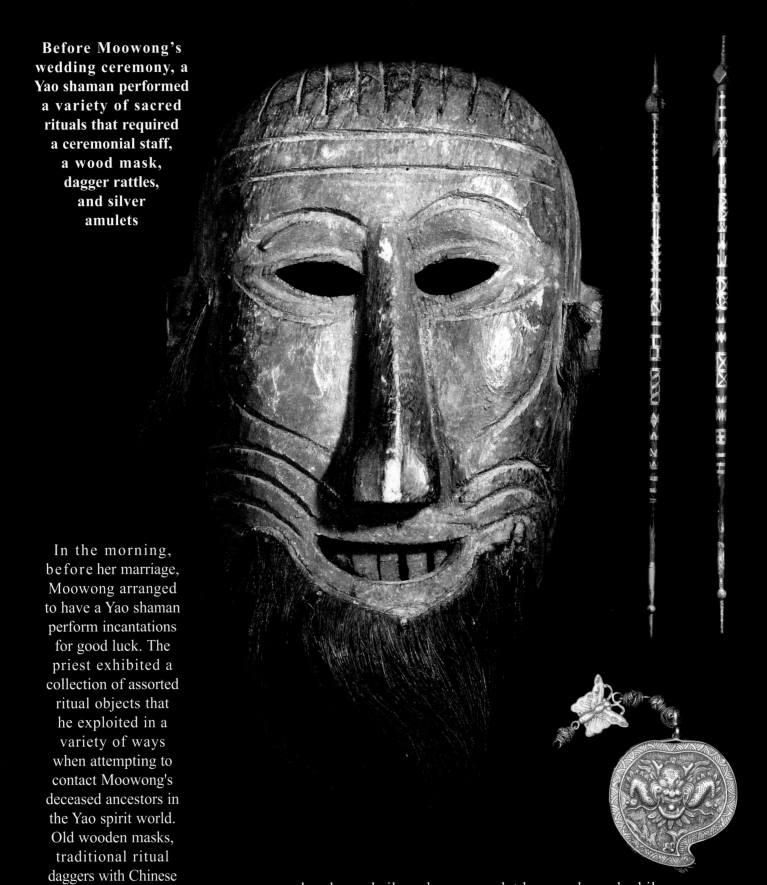

**Before Moowong's wedding ceremony, a Yao shaman performed a variety of sacred rituals that required a ceremonial staff, a wood mask, dagger rattles, and silver amulets**

In the morning, before her marriage, Moowong arranged to have a Yao shaman perform incantations for good luck. The priest exhibited a collection of assorted ritual objects that he exploited in a variety of ways when attempting to contact Moowong's deceased ancestors in the Yao spirit world. Old wooden masks, traditional ritual daggers with Chinese coin handles, silver inlaid wood staffs encased in textile embroidered sheaths, and embossed silver dragon amulet boxes; clanged while dangling on chains from the shaman's waist, were only a few of the many ritual objects the priest used to contact the dead. My senses were stunned by overwhelming noxious, omnipresent odors from pungent burning incense accompanied by repetitious single beats softly sounding from a small circular tambourine-style drum that were laced between series of loud guttural chants. It seemed endless. I was relieved when the shaman's hour-long ritual finally ceased!

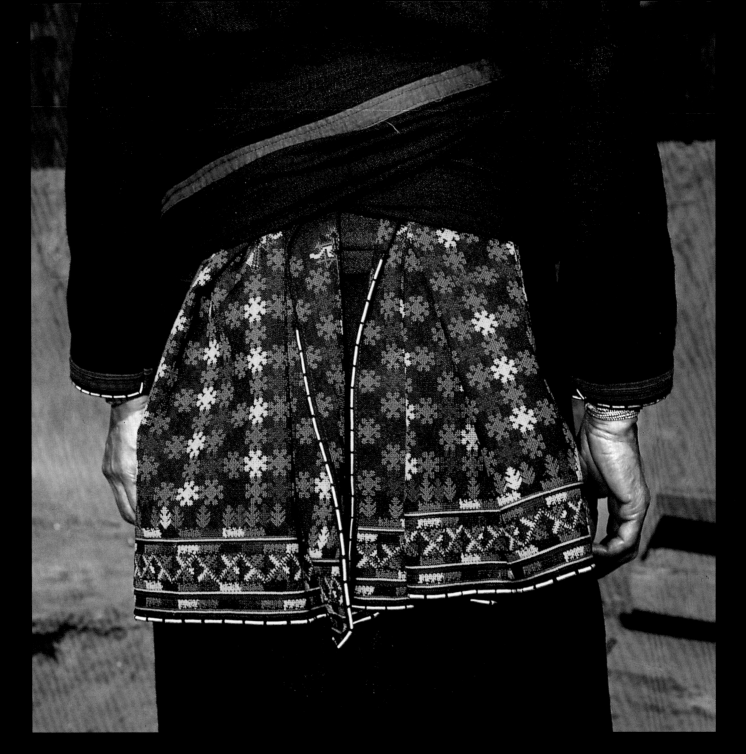

**The blue and yellow textile on a Yao female's waist that got me into trouble**

This story did begin innocently, just about sixteen years ago, when I first walked into "Ban Nam Mai" village to visit the Yao tribe for the first time. But within minutes after entering the enclave a middle age "Mien Yao" tribesman, with an infant strapped to his back, graciously offered opium from his already smoldering bamboo water pipe, and that unfortunately was the beginning of the end of my innocence! I violated the first of four prescribed local covenants. As the sun peaked over bald mountain tops, a single ray of sunlight warmed my icy extremities, while I inhaled the first of the day's many intoxicating refreshments from the tribesman's well-worn, hand honed, blackened water pipe. As a collector I had traveled to Laos hoping to acquire

**One of the Yao seamstresses who sold traditional tribal textiles**

authentic pieces of old tribal art and, as an author, I needed excellent examples of traditional native artifacts to illustrate this book's text. While admiring an extremely attractive blue and yellow textile wrapped around the waist of a Yao female, I inadvertently made an unintentional overture! As soon as my eyes retreated from the sight I was inundated with offers to bargain for the most beautifully embroidered textile pieces I have ever seen. Seamstresses were summoned from the most distant Yao villages after learning of a traveler's insatiable taste for traditional tribal art. I had to stay in Ban Nam Mai village for two days and three nights with little sleep just to accommodate all the Yao women who desired to sell their finest wares. My attraction to them was undeniable as thoughts of the tourist warning posters all but vanished.

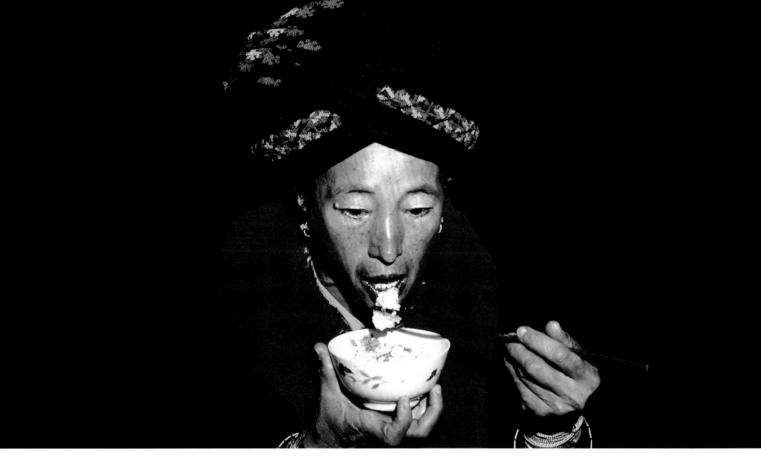

Frequently punctuated by aromatic odors from incinerating opium, my days and nights of bargaining for Yao textiles dragged on. All night long, in the jungle, nocturnal animals orchestrated howling sounds that were as loud as jets landing in Manhattan rush-hour traffic. When displaying textiles, some of the old Yao seamstresses took pity on me, after they discovered I was obviously suffering from hallucinations, lack of sleep, and hunger. They offered modest meals that consisted of

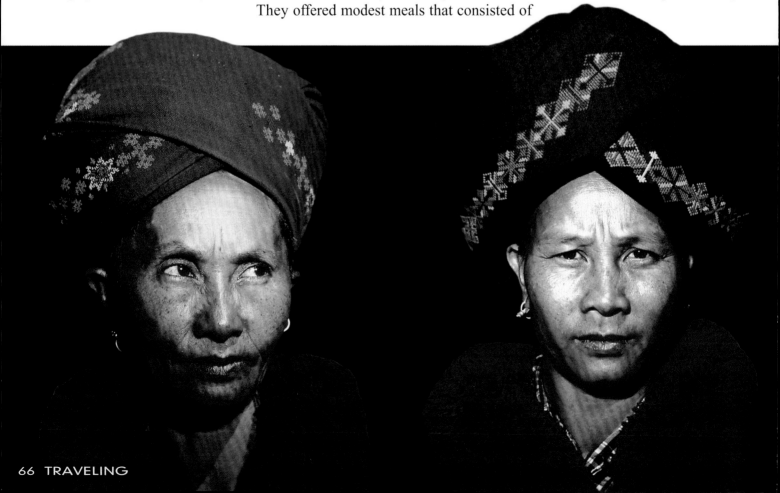

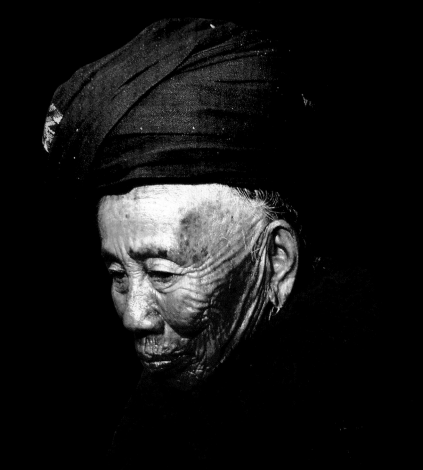

The old Yao seamstresses who took pity on me after I suffered through opium-induced hallucinations, lack of sleep, and hunger: "Ban Nam Mai" village: Laos

rice topped with small condiment-size portions of barbecued chicken or wok-fried vegetables. I never ate so much rice in my entire life. Before slipping into an uncontrolled drug-induced stupor, followed by the most delightful collection of pleasant daydreams, I strived to understand how tribespeople did their daily chores without any ill effects from over-consumption of refined poppies while I, on the other hand, could not stop hallucinating!

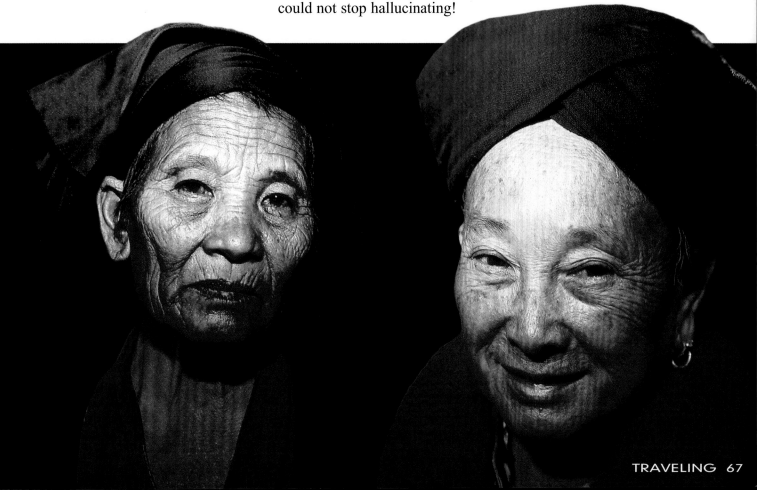

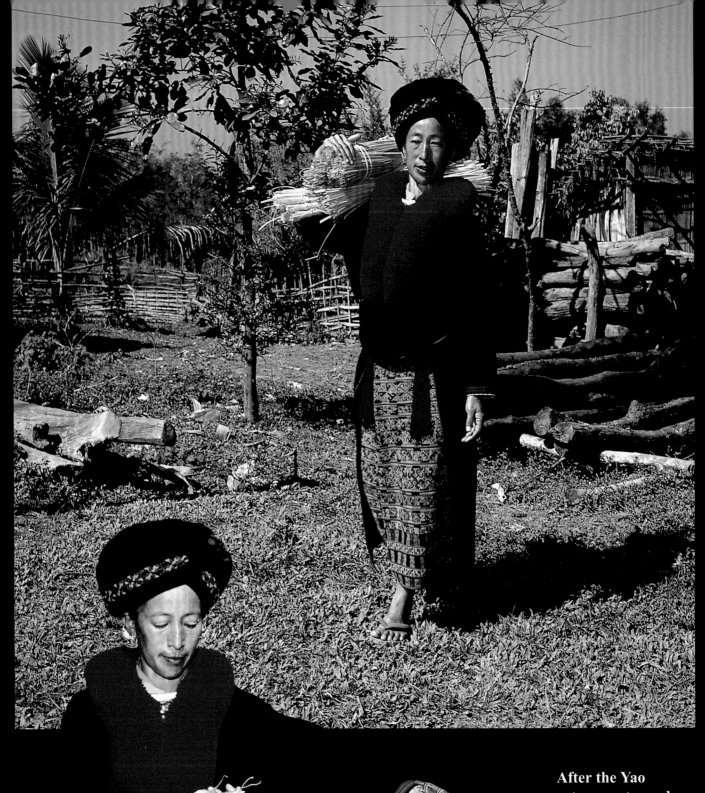

After the Yao
seamstresses stopped
caring for me,
"Moowong Hy"
collected fire
wood and cooked
"matsai" fruit with
barbecued
chicken

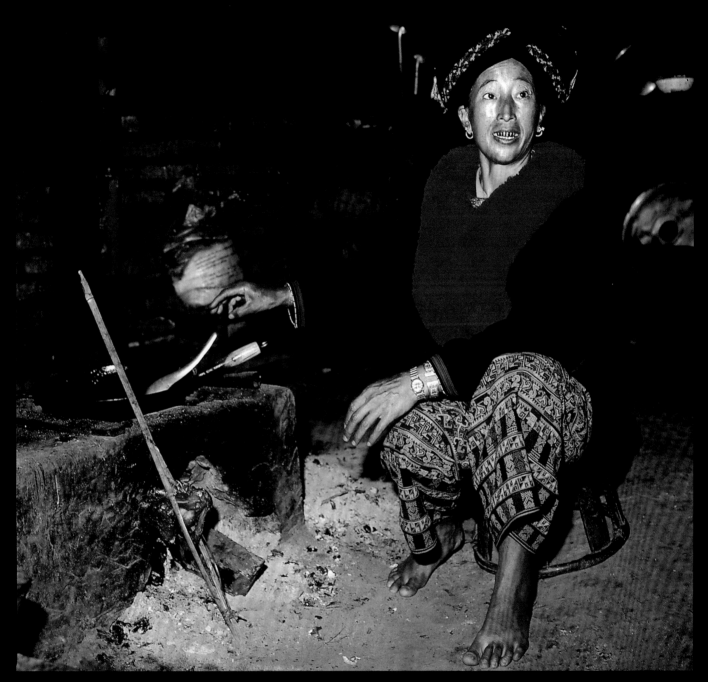

**"Moowong Hy" cooking on an open hearth in her dirt floor hut**

Midway through the second morning in Ban Nam Mai village, after the transient seamstresses stopped feeding me, my friend Moowong Hy assumed care of my creature comforts. She collected dried kindling, that was used to light a fire in her hut's hearth, from a makeshift construction site adjacent to her shack. The inside of her hut was so poorly lit by only light from the cooking fire and sun that streamed through small cracks in the wall boards; it was difficult to see the interior. Eventually my pupils sufficiently dilated and admitted just enough reflected light to see the shocking arrangement of her squalid living conditions. I was disturbed after discovering the inside of her shack offered little more than a dirt floor, but this revelation made Moowong's generosity seem all the more gracious. She served a green cooked "matsai" fruit with barbecued chicken breast over rice, and though this meager meal was served in harsh surroundings, it seemed so much more delectable than any food ever offered by my generous Western hosts!

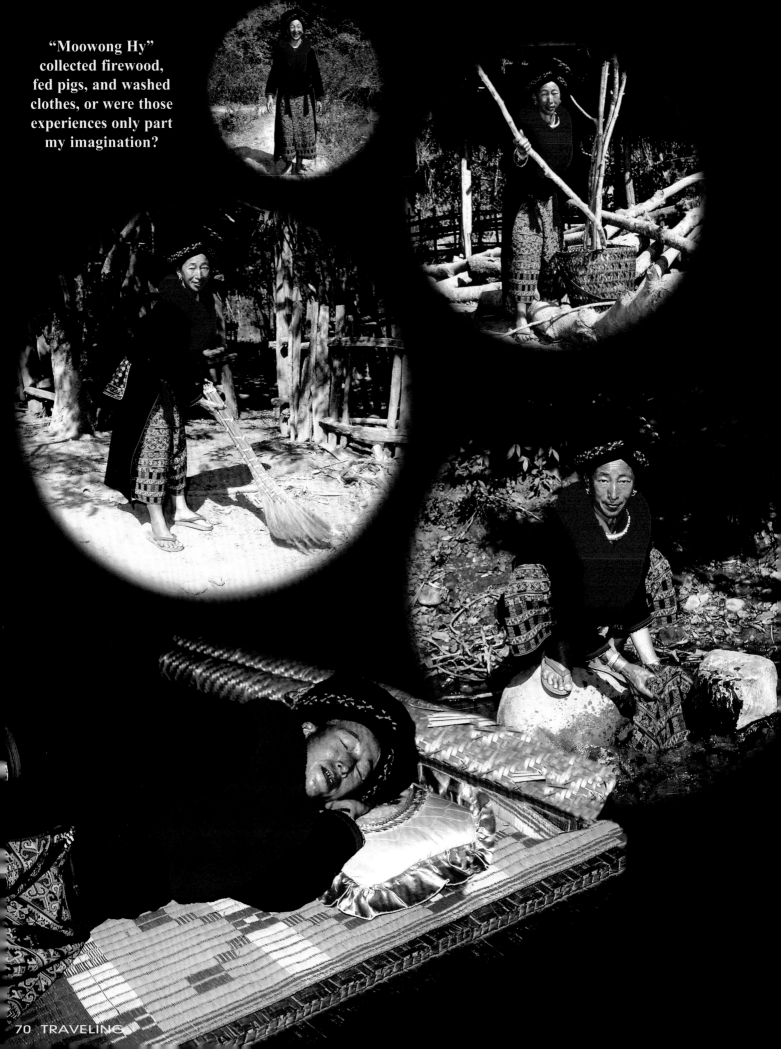

"Moowong Hy" collected firewood, fed pigs, and washed clothes, or were those experiences only part my imagination?

Before the seamstresses ever thought of leaving Ban Nam Mai village I began sleeping, side by side, with Moowong Hy and her husband in their hut. In the early evening, during our second night together, bright colorful, vivid hallucinations stimulated by my overindulgence in the questionable "pleasures" associated with inhaling unrefined black opium surely got the best of me!

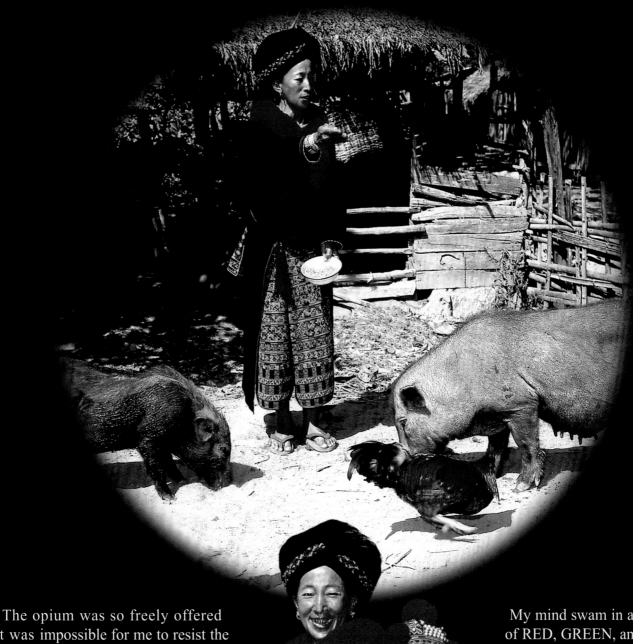

The opium was so freely offered it was impossible for me to resist the drug's temptation and after smoking, more than what Buddha would have liked me to consume, I became paranoid. I was not sure if I was asleep or awake! While night and day were indistinguishable I saw multiple though-filled "balloons" float above my head as Moowong Hy did chores around her house. Were these nightmares or daydreams? Did Moowong Hy actually feed pigs and chickens, wash clothes, and collect firewood or were these experiences simply my opium-induced hallucinations?

My mind swam in an ocean of RED, GREEN, and BLUE imaginary waves! When tasting the color BLUE, I smelled the color GREEN, while having RED thoughts. I envisioned blue tasted a bit like barbecued duck! My synapses continued to misfire. As dusk turned to complete darkness, I was not certain if I saw three furry red monkeys emerge from the mountain jungle or if the aberration I witnessed was simply Yao children in the village wearing hats made of three red "puff balls."

While day blended into night, banana eating baby monkeys danced with their mothers in a fabulous sunset. I could not distinguish between those beautiful real clouds in natural light and my imaginary hallucinatory thought-filled "bubbles." Hoping to take advantage of this compromised mental state, three old Yao seamstresses, who silently spun yearn, attempted to sell terrible textiles at extremely high prices. Being completely incoherent, I did agree to all of their terms, but before the $789 Dollar deal could be struck Moowong came to my rescue. She screamed as she threw every piece I had bargained for out her hut's window down to the mountain's dusty dirt road. The three

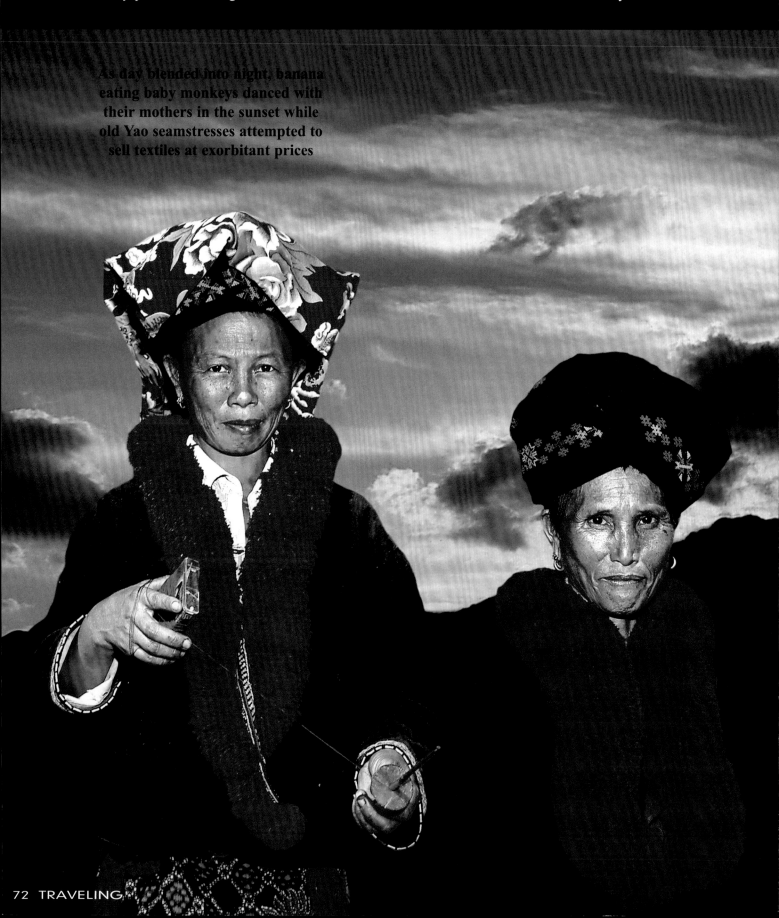

As day blended into night, banana eating baby monkeys danced with their mothers in the sunset while old Yao seamstresses attempted to sell textiles at exorbitant prices

Old "hags" were furious, but before they could react, a fourth "Witch" with rotting teeth, an enormous smile, and a huge goiter on the right side of her neck, ran to us from another Yao village in the very near distance. She carried five handmade opium pipes fashioned with bamboo stems and ceramic bowls that were filled to overflowing capacity with the finest quality "RED, GREEN, and BLUE" black opium the tribe ever tasted. But before I could refuse to indulge my taste for this Yao dope, the goitered old hag insisted she would settle our dispute concerning the aborted textile sale after she offered us her five "peace pipes." I later bought all her opium

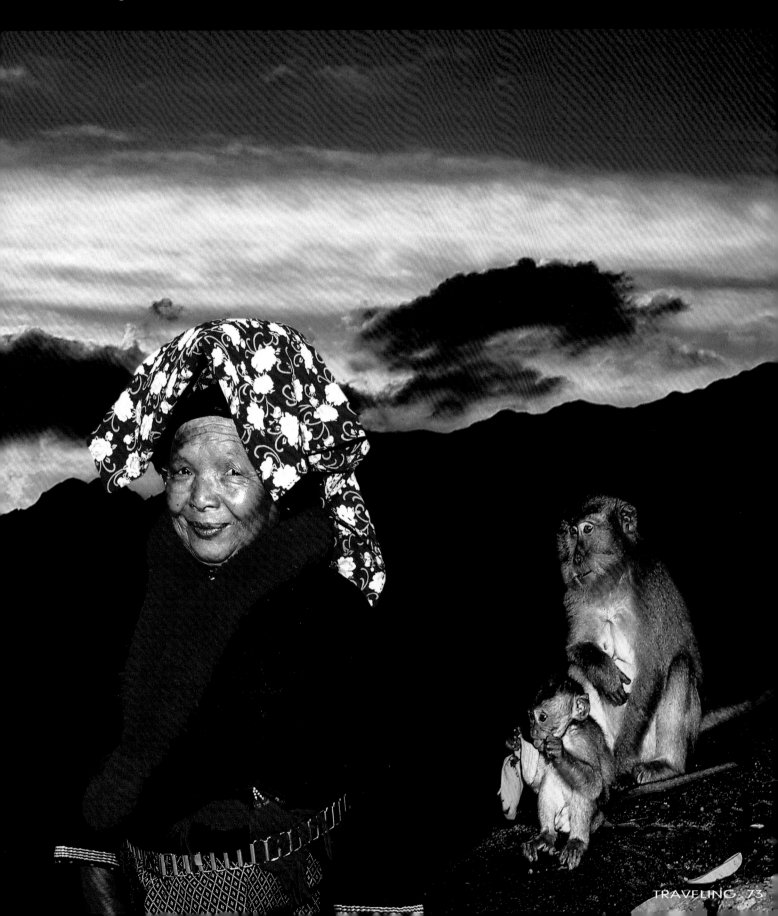

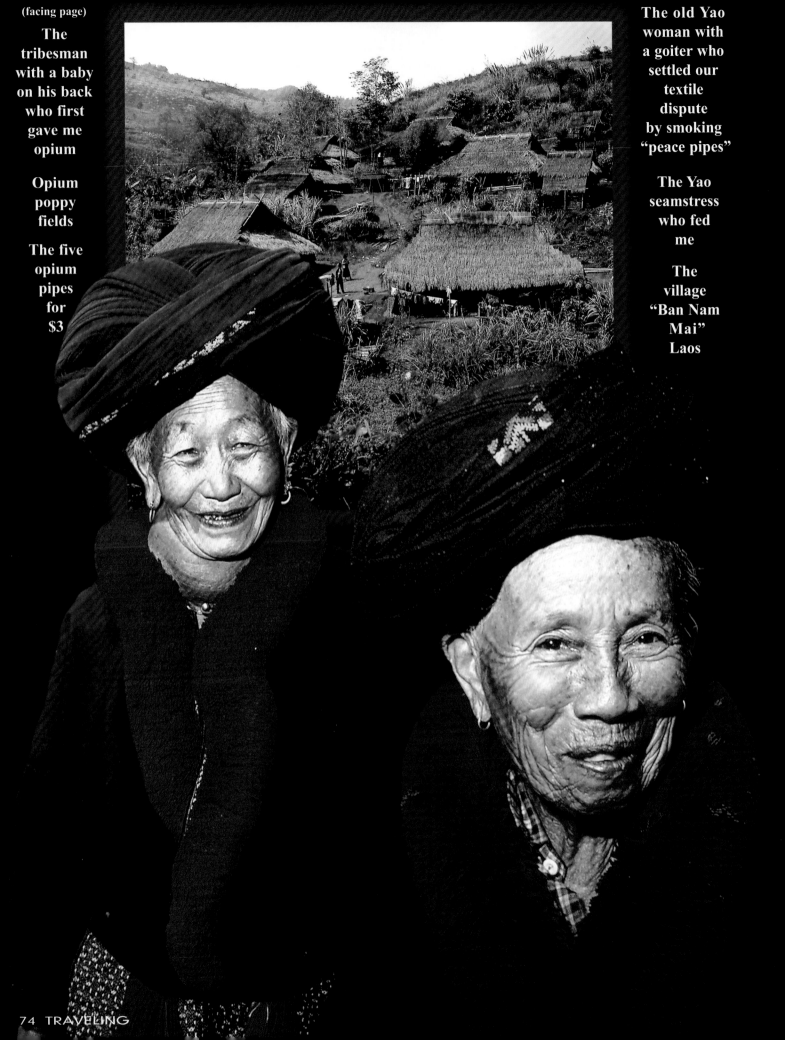

(facing page)

The tribesman with a baby on his back who first gave me opium

Opium poppy fields

The five opium pipes for $3

The old Yao woman with a goiter who settled our textile dispute by smoking "peace pipes"

The Yao seamstress who fed me

The village "Ban Nam Mai" Laos

pipes for only $3 (US) Dollars and she threw in the contents at no additional charge. The only problem was I had to leave Laos within days as I was scheduled for travel in Burma. I hastily dumped the bowls sticky black contents, wrapped the stems in toilet paper, and jammed them deep down into the confines of my backpack. Seventy-two hours later I left Laos but I still have those pipes that will forever remind me of that unforgettable experience I once had with the Yao tribe.

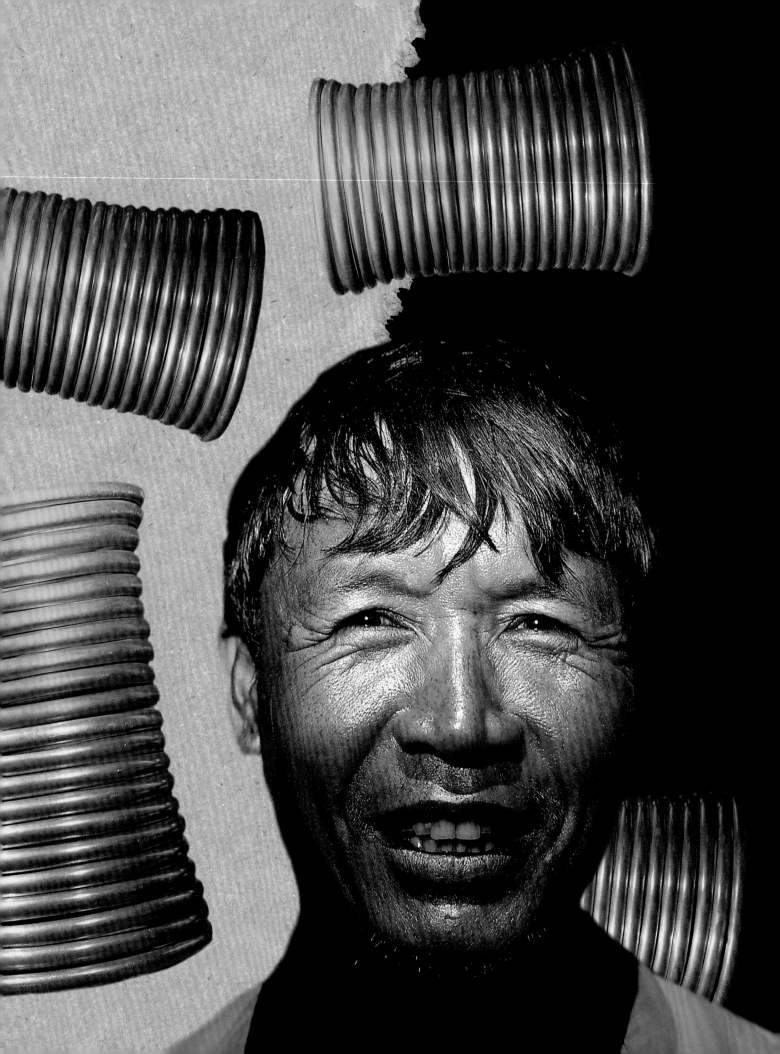

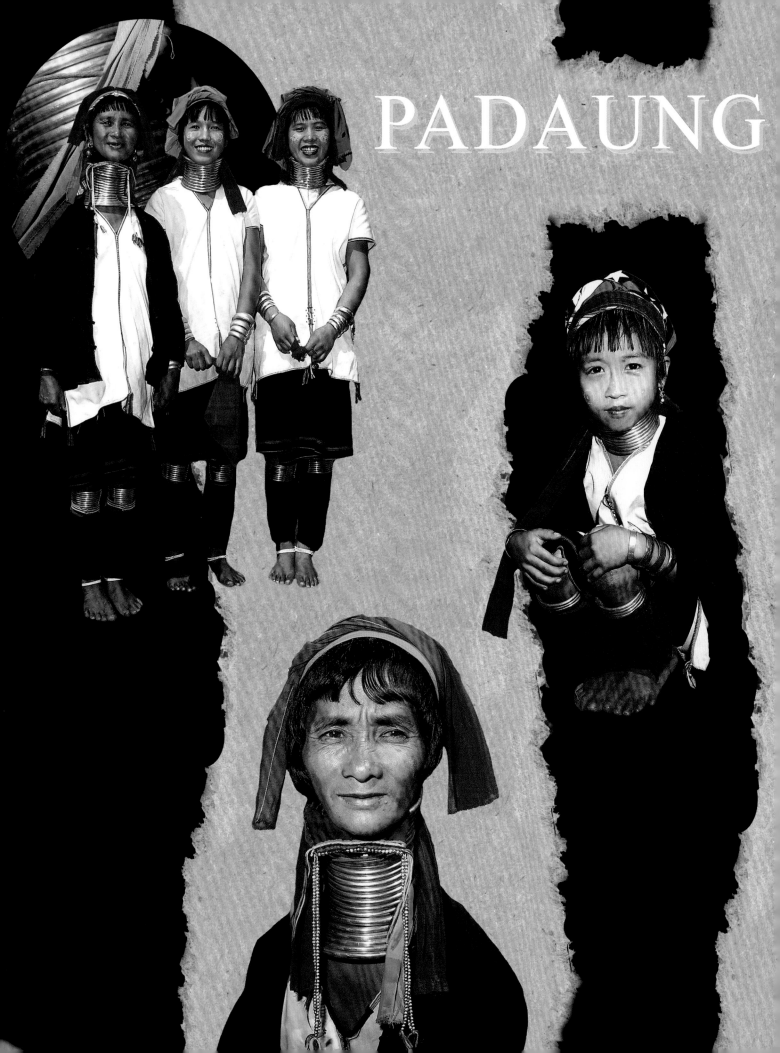

# PADAUNG

Before checking into the four-dollar-a-day "Remember Inn Guest House," after an exhausting twelve hour bus ride from the Burmese capital "Rangoon" to "Inle Lake," fate surely was rooting for me as I easedropped on a conversation between two Australian teenagers who spoke of "Long Necks." My journey, from California through Thailand, into northern Laos, and now Burma, eventually did lead to the "Padaung" (Long Neck) tribe but this chance encounter with two adolescents proved to be more beneficial in this quest to locate the tribe than all my hours of guide book and Internet research combined. "I can not believe the length of her neck! It must be twice as long as any normal neck! How in the world did she do it it?" the dirty blonde, younger of the two, asked his older companion. At that moment, I realized my journey may be a success. Could I be so lucky as to have stumbled upon a nearby Padaung village? While throwing a heavy, dust-covered backpack to the floor I expressed a relentless desire to photograph and trade for "Long Neck" artifacts until I could only scream "Where are they?" One boy distrusted me, while the other replied, "It's not far from here; they're in huts, down by the lake. I'm not sure if they're visiting or what, but go see 'em Dude! They're really a trip!" After I checked into the Remember Inn the boys scribbled, on an empty border in the government-sanctioned Burmese newspaper, "Myanmar Times," precise directions to the tribe's village. My memory fails me as to what happened next, but I am certain; since that day's dawn I had traveled till dusk. Exhaustion surely must have overtaken me because I recall only the following morning's illumination from a twenty-five watt, corkscrew-shaped, energy-saving lightbulb in a windowless room that woke me! I had fallen asleep after a grueling bus ride with my ceiling light on while only dreaming of eating dinner. Now famished, I ran to the guest house cafeteria but only discovered I overslept and also missed breakfast. While standing, hungry and disappointed on the threshold of the closed dining room, I experienced a stroke of good fortune when a

**Padaung**
**"Long Neck" tribe's**
**traditional handwoven textiles**

**(facing page)**
**Padaung brass neck and knee**
**coils from "Daw Kay"**
**village: Inle Lake**
**Burma**

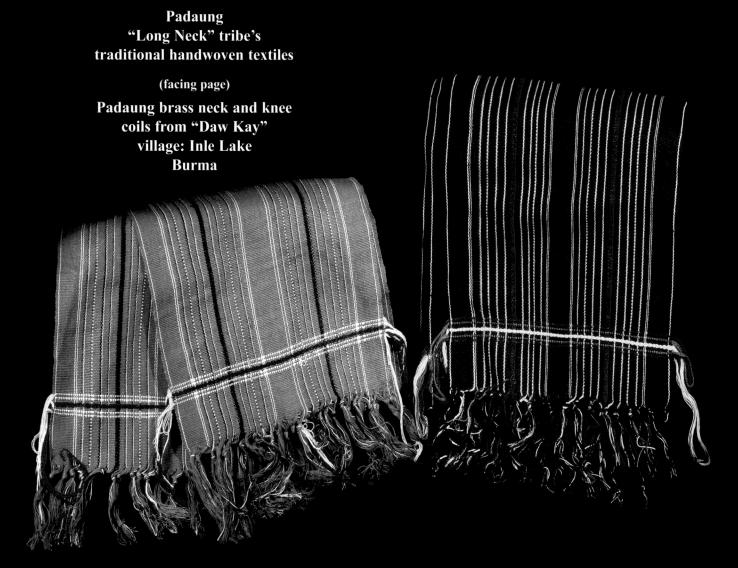

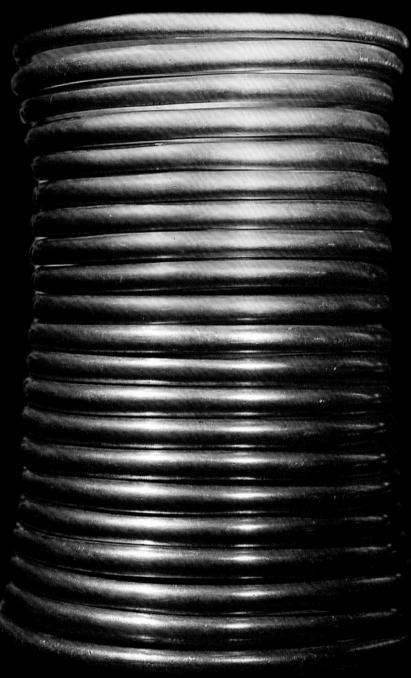

middleaged man with heavy "crow's feet" and a thinly bearded unshaven face smiled up and asked, "You want see da' Long Necks?" The Australian boys must have gossiped around their breakfast table and this was the fallout? At first I mistook the man to be a guide but to my disbelief he informed me, "My name "Daw Mu Nong." I Long Neck! I take you see wife?" At first I doubted his word seeing he was not dressed in traditional tribal clothing but after my first visit to his village I realized only the female Padaung stretch their necks and still wear the tribe's colors. This man's attire consisted of

only typical Western Working-class garb. "Yes I want to meet your wife but I haven't eaten since yesterday! I have to have something to eat before we go. Is that o.k.?" I asked. He looked back at me with what seemed to be the eyes of a broken man and replied, "I feed in village! My wife cook! I give you my food at home! O.K. O.K. O.K.?" I questioned his haste but my curiosity got the best of me when saying, "O.K. lets go! I'll eat with you!" We took a "tri-cycle" three wheel motorbike, from the guest house down to the lake for 150 Burmese "Kyat," about 15 (U.S.) cents.

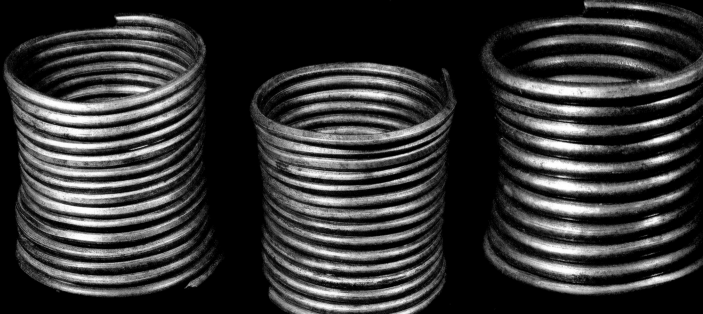

fine "Long Neck" brass neck coils and beautiful hand-woven tribal textiles were displayed together on a crude bamboo bench. This unforgettable experience, with Daw Mu Nong and his Padaung tribe in Daw Kay Village, lasted for more than twenty-eight days. During that time I had the honor of attending two of the most important

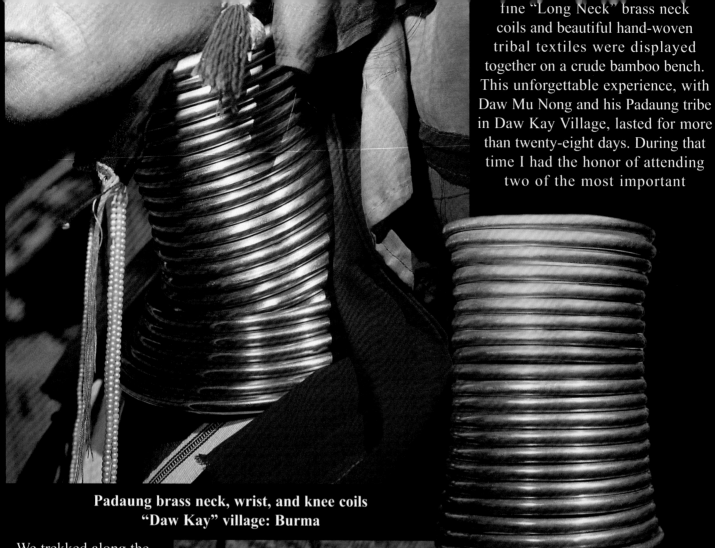

**Padaung brass neck, wrist, and knee coils**
**"Daw Kay" village: Burma**

We trekked along the water's edge for less than ten minutes before reaching the Padaung village, "Daw Kay." Immediately after entering the ram shackle enclave I realized this guy's true objective has little or nothing to do with my hunger. While eating breakfast did the Austrian boys also speak about my desire to trade in tribal artifacts? I thought they must have because within only a few feet of the entrance, just inside the village,

Padaung tribal rituals: Marriage and the first day a coiled ring is placed on a young woman's neck. After numerous discussions and protracted negotiations concerning the artifacts, Nong unknowingly became my teacher as he explained the larger rings are used to stretch the women's necks and the smaller are worn on their legs and wrists.

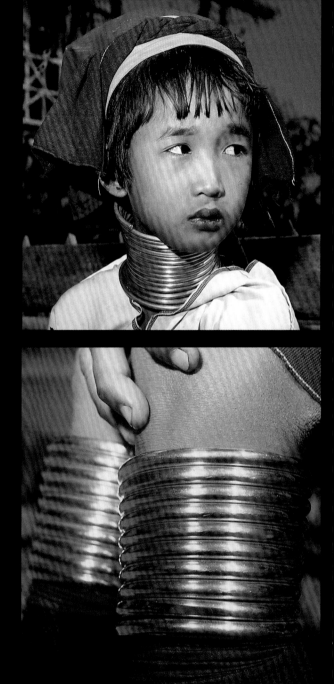

My experience with the Padaung tribe in "Daw Kay" village lasted more than twenty-eight days

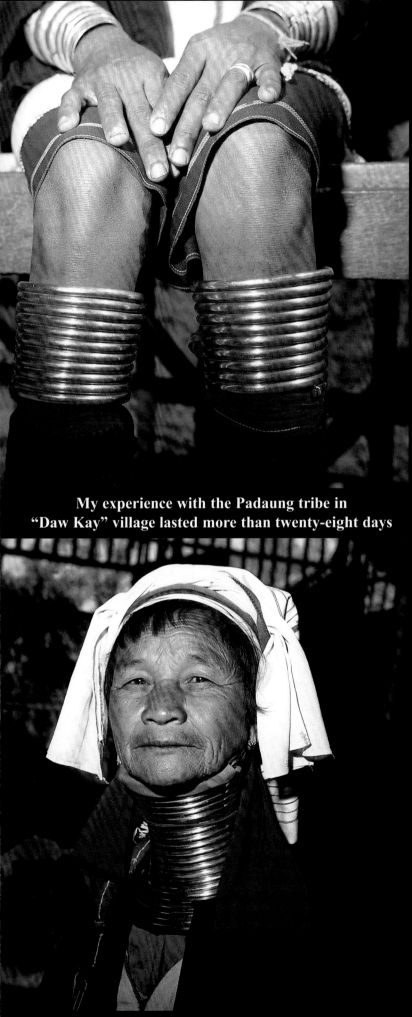

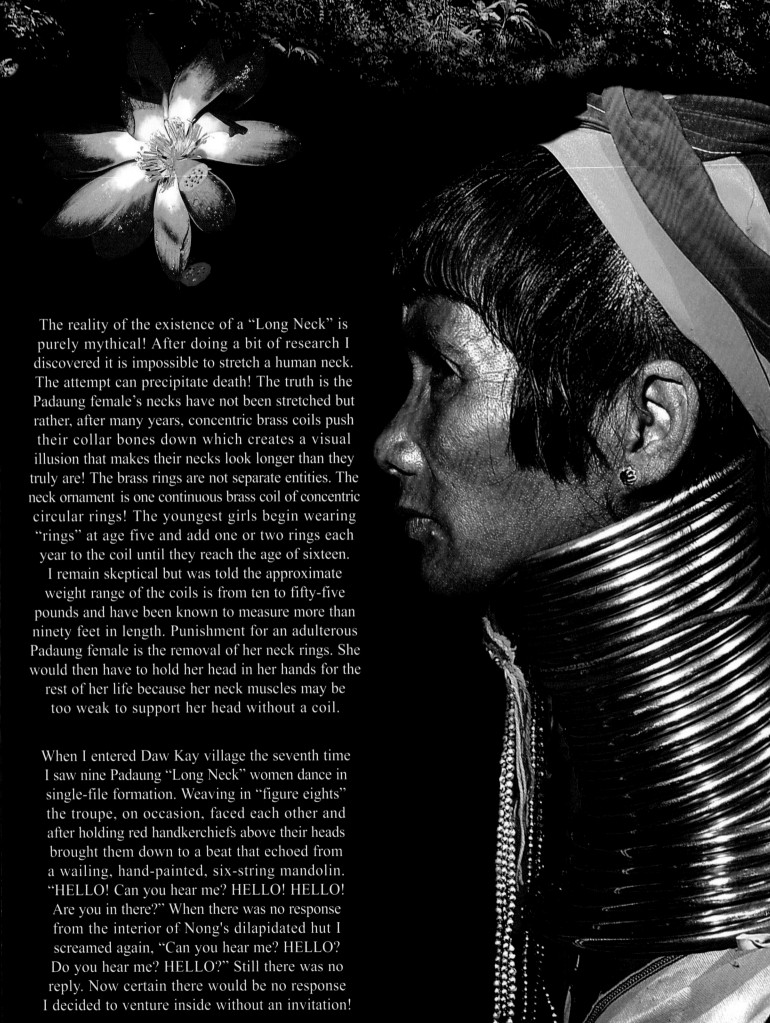

The reality of the existence of a "Long Neck" is purely mythical! After doing a bit of research I discovered it is impossible to stretch a human neck. The attempt can precipitate death! The truth is the Padaung female's necks have not been stretched but rather, after many years, concentric brass coils push their collar bones down which creates a visual illusion that makes their necks look longer than they truly are! The brass rings are not separate entities. The neck ornament is one continuous brass coil of concentric circular rings! The youngest girls begin wearing "rings" at age five and add one or two rings each year to the coil until they reach the age of sixteen.

I remain skeptical but was told the approximate weight range of the coils is from ten to fifty-five pounds and have been known to measure more than ninety feet in length. Punishment for an adulterous Padaung female is the removal of her neck rings. She would then have to hold her head in her hands for the rest of her life because her neck muscles may be too weak to support her head without a coil.

When I entered Daw Kay village the seventh time I saw nine Padaung "Long Neck" women dance in single-file formation. Weaving in "figure eights" the troupe, on occasion, faced each other and after holding red handkerchiefs above their heads brought them down to a beat that echoed from a wailing, hand-painted, six-string mandolin. "HELLO! Can you hear me? HELLO! HELLO! Are you in there?" When there was no response from the interior of Nong's dilapidated hut I screamed again, "Can you hear me? HELLO? Do you hear me? HELLO?" Still there was no reply. Now certain there would be no response I decided to venture inside without an invitation!

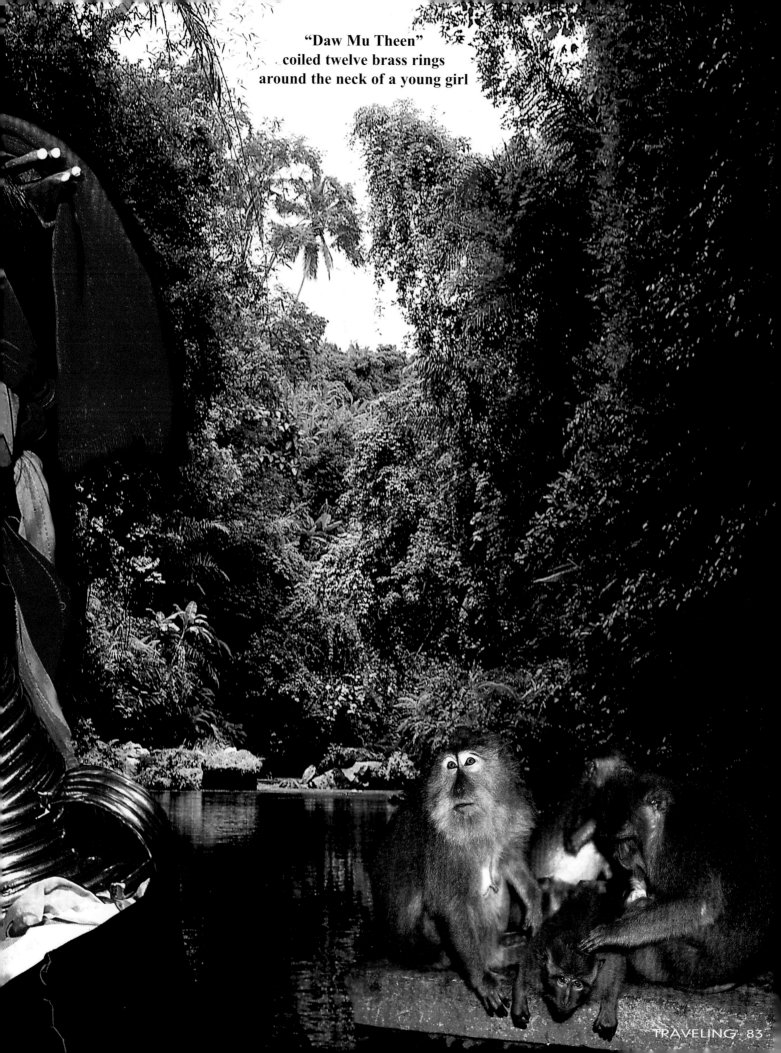

**"Daw Mu Theen"**
**coiled twelve brass rings**
**around the neck of a young girl**

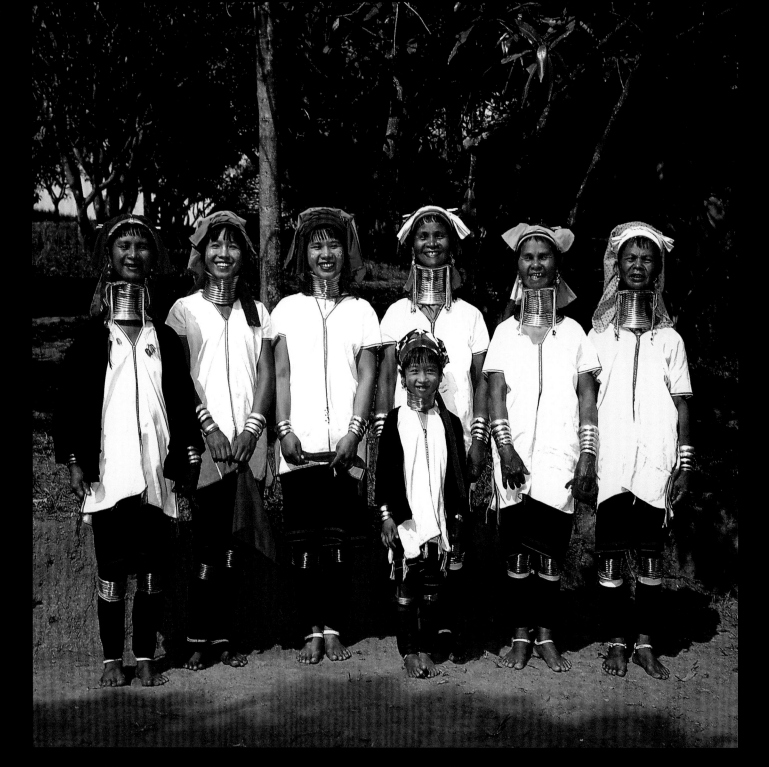

**The Padaung tribe: southern Burma on the "Mai Sai" Thai boarder near "Tachileik"**

I heard pinging, metal hitting metal, but could not determine the location of the noise. I walked through Nong's hovel and exited out a rear door that opened up onto a stone courtyard surrounded by a high wooden fence. There I found the sound's source: "Daw Mu Yoe," Nong's wife, was using a foot-long plumbing pipe as a tool to bend thick brass wire into a coiled spiral while she fashioned a very small and very delicate neck ring coil. I then heard some sort of indistinguishable guttural sounds; repetitive grunting chants emanated from the other side of the yard's high fence but Daw Mu Yoe continued to focus attention on her task. "Yoe, it's me Dave. I tried calling you but there was no answer so I just came in." After saying, "I hope that's O.K.?" I exited the back door of her dank dwelling into the yard's bright sunlight, but she continued working without responding. I crept closer. Within inches of her right ear I repeated the

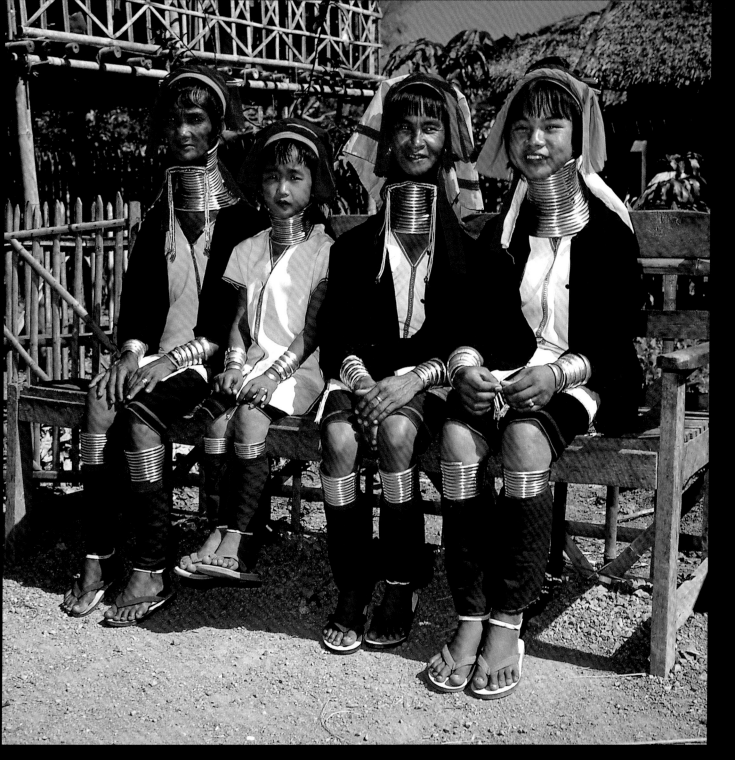

**"Daw Mu Theen," "Daw Mu Yoe," "Matea," and "Ma Dan" in "Daw Kay" village: Inle Lake Burma**

same salutation and to my disbelief she still was unresponsive! When I softly tapped her right shoulder she screamed in fear and whirled around to defend herself, but just before she had a chance to strike her defense melted in recognition. "Dave, what you do here?" she nervously queried. "You know I always come to visit you and Nong every day at this time. Today is the same...!" I said. It was at that point I first realized Yoe is a deaf lip reader as she calmly replied, "You know you always welcomed...!" My heart swelled with sympathy for her condition while she explained, "Nong started making this neck ring. I finish it now. Old man's power will put rings on young girl's neck for the first time today. You want see?" It was an auspicious day for this Padaung female's "rite of passage." Neck rings would be employed to initiate a young woman into the tribe's small group of elite who already wore heavy brass coils around their necks!

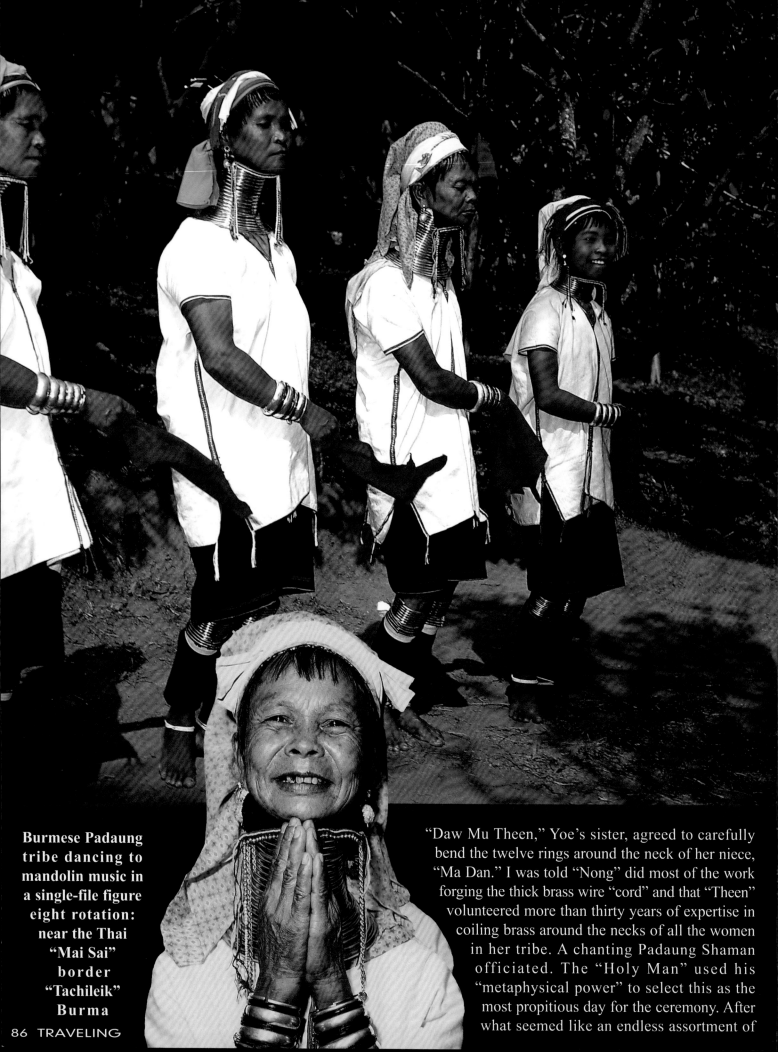

**Burmese Padaung tribe dancing to mandolin music in a single-file figure eight rotation: near the Thai "Mai Sai" border "Tachileik" Burma**

"Daw Mu Theen," Yoe's sister, agreed to carefully bend the twelve rings around the neck of her niece, "Ma Dan." I was told "Nong" did most of the work forging the thick brass wire "cord" and that "Theen" volunteered more than thirty years of expertise in coiling brass around the necks of all the women in her tribe. A chanting Padaung Shaman officiated. The "Holy Man" used his "metaphysical power" to select this as the most propitious day for the ceremony. After what seemed like an endless assortment of

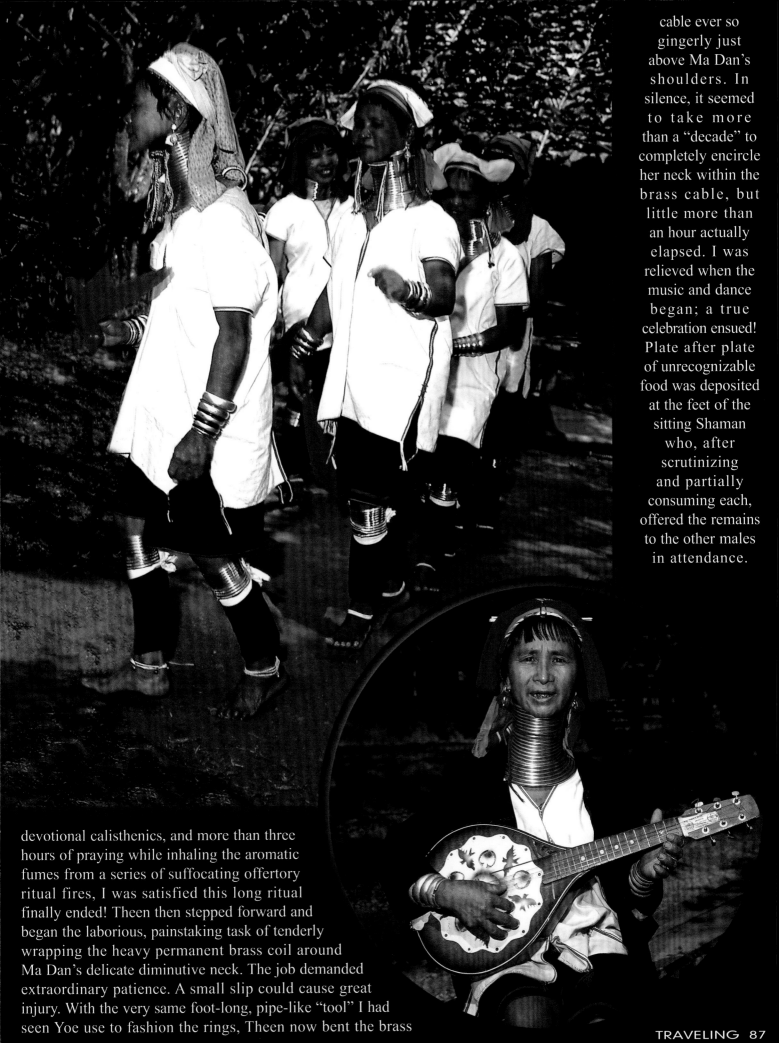

cable ever so gingerly just above Ma Dan's shoulders. In silence, it seemed to take more than a "decade" to completely encircle her neck within the brass cable, but little more than an hour actually elapsed. I was relieved when the music and dance began; a true celebration ensued! Plate after plate of unrecognizable food was deposited at the feet of the sitting Shaman who, after scrutinizing and partially consuming each, offered the remains to the other males in attendance.

devotional calisthenics, and more than three hours of praying while inhaling the aromatic fumes from a series of suffocating offertory ritual fires, I was satisfied this long ritual finally ended! Theen then stepped forward and began the laborious, painstaking task of tenderly wrapping the heavy permanent brass coil around Ma Dan's delicate diminutive neck. The job demanded extraordinary patience. A small slip could cause great injury. With the very same foot-long, pipe-like "tool" I had seen Yoe use to fashion the rings, Theen now bent the brass

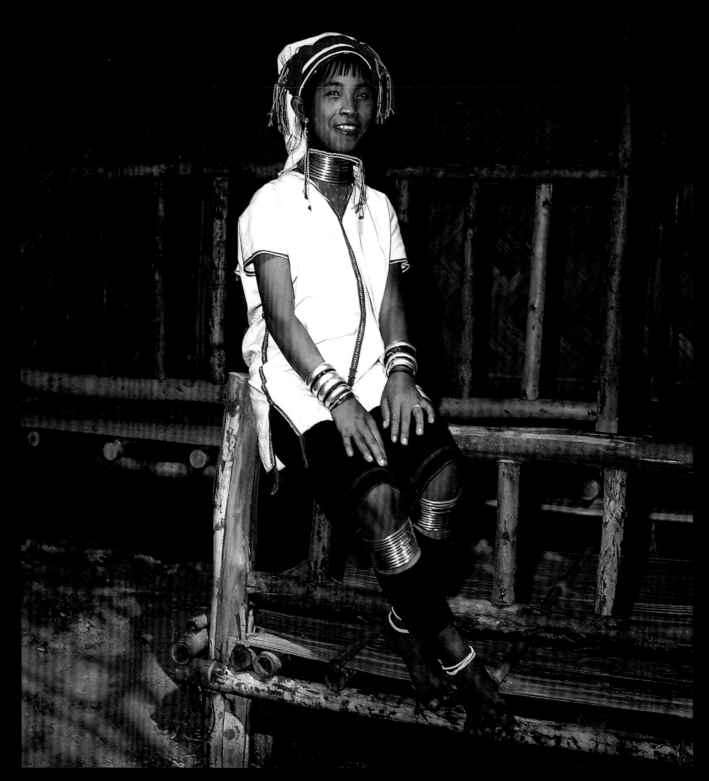

**The young Padaung girl: "Ma Youu," at the tribe's female rite of passage neck ring ritual**

To my delight traditional coconut alcohol refreshments were served but unfortunately caused the eventual premature demise of the celebration! "YOU MORE!" was the most frequently delivered, and I began to believe, sole salutation known to the tribesmen. I am not certain if they even understood what "YOU MORE!" meant, but they did realize if they screamed those words in my direction the anticipated response would surely be, "NO, NO, NO, that's O.K. THANK YOU but NO!" I could then expect another series of, "YOU MORE! YOU MORE! YOU MORES!" until I relented and finally consumed another shot of the foul-smelling alcoholic coconut drink.

Our debauchery continued into the evening, until well after dark, but just before the rancid "dessert"

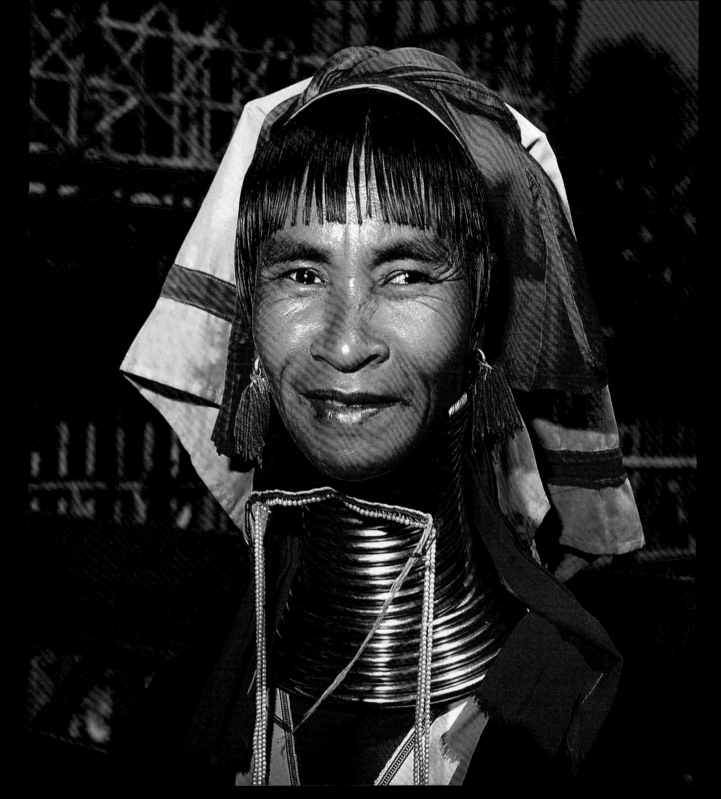

**"Daw Mu Yoe" the deaf, lip reading, wife of my friend Daw Mu Nong: "Daw Kay" village Burma**

could be comfortably served several of the tribesmen, including the Shaman, succumbed to the effects of the putrid drink and stumbled unconscious to the dirt floor in the main celebration hut. For some unknown reason I was held accountable by the female Padaung for the acts of their intoxicated husbands and even though I was not responsible I was forced to run from the celebration fearing the possibility of receiving a violent retaliatory punishment. Of course, all was forgiven by the following morning, but for that entire night I was spared the luxury of sleeping inside a guest house. While hiding outside in the bushes, under my bedroom's front door, I fell asleep still worrying about the feasibility of a dangerous female Padaung reprisal.

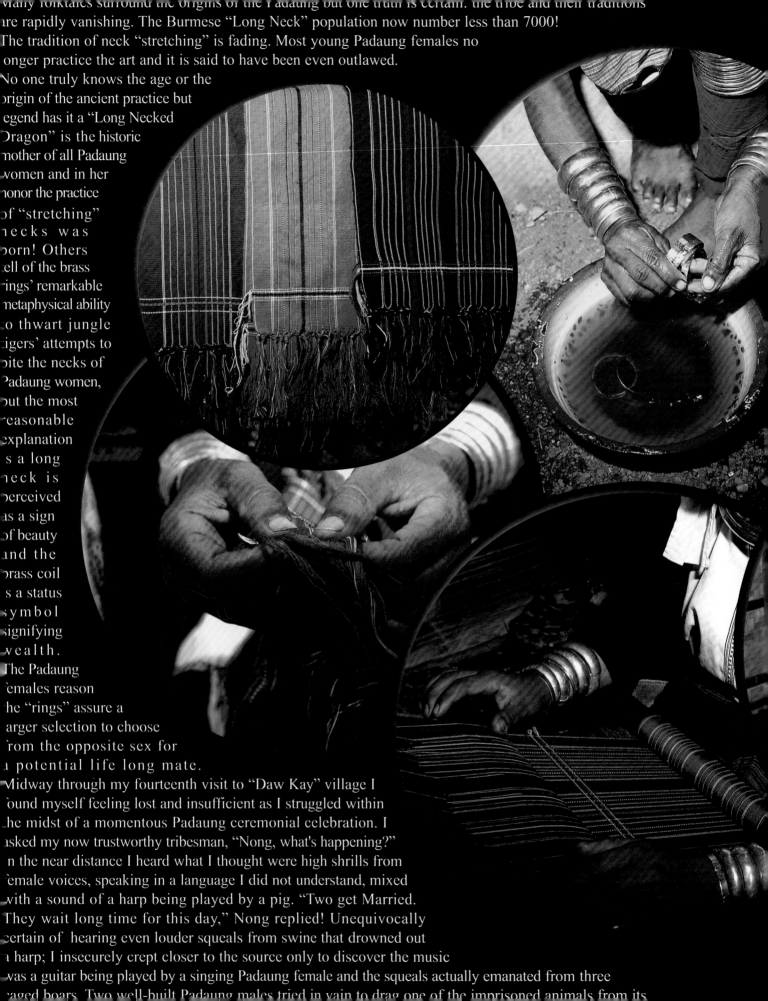

Many folktales surround the origins of the Padaung but one truth is certain: the tribe and their traditions are rapidly vanishing. The Burmese "Long Neck" population now number less than 7000! The tradition of neck "stretching" is fading. Most young Padaung females no longer practice the art and it is said to have been even outlawed.

No one truly knows the age or the origin of the ancient practice but legend has it a "Long Necked Dragon" is the historic mother of all Padaung women and in her honor the practice of "stretching" necks was born! Others tell of the brass rings' remarkable metaphysical ability to thwart jungle tigers' attempts to bite the necks of Padaung women, but the most reasonable explanation is a long neck is perceived as a sign of beauty and the brass coil is a status symbol signifying wealth.

The Padaung females reason the "rings" assure a larger selection to choose from the opposite sex for a potential life long mate.

Midway through my fourteenth visit to "Daw Kay" village I found myself feeling lost and insufficient as I struggled within the midst of a momentous Padaung ceremonial celebration. I asked my now trustworthy tribesman, "Nong, what's happening?" In the near distance I heard what I thought were high shrills from female voices, speaking in a language I did not understand, mixed with a sound of a harp being played by a pig. "Two get Married. They wait long time for this day," Nong replied! Unequivocally certain of hearing even louder squeals from swine that drowned out a harp; I insecurely crept closer to the source only to discover the music was a guitar being played by a singing Padaung female and the squeals actually emanated from three caged boars. Two well-built Padaung males tried in vain to drag one of the imprisoned animals from its

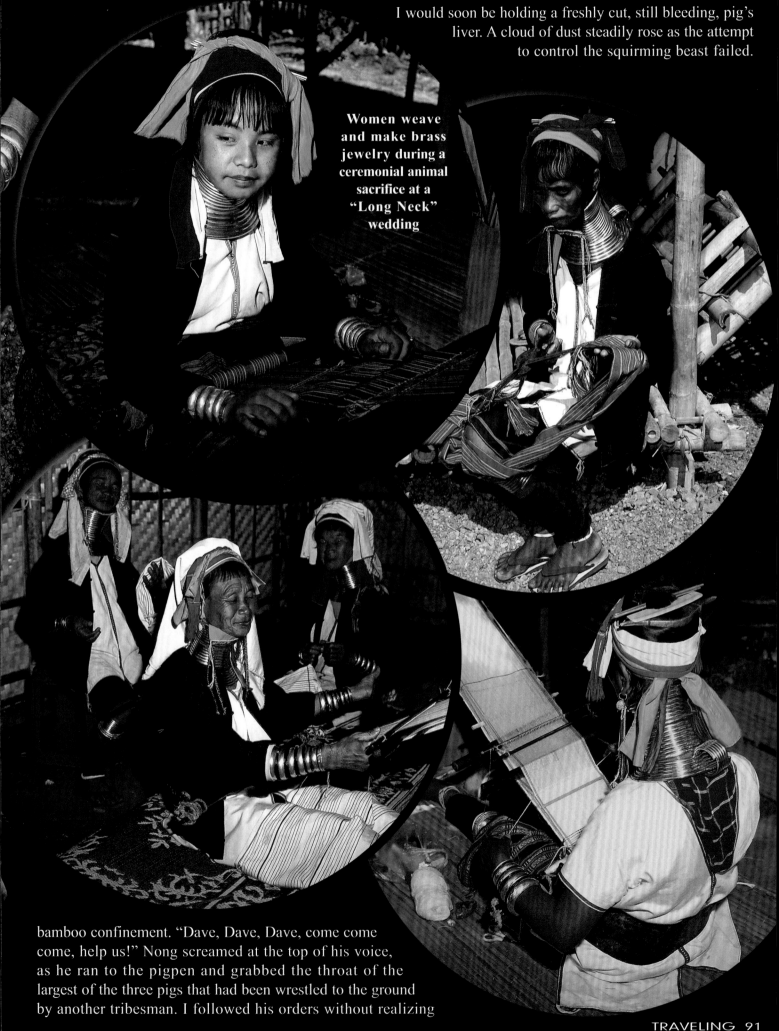

I would soon be holding a freshly cut, still bleeding, pig's liver. A cloud of dust steadily rose as the attempt to control the squirming beast failed.

**Women weave and make brass jewelry during a ceremonial animal sacrifice at a "Long Neck" wedding**

bamboo confinement. "Dave, Dave, Dave, come come come, help us!" Nong screamed at the top of his voice, as he ran to the pigpen and grabbed the throat of the largest of the three pigs that had been wrestled to the ground by another tribesman. I followed his orders without realizing

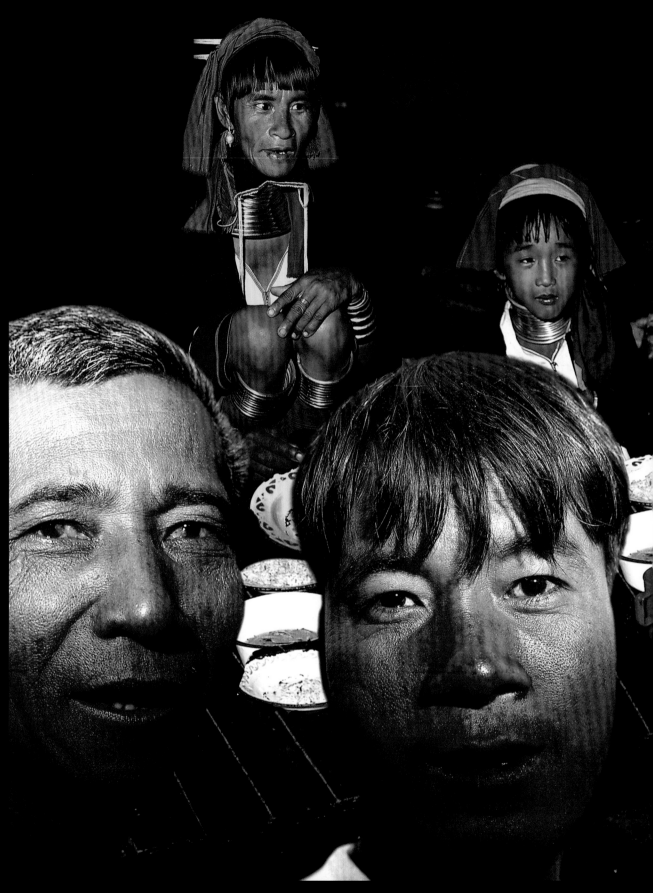

In the commotion someone used a paring knife to cut a hole in the chest of the creature, between the two front legs, right below it's head. Nong searched for the beast's heart, using a circular motion, after he inserted a long narrow sharp bamboo sliver into the wound made by the tiny knife. It did not take long to locate the organ but the agonizing sound of the boar's death rings in my mind's eye to this day. After twenty or thirty seconds, which seemed an eternity, the powerful animal finally stopped struggling and, in the sound of a last gasp for breath, collapsed into

**A Padaung shaman through a sacrificed pig's liver at me during a tribal wedding ceremony**

an unrecognizable heap in swirling dust! The Padaung priest then cut the liver out of the dead animal's still beating chest! The shaman, exhibiting great fanfare and showmanship while dancing, scrutinized the organ from several different angles. A roar of approval emanated from the wedding party as the liver was deemed healthy! The two remaining pigs would not have to be slaughtered as the tribe believes the omen of one healthy animal is sufficient to officially consecrate a wedding union. Padaung tradition dictates: A scheduled wedding must be canceled

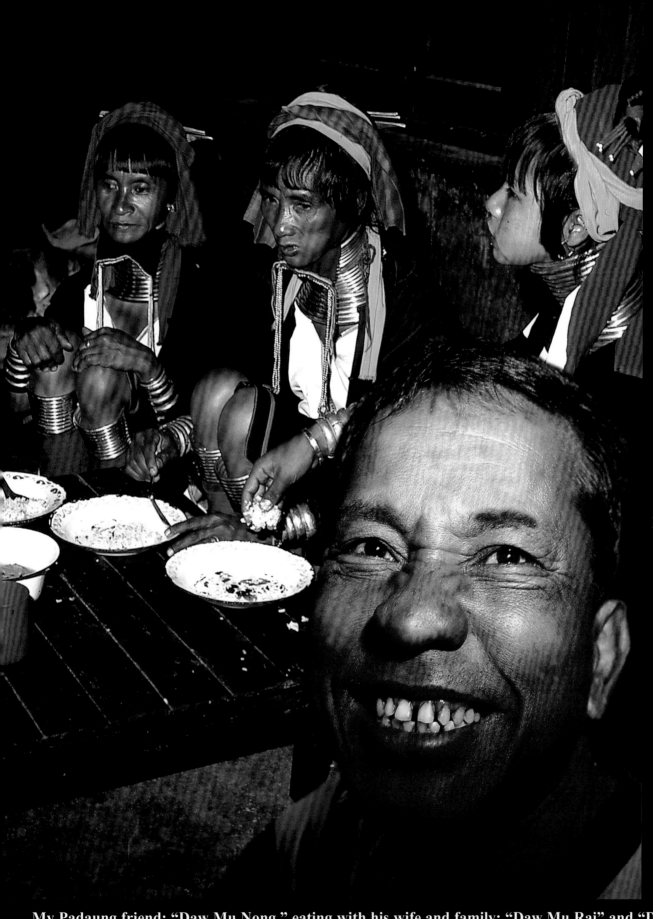

if, on the day of the ceremony, the livers of three pigs are all found to be unhealthy. The eventuality of that couple's marriage is certain to yield an unhappy and childless union! Nong's wife, Daw Mu Yoe and his two daughters, "Matea" and "Ma Dan," danced with glee as the carcass was hacked into small "shares" for distribution, while blood soaked banana leaves served as platters to hold the cubed meat portions, still partially covered in bristles of spiny boar hair. As the crowd cheered, the standing priest held the still bleeding dripping liver high above his head and, for a reason that I can not fathom to this

**My Padaung friend: "Daw Mu Nong," eating with his wife and family: "Daw Mu Rai" and "Daw Mu Kai"**

day, flung it in my direction! I lunged for the organ and caught it, both hands in mid-air. Even though it made me feel nauseous I surreptitiously waited before depositing the still "beating wedding vow" onto a blood-soaked banana leaf. I unsuccessfully tried to blend into the raucous crowd but only after receiving great affection and attention was I permitted to finally dismiss myself and retire to the confines of my windowless guest room for another night of reflection and anticipation of my next experience with the "Long Neck."

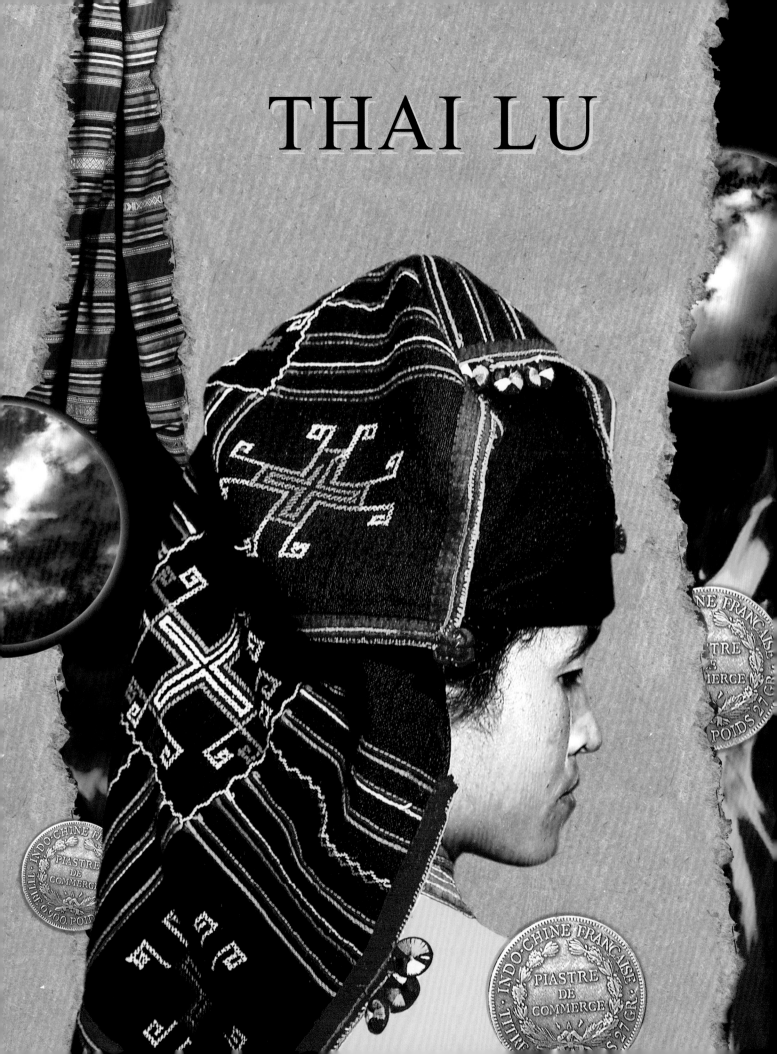

# THAI LU

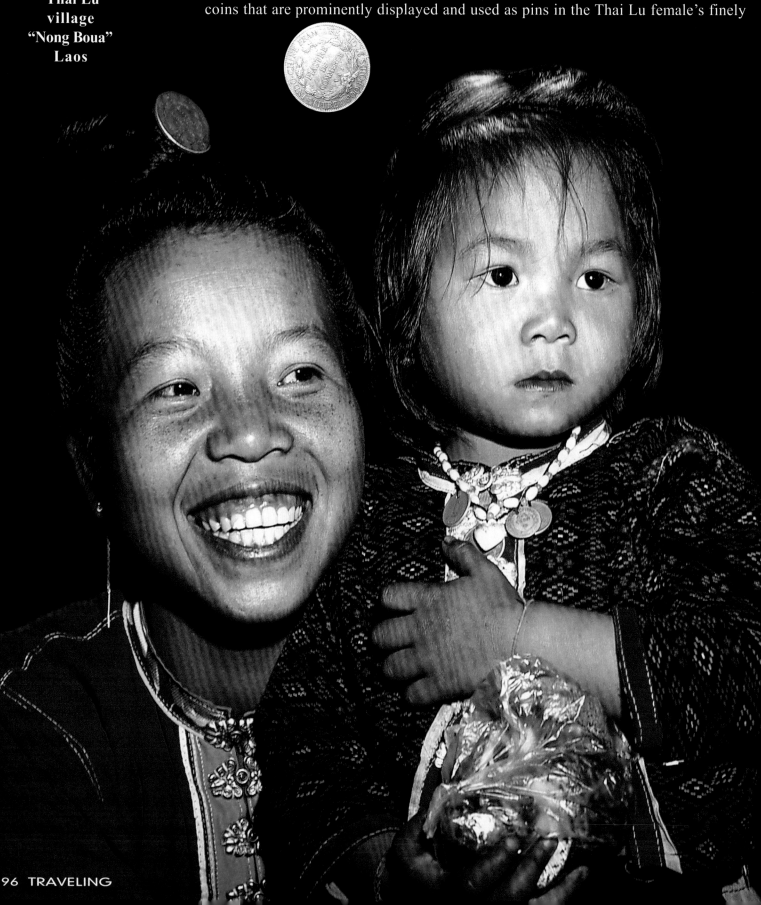

I felt like a commuter when stepping onto the smallest passenger jet in Bangkok, Thailand bound for Laos. Less than a week ago I was in Laos documenting "opium antics" with the "Yao" tribe! I returned seeking the obscure Laotian "Thai Lu" after hearing rumors of their ancient tribal jewelry fetish. As the plane touched down I feverishly wondered, what's my goal? After considering this journey could possibly be the most strenuous exercise ever attempted in aimless endeavors, I studied illustrations of 19th-century Indo-Chinese French franc silver coins that are prominently displayed and used as pins in the Thai Lu female's finely

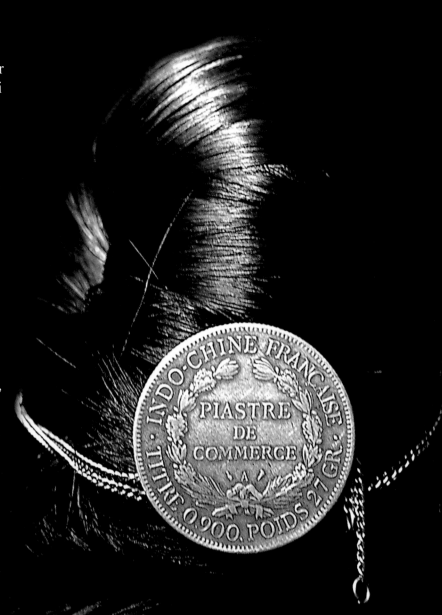

groomed hair, while waiting for a connecting flight north. While looking for evidence of those Thai Lu artifacts I again stepped into the three block Laotian town, nine "clicks" from the Chinese border, known as "Muang Sing." I sat in the town's only opened-air cafe and, while sipping strong, thick brown coffee followed by "chasers" of weak tea, asked, "Is Laos the only country in the world that traditionally serves coffee and tea together?" when, in the hair of a most attractive Thai Lu female, I spotted an old coin hairpin refract in a flash of fleeting morning sunlight! She wore an extraordinary, finely tailored, magenta

tapered top, fashioned with small horizontal silver buckles and a cyan-colored narrow vertical clothband background! It ran from her delicate throat to her diminutive waist. The sleeves and neck on her beautiful blouse were adorned with delicate hems made from a rose colored textile. It is not possible to imagine someone more attractive!

**Thai Lu 19th century French franc silver coin hair pins**

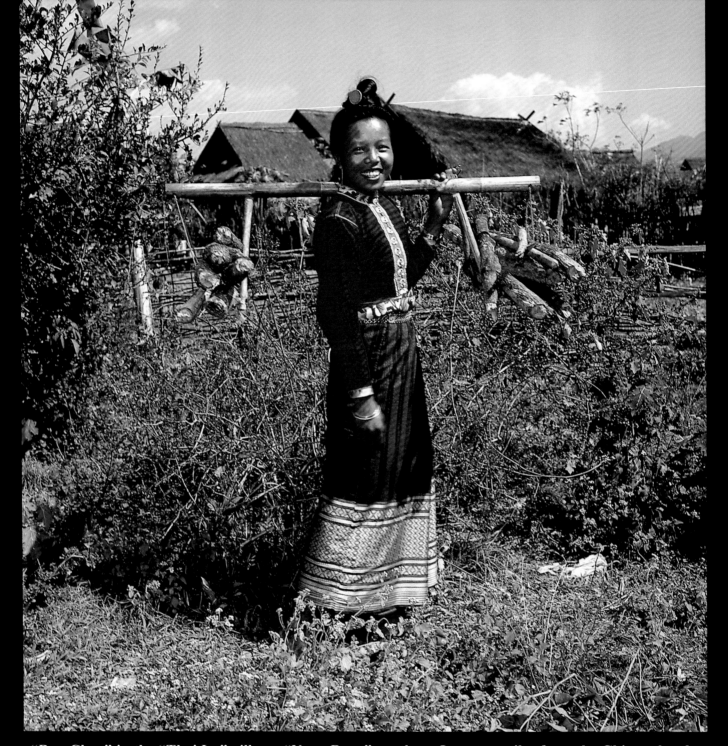

**"Bon Chen" in the "Thai Lu" village: "Nong Boua" northern Laos ten miles from the Chinese border**

A more striking woman could never be found on Manhattan's fashionable 57th street. "Yo', Thai Lu, what ya doin'? Do ya' want me ta' take photos of ya' and maybe, if ya' want, I'll buy your hairpin?" I yelled as she darted past on a rusting bicycle with untrue, cracked, almost flat tires. She demurred, and then ignored me, but after circling the block she must have thought better of it as she came to a complete halt right in front of my circular cafe table. Her head seemed as small as an orange, with a smile surley longer than a banana, when she looked down from her bike and simply said, "I'm Bon Chen. O.K. let's go!" She took me to her Thai Lu village, "Nong Boua," five miles south of Muang Sing and introduced me to her constantly sobbing daughter, "Bon Sen," and her strong, virile, though slow-witted husband "Chun." I brought simple modest gifts, household items, small useful things; soap, dish towels, toothpaste, and cotton balls but was mesmerized when Chun picked up the toothpaste tube and squeezed a healthy serving of the contents onto the palm of his right hand. My blood ran cold when I realized Chun is a dichotomy of nefarious innocence as he sheepishly dropped his shorts and rubbed a Ping-Pong ballsize handful of toothpaste onto his testicles

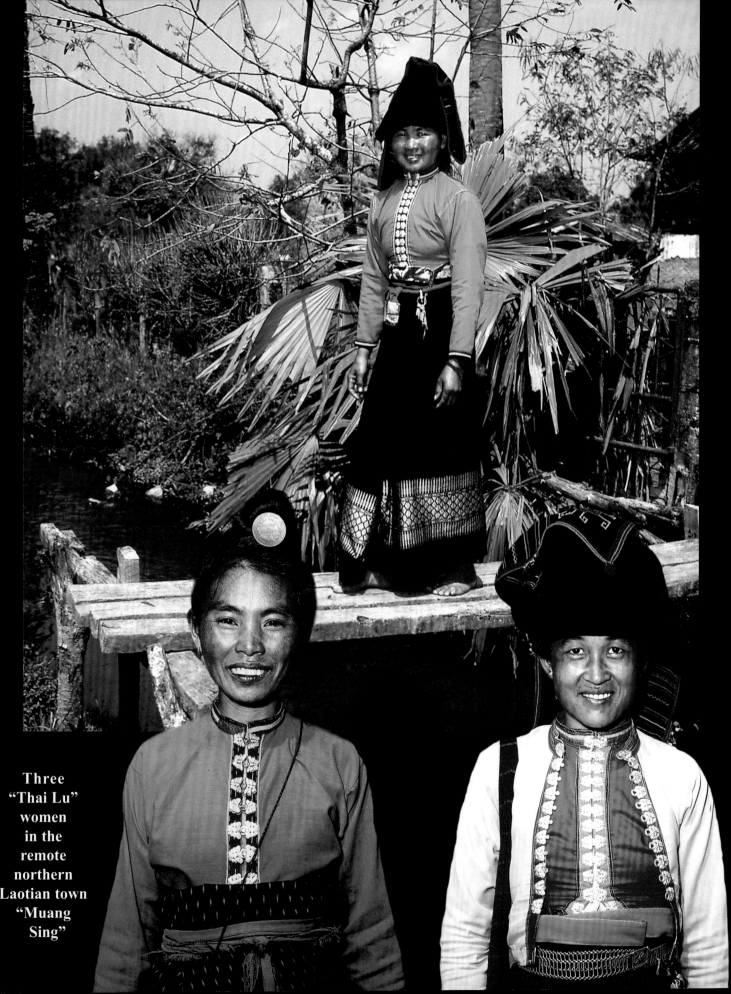

Three "Thai Lu" women in the remote northern Laotian town "Muang Sing"

He spasmodically convulsed, realizing the paste's tingle provided none of the soothing effects expected from hand cream. Without hectoring I dismissed Chun's obvious oblivion. After he surely misjudged the tube's contents his wife, Bon Chen, collected firewood for our evening meal. When she started cooking on a filthy hearth her elegant floor length dress and beautiful blouse seemed incongruous in the sunlight that poured through woven bamboo wall cracks in her "paper thin" hovel.

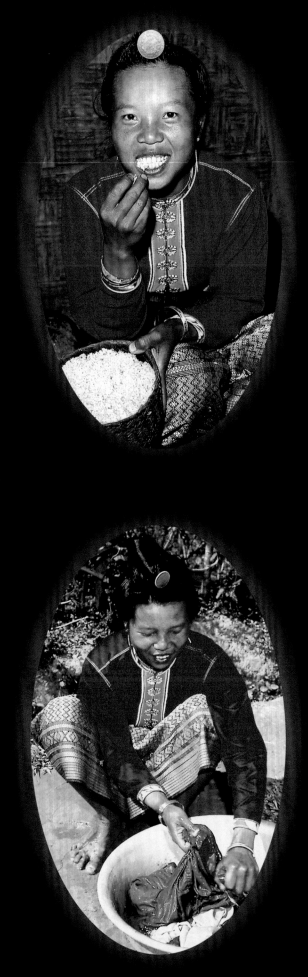

"Bon Chen" in the "Thai Lu" village "Nong Boua" was always happy and elegantly dressed when working under difficult conditions. When she died I broke down and found it difficult to leave Laos after I saw her body burn!

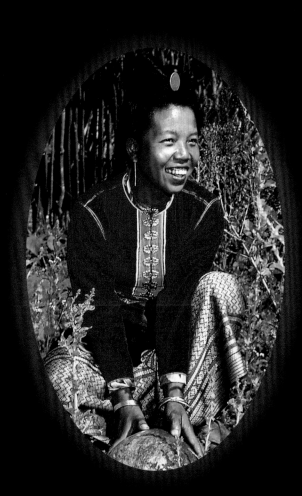

When she was on hands and knees, sifting rice and cutting vegetables on the dirt floor in her hut, I realized for the first time Bon Chen dresses more elegantly than most western woman and does, every day, even when doing strenuous manual labor! I enjoyed her company so much I visited Bon Chen and her family, in Nong Boua, more than twelve times. Always gracious, generous and gregarious, she never stoped smiling! No matter how difficult her situation was, she always manifested an extraordinary aura that surrounded her every move.

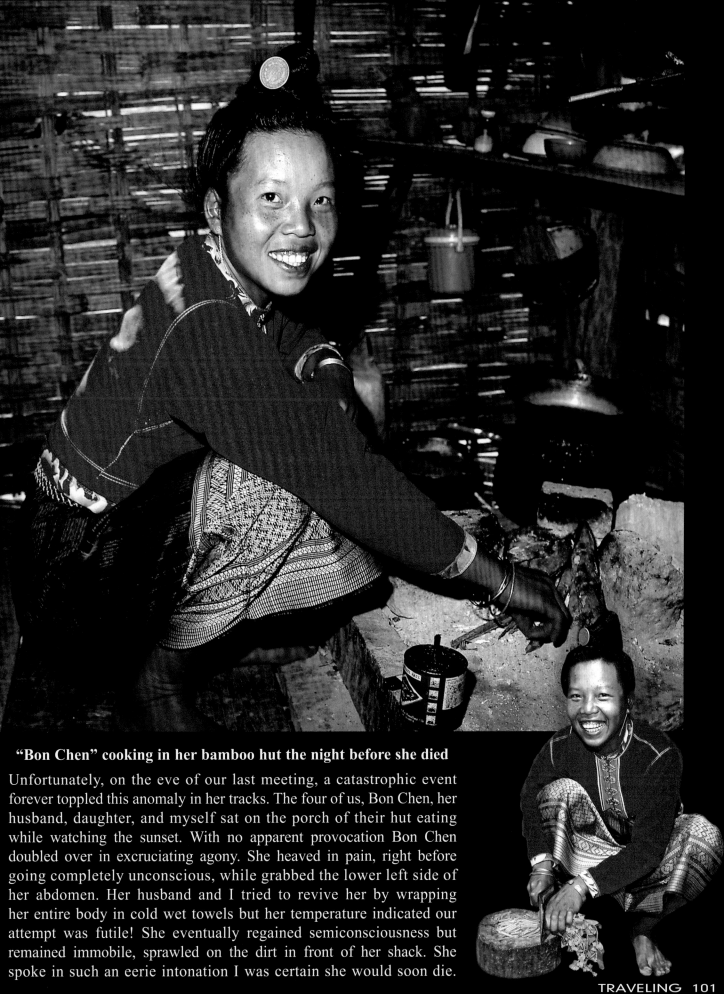

**"Bon Chen" cooking in her bamboo hut the night before she died**

Unfortunately, on the eve of our last meeting, a catastrophic event forever toppled this anomaly in her tracks. The four of us, Bon Chen, her husband, daughter, and myself sat on the porch of their hut eating while watching the sunset. With no apparent provocation Bon Chen doubled over in excruciating agony. She heaved in pain, right before going completely unconscious, while grabbed the lower left side of her abdomen. Her husband and I tried to revive her by wrapping her entire body in cold wet towels but her temperature indicated our attempt was futile! She eventually regained semiconsciousness but remained immobile, sprawled on the dirt in front of her shack. She spoke in such an eerie intonation I was certain she would soon die.

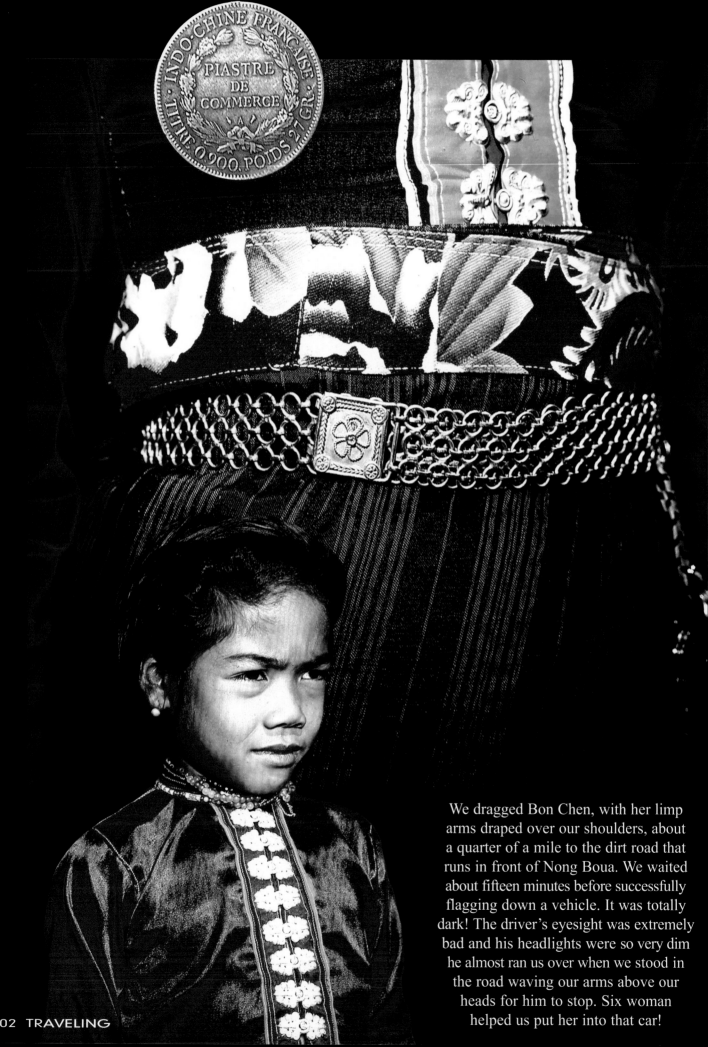

We dragged Bon Chen, with her limp arms draped over our shoulders, about a quarter of a mile to the dirt road that runs in front of Nong Boua. We waited about fifteen minutes before successfully flagging down a vehicle. It was totally dark! The driver's eyesight was extremely bad and his headlights were so very dim he almost ran us over when we stood in the road waving our arms above our heads for him to stop. Six woman helped us put her into that car!

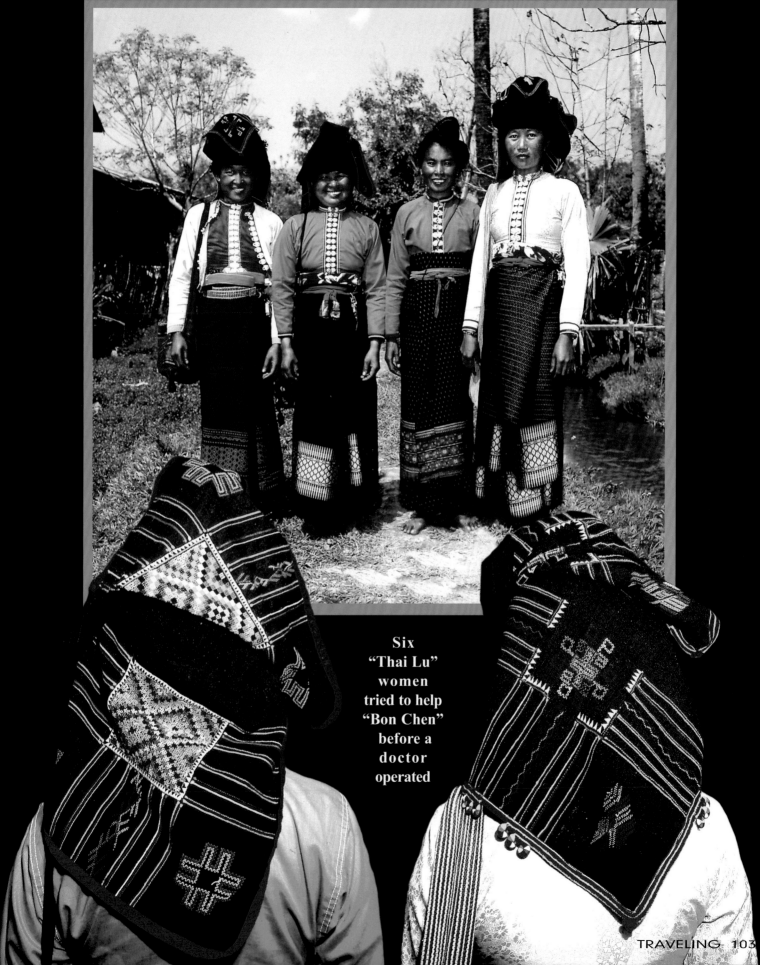

Six
"Thai Lu"
women
tried to help
"Bon Chen"
before a
doctor
operated

**"Bon Chen's" cremation was attended by mourners who moaned in unison while she burned**

We loaded Bon Chen's inanimate body into the backseat and headed as fast as we could possibly go to the town, Muang Sing. Only one doctor lived in this isolated area and though I smelled liquor on his breath I was relieved to place Bon Chen in his care. He suggested the symptoms may require a one-hour appendectomy as he closed a white curtain around himself and Bon Chen. Three hours later she bled to death. Apparently nothing was wrong with Bon Chen's appendix but rather a hemorrhage, from a ruptured fallopian tube, caused internal bleeding that precipitated into her final demise. Bon Chen, unknowingly pregnant, had spawned a child in one of her fallopian tubes rather than in her womb. The tube exploded when the ever-increasing stress from the growing fetus became too great!

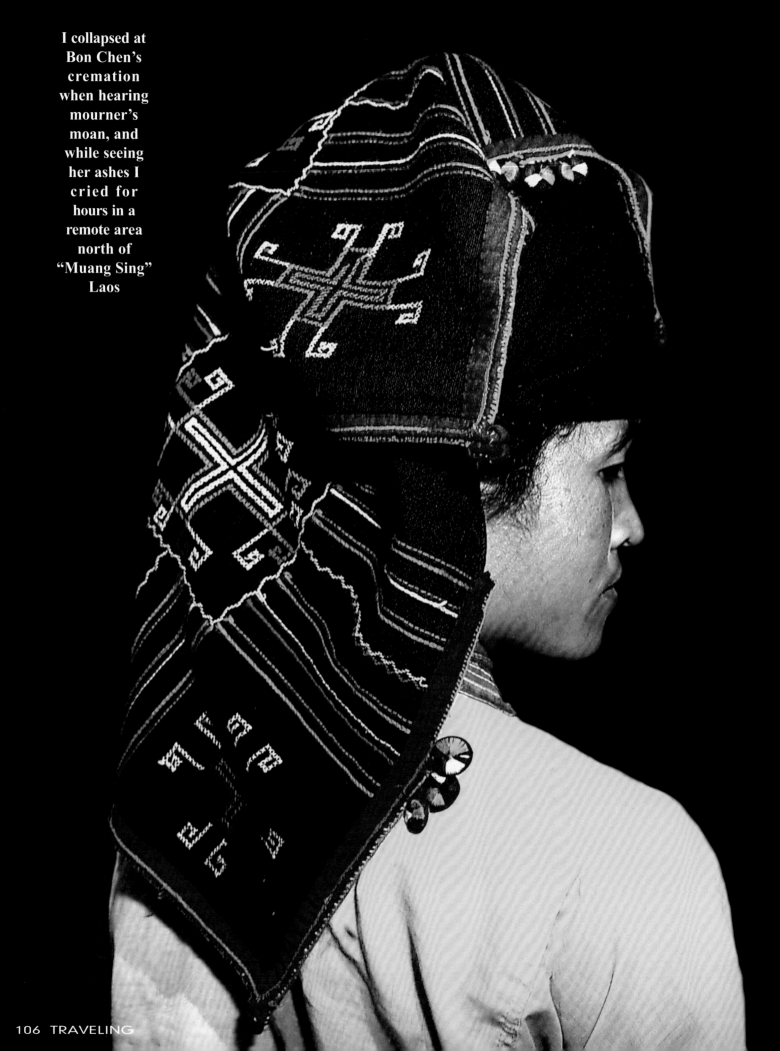

I collapsed at Bon Chen's cremation when hearing mourner's moan, and while seeing her ashes I cried for hours in a remote area north of "Muang Sing" Laos

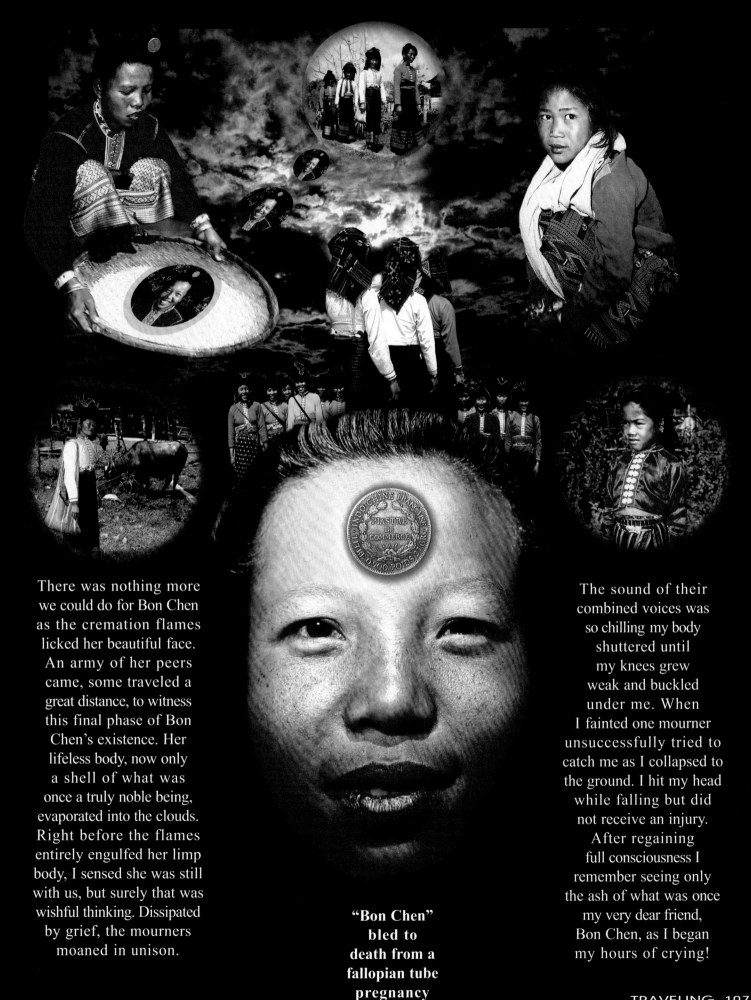

There was nothing more we could do for Bon Chen as the cremation flames licked her beautiful face. An army of her peers came, some traveled a great distance, to witness this final phase of Bon Chen's existence. Her lifeless body, now only a shell of what was once a truly noble being, evaporated into the clouds. Right before the flames entirely engulfed her limp body, I sensed she was still with us, but surely that was wishful thinking. Dissipated by grief, the mourners moaned in unison.

**"Bon Chen" bled to death from a fallopian tube pregnancy**

The sound of their combined voices was so chilling my body shuttered until my knees grew weak and buckled under me. When I fainted one mourner unsuccessfully tried to catch me as I collapsed to the ground. I hit my head while falling but did not receive an injury. After regaining full consciousness I remember seeing only the ash of what was once my very dear friend, Bon Chen, as I began my hours of crying!

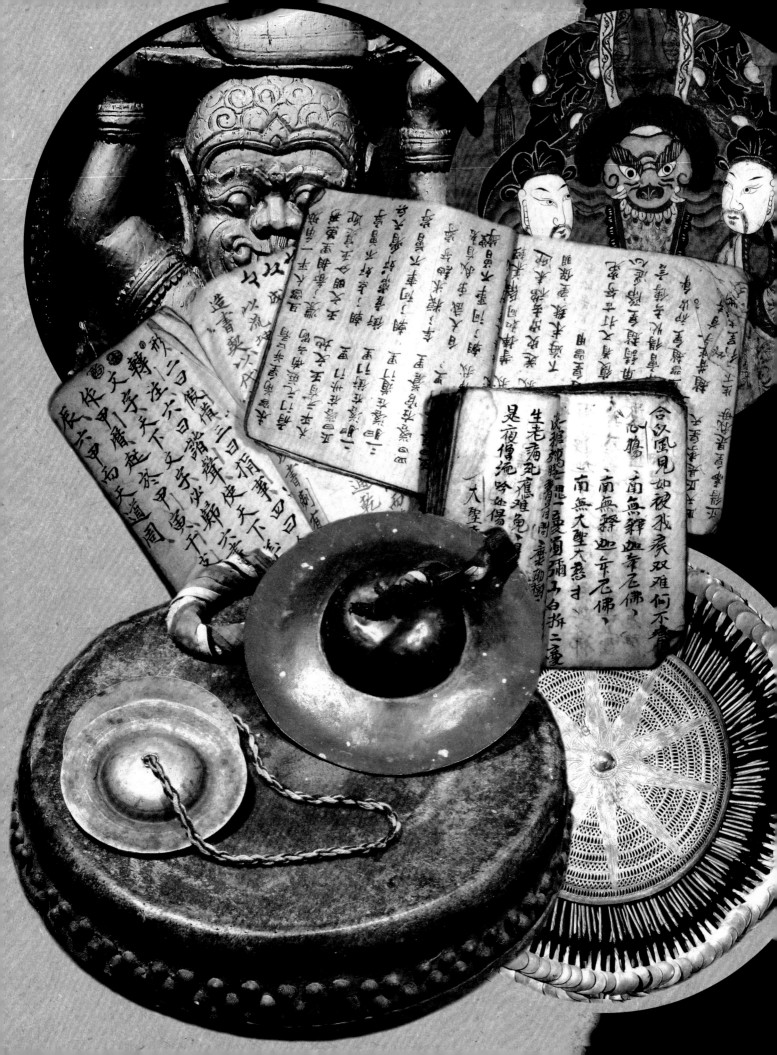

# LANTIEN

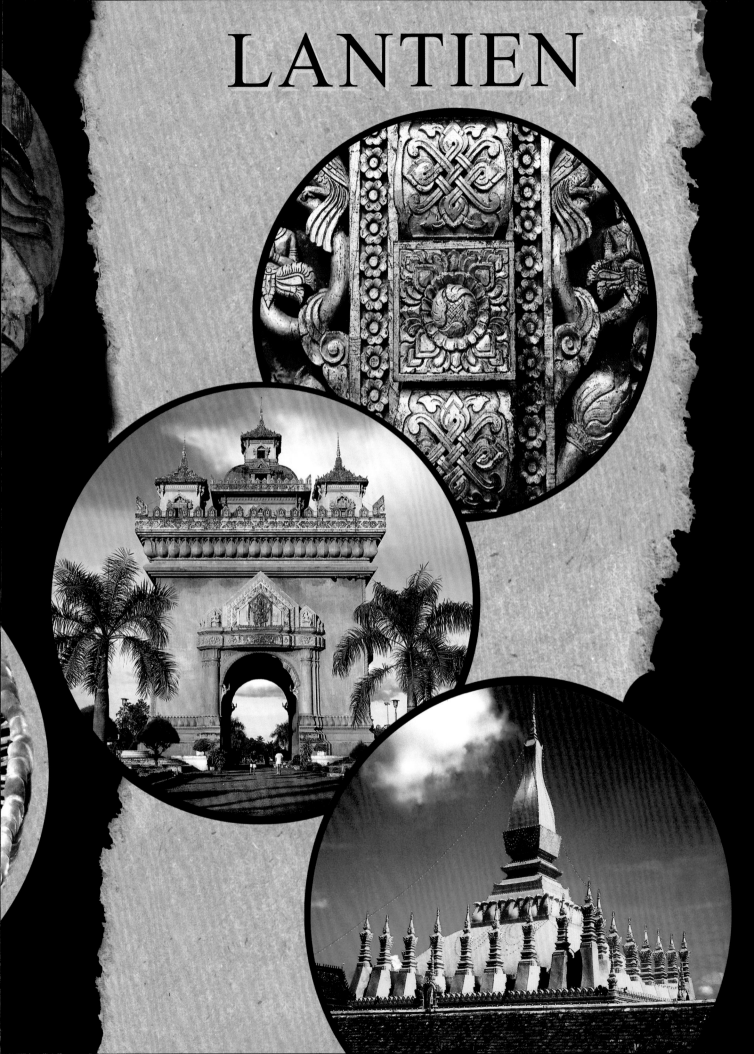

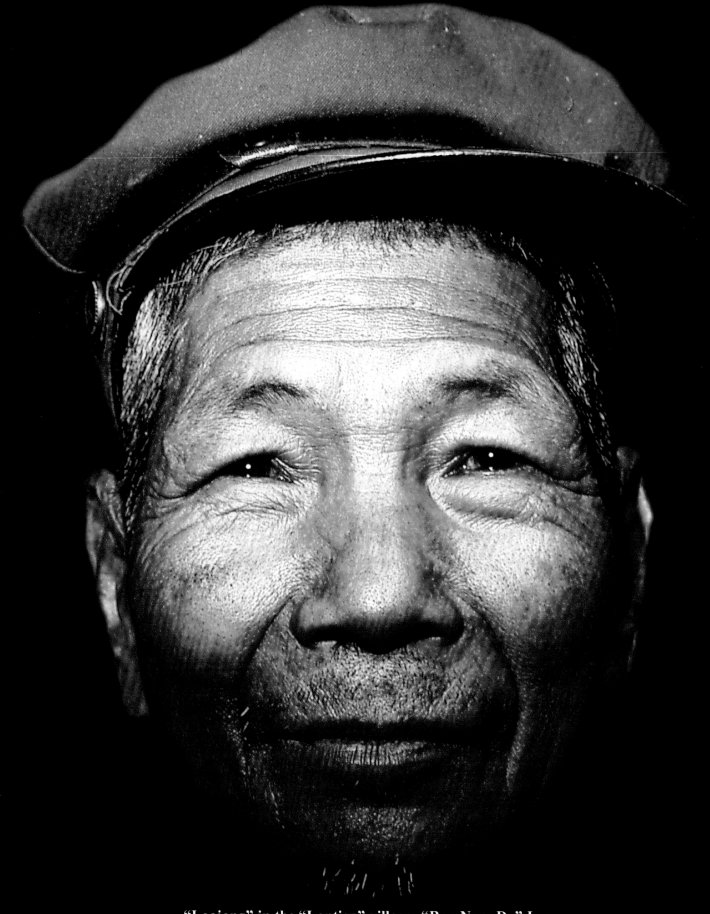

**"Loajang" in the "Lantien" village: "Ban Nam Dy" Laos**

It was emotionally painful; leaving Laos while struggling with depression after Bon Chen's death. Without caring for the financial consequence I canceled a scheduled flight to "Palawan Island," Philippines, but regretted not following through with an agreement to meet a tribesman in that archipelago. I was distraught, confused, delirious and in a horrendous rage over Bon Chen's passing. Her husband gave me her old French

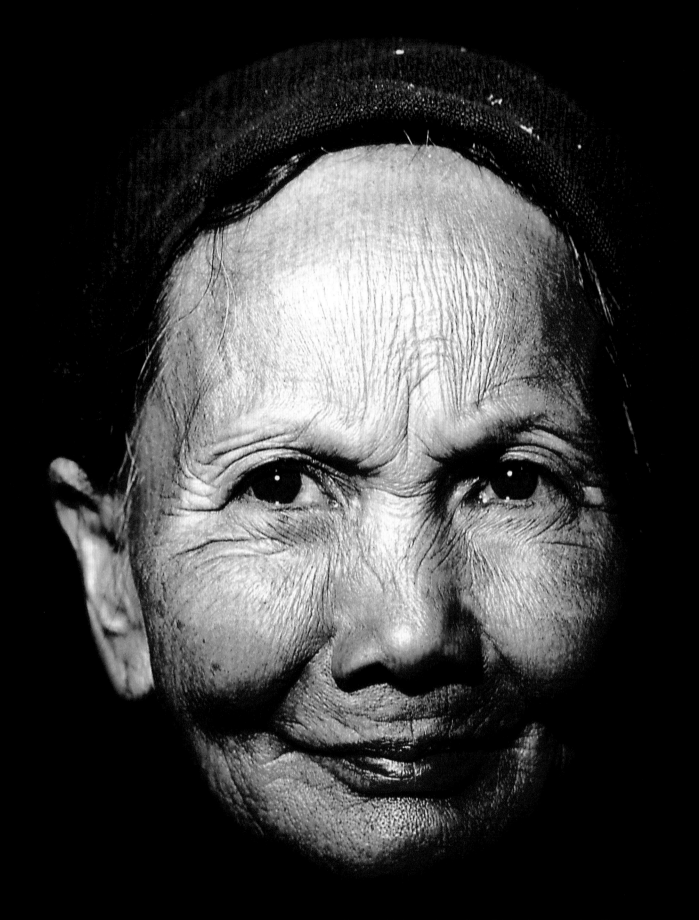

**"Loajang's" wife, "Man Nong La," said "There is Life within Everything!"**

franc silver coin hairpin, as a memento that I forever carry wrapped in a handmade textile close to my heart. I was unhappy, but felt resilient, when I took a taxi to Muang Sing's bus station. The effect of Bon Chen's traumatic death slowly diminished in the warm morning light, but when I saw the reflection of my driver's "reptilian eyes" in the cab's rearview mirror, I felt a new sense of vulnerability. I immediately realized something was amiss, but

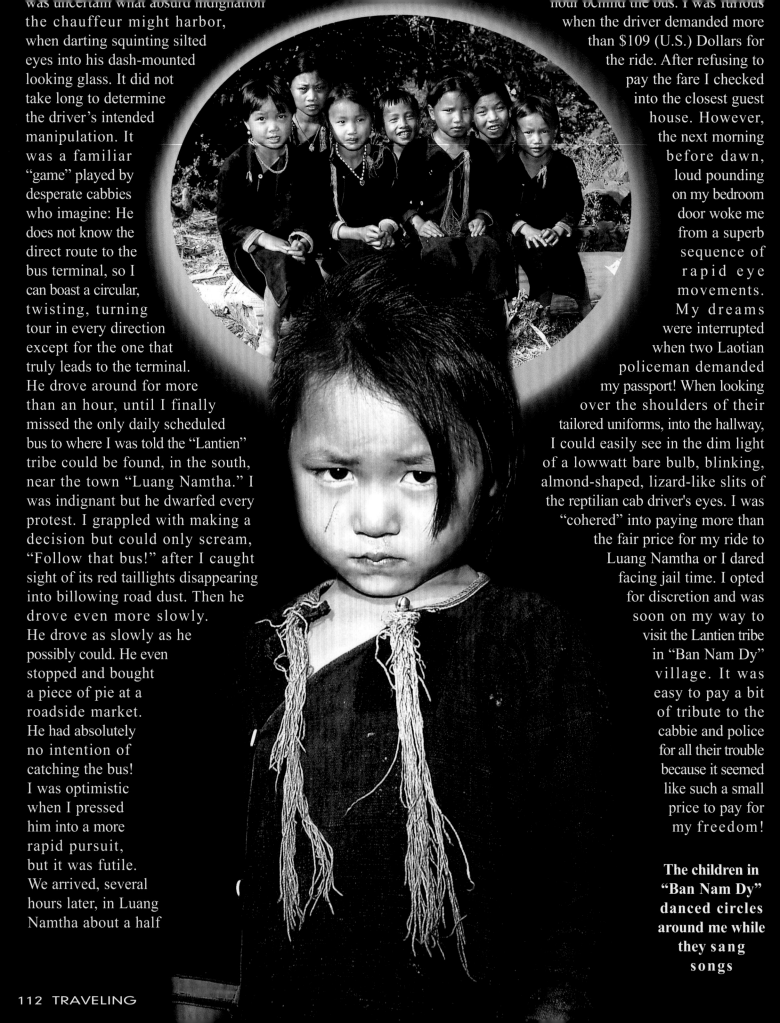

was uncertain what absurd indignation the chauffeur might harbor, when darting squinting silted eyes into his dash-mounted looking glass. It did not take long to determine the driver's intended manipulation. It was a familiar "game" played by desperate cabbies who imagine: He does not know the direct route to the bus terminal, so I can boast a circular, twisting, turning tour in every direction except for the one that truly leads to the terminal. He drove around for more than an hour, until I finally missed the only daily scheduled bus to where I was told the "Lantien" tribe could be found, in the south, near the town "Luang Namtha." I was indignant but he dwarfed every protest. I grappled with making a decision but could only scream, "Follow that bus!" after I caught sight of its red taillights disappearing into billowing road dust. Then he drove even more slowly. He drove as slowly as he possibly could. He even stopped and bought a piece of pie at a roadside market. He had absolutely no intention of catching the bus! I was optimistic when I pressed him into a more rapid pursuit, but it was futile. We arrived, several hours later, in Luang Namtha about a half

hour behind the bus. I was furious when the driver demanded more than $109 (U.S.) Dollars for the ride. After refusing to pay the fare I checked into the closest guest house. However, the next morning before dawn, loud pounding on my bedroom door woke me from a superb sequence of rapid eye movements. My dreams were interrupted when two Laotian policeman demanded my passport! When looking over the shoulders of their tailored uniforms, into the hallway, I could easily see in the dim light of a lowwatt bare bulb, blinking, almond-shaped, lizard-like slits of the reptilian cab driver's eyes. I was "cohered" into paying more than the fair price for my ride to Luang Namtha or I dared facing jail time. I opted for discretion and was soon on my way to visit the Lantien tribe in "Ban Nam Dy" village. It was easy to pay a bit of tribute to the cabbie and police for all their trouble because it seemed like such a small price to pay for my freedom!

**The children in "Ban Nam Dy" danced circles around me while they sang songs**

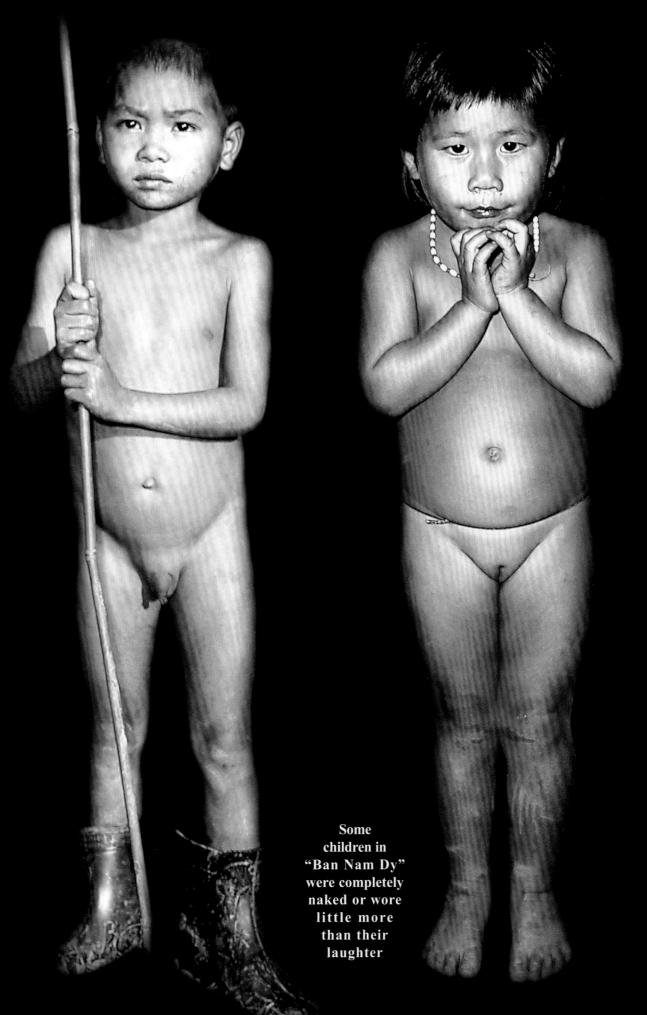

Some children in "Ban Nam Dy" were completely naked or wore little more than their laughter

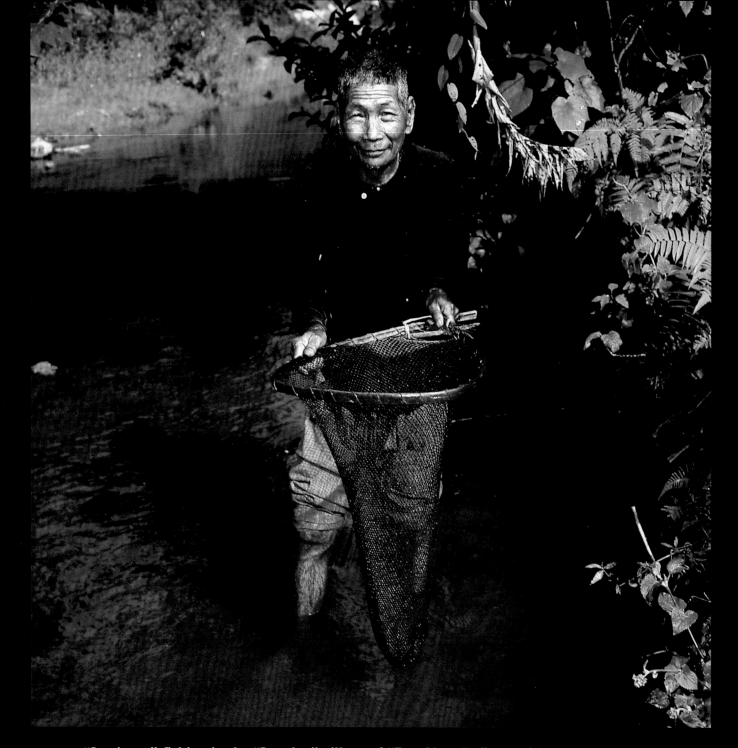

**"Loajang:" fishing in the "Lantien" village of "Ban Nam Dy" was either mad or senile!**

I was immediately encircled, in Ban Nam Dy, by a throng of singing children who, while holding hands, danced around me on the riverbanks. Some, almost completely naked, wore little more than laughter, while others dressed simply in traditional Lantien attire: extremely dark indigo colored, longsleeve, calf-length tops with purple tassel fringe dangling from the necklines. While they danced rings around me I wondered, why are they not afraid of strangers? Is this a dream or a scene from a nonexistent version of "Paradise Lost?" When I attempted to determine what was real and what was imaginary I flailed in disbelief. Shaking from side to side, while hopping up and down, I tried to shake loose what was inside my head that envisioned this unbelievable group of "Surreal" children, when an old Lantien tribesman screamed something from across the river that I don't quite remember, but it went something like this: "My name is Loajang. I was born in this village: Ban Nam Dy seventy-one years ago. What's your name and where da' ya' come from?" Being uncertain of his "game" I hesitated, but after responding to his quizzical cache of queries my reservations turned to intrigue. Although his power of recall was impressive, he appeared to be senile when he

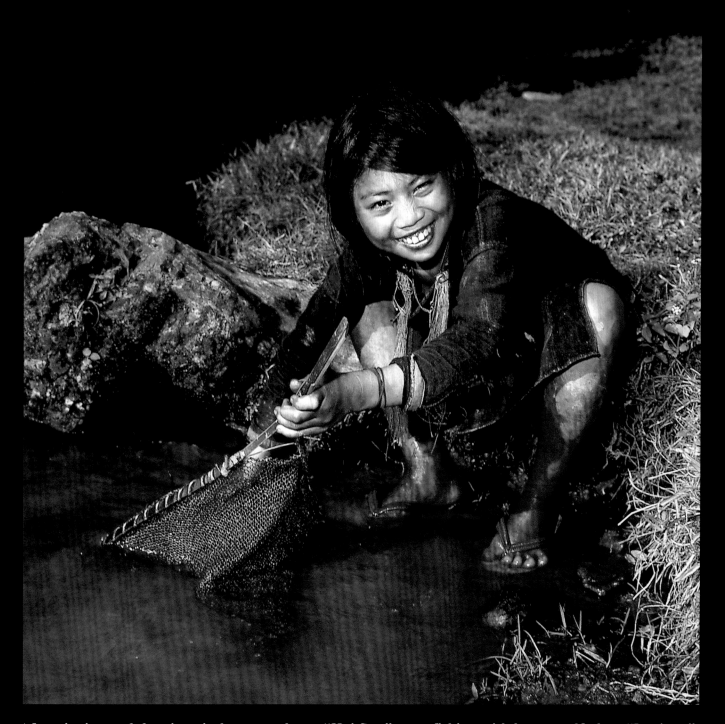

**After singing and dancing circles around me: "Hai Sun" went fishing with her grandfather, "Loajang"**

continued: "Do you know my Lantien tribe is also known as the "Stream" and that we believe all things are "Alive" including Rocks, Rivers, and the Sky? We have "Spirits" in this village that communicate with "Dead Ancestors" who we worship as "Gods," but I want to ask you, Do you know the "Way?" I was not sure if the old man was daft or sarcastic but before it was possible to answer or question him, he put me off by saying, "I'm sorry! I do not have more time to talk of such things. I'm going fishing with my granddaughter. We do not have much food right now so we must fish and then I have to make sure my wife finishes making that "Big" piece of paper. I'm very, very, very busy right now, so I have to say Bye Bye!" Now I was even more suspicious the old man could possibly be a member of the "Mad Hatter's Club" but while he wore a "Mao" cap, he would never qualify for inclusion in the "Hatter's" ranks. After envisioning "Men in White Coats" chasing him down, I decided it would be possible to reach a definitive conclusion concerning his sanity if he were followed. I stalked Loajang just long enough to ascertain he did indeed fish with his granddaughter in the river that runs directly through Ban Nam Dy village.

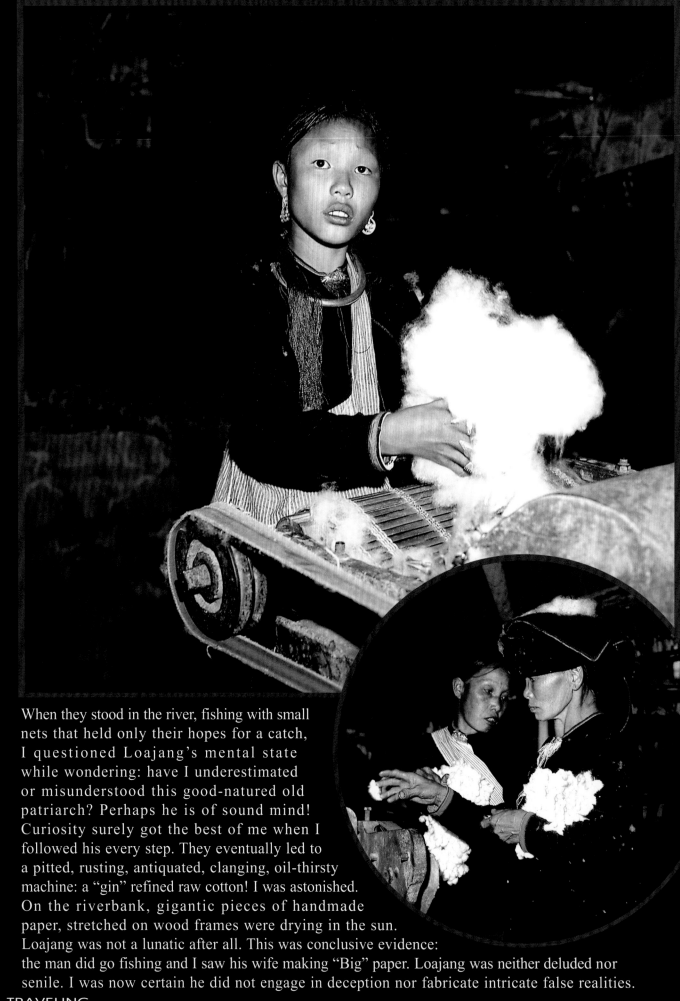

When they stood in the river, fishing with small
nets that held only their hopes for a catch,
I questioned Loajang's mental state
while wondering: have I underestimated
or misunderstood this good-natured old
patriarch? Perhaps he is of sound mind!
Curiosity surely got the best of me when I
followed his every step. They eventually led to
a pitted, rusting, antiquated, clanging, oil-thirsty
machine: a "gin" refined raw cotton! I was astonished.
On the riverbank, gigantic pieces of handmade
paper, stretched on wood frames were drying in the sun.
Loajang was not a lunatic after all. This was conclusive evidence:
the man did go fishing and I saw his wife making "Big" paper. Loajang was neither deluded nor
senile. I was now certain he did not engage in deception nor fabricate intricate false realities.

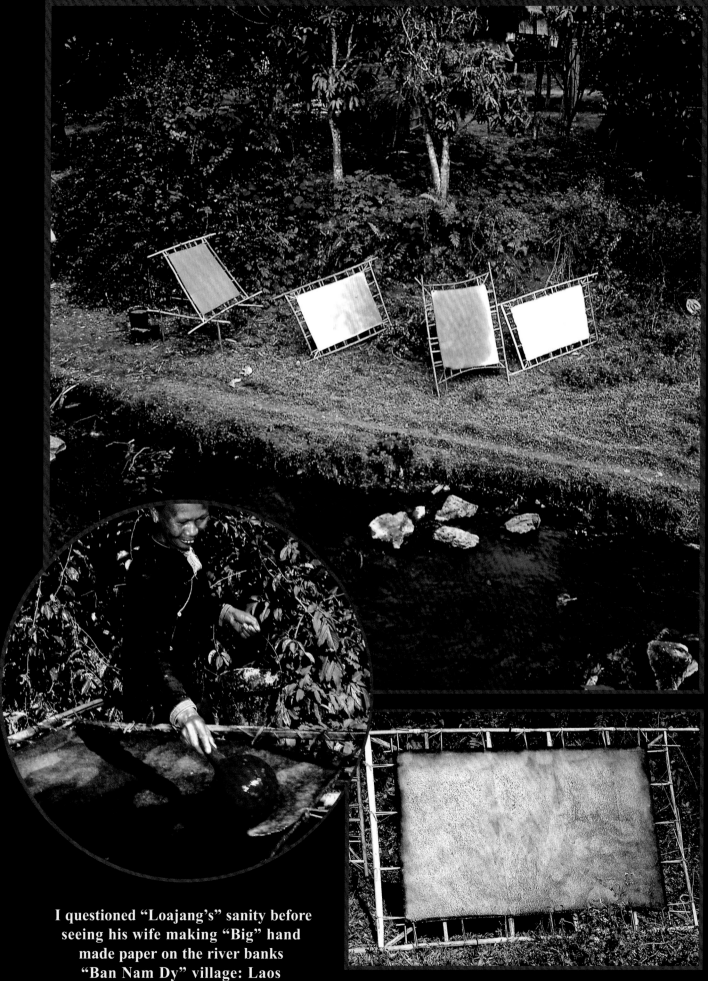

I questioned "Loajang's" sanity before
seeing his wife making "Big" hand
made paper on the river banks
"Ban Nam Dy" village: Laos

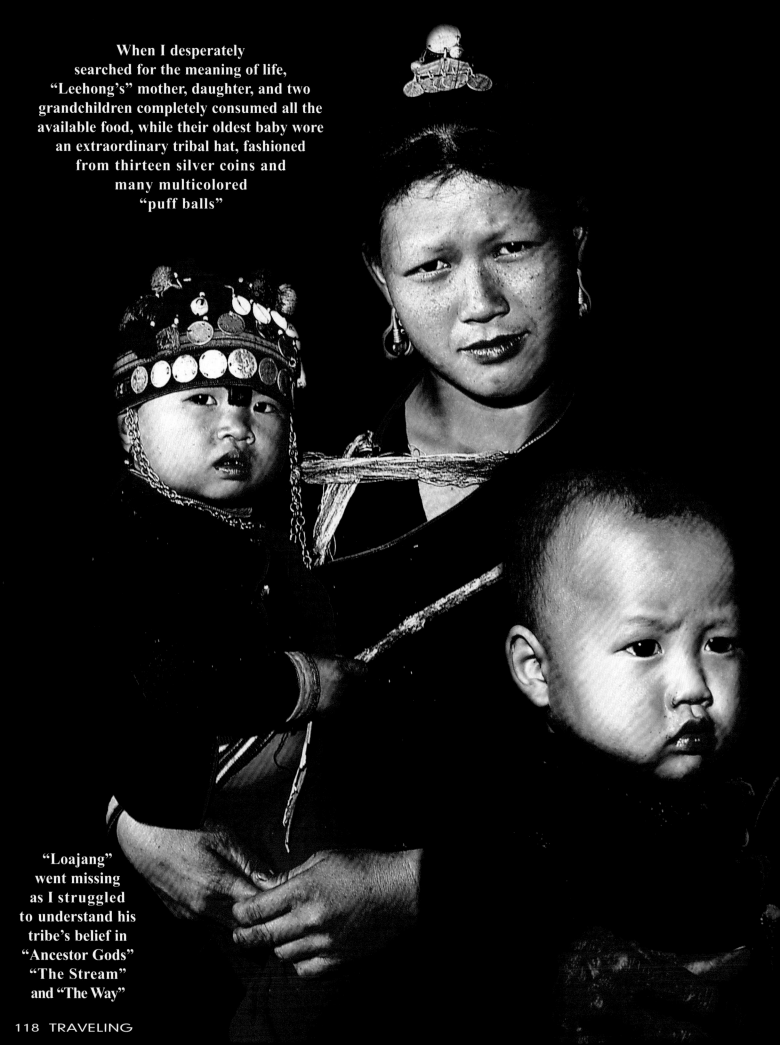

When I desperately searched for the meaning of life, "Leehong's" mother, daughter, and two grandchildren completely consumed all the available food, while their oldest baby wore an extraordinary tribal hat, fashioned from thirteen silver coins and many multicolored "puff balls"

"Loajang" went missing as I struggled to understand his tribe's belief in "Ancestor Gods" "The Stream" and "The Way"

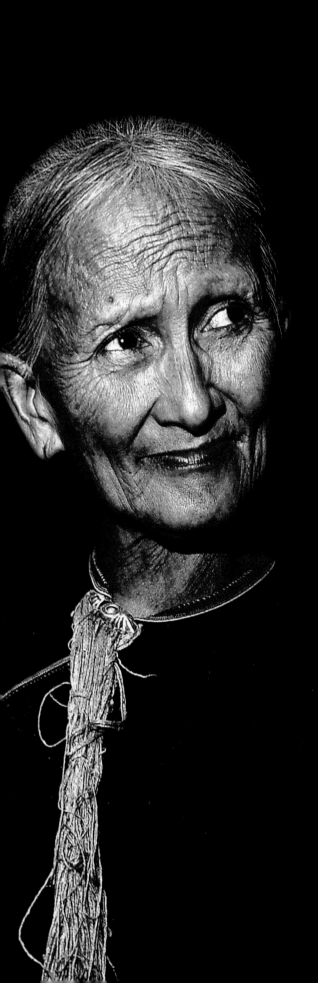

Is it possible Loajang's metaphysical babble is based in fact? While trying to confirm that possibility I lost sight of the old man when he disappeared down a river gully. I panicked and ran in that general direction hoping for answers to questions concerning the mysterious "Ancestor Gods," "The Way," "The Stream," and "Life Within all Things" that Loajang had mentioned, but I found only disappointment and a woman feeding pigs! "Where is Loajang?" I wailed! The question elicited an abrasive, though cordial, reply from the hog's mistress: "He left the village. I'm here for you now! My name is Leehong." I immediately recognized her Lantien-style shaven eyebrows, earrings, circular silver necklace and coin hairpin that held back her hair. While patiently waiting for Loajang I sat on top of a large boulder on a hill next to Leehong's hut. I looked down and saw her washing clothes in the river. She then hoed a garden, collected firewood, and cooked a splendid meal on an open fire. Her mother, daughter, and two grandchildren showed up and completely consumed Leehong's sumptuous cuisine. The oldest grandchild wore an extraordinary hat made from thirteen silver coins, brightly colored "puff balls" and a chain chin strap. While admiring the child's tribal clothes I asked the same question over and over again: "Where is Loajang?" "Where is Loajang?" "Where is Loajang?" After accepting the fact I may never see him again, I finally stopped asking. My mind, however, relentlessly swam in a pool of fables and folktales that I imagined Loajang collected in an enormous cavern crammed full of myths and legends concerning "The Way," "The Steam" and "Ancestor Gods." Impatient and frustrated, I needed more information about those supernatural tales before I could sleep. While feverishly pacing the dirt floor in Leehong's hut I hoped for answers to the meaning of life.

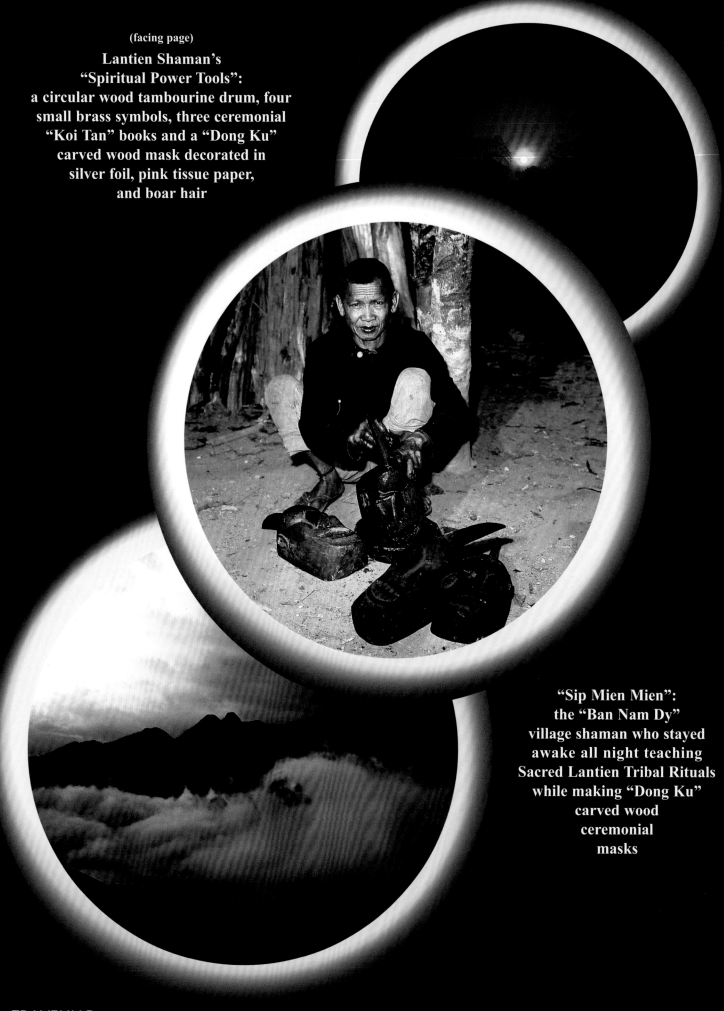

(facing page)
Lantien Shaman's
"Spiritual Power Tools":
a circular wood tambourine drum, four
small brass symbols, three ceremonial
"Koi Tan" books and a "Dong Ku"
carved wood mask decorated in
silver foil, pink tissue paper,
and boar hair

"Sip Mien Mien":
the "Ban Nam Dy"
village shaman who stayed
awake all night teaching
Sacred Lantien Tribal Rituals
while making "Dong Ku"
carved wood
ceremonial
masks

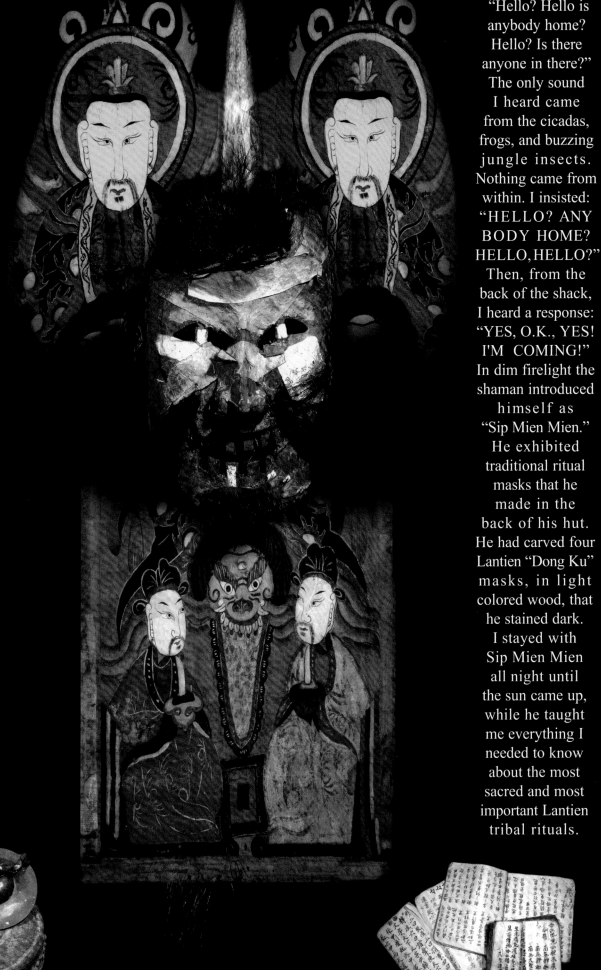

After the sun set, in total darkness, I stumbled on old tribal art that was stored in a corner of Leehong's shack: a circular wooden tambourine drum, four small brass symbols and an elaborate hand carved wood mask decorated in silver foil, pink tissue paper and boar hair. "What's this stuff?" I asked. "Those are the shaman's power tools," Leehong replied. I asked the question again, but more simply: "Power Tools?" Leehong lost patience with me while yelling, "YES, THOSE ARE THE SHAMAN'S SPIRITUAL POWER TOOLS!" After hearing those words it took me less than an a minute to locate the threshold of the shaman's hut. Envisioning haunting masquerades, I knocked on his door while imagining: this "Priest" can satisfy my desire to understand the tribe's beliefs!

"Hello? Hello is anybody home? Hello? Is there anyone in there?" The only sound I heard came from the cicadas, frogs, and buzzing jungle insects. Nothing came from within. I insisted: "HELLO? ANY BODY HOME? HELLO, HELLO?" Then, from the back of the shack, I heard a response: "YES, O.K., YES! I'M COMING!" In dim firelight the shaman introduced himself as "Sip Mien Mien." He exhibited traditional ritual masks that he made in the back of his hut. He had carved four Lantien "Dong Ku" masks, in light colored wood, that he stained dark. I stayed with Sip Mien Mien all night until the sun came up, while he taught me everything I needed to know about the most sacred and most important Lantien tribal rituals.

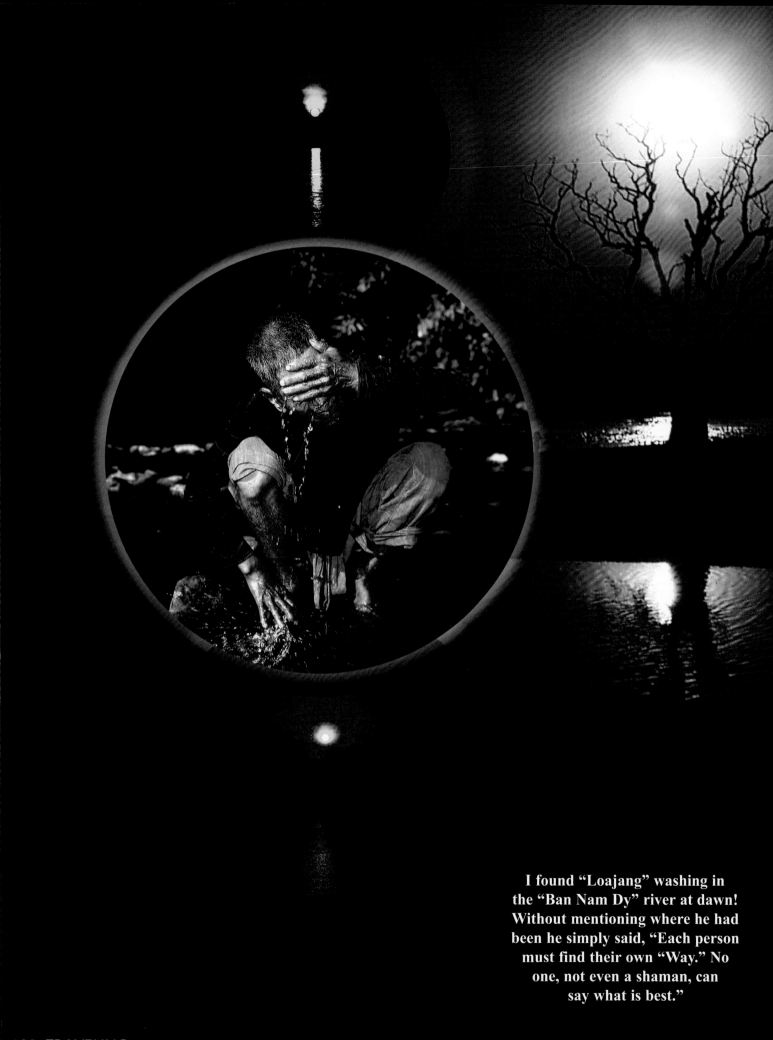

I found "Loajang" washing in the "Ban Nam Dy" river at dawn! Without mentioning where he had been he simply said, "Each person must find their own "Way." No one, not even a shaman, can say what is best."

**"Loajang's" wife: "Man Nong La" practices "The Way" when offering fish to "Taoist" dead "Ancestor Gods"**

While he explained the difference between Taoist high priests and shamans Sip Mien Mien mentioned the Lantien are also historically known as "The Stream" because, after migrating from China in the 17th century, the tribe's encampment was near streams and rivers. When Sip Mien went on to express a belief in "Ancestor Gods" and "Life Within all Things" I realized he practiced a "Taoist" religion based on a combination of Ancestor Worship and Animism. "The Way" ultimately led to a greater understanding of myself after he demonstrated the ancient esoteric Lantien rituals used to cure sickness, throwing "joss sticks" to predict the future, exorcism of evil, the creation of charms and the use of magic. At dawn, exhausted from a sensory overload of metaphysical wisdom, I emerged from the shaman's candle-lit hut and spotted Loajang, in dim dawn light, washing in the river. I ran to his side and with a face still teared in water, he said, "Each person must find their own "Way." No one, not even a shaman, can say what is best. I left so you would find yourself. Now you know your "Way!" It was at that moment I forever stopped questioning Loajang's sanity.

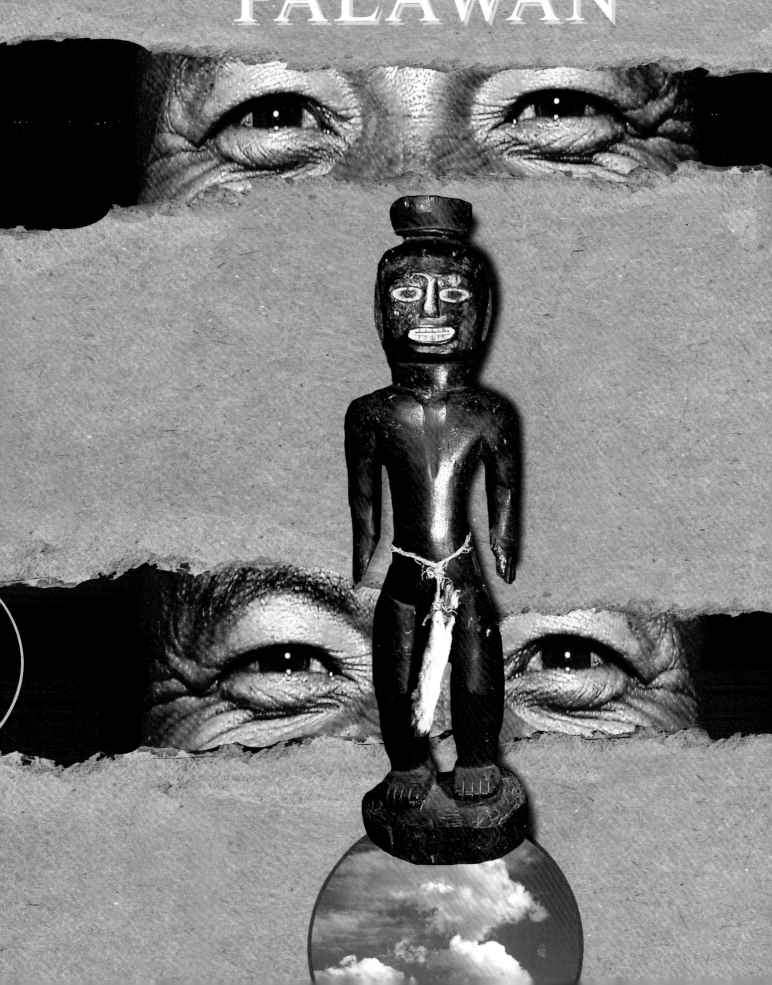

"No boat,
no color,
no card! No boat,
no color, no card! No
boat, no color, no card!"
rang inside my head like
a meditation mantra!
I said, over
and over again,
with progressively
increasing volume, in the
same hypnotic staccato
cadence: "no boat, no
color, no card!" NO boat,
NO color, No card!
NO BOAT,
NO COLOR,
NO CARD!"
I continued repeating
this six-word phrase
while stepping off
"Sulpicio Ferry Line's"
gangplank onto the
Filipino island,
"Palawan."
Docking on the island's
capital city "Puerto
Princesa" seemed an
easy chore after my
twenty-three hour
journey from Manila
on rough seas. As I
reiterated this circular
sounding chant
even louder:
"NO BOAT,
NO COLOR,
NO CARD!"
endless pestering barkers
were thwarted who
offered connecting
outrigger BOAT services,
cosmetic facial COLOR
and hand-tinted post
CARDS while the
ferry unloaded on
Sulpicio's pier.

"Palawan"
bamboo poison
dart quivers, with
intricately carved wooden
handles shaped in the form
of wild boar, are made by
the Palawan tribesman;
"Languyod" near
"Brooke's Point"
Palawan Island:
Philippines

(facing page)
What was the priority:
to look for tribal art or see
the site of the First Filipino
Civilization? After deciding to
hunt for artifacts, I found an
ancient "Palawan" human
skull wrapped in sea
shells with inlaid
shell eyes

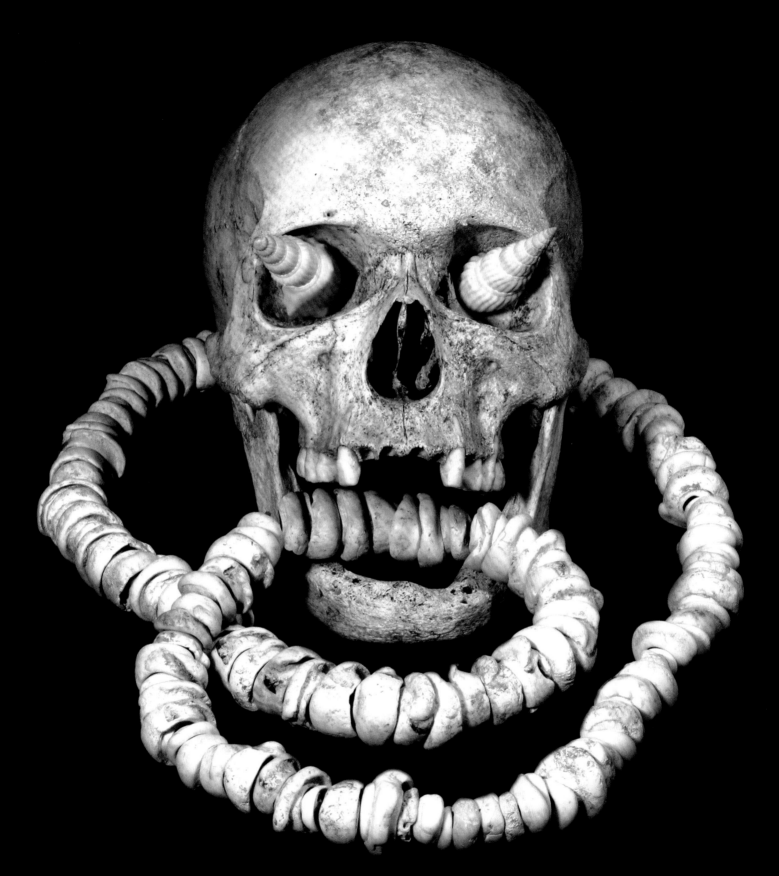

I traveled from Laos to the third largest island in the Philippines, Palawan, searching for the most sought after tribal artifacts, ancient human skulls with inlaid seashell eyes, intricately carved poison dart quivers, exotic reptile skin hand drums, bamboo blowguns, ritual offertory vessels and the rarest of the island's offerings: the Palawan tribe's deity known as "Tao Tao!" "The Last Filipino Frontier," Palawan is the site of the first Filipino civilization at "Tabon Cave." When excavated the cave's burial pit shed the most beautifully crafted "Manunggul Jar," now considered a national treasure is pictured on Filipino currency. I was undecided! What is more valuable: a magnificent collection of the island's most extraordinary tribal art or a glance into the mouth of that infamous cave. After a sleepless ferry boat ride, before considering lodging, my sight was set on finding artifacts when I jumped on the first "jeepney" out of town!

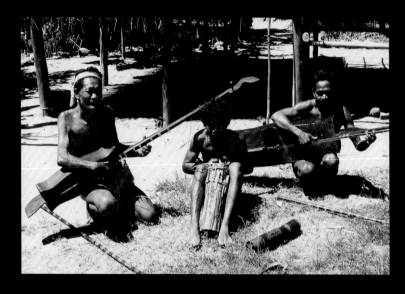

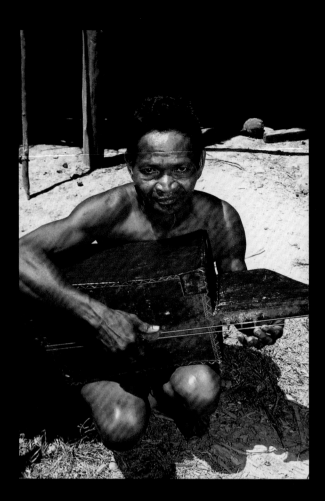

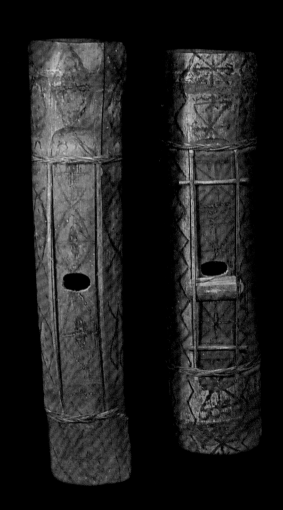

With only a need to travel as far as possible
I headed south to "Brooke's Point," where
I expected to find a connecting ride to
"Batazara," but was "sidetracked" by
three Palawan tribesman who waited on
the road for a lift to their village. I was
instantly attracted to their oversized
"guitars" and drums stretched in snakeskin.
"What the hell are those things ya' got?"
I asked, but while they spoke no English
I learned only their names: "Tagban,"
"Kayan," and "Languyod."

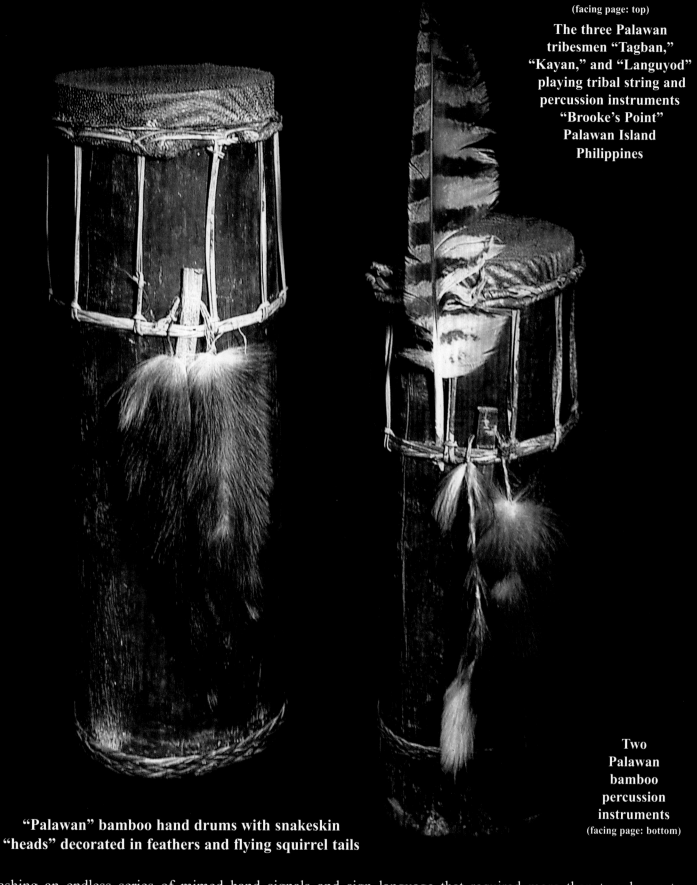

"Palawan" bamboo hand drums with snakeskin "heads" decorated in feathers and flying squirrel tails

After flashing an endless series of mimed hand signals and sign language that required more than two hours to decipher, I finally understood and accepted an unspoken invitation to their Palawan village. While using the name of the artifact I most wanted to acquire as a question: "Tao Tao?" I imagined being showered in finely carved wood deity statues blessed by their Lord and Master, "Ampu!" As my double-word question was repeatedly ignored, I remembered the Filipino tendency to use one word twice in a single name and when several twin-word names are strung together in a single sentence, I always laugh. "Ne Ne" took a "Tuk Tuk" to "Ilo Ilo" to eat "Lapu Lapu" after he saw the "Tao Tao!"

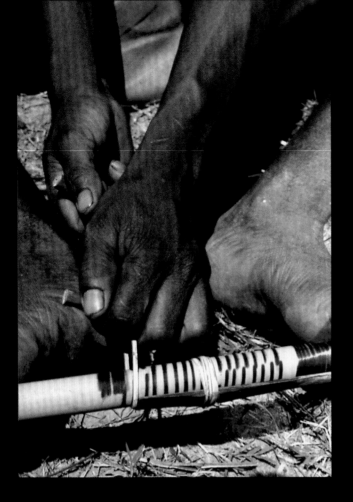
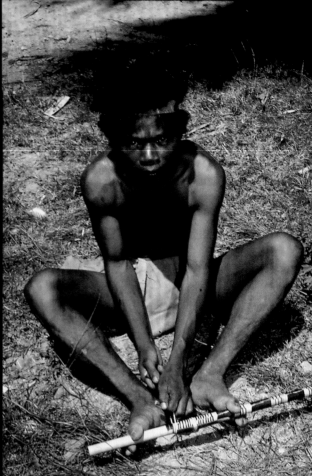
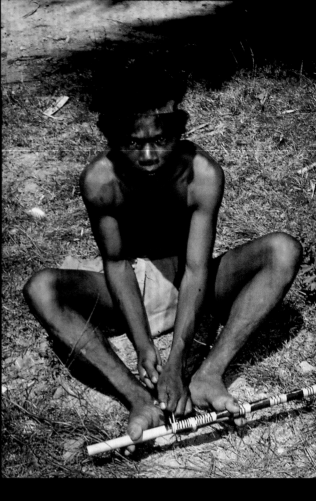
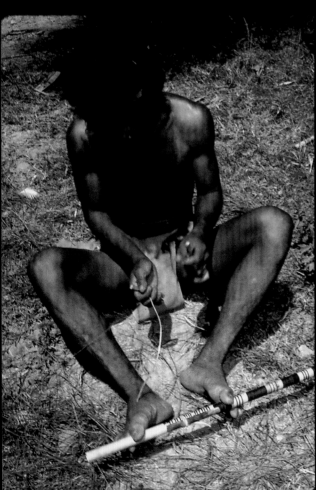

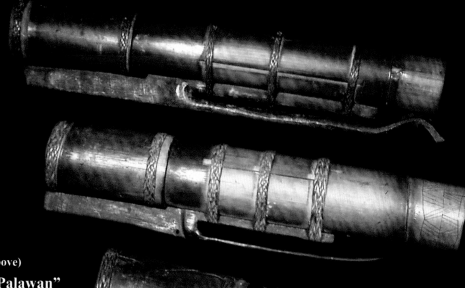

(facing page)
**"Languyod" held the blow guns between the two largest toes on each of his feet and while using a manicured, thin bamboo strip, burnished by friction abstract designs on the barrel of each weapon**

(above)
**Three "Palawan" bamboo poison dart quivers**

(below)
**Burnishing by friction; abstract designs on a bamboo blowgun, while holding the barrel between two toes on each foot**

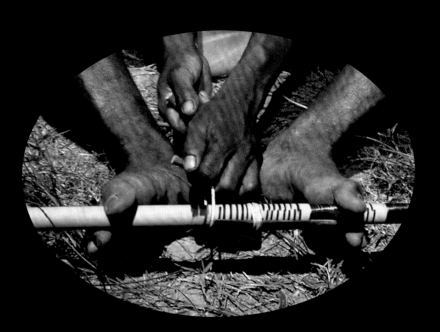

I surely was disappointed when a "Tao Tao" was not immediately found, but was consoled after realizing Languyod makes exquisite beautifully crafted bamboo blow guns and poison dart quivers for trade. The most interesting element in his craft is how bamboo is held between the two largest toes of each foot, while using manicured, thin, narrow, bamboo strips to burnish by friction abstract brown designs on the barrel of each beautiful weapon.

Languyod's craft was entertaining but I lost interest after successfully negotiating for three poison dart quivers and seven beautifully burnished bamboo blowguns. With a fading possibility of acquiring a "Tao Tao," my mind wandered through the Paleolithic and Neolithic ages until finally my thoughts caught up to the 35,000-year-old stone tools I was promised to find on Palawan Island at the site of the first Filipino civilization: "Tabon Cave!"

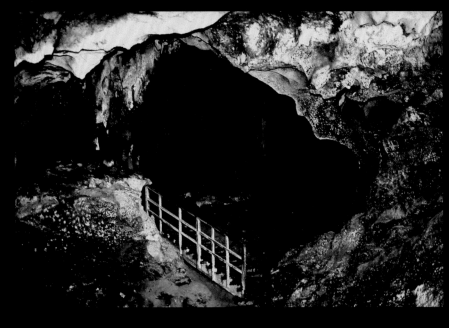

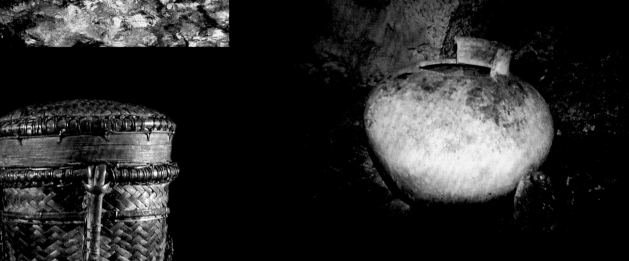

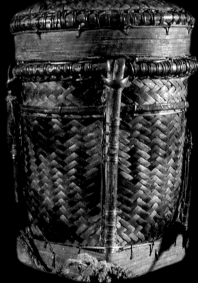

**"Tabon Cave"**
**Palawan Island: site of the first**
**Filipino civilization and burial jars**

**A Palawan basket that**
**was found in a remote market**

(facing page)

**The ancient infamous**
**"Manunggual Burial Jar"**

Before leaving, Tagban, Kayan, Languyod, and I held hands while I suggested a proposal: "I will return in exchange for your promise to find me an old "Tao Tao." Initially they hesitated after hearing the translation of what I had said, but when I bid them fond farewell forever when setting foot on the running board of a "jeepney" heading south, they anxiously agreed to my terms. After missing the only overland connection that would have gotten me to Tabon Cave that day I was left with only one choice: the "Island Guesthouse," where after bunking down I met the overweight, negative, American "loner" named "Tony" who longed for change. He begged for inclusion in the adventure after he heard I was on my to Tabon Cave. His pleadings were so childlike I foolishly gave into his infantile demand. He is an American embarrassment, who I tried to hide from the guesthouse staff, but they finally did see the unsavory site of an extremely mentally disturbed spoiled American. I did not want the "word" to get out: many Americans may have serious emotional "problems," but Tony's "mental disorder" escalated into a full-blown "natural disaster" the moment we set out for the cave. I hoped, beyond all hope, the situation would rectify itself. But after silently putting up with his tantrums I thought he was on the verge of "imploding." He briefly redeemed himself by finding an excellent example of

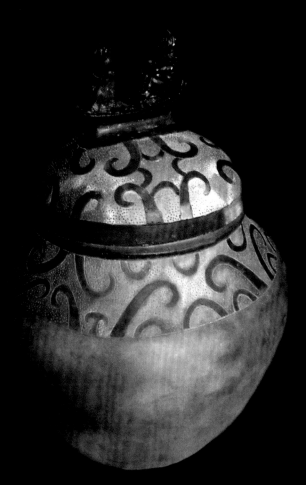

an old Palawan basket for sale when we huddled under a vendor's makeshift "beach" umbrella that was propped up over sales items. Torrential rain prevented our progress to Tabon Cave. While the sun set, Tony, now barely lucid, pointed out the artifact to me. From that moment on it was a "downhill" slide! He became completely incoherent after wandering from under the vendor's shelter! I will never forget the look on his face when his pupils dilated into big black saucers! I tried to follow him but could only imagine his hallucinations did not bring him any friends! While standing in a pool of rainwater, he cried out from darkness until clouds shot bolts of blinding lightning through the night sky. While hoping

he survived this emotionally painful ordeal, my memory processed the experience as purely horrific, but before reaching Tabon Cave that afternoon, I was certain Tony survived! While standing on the beach, when trying to forget that companion, I looked out to sea and discovered a boat would best get me to the cave. It was possible to walk for more than a half a day on a narrow "cape" that arcs to the cave's entrance or I could get there, within less than a half hour, by boat. I opted for a boat. A guided vessel was available for as little as 250 Filipino pesos, (about 5 U.S. dollars), but I foolishly tried to save money and rented a 50 peso kayak that I paddled to the tip of the cape. With the wind at my back I easily reached the mouth of cave in less than twenty minutes. The site was spectacular but I was disappointed after learning exuberant drunken local fisherman, who frequent the cave for overnight sleeping accommodations, smashed most of the burial jars. I spent the afternoon in a trance, looking back into unrecorded history, walking from cavern to cavern, but as daylight faded my attention turned to the beach. Now, with the wind against me, my task of returning was daunting! On several occasions, I did not have enough strength to reach my destination as wind continually turned the kayak in the opposite direction of my mark. After more than three hours, in struggling sweat, I reached the beach dehydrated and exhausted.

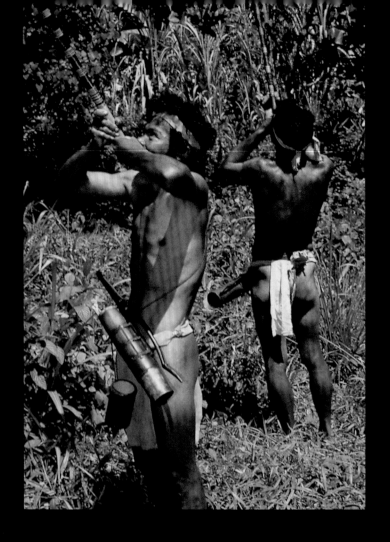

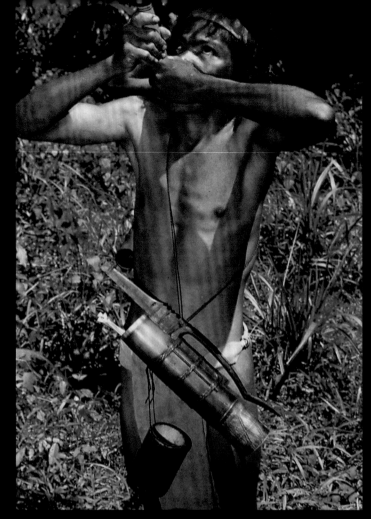

**(facing page) "Palawan" carved wood bird and mortar**

**(below) "Palawan" and "Batak" tribal bamboo vessels**

I was anxious to see if Tagban, Kayan, or Languyod had found an old "Tao Tao" for me as promised. My return trip to see them was full of hazardous jeep breakdowns, one accident, and two flat tires but when arriving I was immediately informed a child in their village experienced an horrendous fate. A poisonous "Naja" cobra killed a vulnerable unattended tottler that morning and an equal price was now demanded from the snake. While tribesmen loaded blowguns with poison darts I clearly saw the huge grotesque reptile sunning in the tree tops. The poison darts were not intended to kill the cobra

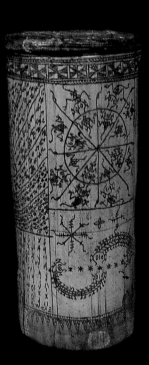

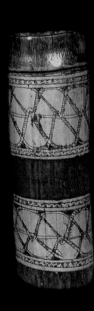

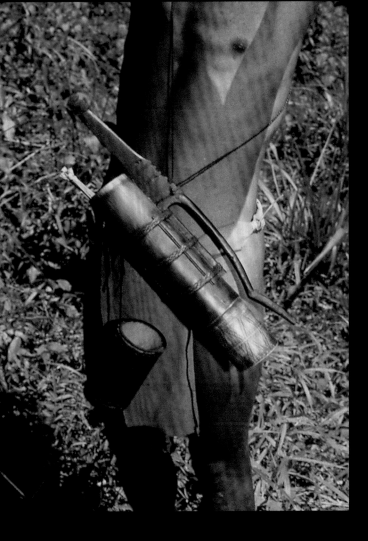

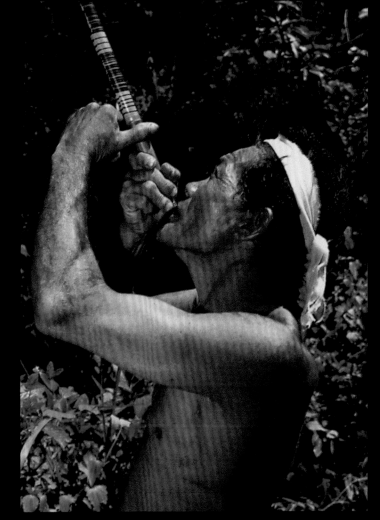

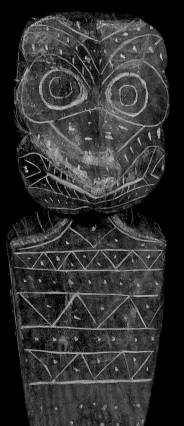

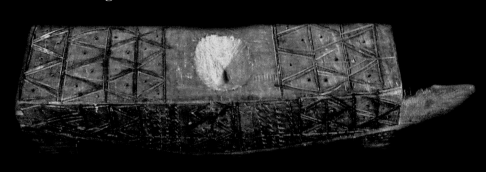

(above)

**"Palawan" tribesmen hunt a "Naja"cobra with bamboo
blowguns and poison darts after it killed an infant in
their village that morning. They stunned the reptile
with a single dart and then crushed the animal's head.**

but rather to only paralyze the animal long enough for the men to
reach their combatant and apprehend it. After the blowguns were
leveled at the sky, no more than two volleys were required, as one
bamboo, cork-tailed, poison dart reached piercing contact with the
snake's soft white abdomen. At first it appeared the dart had little
or no effect, as the reptile retreated, but within minutes it lost the
ability to control movement. As the distressed reptile fell to the
ground men rushed the struggling beast and crushed it's head.

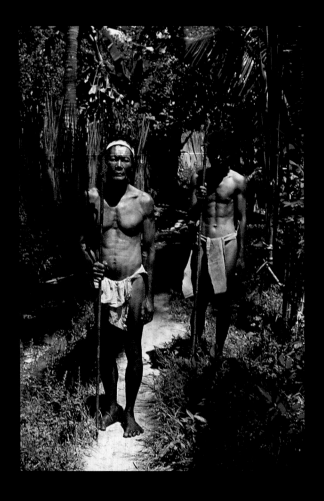

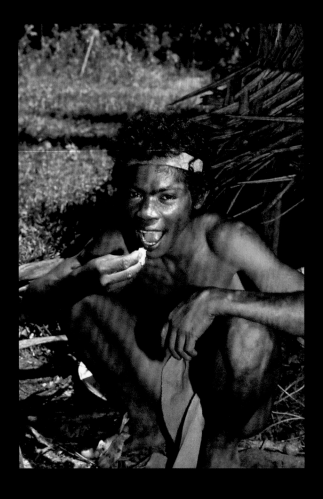

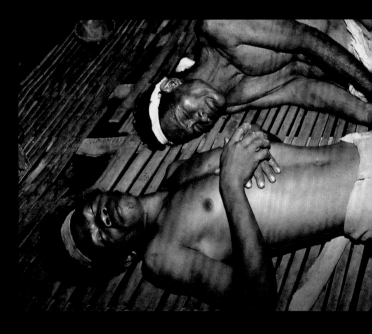

The "mop-up operation" was only complete when the snake's corpse was finally buried. Tagban, Kayan, and Languyod rested easily knowing they did all that was humanly possible to avenge the death of a child, while also guaranteeing the exact same fate will not hide in tall grass for another.

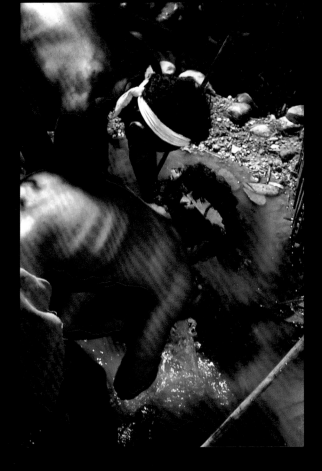

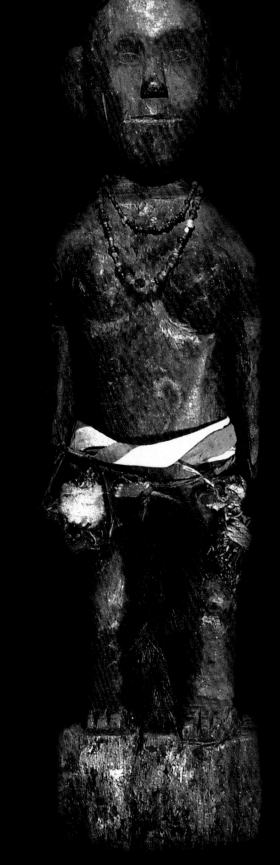

After washing in a shallow stream close to the village the men prepared a simple meal that only consisted of rice on dried banana leaves. While consuming the starchy, under cooked nourishment Languyod displayed an exceptional, very old ceremonial "Tao Tao" that was hidden under the floorboards of his hut. I was not certain: did he hide the statue because he did not want me to know he had one, or did he recently get the piece to satisfy my request? His motive truly does not matter! What does matter is Languyod trusted me enough to give of himself, even when resisting, because the only thing I wanted from him was what he most wanted to keep: his dead ancestor's "Tao Tao" that he now willingly sacrificed for nothing more than my friendship!

**The Palawan tribe's sacred ceremonial "Tao Tao"effigy given to me by the Palawan tribesman: "Languyod"**

(facing page)

**"Kayan" and "Languyod" after killing a cobra washed in a stream before eating and sleeping**

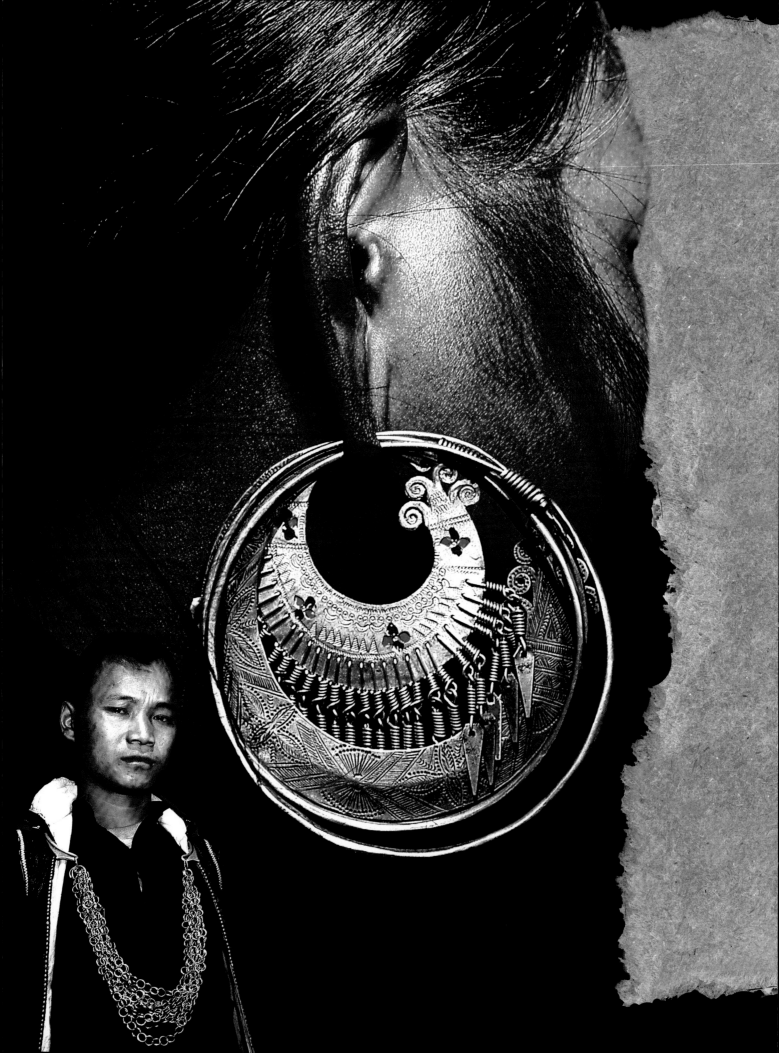

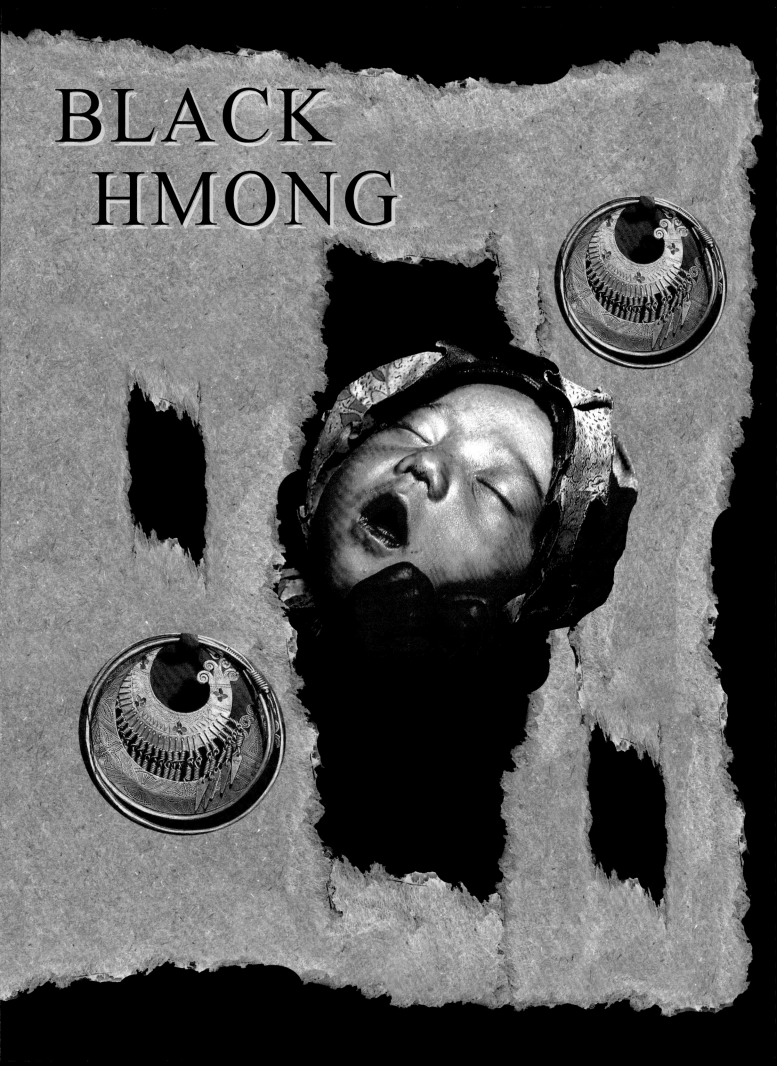

# BLACK
# HMONG

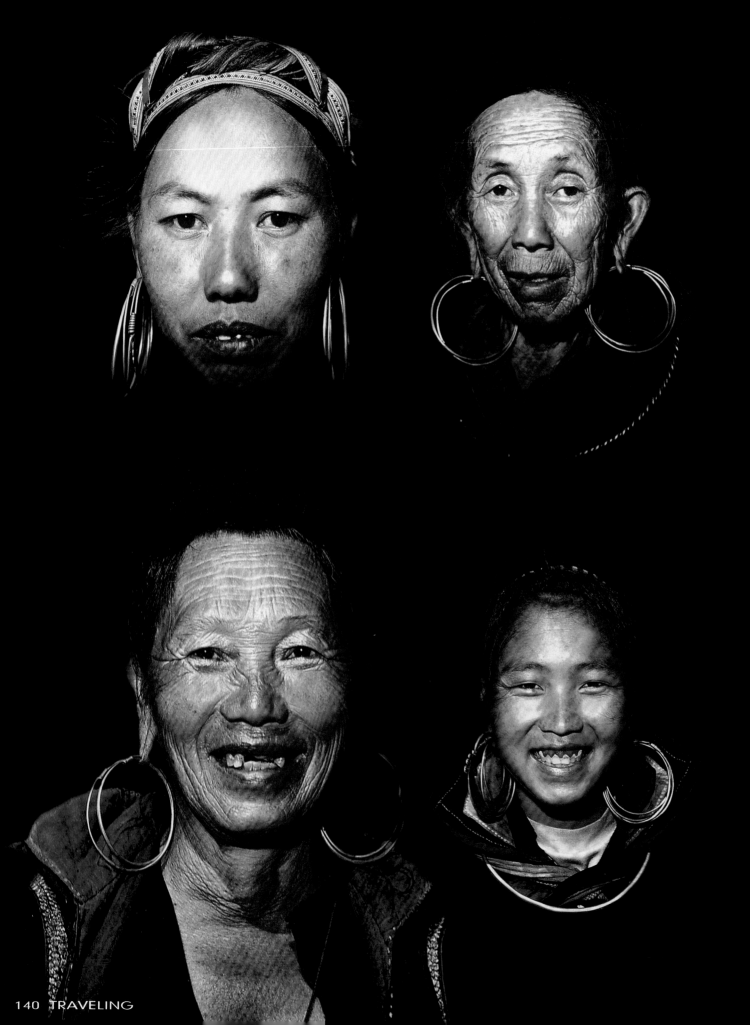

My 14-hour drive from Hanoi to a small provincial town near the Chinese border was perhaps the most horrendous experience ever endured! I was influenced, but accept full responsibility for that heinous experience. After being ill-advised, "Get a Russian jeep, a Vietnamese driver, and a guide who can translate!" I agreed to a ridiculously expensive fee, after foolishly following this suggestion, before setting out on a tedious "expedition" to the erroneously described **"Remote Outpost: Sapa."** It would have been so much more enjoyable, and much less expensive, to have taken the trip by rail, but I unfortunately relied on the most popular and well-know of all guidebooks and my reward was an extremely painful two-day neck cramp and dog-meat soup. I assumed the publisher verified the book's content for accuracy, but oh, no, my ass had to be hammered to the line! While destiny determined the elements in this story, fate also played with the results, but surely this total fiasco could have been avoided if I had not been so "Pig Headed" when insisting, "I'll crush or eliminate any and all obstacles that block my way to the Black Hmong tribe!"

**The Black Hmong women, who served dog-meat soup, in the "remote outpost:" "Sapa" Vietnam**

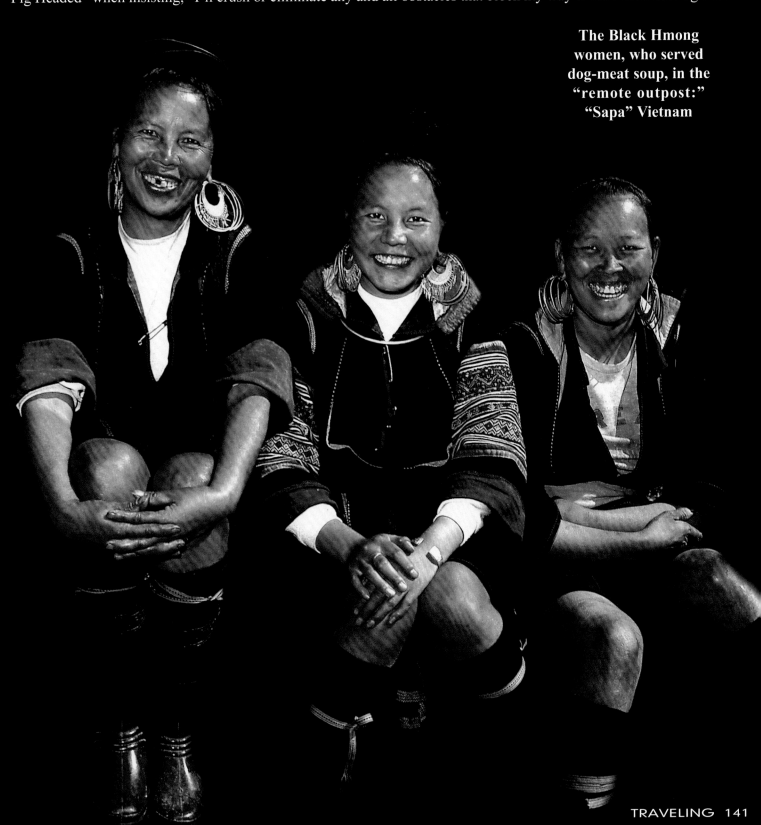

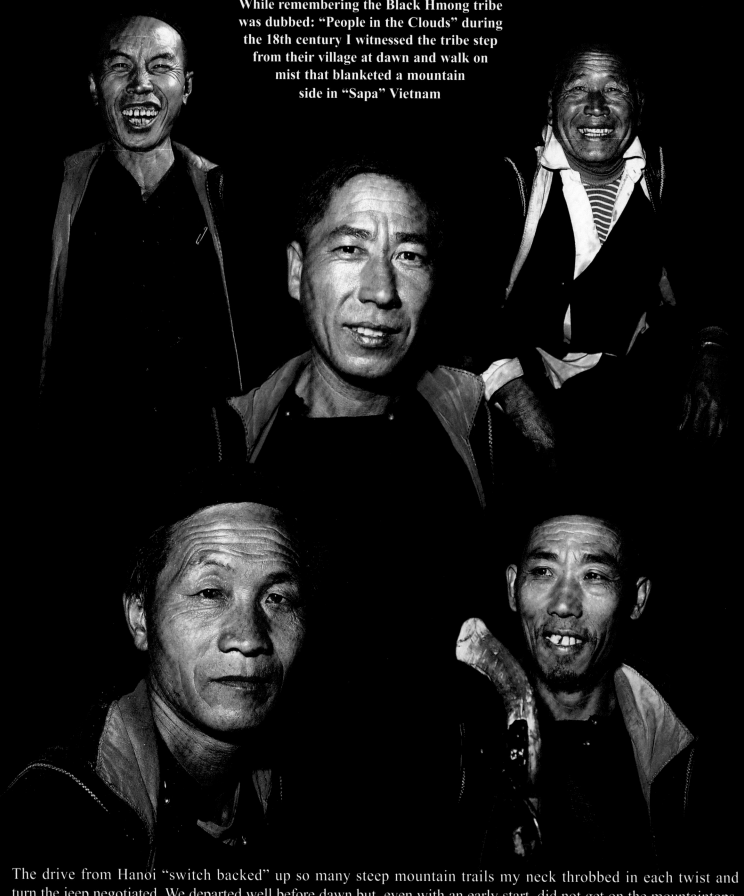

While remembering the Black Hmong tribe was dubbed: "People in the Clouds" during the 18th century I witnessed the tribe step from their village at dawn and walk on mist that blanketed a mountain side in "Sapa" Vietnam

The drive from Hanoi "switch backed" up so many steep mountain trails my neck throbbed in each twist and turn the jeep negotiated. We departed well before dawn but, even with an early start, did not get on the mountaintops, until well after dark. Before realizing; Sapa is much colder than Hanoi's low lands, I unexpectedly billowed clouds of steam into the chilly evening air. Food was a priority but being in an unfamiliar town with few choices I, against my better judgment, relied on my "guide's" advice: "The only opened restaurant is on the outskirts of town." And yes on the menu, as you might expect, was dog-meat soup deluxe, and only dog-meat soup deluxe; take it or leave it! While hastily wolfing down the meal I imagined it as a "Wolfgang Puck's" gourmet

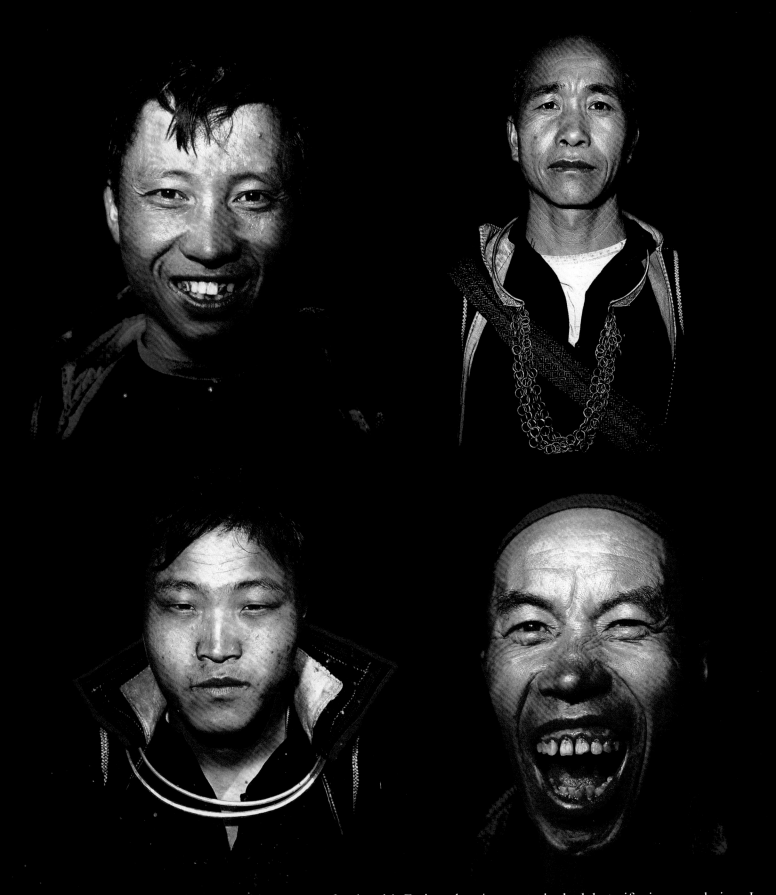

delicacy after remembering; we did not stop for lunch! Eating dog is not truly bad but, if given a choice, I never would willingly eat that animal! As it was the only available meal, I endearingly recall, it was the best item on the menu! The following morning, while trying to forget I had eaten "dog food," sunlight peeked over bald mountain tops which made it very easy to identify Black Hmong as they stepped from their village into the dim dawn light. The females wore enormous circular silver "hoop" earrings, gaudy dangling chainmail necklaces and traditional, extremely dark-blue, handwoven hemp tunics. As I remembered; the Hmong migrated to Vietnam from China in the 18th century and were affectionately dubbed "People in the Clouds" after they settled above 4000 feet,

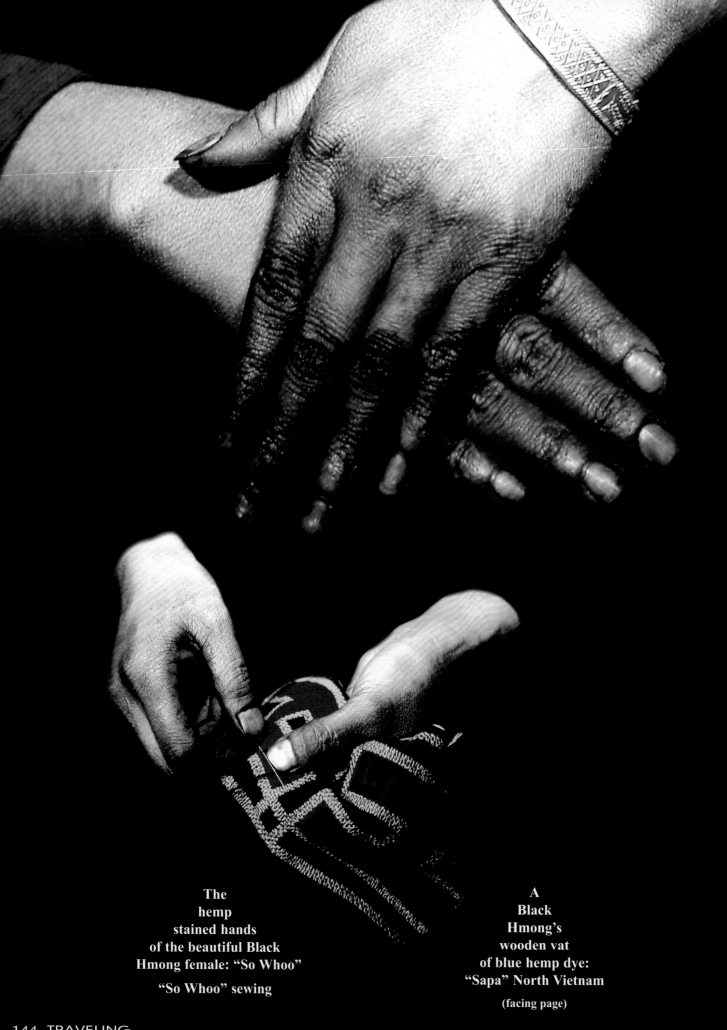

The
hemp
stained hands
of the beautiful Black
Hmong female: "So Whoo"

"So Whoo" sewing

A
Black
Hmong's
wooden vat
of blue hemp dye:
"Sapa" North Vietnam

(facing page)

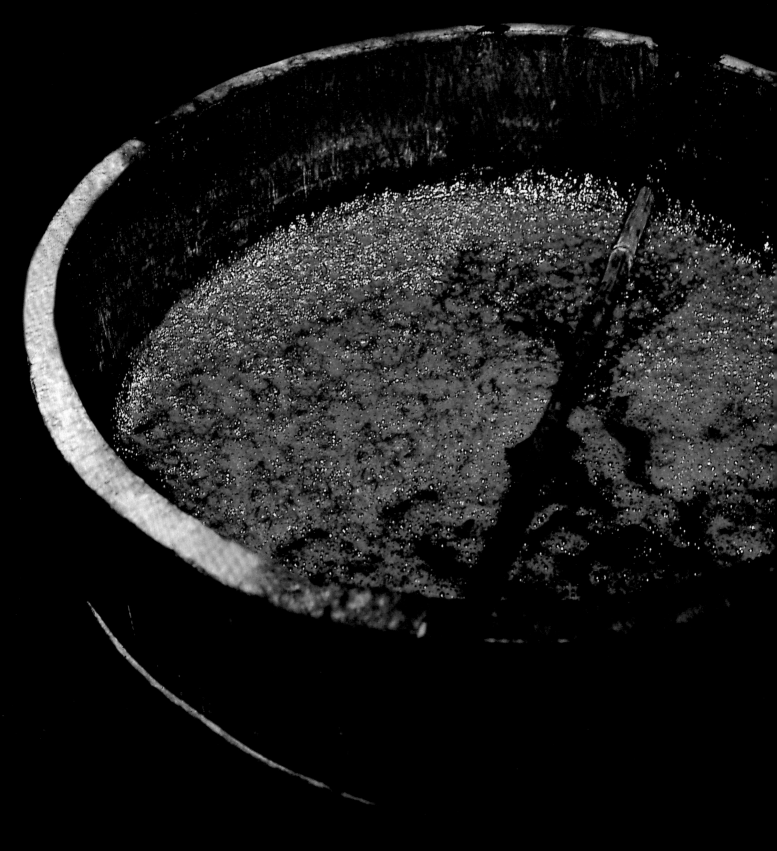

which always brings to mind: "So Whoo" stepping from her hut into early morning mountain mist. When "floating" on low-lying clouds she is, without a doubt, the closest thing to a "Beatific Vision" in existence, but there was something "off" about my epiphany. "Yo, "Miss Hmong!" I hectored, "Why are your hands so dirty?" I hoped to disarm this beautiful young thing with a flippant ploy but found only marginal success when, without warning, she turned and screamed, "My hands no dirty! It's color. I want color. Many things come from this color! It's a big part of my life!" After asking myself, "Do I have a psycho on my hands?" I remembered severely misjudging "Loajang" back in Laos. While hoping to avoid the tendency to repeat mistakes I decided to give So Whoo more than enough latitude before I said, "You must be right. Please tell me more. What is that blue color on your hands?" Because the stain was so incredibly dark and appeared to be a permanent pallor on her fingertips I thought that color must be significant!

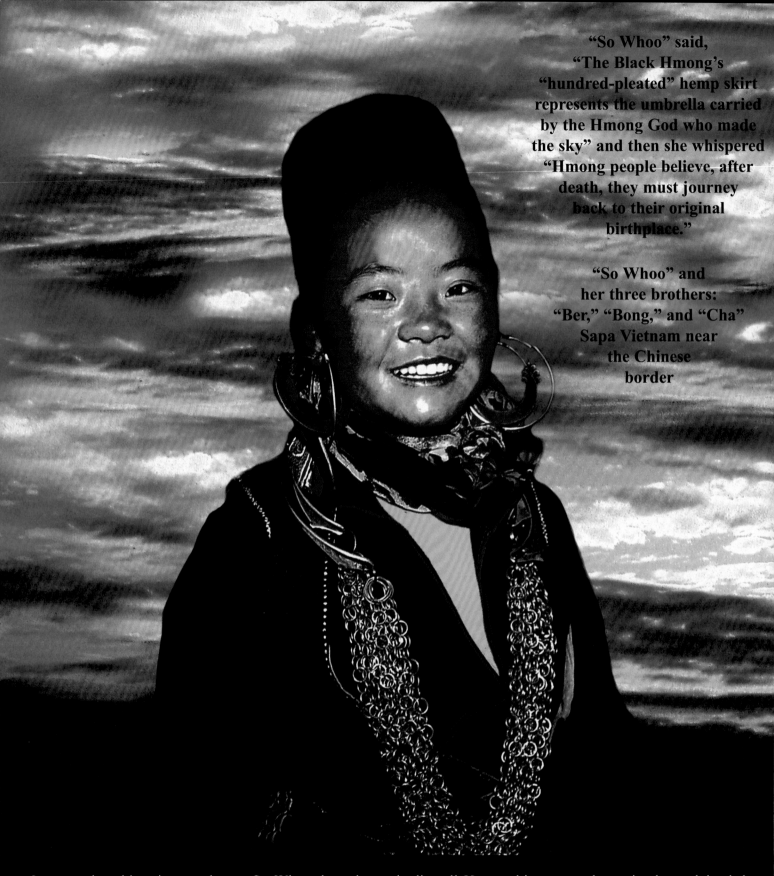

"So Whoo" said,
"The Black Hmong's
"hundred-pleated" hemp skirt
represents the umbrella carried
by the Hmong God who made
the sky" and then she whispered
"Hmong people believe, after
death, they must journey
back to their original
birthplace."

"So Whoo" and
her three brothers:
"Ber," "Bong," and "Cha"
Sapa Vietnam near
the Chinese
border

It was only a blue tincture, but to So Whoo the color embodies all Hmong history, as she patiently explained the reasons for, and the importance of, the dark mystery that stained her hands. The blue dye, derived from hemp, is extensively and almost exclusively used when making the tribe's clothing. The Hmong believe the hemp plant is particularly significant because the "hundred-pleated" woven Black Hmong hemp skirt represents and echoes the visual image of the mythical umbrella carried by the Hmong "God" who made the sky! The abstract iconography embroidered on those pleated skirts is a record of important historical Hmong ancestry, such as the location of dead relative's homes in the mountains or the low lands along rivers. The tribe wears hemp in life as well as death. Deceased Hmong males are traditionally dressed in long hemp robes, while dead female's are ceremonially

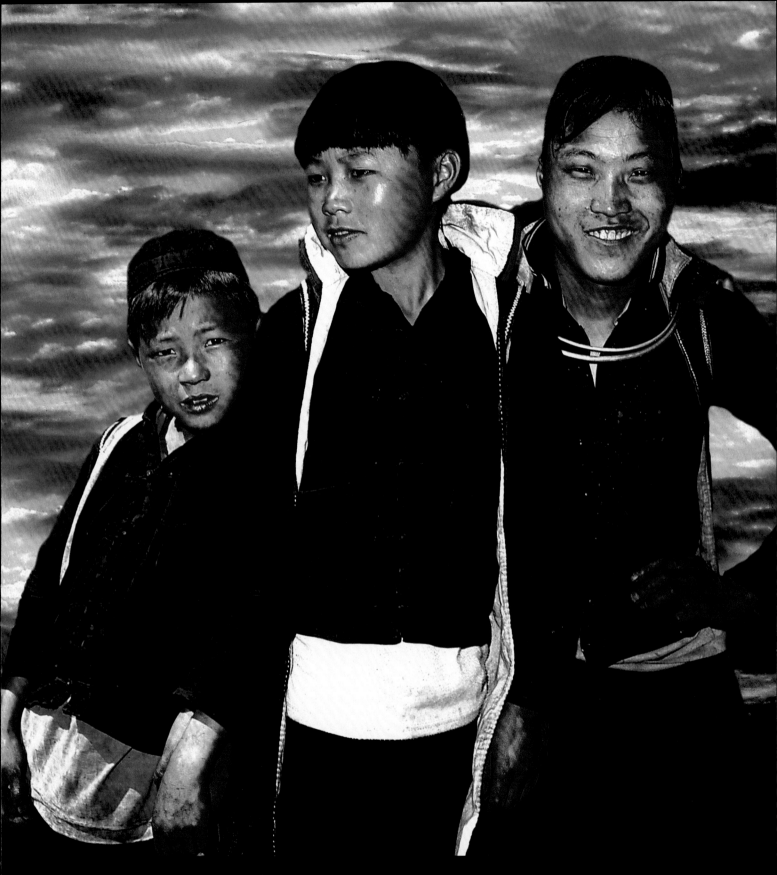

vested in hemp leggings skirts and jackets. All deceased Hmong, male and female, are outfitted in traditional ceremonial hemp shoes that help them "cross" mountains to find their resting ancestor's original birthplace. As she spoke I entertained a secret silent desire to marry So Whoo if only she were older! It was difficult to push that irresistible unconscious desire back under some unrelated conscious thought, but I easily forever buried it when saying, "Wait, Wait, Wait! What's this 'bout returning to your original place of birth after death? I never heard 'bout that! What ya' say?" So Whoo whispered: "Hmong people believe, after death, they must journey back to their original birthplace. A money "Toll" is burned at funerals, while a "Txiv Tai Kev" shaman priest acts as a guide to assure a successful trip through the "Spirit World" past the "Gates" of their original birthplace so they can live again."

She continued telling extraordinary tales of Hmong myths and rituals until we heard strange, unfamiliar, haunting sounds increase and decrease in volume as the wind whipped and fell. I attempted to find the source by jumping over several wide wet gullies in dim daylight, before stepping into semi darkness on the north side of the mountain, where I immediately located the fountainhead: four Hmong musicians wailed on some unusual looking bamboo wind instruments. "What are those things they're blowing?"

So Whoo deferred my question to the leader of the band after he finished his first "set." "Our name for this bamboo blowpipe is "qeej!" We tell epic stories about ancient Hmong history in the music we play. We do not need words only music to tell our tales!" I was told by a French anthropologist, "Only Hmong men are permitted to play the qeej," but the truth of the matter was reviled after I found the most proficient musician in the quartet was female! "Ancient epic stories? How can you tell stories without words?"

**Black Hmong musicians tell epic stories about ancient tribal history in music. They do not use words!**

**The Black Hmong tribe believes ancient musicians knocked down elephants and tamed tigers with their beautiful music**

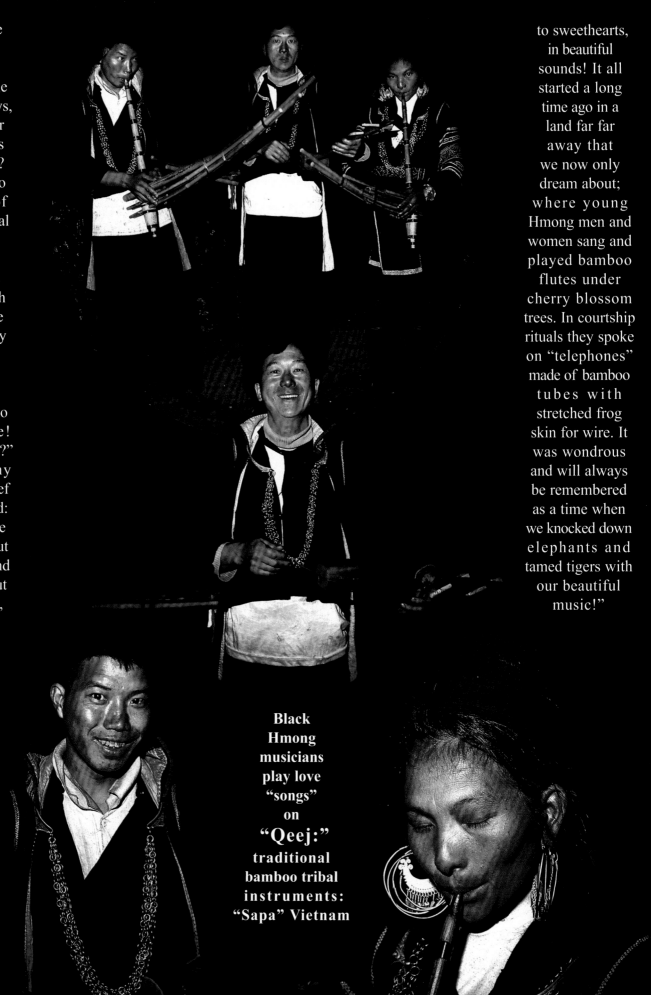

I asked, while wondering: Could it be possible, on the finest of all days, to hear color and tell stories only in music? He went on to say, "Some of our instrumental pieces have equivalent unsung songs associated with them that are remembered by our Hmong tribe. It's a simple but effective way to communicate! Don't you think?" I scratched my head in disbelief as he continued: "Some of the stories are about mother earth and others are about the sun, moon, and sky. We tell love stories to sweethearts, in beautiful sounds! It all started a long time ago in a land far far away that we now only dream about; where young Hmong men and women sang and played bamboo flutes under cherry blossom trees. In courtship rituals they spoke on "telephones" made of bamboo tubes with stretched frog skin for wire. It was wondrous and will always be remembered as a time when we knocked down elephants and tamed tigers with our beautiful music!"

Black Hmong musicians play love "songs" on **"Qeej:"** traditional bamboo tribal instruments: "Sapa" Vietnam

The Hmong market in Sapa is an unbridled "Freak Show." Old, rotund, toothless women push to sell handwoven embroidered textiles using similar tactics as do desperate Las Vegas used-car salesmen. They fight for every bargain and exhibit little credibility when hoping for food for their families. Hucksters chase prospective buyers down main street, in this six-block town, haggling to force sales! As groups of Hmong woman anxiously cluster around empty baskets waiting to be filled, young Hmong men demand the best price when purchasing bamboo-strung ginger root. Hand-balanced scales are the tools of this trade while, blue-stained hands mis-weigh especially wanted items, bald middle-aged men inspect the quality of yellow hemp bark spun thread. Pressed rat and "sticky rice" is the

**Sapa's Market is a "Circus Side Show"**
**of diversity, until after dark, when affection**
**is the only available commodity in the**
**"Love Market," which opens at**
**night, in the vendor's stalls**
**"Sapa:" Vietnam**

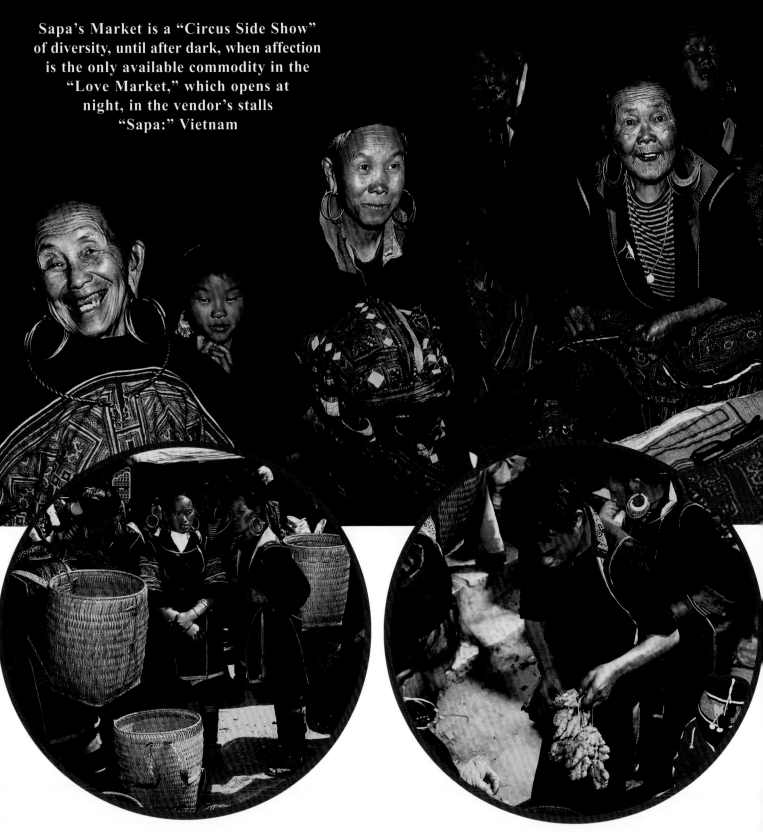

preferred delicacy of the day after entire cut-up carcasses of skinned bovine are thrown onto already blood soaked table tops. But the sideshow has only just begun for the most sought-after item is only offered, after dark, in the most extraordinary retail outlet of them all: **"The Love Market."** When daylight dissipates into shadows unmarried adolescents discretely filter into the very same stalls that sell produce and textiles during business hours. The market remains, in every detail, the same except for one very big difference: **LOVE** is the only available commodity! It is not prostitution but rather "innocents" attempting to locate lifelong mates in leu of accepting little more than the cold offering of a lonely experience in an isolated village.

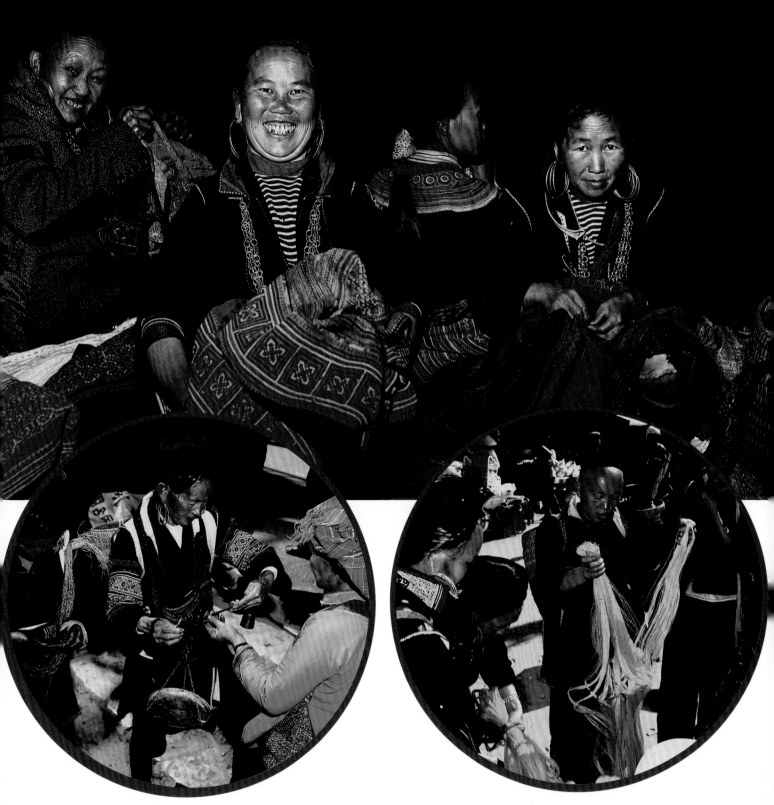

I first met "Leea Yong," and his "whooper size" extended family at the "Love Market" the night before So Whoo took me to see him, sick and unconscious on what I imagined to be his death bed. After experiencing the demise of so many people I expected this would be no different. It was said: "He walked too close to "Spirits in the Forest" and now a toll was being sucked from his normally peaceful existence as payback for his "Spiritual Trespass." His family already was rehearsing the traditional ceremonial Hmong hour-long "Khxa k" farewell death song, when he first regained consciousness. I suggested he consume raw ground cannabis seeds and suck on a hemp stalk but, before he could agree, he once again fell unconscious. When his sister summoned a Txiv Tai Kev shaman to sacrifice a rooster to appease the "Spirit World," he rallied again, but just long enough to eat the hemp seeds and suck a stalk. He became conscious and then unconscious; back and forth, for more than eleven hours before finally standing up and winning the battle against his "demons." He recovered before dawn and went back to woodworking, while smoking the very same vile hand-rolled cigarettes he had ingested for the last two decades, without a complaint or a single complication.

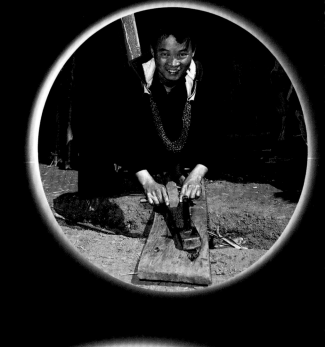

A "Txiv Tai Kev" Shaman was summoned to sacrifice a rooster to appease the "Spirit World"

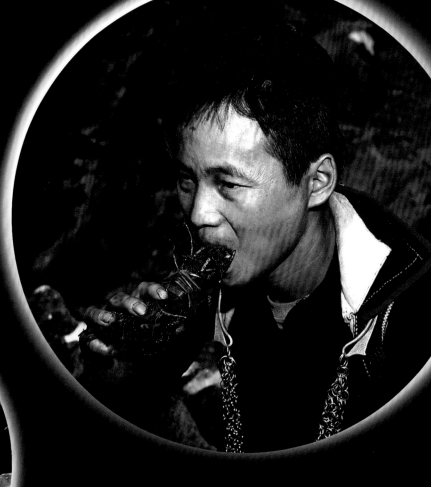

After walking too close
to "Spirits in the Forest,"
"Leea" retired to his "deathbed" but,
before his family finished rehearsing The
Black Hmong's "Khxa k" farewell death song, he
fully recovered after consuming cannabis seeds and stalks

I saw "Leea" sick and unconscious on what I imagined would be his deathbed. After experiencing the demise of so many people I expected this would be no different. His superstitious family thought his sickness was caused by "Spirits in the Forest"

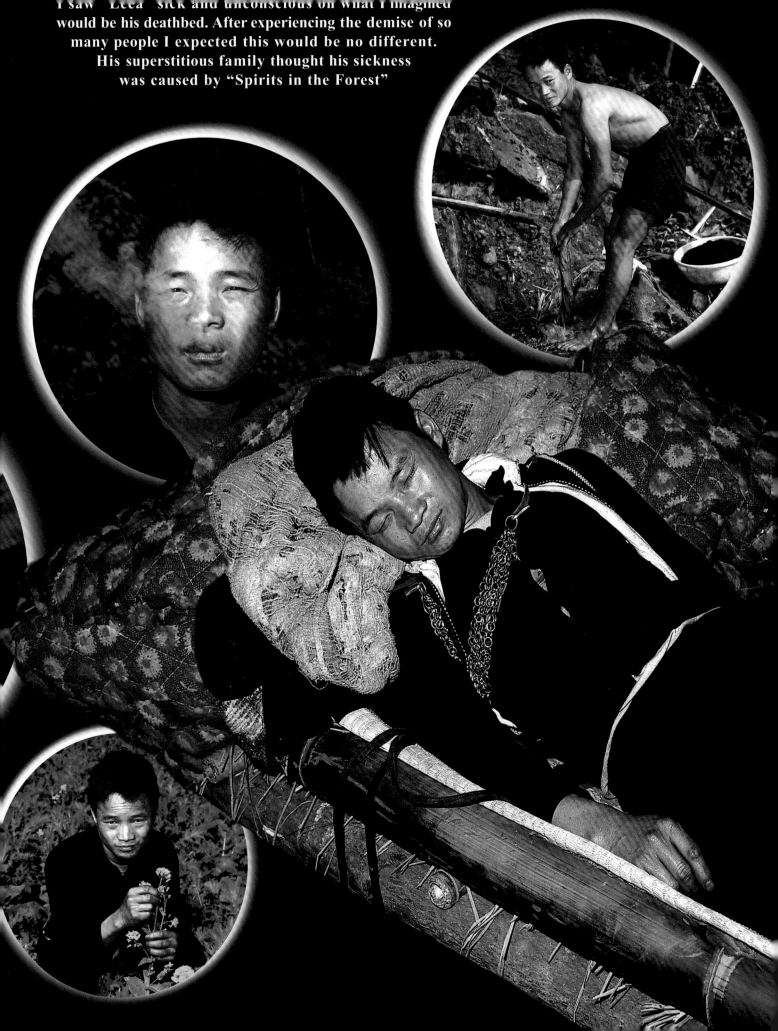

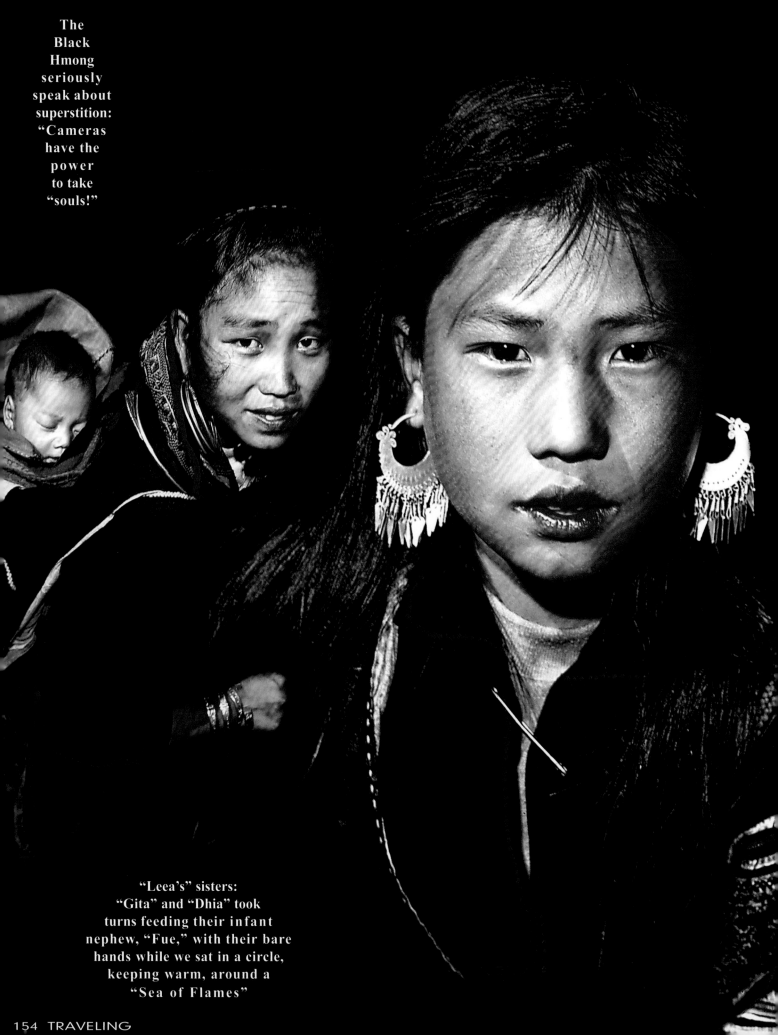

The
Black
Hmong
seriously
speak about
superstition:
"Cameras
have the
power
to take
"souls!"

"Leea's" sisters:
"Gita" and "Dhia" took
turns feeding their infant
nephew, "Fue," with their bare
hands while we sat in a circle,
keeping warm, around a
"Sea of Flames"

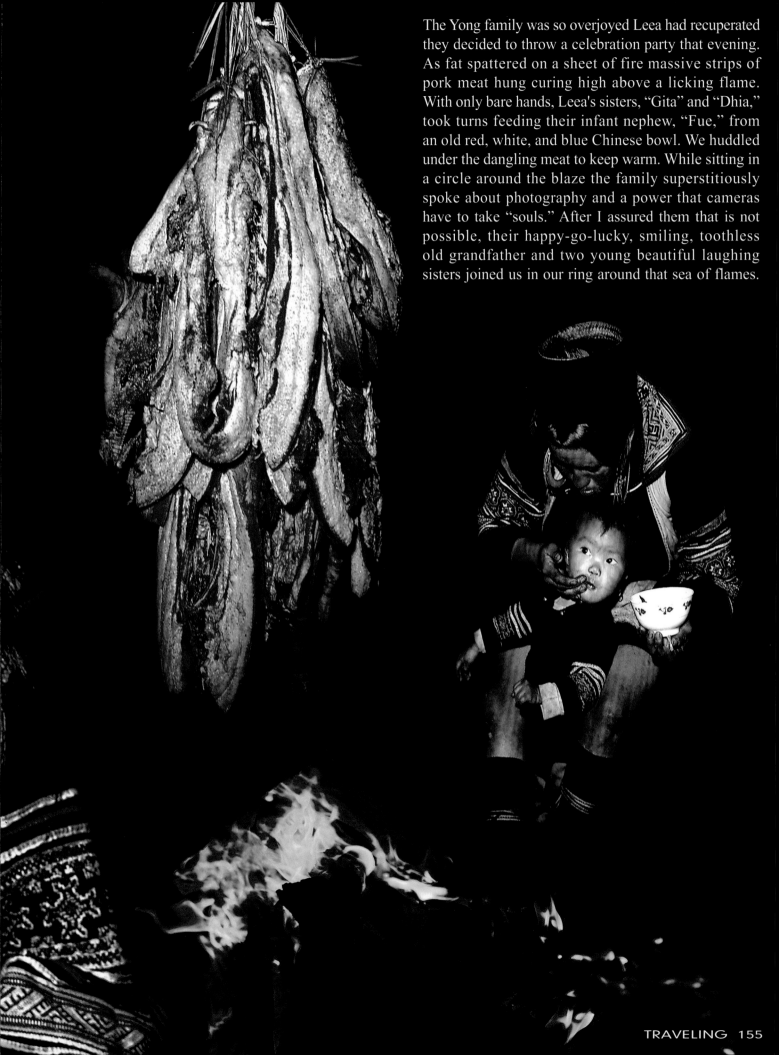

The Yong family was so overjoyed Leea had recuperated they decided to throw a celebration party that evening. As fat spattered on a sheet of fire massive strips of pork meat hung curing high above a licking flame. With only bare hands, Leea's sisters, "Gita" and "Dhia," took turns feeding their infant nephew, "Fue," from an old red, white, and blue Chinese bowl. We huddled under the dangling meat to keep warm. While sitting in a circle around the blaze the family superstitiously spoke about photography and a power that cameras have to take "souls." After I assured them that is not possible, their happy-go-lucky, smiling, toothless old grandfather and two young beautiful laughing sisters joined us in our ring around that sea of flames.

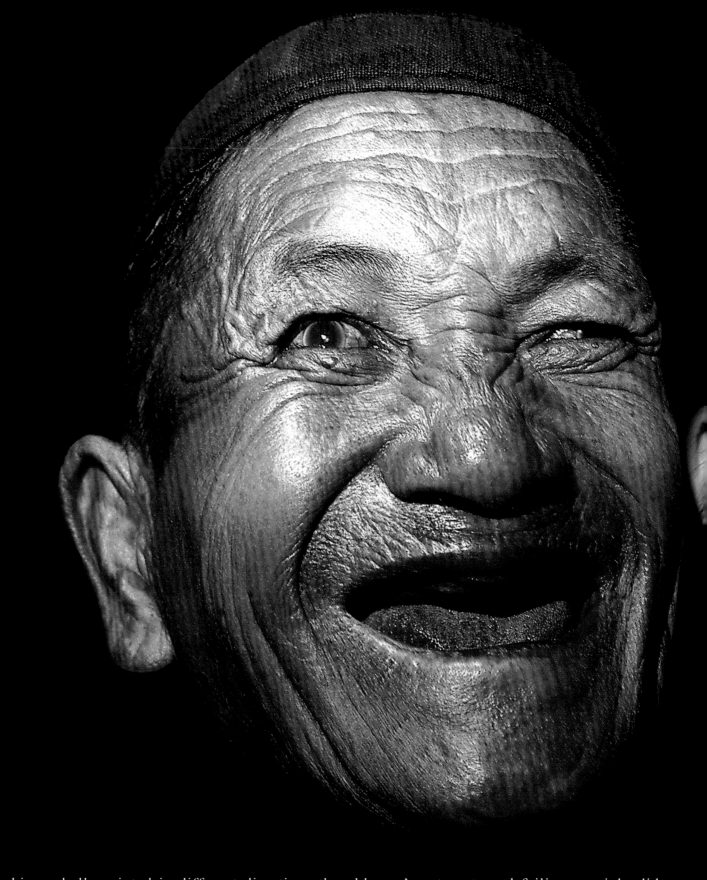

Though his eyeballs pointed in different directions the old man's cataracts and failing eyesight did not deter his jovial disposition and hearty boisterous laugh that rang through dense low-lying mountain fog. His time-worn face wrinkled into a heart shape with his every inhalation, while each exhalation sighed in laughter. Only gums were visible through the gurgling yellow saliva that escaped from deep within the pit of this beast's toothless ruby-red mouth. Crimped arrow-shaped flesh had formed on the bridge of his nose and massive horizontal lines criss-crossed the sagging creased skin that ran above his eyes to

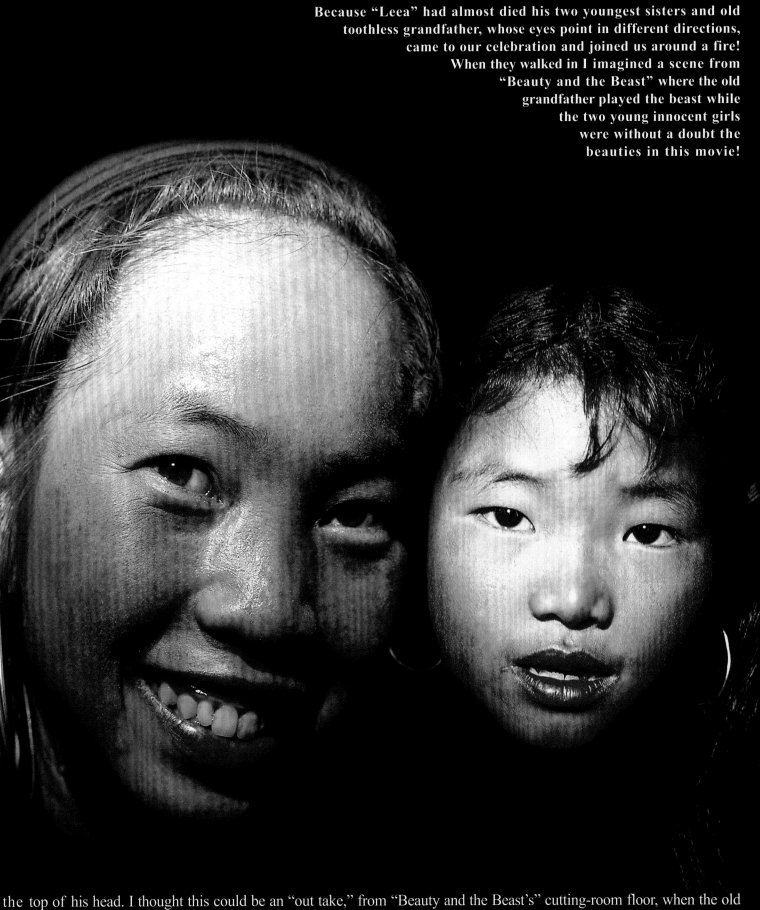

Because "Leea" had almost died his two youngest sisters and old toothless grandfather, whose eyes point in different directions, came to our celebration and joined us around a fire! When they walked in I imagined a scene from "Beauty and the Beast" where the old grandfather played the beast while the two young innocent girls were without a doubt the beauties in this movie!

the top of his head. I thought this could be an "out take," from "Beauty and the Beast's" cutting-room floor, when the old man's two youngest granddaughters walked in, for they were models of true health, innocence, and beauty. The "beast" started chanting and throwing a red painted wood stick that was split down the middle into equal halves after his "beauties" sat down. He picked up the two pieces and tossed them over and over again in the corner of the hut from where I could hear the sound of wood hitting wood. But I was never more confused when after throwing the sticks, he crawled out of that dark corner on his hands and knees and screeched, "Now Surely! Is it a BOY? No, NO, It's, IT'S A GIRL!"

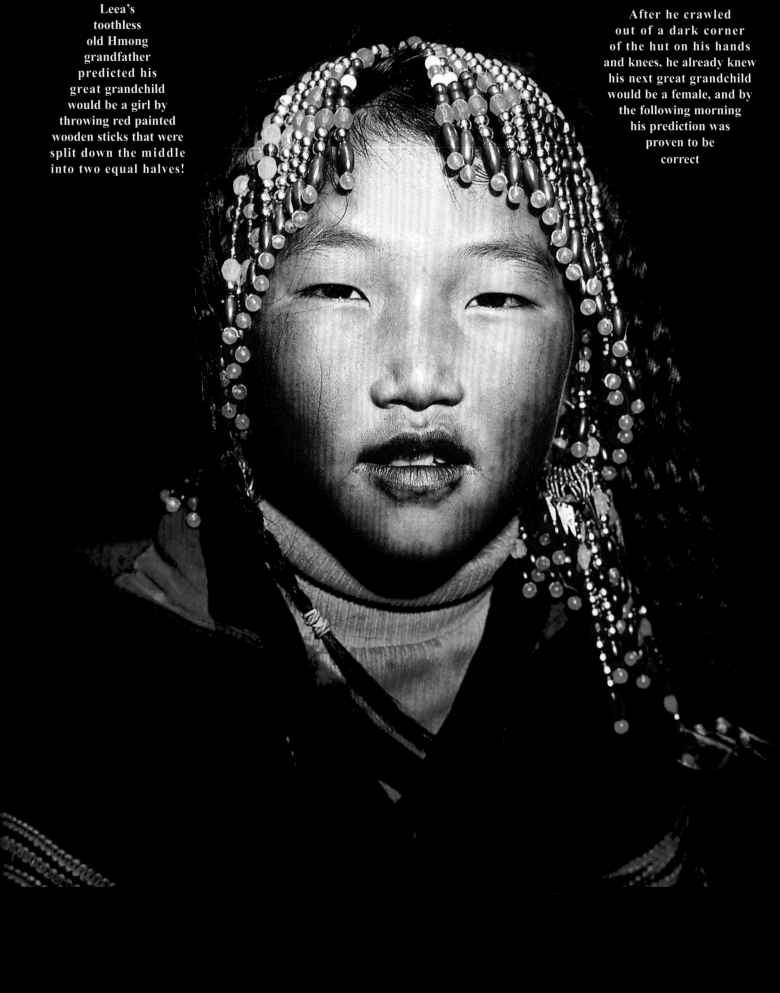

Leea's toothless old Hmong grandfather predicted his great grandchild would be a girl by throwing red painted wooden sticks that were split down the middle into two equal halves!

After he crawled out of a dark corner of the hut on his hands and knees, he already knew his next great grandchild would be a female, and by the following morning his prediction was proven to be correct

"He only wants to know the sex of my sister's unborn child" Gita said with a sheepish frown. "I know my grandfather may disturb you but the Txiv Tai Kev shaman gave him those sticks so he could see the future." Now I was even more confused, when asking, "What do you mean; he can see the future?" "The "Kev" priest told my grandfather he could find out a yes or no answer to any question by throwing those two red sticks." Gita explained, "If two halves of the stick face up or down the answer is yes, if one of the two sticks faces up and the other down the answer is always no. He landed a "no" and found out my pregnant sister will give birth to a girl!" I was still not sure what to believe, but by the following day, in bright, glaring, midmorning sunlight, I saw what was undeniable: the old man's granddaughter had already delivered his great granddaughter that night.

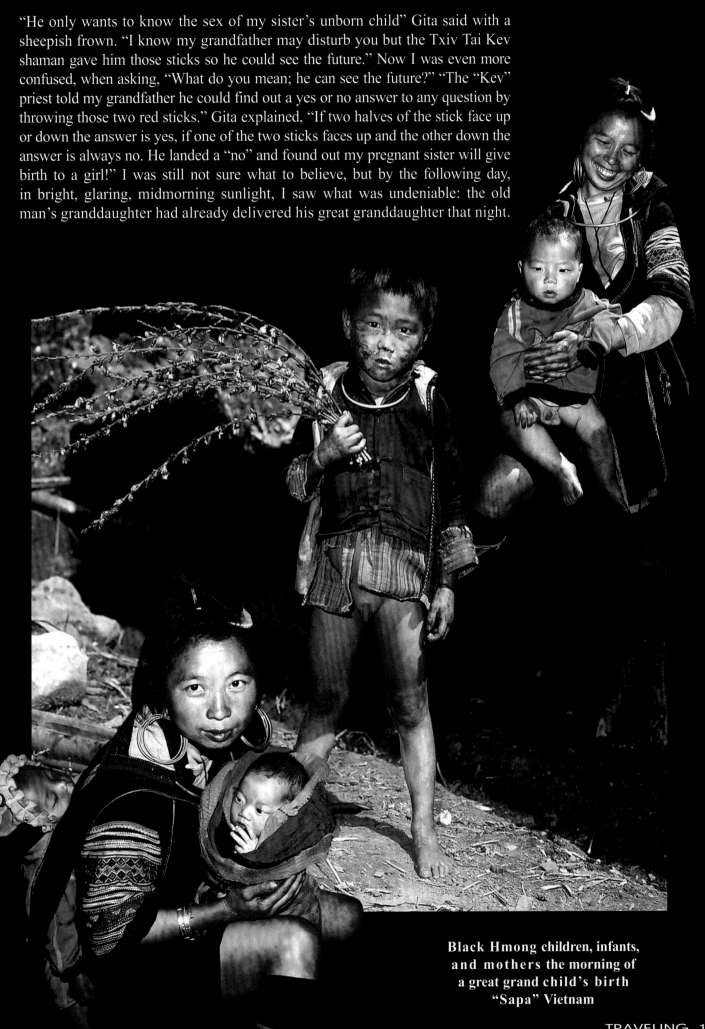

**Black Hmong children, infants, and mothers the morning of a great grand child's birth "Sapa" Vietnam**

floated in a supernatural daze in the most blissful time of my existence. It was a very secure daze. I found satisfaction and the greatest of all joys! After the Black Hmong's assortment of priceless intangible lessons, I had to give them credit for this moment. I could now safely travel through the Spirit World, back to my original place of birth, after death, while seeing my entire future reflect in two shiny red sticks! I tried to grasp the elusive lessons the tribe had taught. As Gita and her mother collected firewood and sugarcane, the day waned into spectacular red and yellow light that danced on silver clouds. Unfortunately the sun set on the most blessed day in my existence, before realizing: I will never be able to repeat or equal this experience again, but will always be forever indebted to the Black Hmong for giving me the opportunity to live one unforgettable full day of complete and total happiness.

**Black Hmong "Gita," with her mother and daughter, collecting sugarcain and fire wood near rice terraces at sunset: "Sapa" Vietnam**

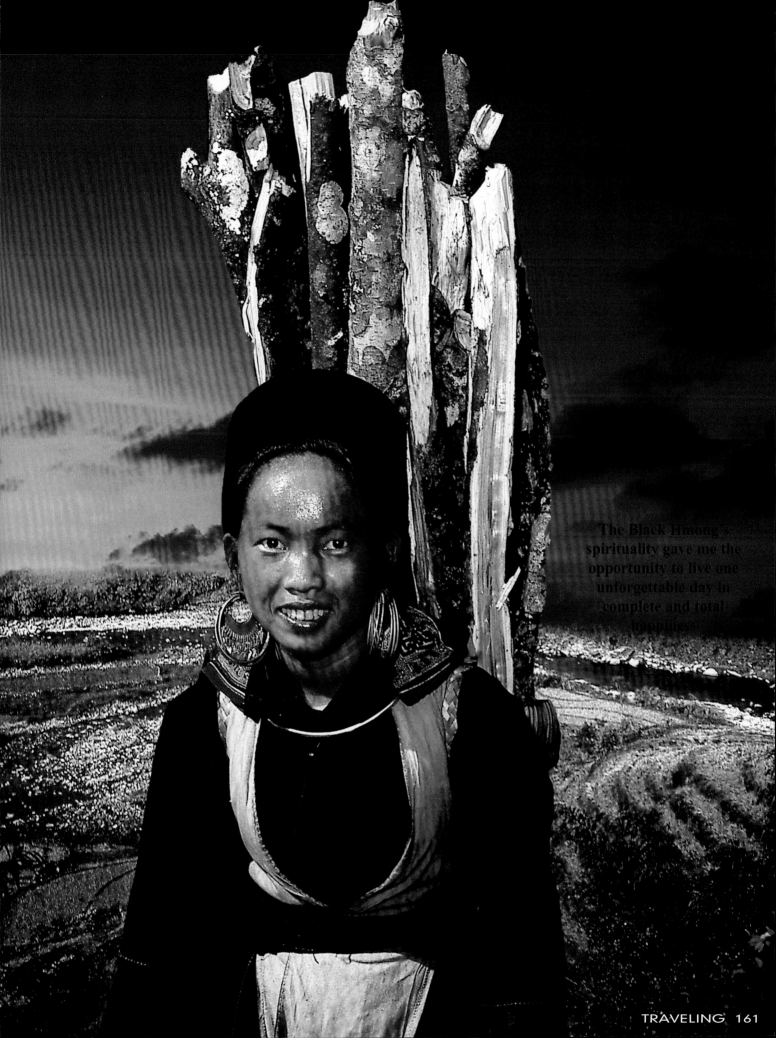

The Black Hmong's spirituality gave me the opportunity to live one unforgettable day in complete and total happiness.

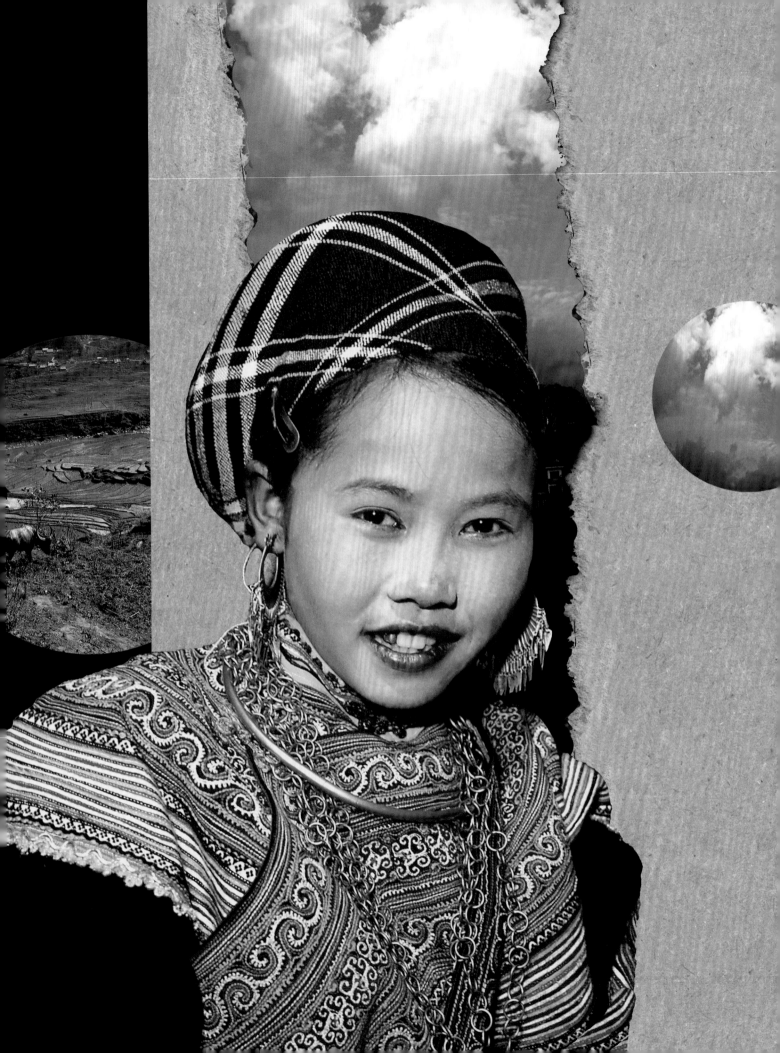

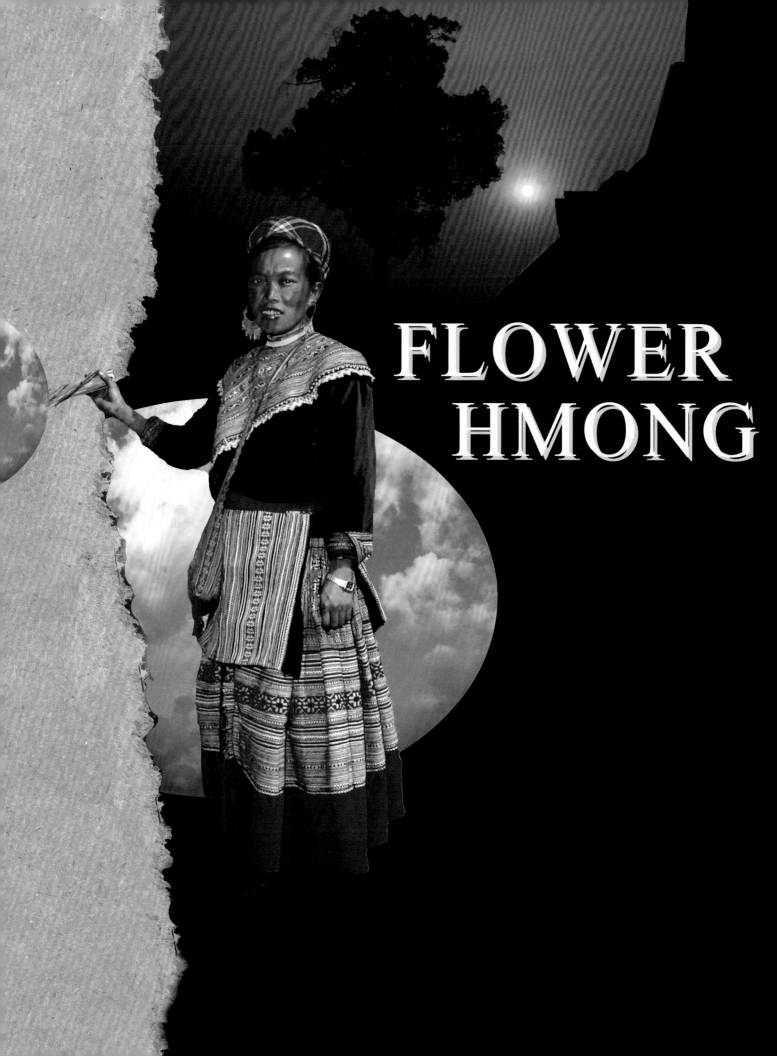

FLOWER
HMONG

I took a "hit" off a Thai "Poy-Sian" 15 baht inhaler and, while waiting for that mild stimulant to "kick in," wondered: what should I do next? I was not certain which active ingredient is most additive in that "over-the-counter" plastic-tipped Poy-Sian but after reading the inhaler's contents I ruled out eucalyptus, menthol, and camphor when deciding: "borneol" is the "boost" in this "bottle!" Longing for another chance to experience the Black Hmong, I sniffed that inhaler and while borneol "triggered" my introspective realization: "I do not want to leave these hospitable Vietnamese tribal people." A Frenchman said, "The most colorful tribe "hangs out" just a few hours from here!" He provided simple details that satisfied my desire by logically suggesting, "You can stay in Vietnam and see the "Flower Hmong" at their market in the small town of "Bac Ha." He was informative but boring! After hearing his many lengthy

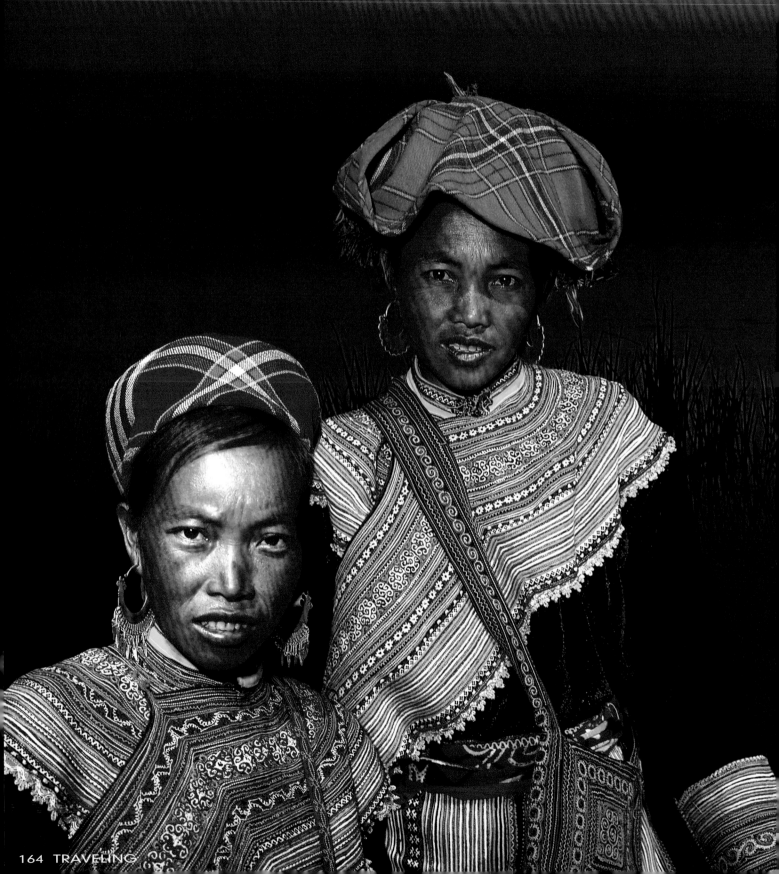

accounts of that tribe I concluded: an encounter with the Flower Hmong may be more than worthwhile considering the possibility of acquiring both extraordinary photographic results and rare tribal artifacts! "They dress in fantastic, bright colors, intricately woven embroidered clothing that go way beyond your wildest dreams and imagination..." but before the goateed, beret-wearing "Frog" could finish his description I was on my way to "Bac Ha." I left Sapa, floating in a surreal "out of body" experience, only to be dazed by a tedious trip consisting of lonely dusty dirt roads along the winding "Red River." I could see China, only a few hundred feet away, on the opposite bank. When nearing Bac Ha I almost lost sight of four Flower Hmong we passed in deep morning mist, who stood as silhouettes in the sunrise on the Vietnamese side of the river. That single site far surpassed all the Frenchman's best descriptions of the tribe!

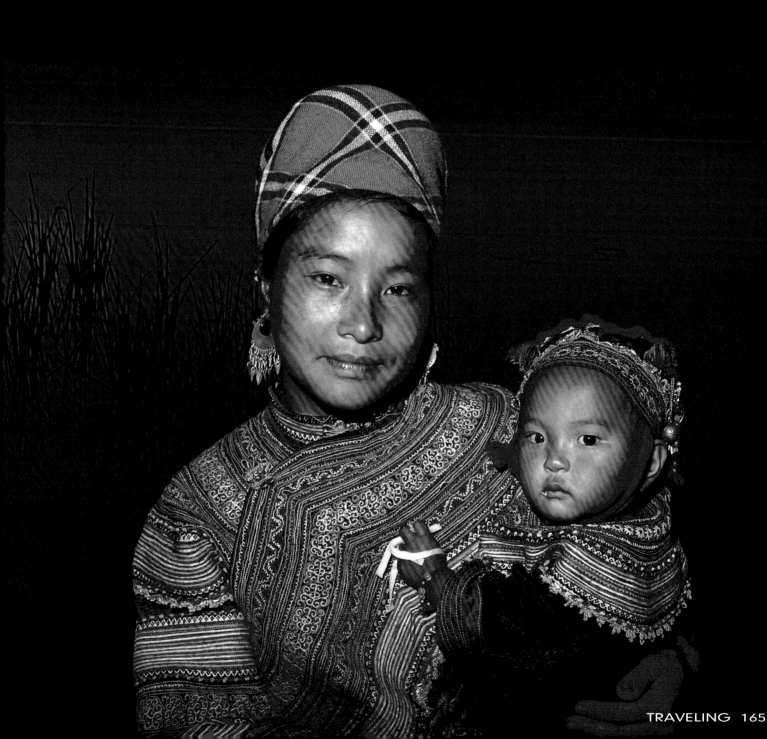

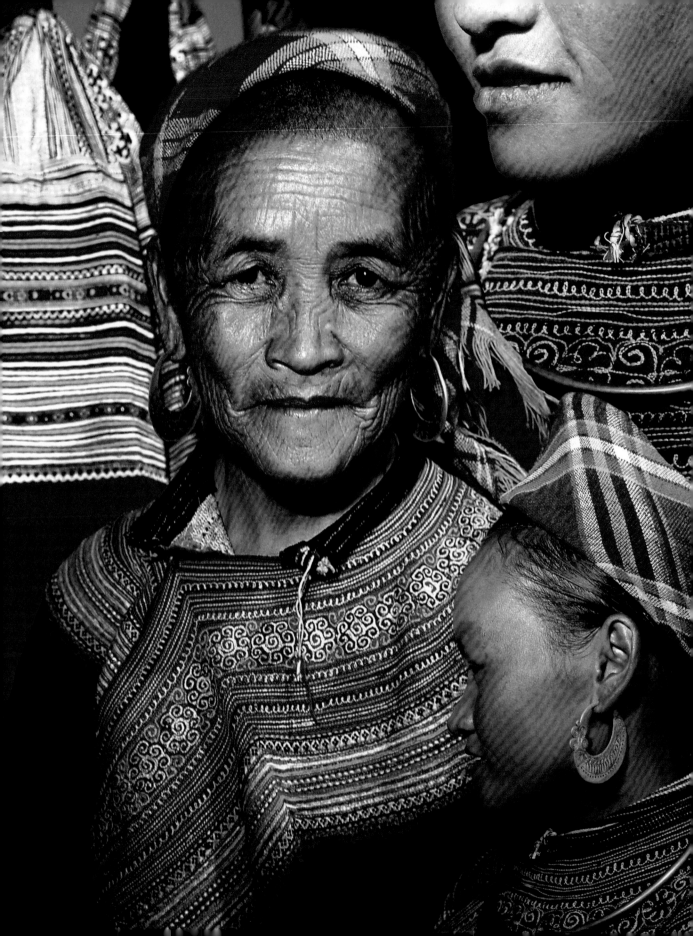

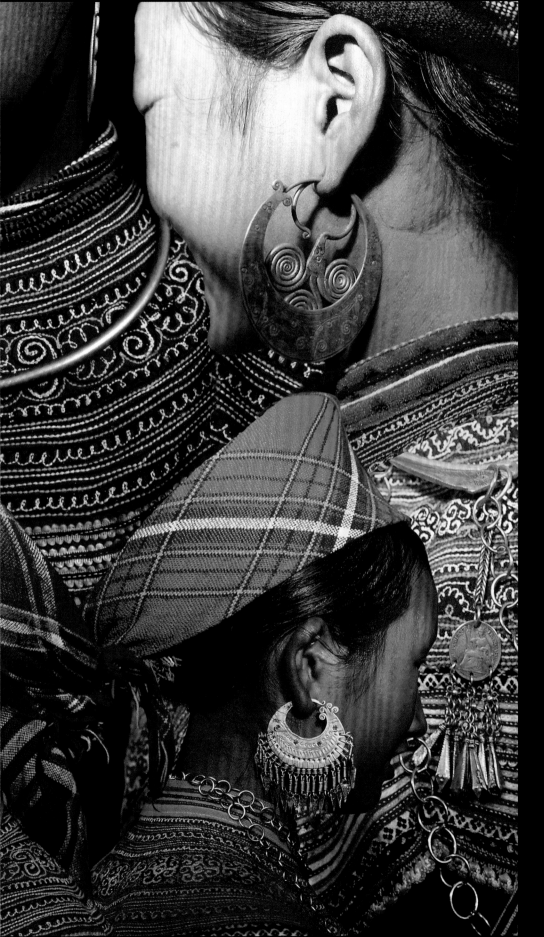

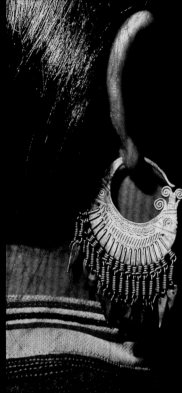

The Flower Hmong market was a crush of umbrella-toting, sugarcane chewing, silver-studded females fighting for price. Many "humped" wicker baskets or infants on their backs. While looking for exceptional artifacts I stopped any and all members of the tribe, male or female, who would cooperate in taking photo portraits when, in my peripheral vision, I caught sight of a very old, very fine, extremely rare beautiful "Paj Ntaub:" Flower Hmong Tribal Artifact!

**Flower Hmong females in the "Bac Ha" market where an historic "Paj Ntaub" tribal textile was found "Bac Ha:"**

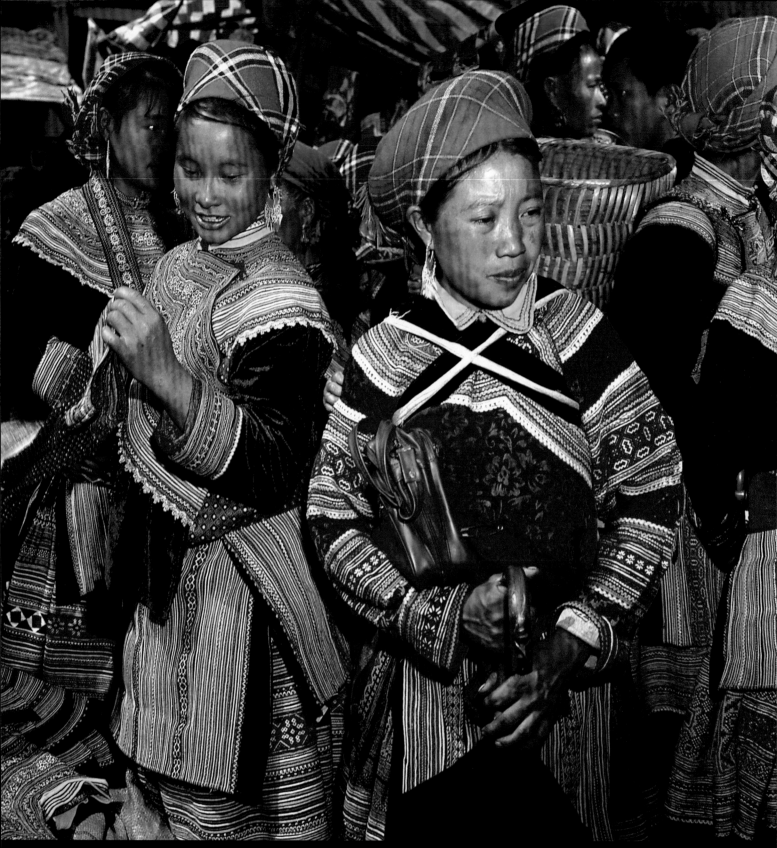

**The "Bac Ha" market is a crush of color as umbrella-toting "Flower Hmong" females fight for price**

The most sought-after, most rare, most beautiful Flower Hmong artifact is a "Paj Ntaub" cloth, but there is a challenge in finding one. I effortlessly overcame that time-consuming task after stepping on the finest example of an historic Flower Hmong's Paj Ntaub banner that will ever be found. "What's this piece of junk and how much do you want for it?" I surreptitiously questioned the vendor who stood in a stall composed of little more than a folding card table and the cement floor in that open air market. As blinding, midmorning, burning hot sun beat down I felt like a spy on a clandestine espionage mission, attempting to get the best discount on that embroidered artifact, even though it was rare and the most valuable Flower Hmong piece in the market that day. The oversized, eight-by-ten foot Paj Ntaub "flag's" top half was displayed on the table, while the bottom half draped to the ground where the crowd occasionally walked

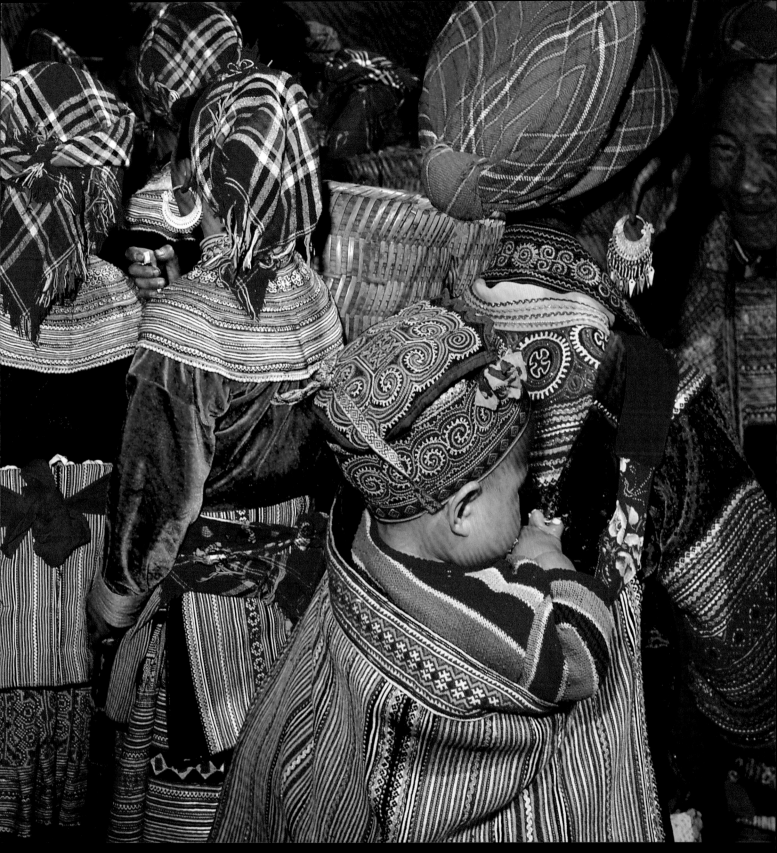

**"Flower Hmong" females carrying baskets and infants on their backs while working: "Bac Ha Vietnam"**

on it! I envisioned the vendor had little or no regard for the valuable textile, as it was trampled under foot, but when she replied, "That's no piece of junk. That's my grandmother's history of my ancestors' travels, lives, greatest fortunes and most rewarding experiences. Please do not ever call it junk again!" My foot was in my mouth before I realized: I have to dig myself out of this deception gracefully or I surely will lose this extraordinary artifact to greed. "Oh I'm sorry! I didn't know it was so dear to you. I thought it was something you wanted to get rid of; selling it here in the market. I'm sorry! I'm still interested in your blanket! Thank you for your consideration. I'm sorry! I don't mean to offend you. Please forgive me!" I said while thinking: have I dug myself a deeper burial pit or will she be sympathetic? She simply replied without emotion, "Yes I want to sell it but it's no piece of junk. It's my tribe's way of preserving history!"

"Don't you understand; two hundred years ago the Chinese persecuted my Hmong tribe and we saved our history and fought for independence symbolically on textiles like this? This Paj Ntaub is a Hmong's freedom banner! It has great value!" After she finished speaking I eased my burden of deceit by willingly paying through the nose for the Paj Ntaub Flower Cloth, but before sleeping like a guiltless infant I heard a women scream over the loud roar of the market's haggling crowd, "I'll give you two skirts, a basket, and 20,000 dong for just one goat!" A disheveled deformed dwarf, in a "Mao" cap, who dressed in black from head to toe refused as he insisted, "No, No I want your rifle and 20,000 dong for the goat!" After crossing the square to the shady side of the market, I got a closer look at the argumentative negotiations. As the woman became hysterical she screamed, "Please, please let me have the goat! I must help my father. My family needs a goat. I can't give you this gun because it's not mine. Please, please, let me have the goat. I'll do anything but I must have that goat!" she tragically pleaded in tears. I wanted to help but was unsure what to do as I inched closer to the disputing couple and said, "Why don't you let her have the goat?" The deformed single-toothed midget, with one half-closed eye, smiled then indignantly responded, "Who are you to come into this market and make our business yours? You are not even a Hmong tribesman!"

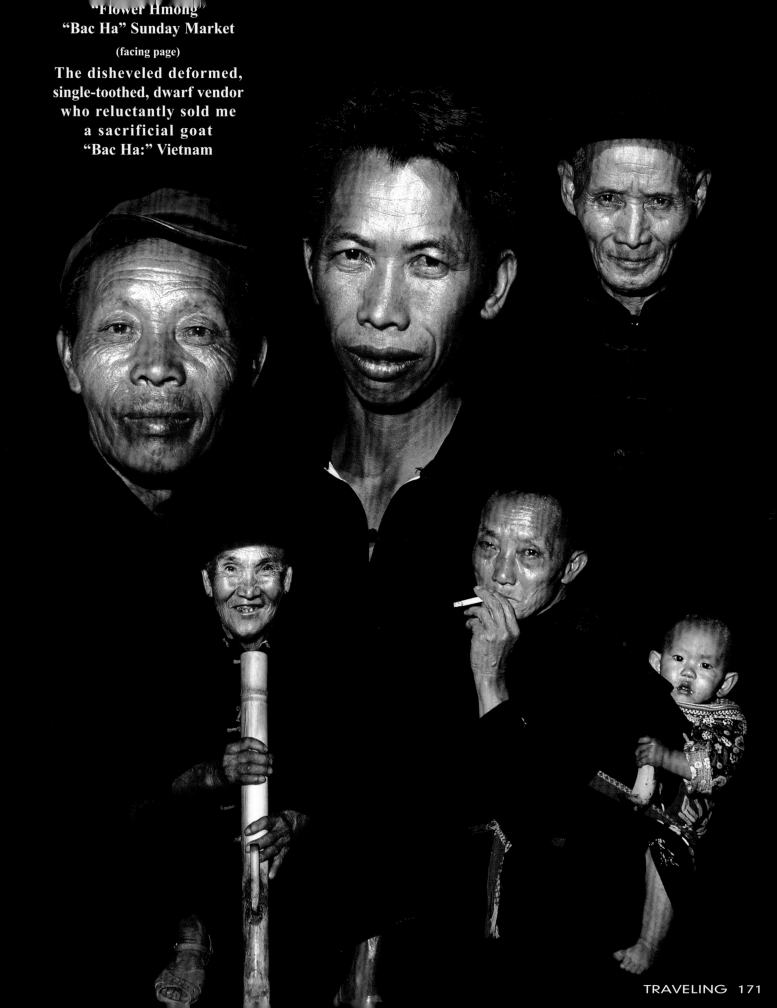

"Flower Hmong"
"Bac Ha" Sunday Market
(facing page)
The disheveled deformed,
single-toothed, dwarf vendor
who reluctantly sold me
a sacrificial goat
"Bac Ha:" Vietnam

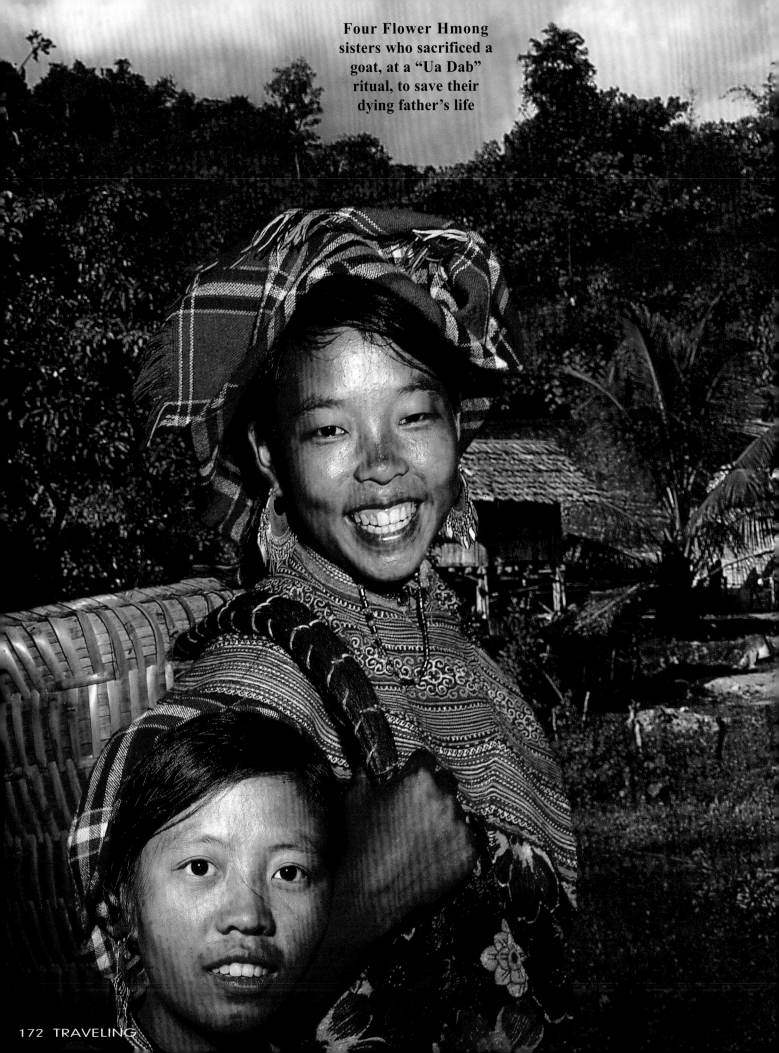

**Four Flower Hmong sisters who sacrificed a goat, at a "Ua Dab" ritual, to save their dying father's life**

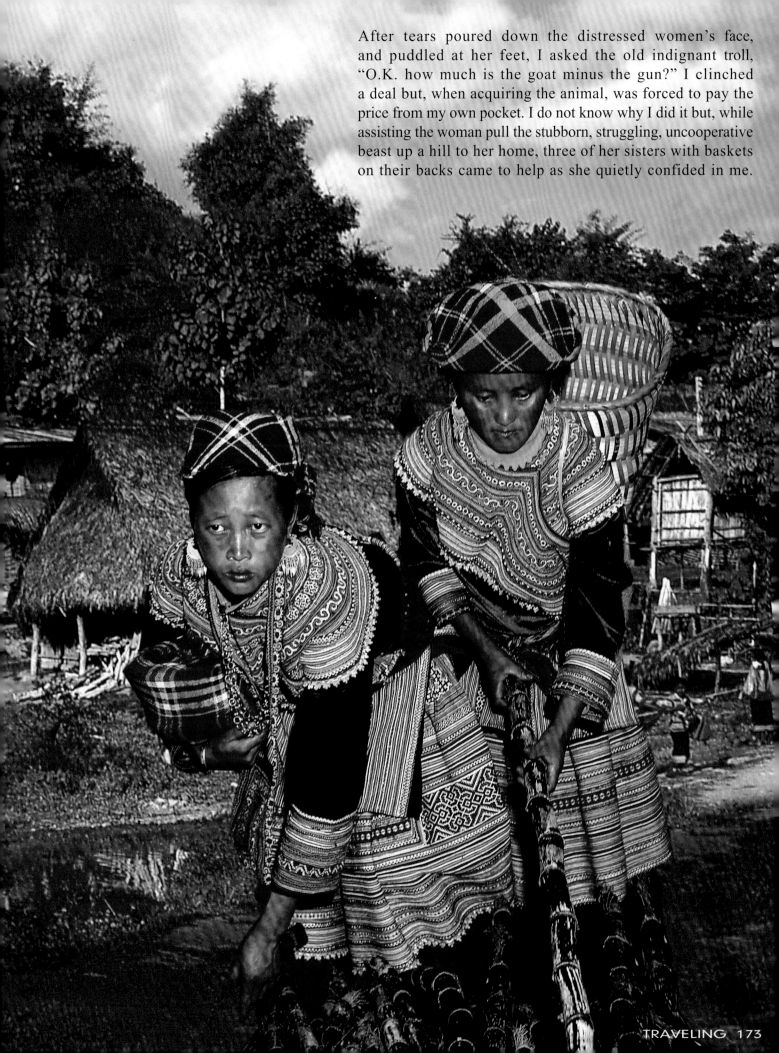

After tears poured down the distressed women's face, and puddled at her feet, I asked the old indignant troll, "O.K. how much is the goat minus the gun?" I clinched a deal but, when acquiring the animal, was forced to pay the price from my own pocket. I do not know why I did it but, while assisting the woman pull the stubborn, struggling, uncooperative beast up a hill to her home, three of her sisters with baskets on their backs came to help as she quietly confided in me.

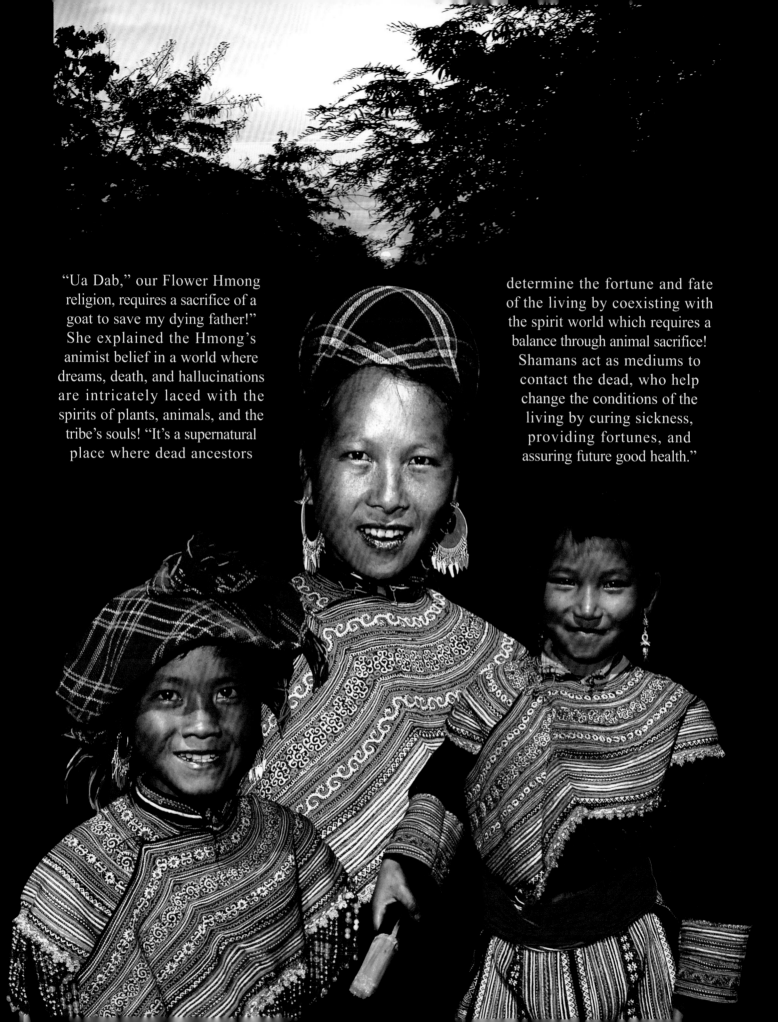

"Ua Dab," our Flower Hmong religion, requires a sacrifice of a goat to save my dying father!" She explained the Hmong's animist belief in a world where dreams, death, and hallucinations are intricately laced with the spirits of plants, animals, and the tribe's souls! "It's a supernatural place where dead ancestors determine the fortune and fate of the living by coexisting with the spirit world which requires a balance through animal sacrifice! Shamans act as mediums to contact the dead, who help change the conditions of the living by curing sickness, providing fortunes, and assuring future good health."

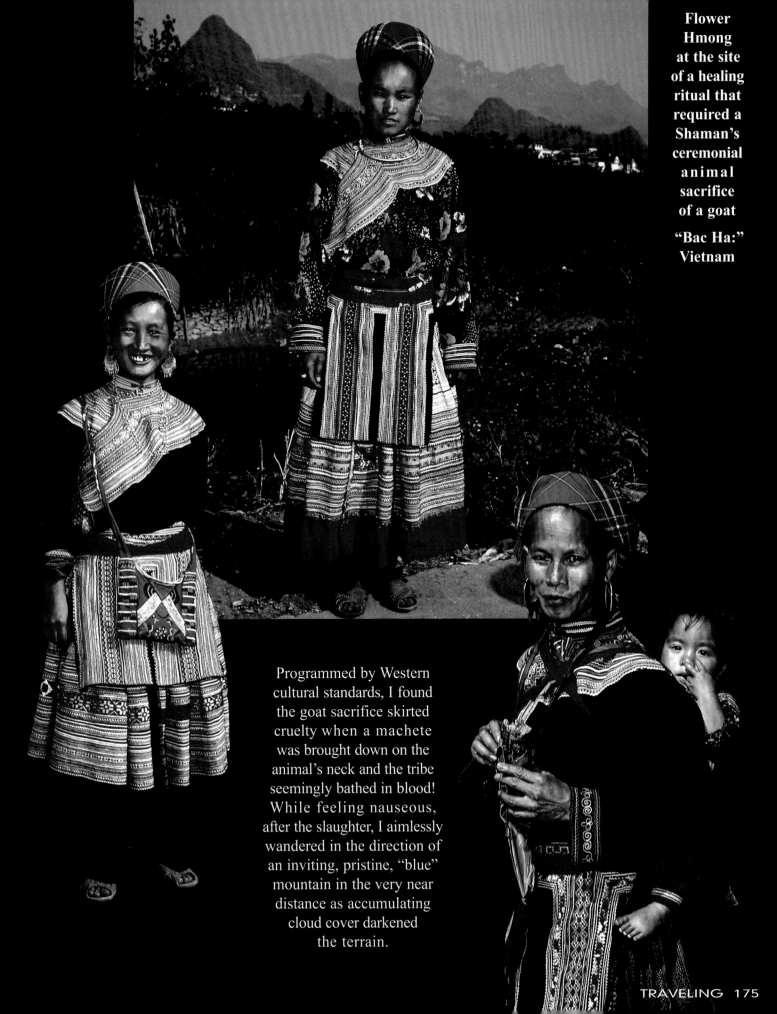

**Flower Hmong at the site of a healing ritual that required a Shaman's ceremonial animal sacrifice of a goat**

**"Bac Ha:" Vietnam**

Programmed by Western cultural standards, I found the goat sacrifice skirted cruelty when a machete was brought down on the animal's neck and the tribe seemingly bathed in blood! While feeling nauseous, after the slaughter, I aimlessly wandered in the direction of an inviting, pristine, "blue" mountain in the very near distance as accumulating cloud cover darkened the terrain.

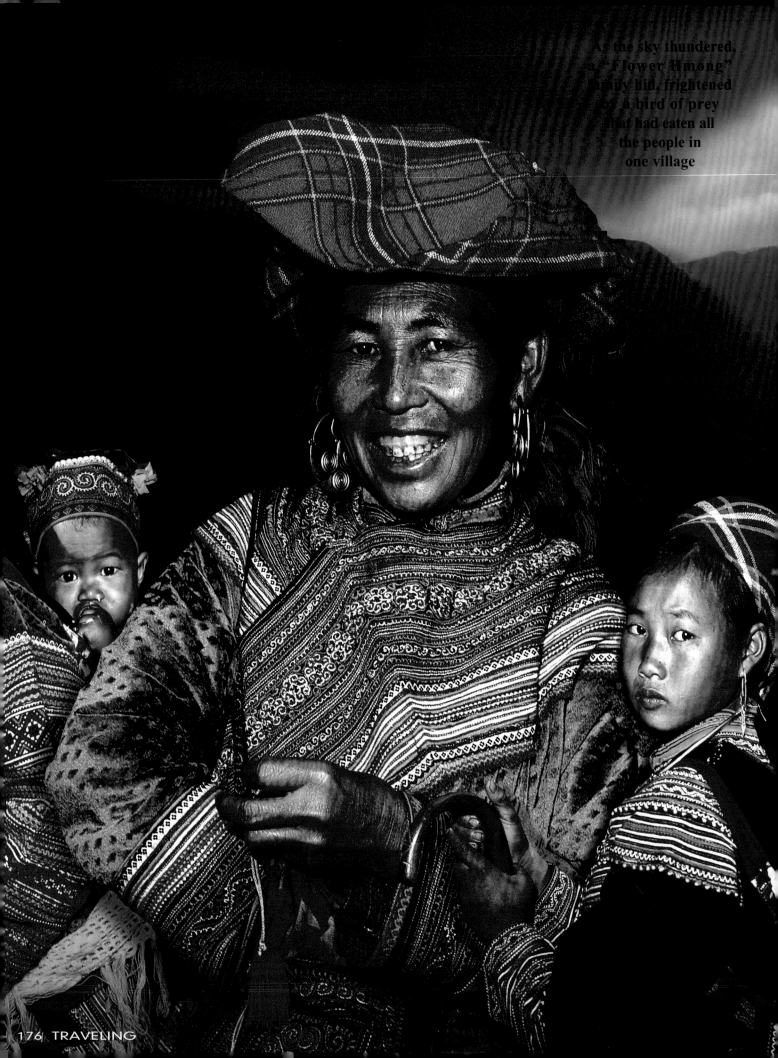

As the sky thundered, a "Flower Hmong" family hid, frightened of a bird of prey that had eaten all the people in one village

The sky thundered after I found a Flower Hmong family picnicking, in the mountain's foothills. As a black and white bird of prey flew overhead the tribe ran for cover. I assumed, in anticipation of rain, they sheltered under low-hanging pine trees but I soon realized my mistake when the Hmong remained in hiding well after the downpour's threat had vanished. While the bird circled, in a now azure sky, I demanded an explanation! "What are ya' doing? Why do ya' hide? It's not gonna' rain. Come outta' there!" An uncertain, beret-wearing Hmong tribesman poked a smiling face out of a long, narrow, hollow log that he was hiding in and said, "Is that bird gone? Some of our tribe was taken away and eaten by birds. One of those eagles ate all the people in one village."

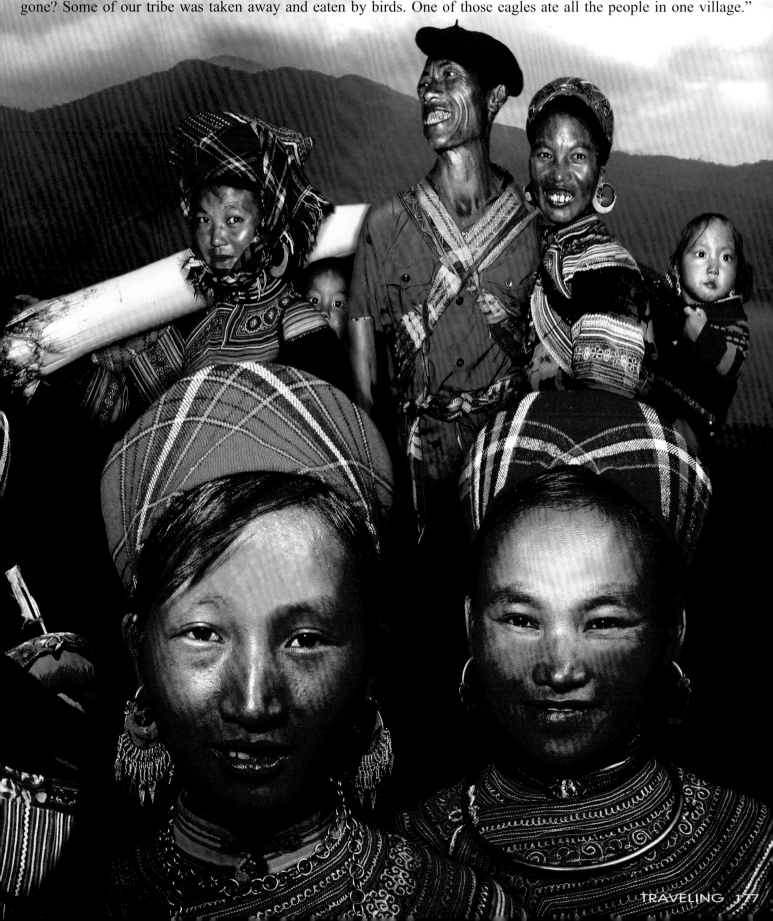

I was tempted to say, "You sound like a 'Harry Potter' fairy tale." But when the eagle took off, I thought better of it, and only said, "It's gone! It flew away! You can all come out now. What's the problem anyway? It's just a bird." The strapping young Hmong leader replied, "Do you know why some people are right handed and why some are left handed?" While I questioned: What does that have to do with the price of eagle eggs? the chief began a detailed account of a well known Hmong myth concerning birds of prey that went something like this: "It's difficult to imagine but hundreds of years ago in a small village a huge eagle, bigger than eleven huts, flew down and ate people! The bird frequently returned and consumed every villager it found. On the bird's final flight a crossbow was drawn and the animal

A "Flower Hmong" family, while picnicking in a mountain's foothill, told myths that explain why some people are left handed and why others forever remain right handed

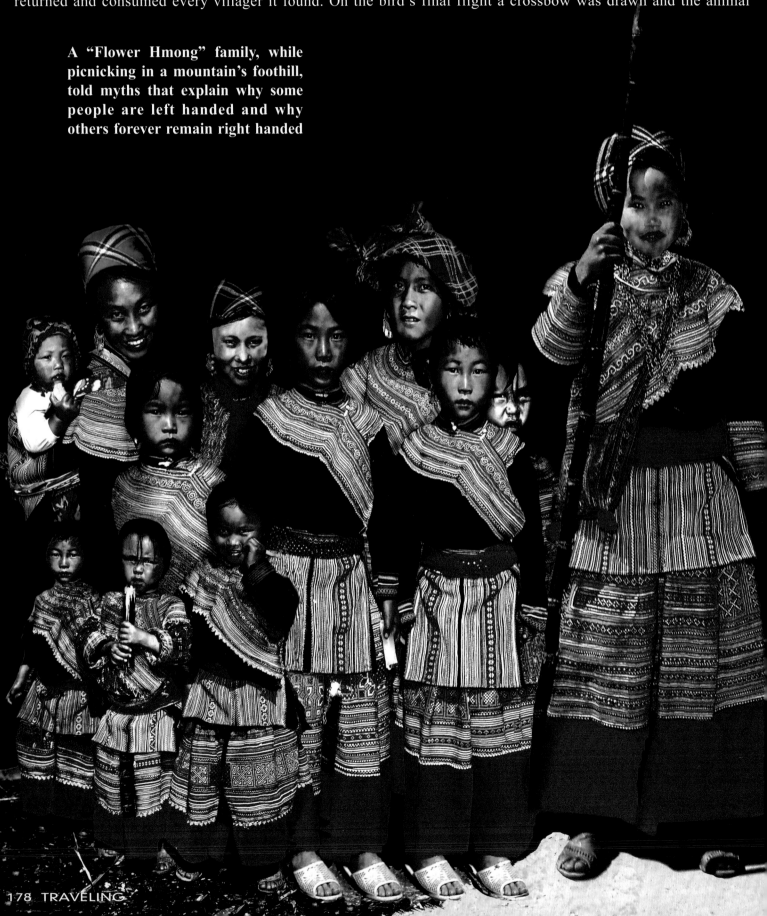

perished. The archer, before eating the bird, cut open its belly and discovered a cache of undigested human remains. For nine days and nights, without sleep, the tribe reconnected the bones hoping to put the people back together! At first, energetic and alert, they selected the elements carefully and put the pieces correctly on the left and right sides. But when the tribe became tired, they were careless, and indiscriminately reassembled the remaining pieces. And that is why, ever since that bird was killed, some people forever are right handed while others eternally remain left handed!" I slowly walked silently away but still smile to this day when I pick up a pen in either hand to write a story. I remember that Hmong myth and always wonder from what stack of ambidextrous bones was I reconstructed?

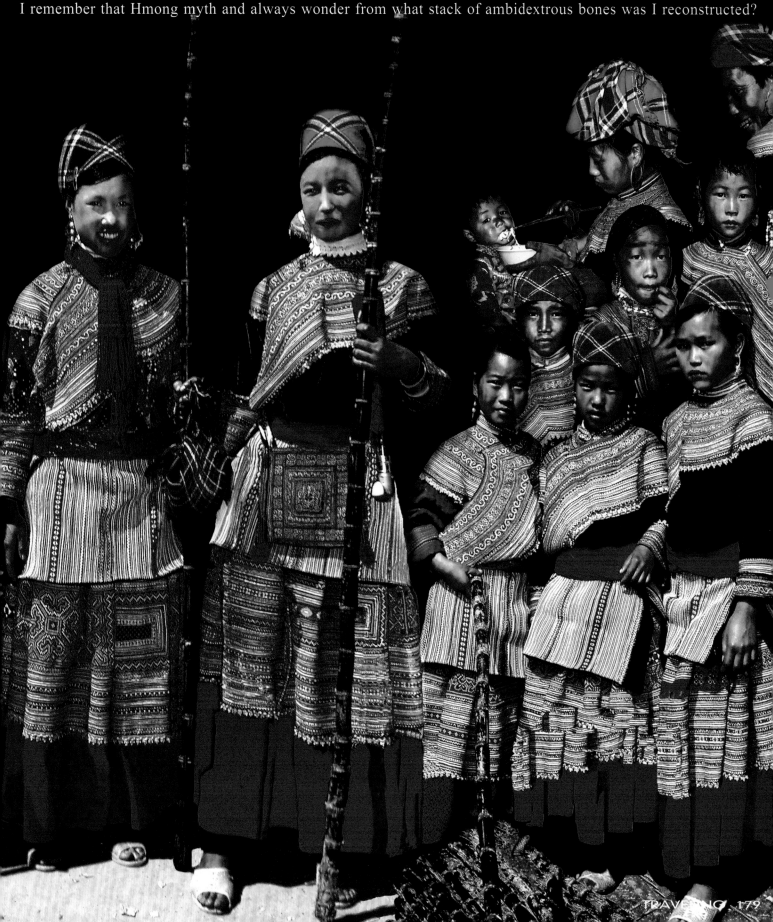

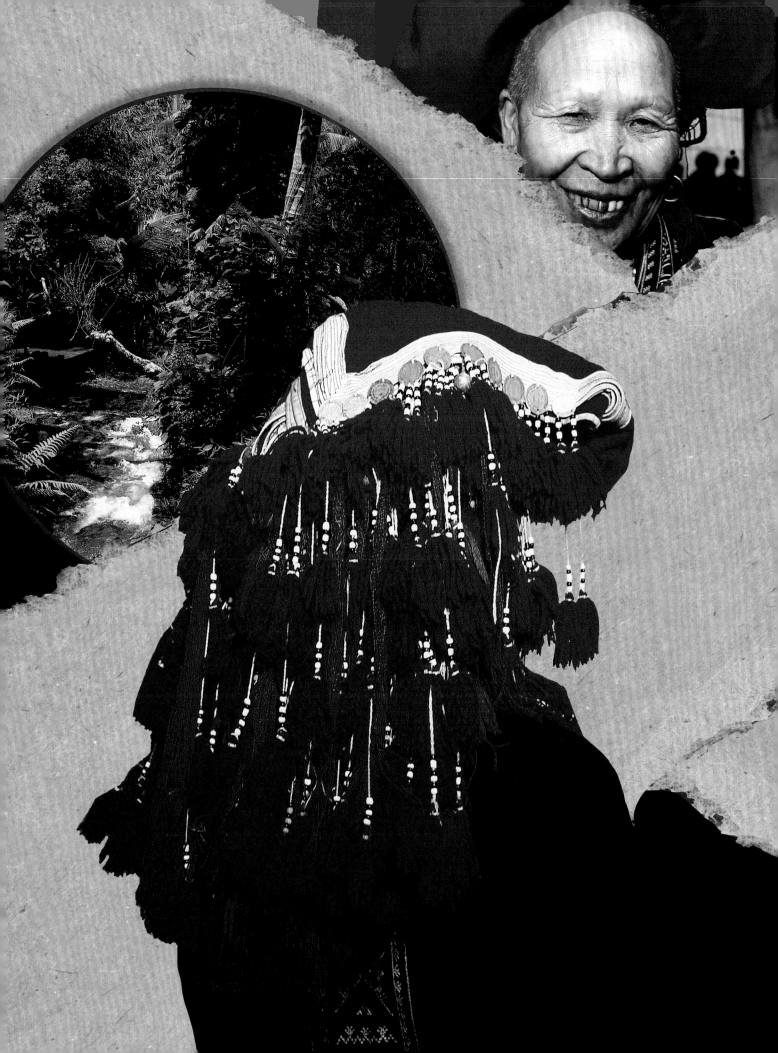

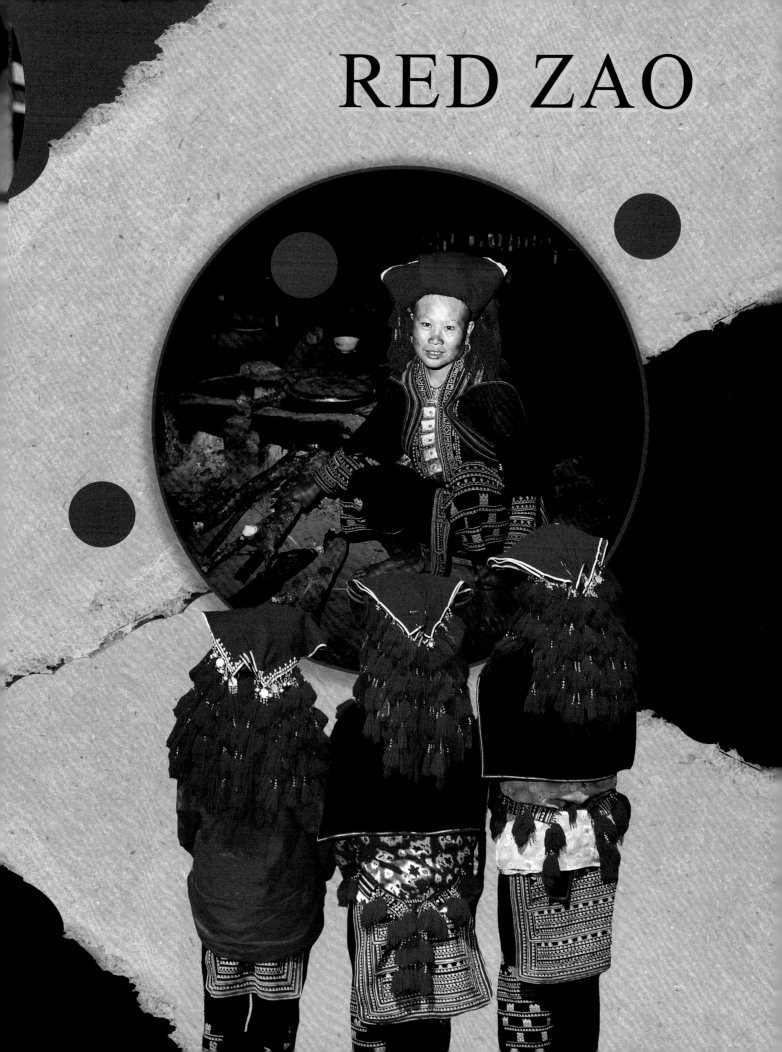

# RED ZAO

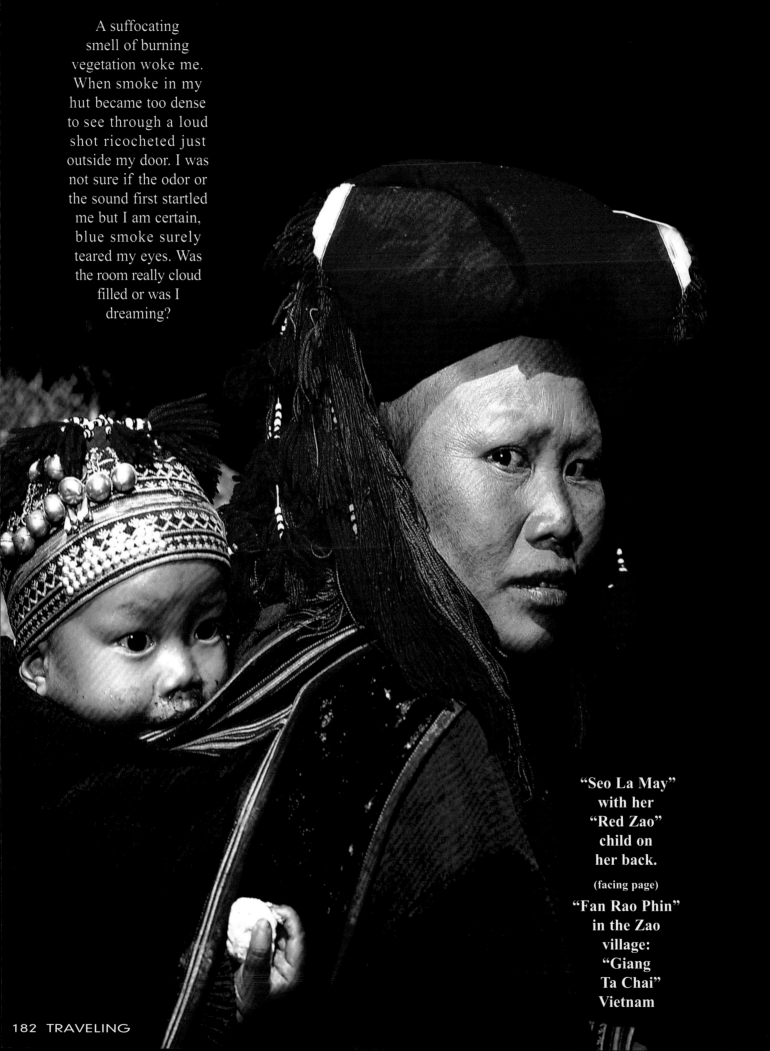

A suffocating smell of burning vegetation woke me. When smoke in my hut became too dense to see through a loud shot ricocheted just outside my door. I was not sure if the odor or the sound first startled me but I am certain, blue smoke surely teared my eyes. Was the room really cloud filled or was I dreaming?

"Seo La May" with her "Red Zao" child on her back.

(facing page)

"Fan Rao Phin" in the Zao village: "Giang Ta Chai" Vietnam

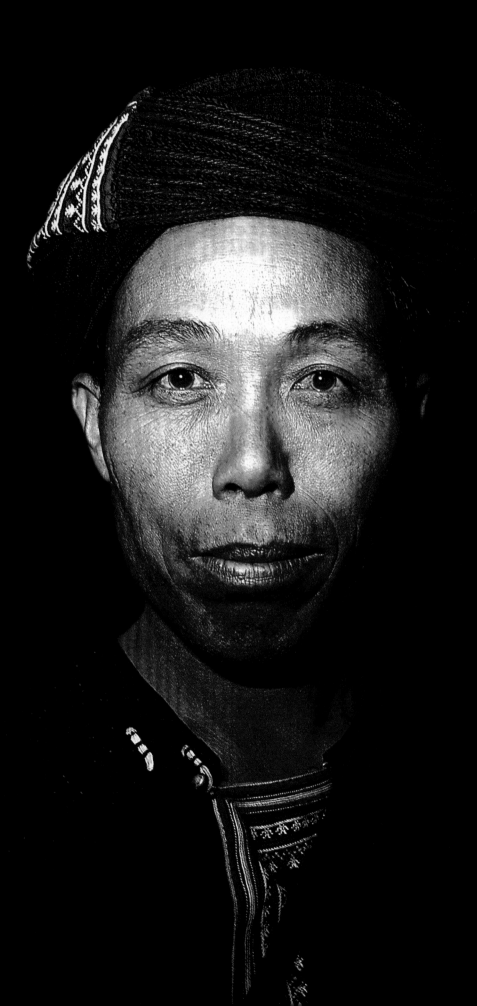

Those questions were definitively answered when the shadow of an H.I.V. positive carrier ran across the jungle landscape then tore through billowing vapor that poured from the front door of my shack. While I imagined drowning in a sea of flames an archangel dragged me through waves of smoke, over an ocean of fire, into dawn daylight as I choked and gasped for breath. My life flashed before me in a matter of moments, every detail complete! I passed through this incoherent sequential vision, struggling to free myself from a dark vertical tunnel to a pinpoint of light that was sky. I kept looking up, trying to get hold of that tiny light source, until a bucket of water was thrown on my face! As my guardian angel slowly vanished I woke for the first time, that beautiful, unforgettable morning, in the Red Zao village "Giang Ta Chai" Vietnam.

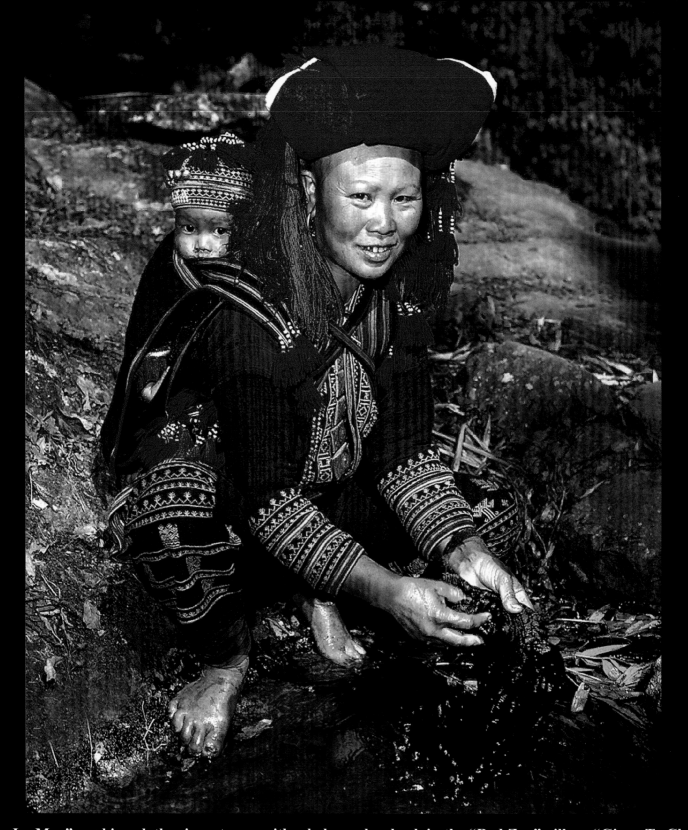

**"Seo La May" washing clothes in a stream with a baby on her back in the "Red Zao" village "Giang Ta Chai"**

"Where am I? What's goin' on? What happened?" I thrashed from side to side, while screaming, in an uncontrollable fit. The Red Zao tribesman, "Fan Rao Phin," who moonlights as my savior, also acted as my host for in this part of North Vietnam there is not a single guesthouse for miles. With water-soaked hair, welted red eyes, and blackened phlegm, I looked up from the ground at a turbaned tribesman, who sat in the jungle next to a huge bonfire holding an ancient flintlock rifle, and simply said, **"Phin what the hell happened?"** It did not take long to understand his short explanation: "The opium pipe you smoke last night fell down when you sleep and knock over light!"

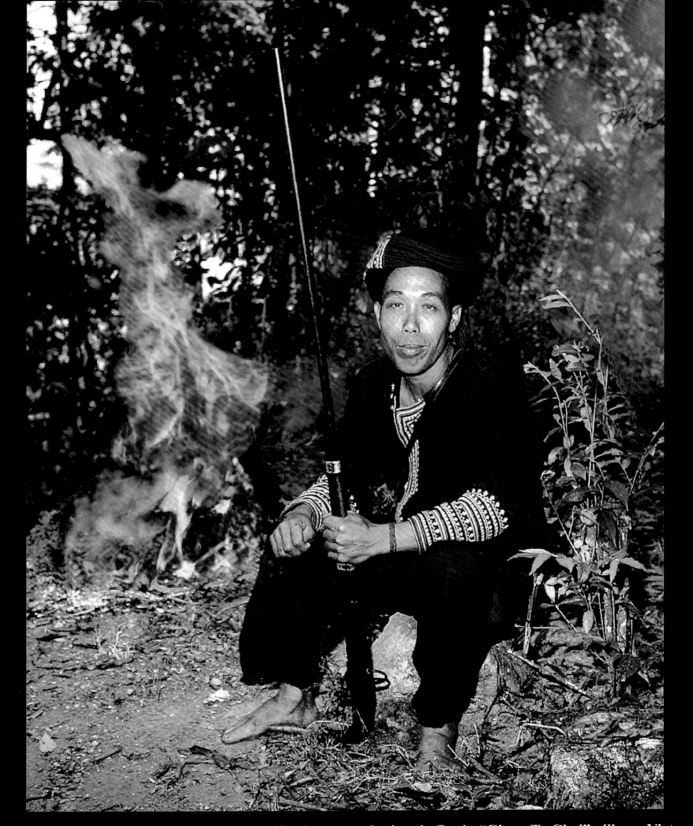

**"Fan Rao Phin" accidentally shot a flintlock rifle that caused a jungle fire in "Giang Ta Chai" village: Vietnam**

The light source, after dark, in this remote region of Vietnam is kerosene. Seeing as there is no electricity, it does not require much imagination to envision a clumsy "stoner" unknowingly tipping over a kerosene lamp with an opium pipe that fell from his hands after last night's final "hit." Phin successfully extinguished the fire in my hut's floorboards, but after he dragged my smoking bedding to dry jungle tinder, the bed cover caught flames when he accidentally shot it with his ancient weapon. While he sat barefoot around the fire, smirking, I heard the sound of running water that his wife, "Seo La May," was using to wash clothes that Phin tapped to save my life!

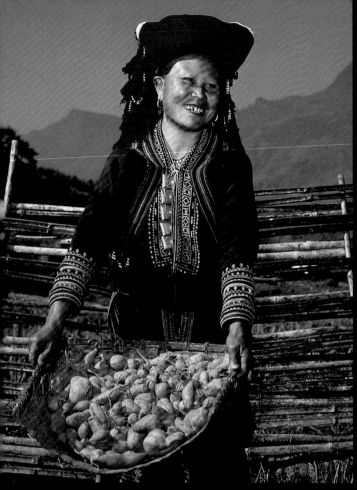

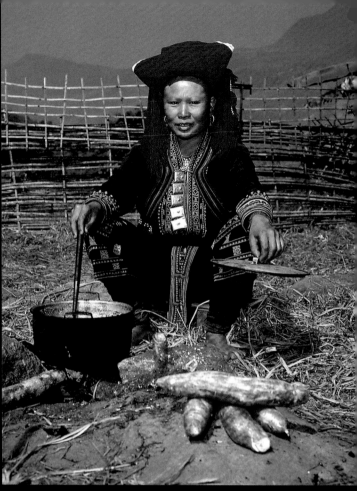

**The Red Zao grow a variety of vegetables**

**Seo La May cooking on an open fire**

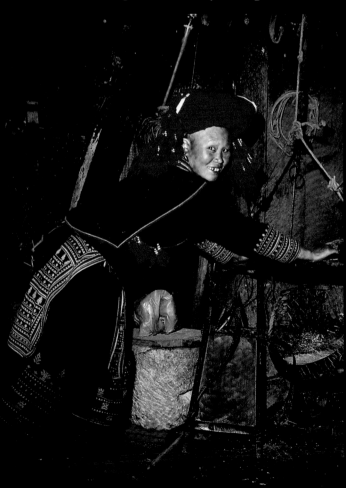

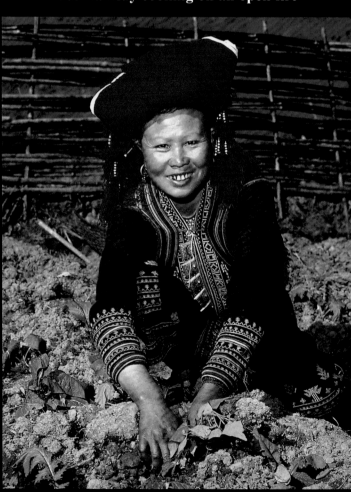

**May using a wood-crank rice pounder**

**The tribe is extremely proud of a successful harvest**

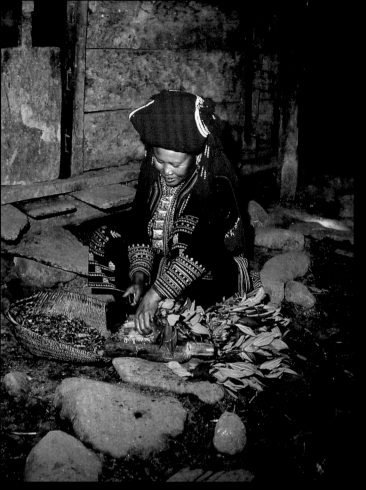

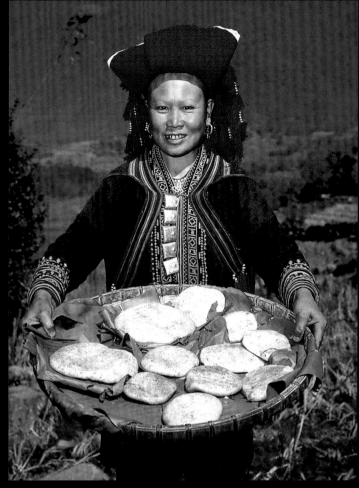

**Many Red Zao families only eat food they grow**

**Seo La May serving home-baked bread**

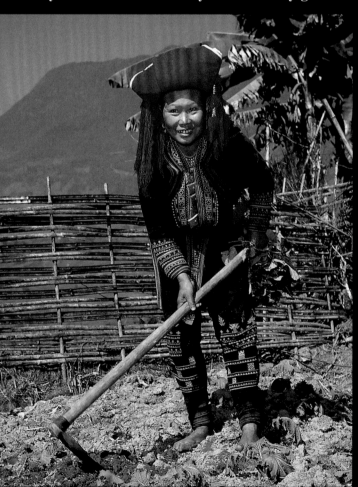

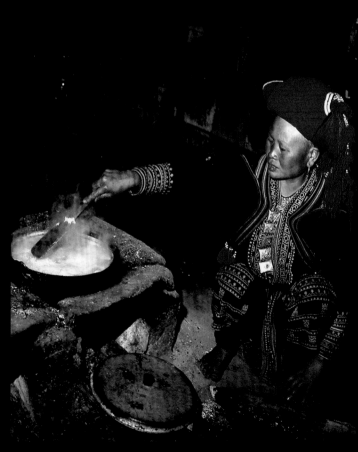

**Seo La May garden hoeing**

**Cooking rice on an indoor open-fire hearth**

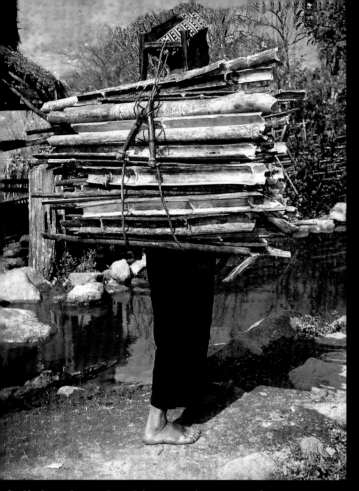

**Split bamboo plumbing carries water from streams**

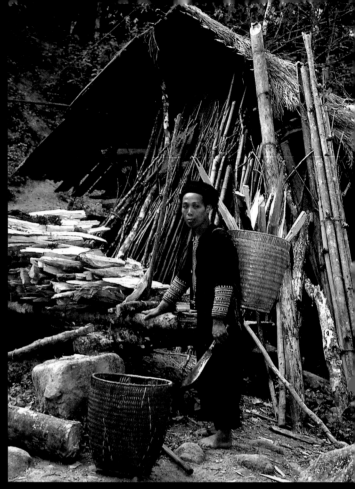

**Backpack baskets are used for carrying firewood**

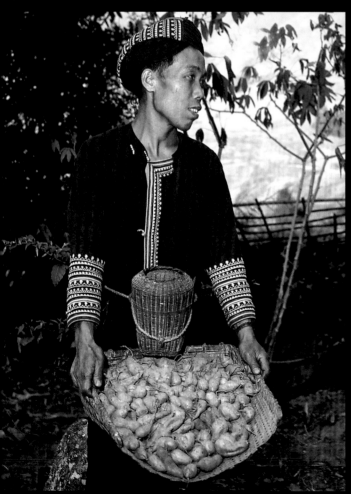

**Small baskets are used for collecting garden snails**

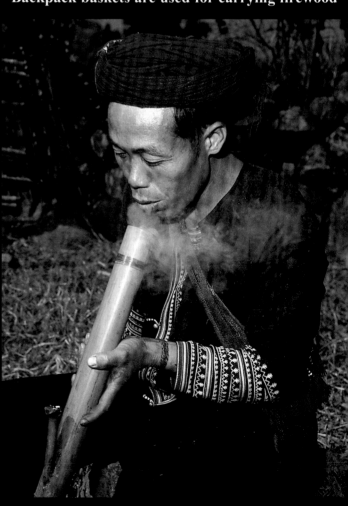

**The Hmong smoke bamboo "bong" pipes**

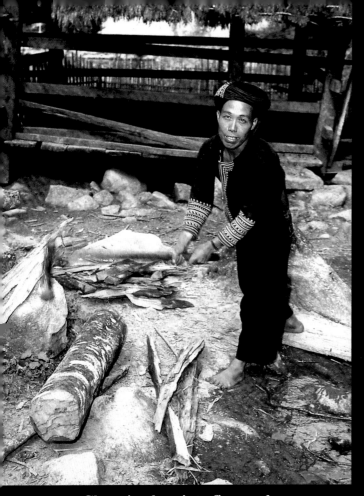

**Chopping logs into firewood**

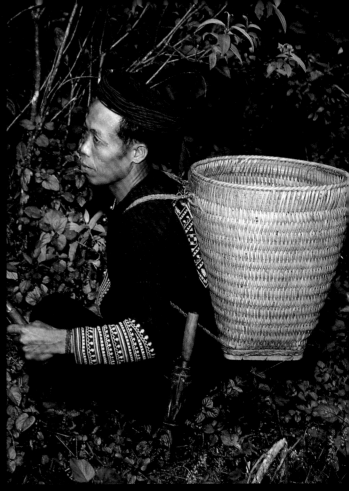

**Fan Rao Phin collecting kindling wood in the jungle**

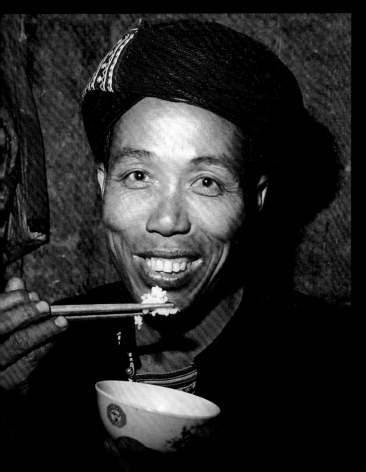

**The tribe's main staple is rice**

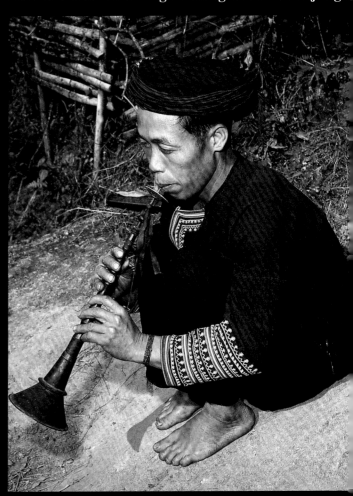

**Wood trumpets are played at religious rituals**

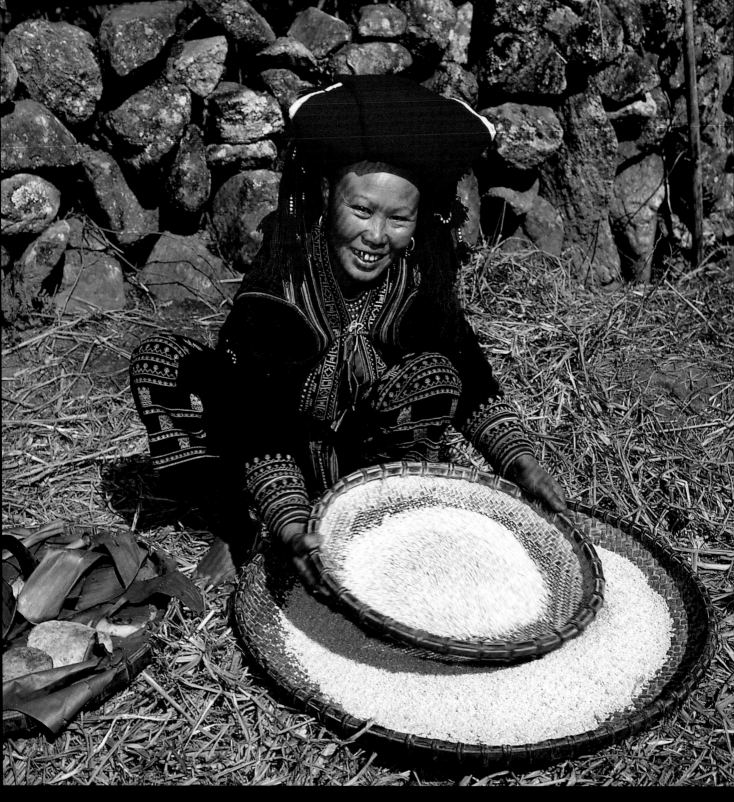

**Seo La May cleaning rice on two circular straw baskets without a thought for her fatal illness**

I was listless and lethargic, for three days after my near death experience, as I followed Phin and May around as they did their chores. May spent most of her time tending a garden and cooking our meals while Phin chopped wood that he collected from the surrounding jungle. In off hours, to pass time, we smoked bamboo "bongs" while playing traditional Zao music on old wooden trumpets. It seemed an ideal existence: exotic hosts going about their daily ritual of life but, I soon realized, what I envisioned as a paradigm was in fact, tragedy under a thin veneer of smiling pleasantries. "The women and infant are extremely sick," I was told by sympathetic neighbors when I wandered through the jungle looking for Phin's lost gunpowder horn. "They both have H.I.V." I skeptically questioned the outrageous accusation: "How is it possible for May and the child to be sick while the father; Phin, remains healthy?"

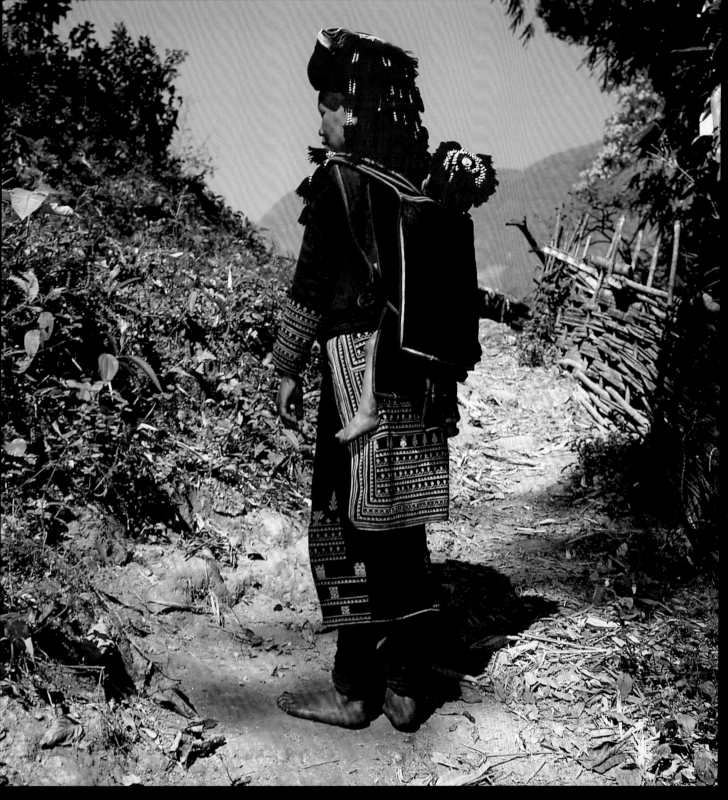

**Warm yellow sunlight enhancing the natural beauty of a Red Zao infant with her mother**

The answer was so astounding I could only accept it as truth: "Phin used plastic plunger, from a doctor's needle, to put his seed in May." The horrific explanation seemed possible, but not plausible! I struggled to confirm the truth, while I continued questioning that outrageous notion, until I was left with no choice but to admit, Phin is the biological father of the child but it is possible for him to have artificially self-inseminated May without receiving an H.I.V. scathing! I never mentioned what was breached in the jungle to another soul, though I question it to this very day. I have since found not a single conflicting explanation that makes sense as to why anyone would make such a wicked accusation if it were not true. I remain in doubt, but open minded! While remembering the cliche: Life is stranger than fiction, I wandered to the Red Zao market in Sapa pledging never to fall asleep again while smoking!

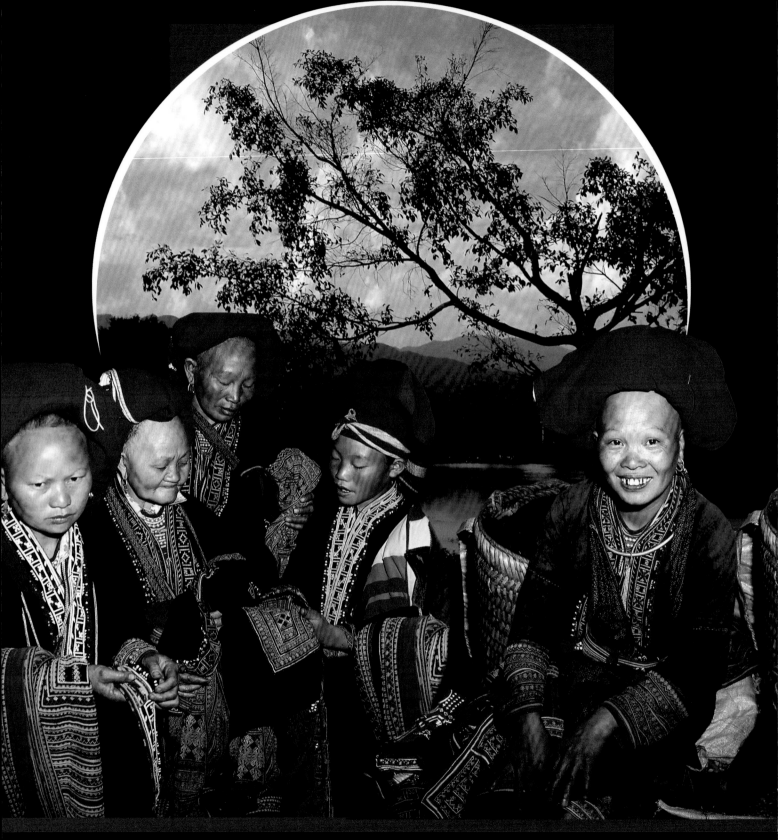

**The "Moi" Red Zao "savages" selling hand-embroidered textiles at the market in "Sapa:" Vietnam**

The "Mountain View Hotel" in Sapa, which overlooks the beautiful "Hoang Lien Son Valley," is where I first encountered the Red Zao tribe, who the mainstream "lowland" Vietnamese refer to as "Moi," or savages. Only blocks from that hotel, in a lively market, extremely fine embroidered textiles are made only by "savage" hands! Where gold teeth bite coin currency at sunset, females with shaved heads, covered in layers of red cloth, grin when hoping to make sales! A female Zao's display rivals only her hairless head while her backpack basket holds her most coveted possessions. "What the FUCK is going on? I already gave ya' the twenty bucks for the jacket! What ya' want now? I'm NOT gonna give ya MORE!" a Canadian tourist bellowed at the top of a voice that echoed off the cement walls in the trading hall. Tempers fray at the end of the day and this was no exception as the steamed tourist dug through

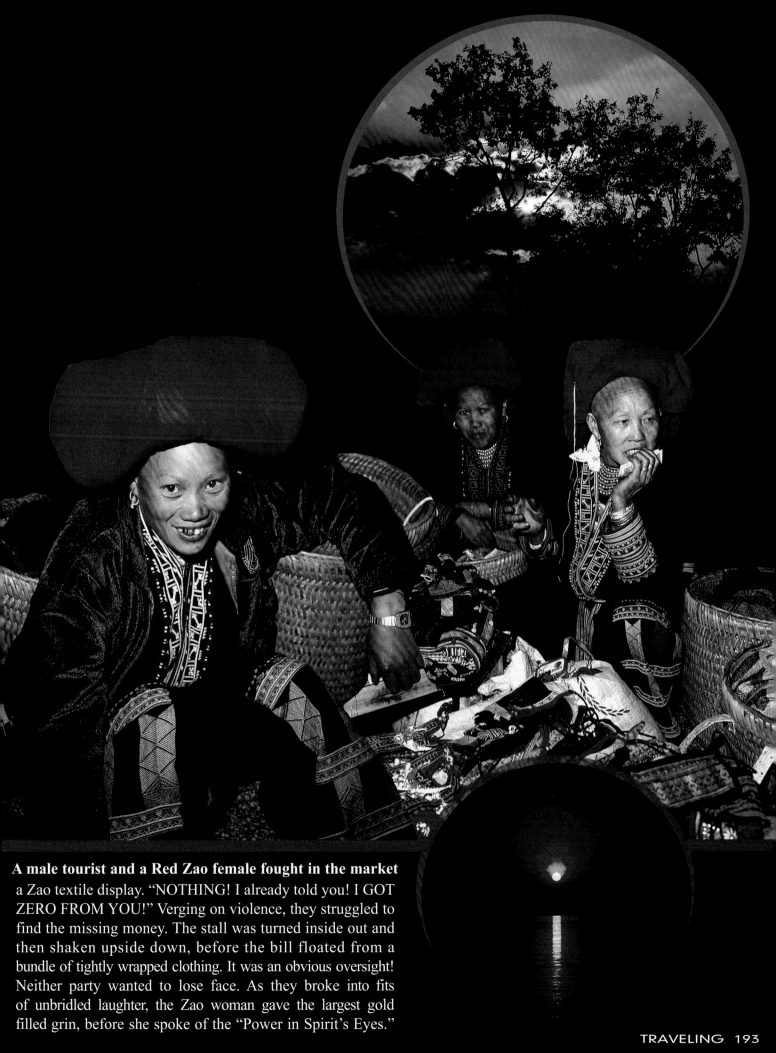

**A male tourist and a Red Zao female fought in the market** a Zao textile display. "NOTHING! I already told you! I GOT ZERO FROM YOU!" Verging on violence, they struggled to find the missing money. The stall was turned inside out and then shaken upside down, before the bill floated from a bundle of tightly wrapped clothing. It was an obvious oversight! Neither party wanted to lose face. As they broke into fits of unbridled laughter, the Zao woman gave the largest gold filled grin, before she spoke of the "Power in Spirit's Eyes."

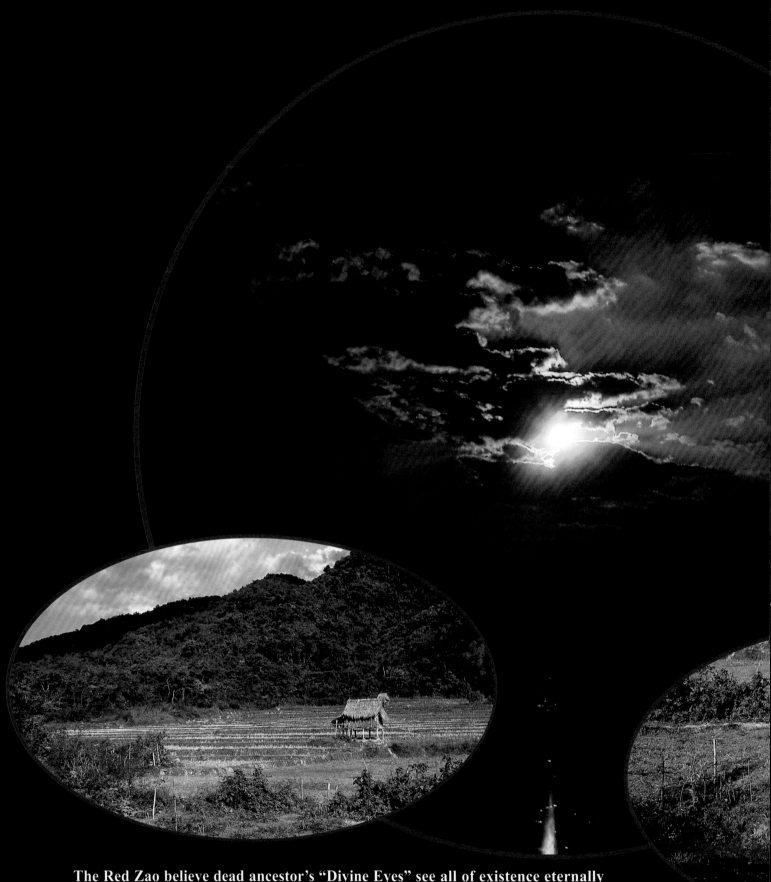

**The Red Zao believe dead ancestor's "Divine Eyes" see all of existence eternally**

When daylight faded into colorful clouds, I walked over rice terraces and paddies from the market back to see Phin, while that Red Zao female vendor introduced me to one of the tribe's concepts: "Divine Eyes" of deceased ancestors are forever omnipotent and omnipresent and see all existence eternally. In this world of enlightened bliss dead elders foretell living mediums the names of newborn infants during the "Hu Plig Tis Npe" ritual which is conducted thirty days after a child is born. This animal sacrifice is sponsored by family members for the entire Zao community but in a final ceremony, preformed when the infant is ten years old, the child is actually named. As a newborn soul is welcomed into existence the Spirit, "Niam Txiv Kab Yeeb," is thanked for granting life to the baby, the family, and the tribe.

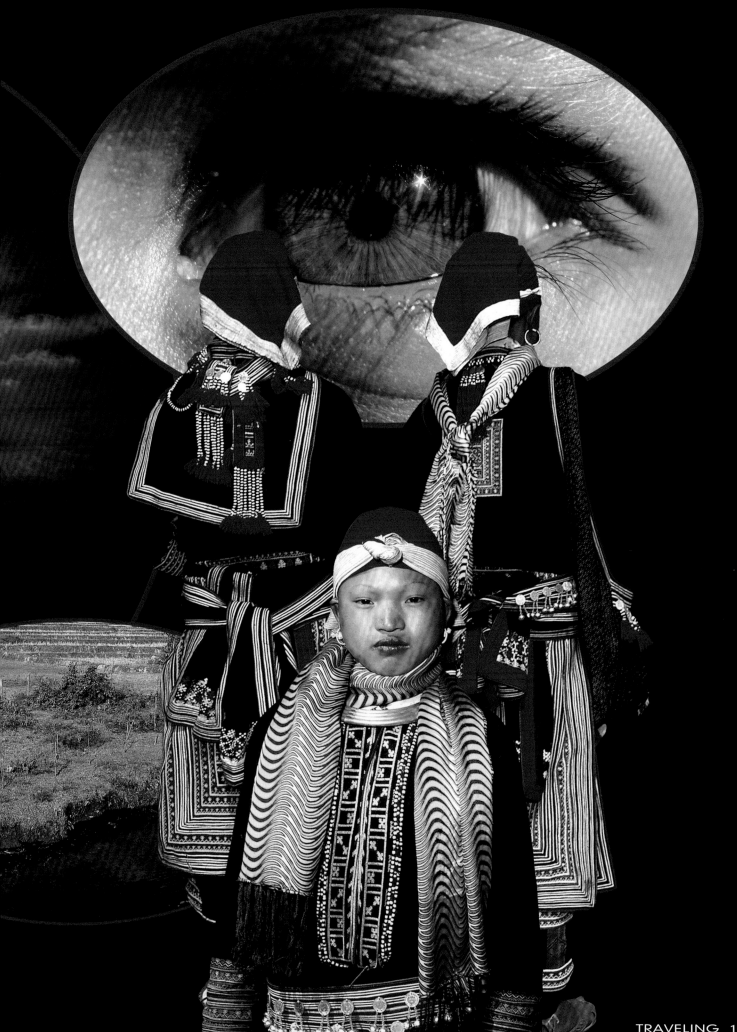

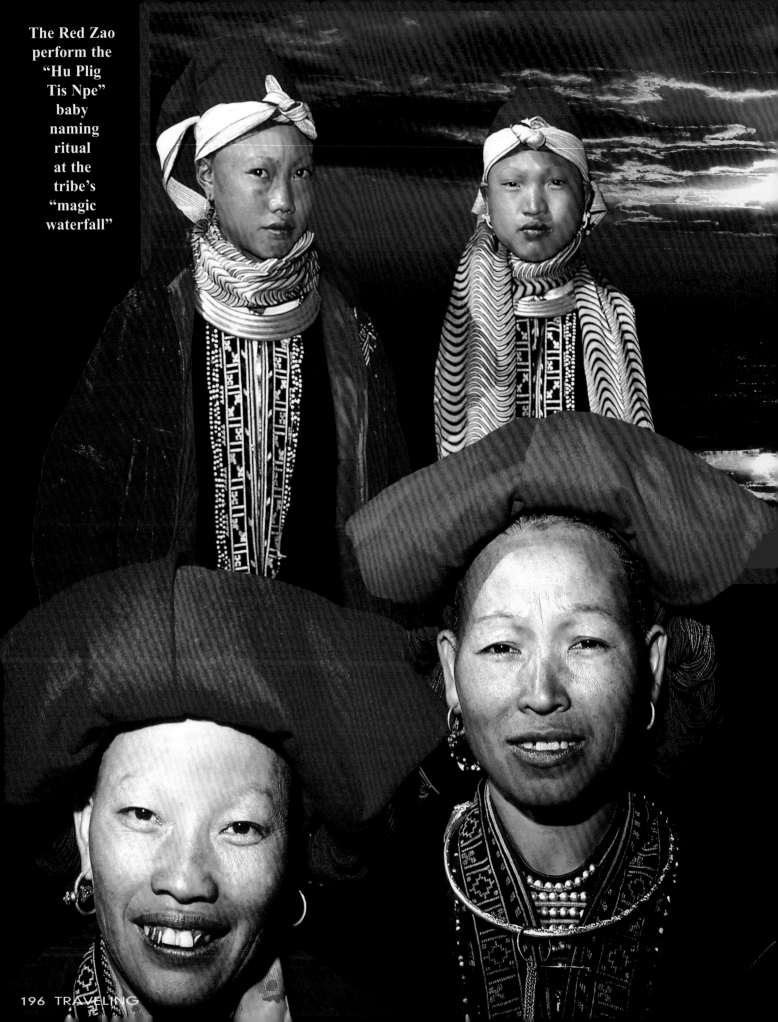

The Red Zao perform the "Hu Plig Tis Npe" baby naming ritual at the tribe's "magic waterfall"

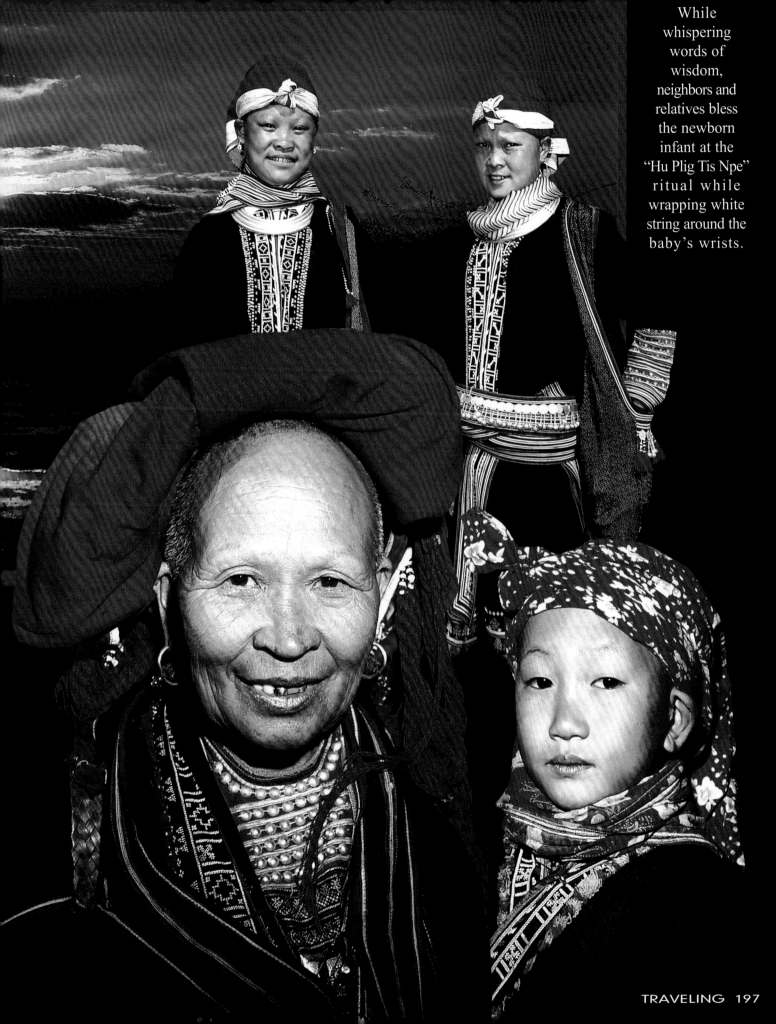

While whispering words of wisdom, neighbors and relatives bless the newborn infant at the "Hu Plig Tis Npe" ritual while wrapping white string around the baby's wrists.

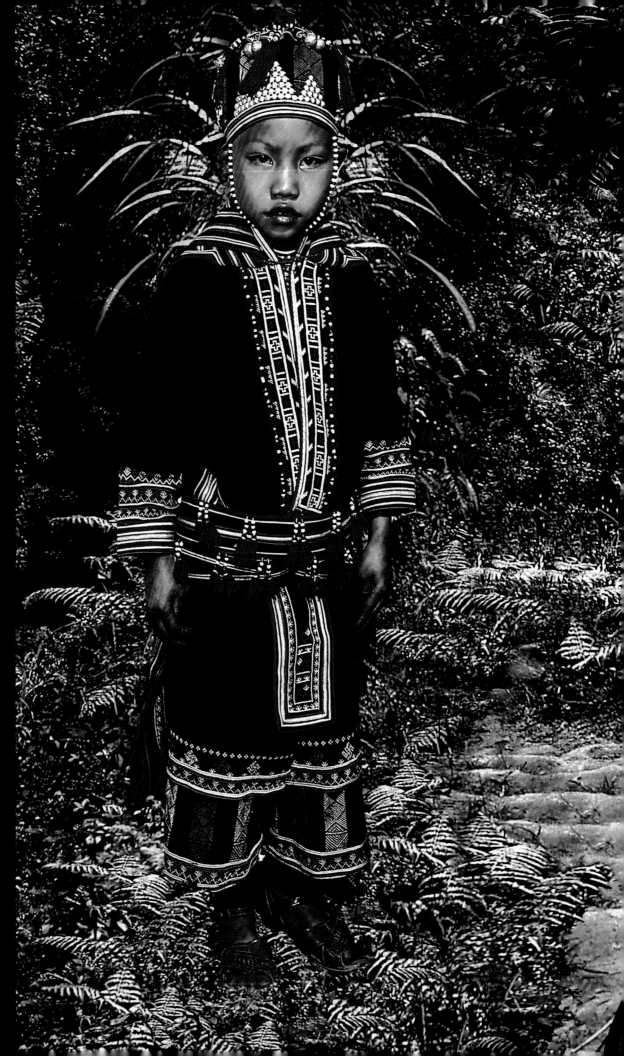

Although I never had the pleasure of attending a Zao "Hu Plig Tis Npe" birth ceremony I did have an opportunity to attend a ten year old girl's naming ritual. As the child dressed in the most extraordinarily decorated Red Zao beaded hat with extremely finely hammered silver coins, her double-wrapped meticulously embroidered waist sash dangled ten red tassels that were attached through ten multi-colored beads. An elder acted as a medium to contact dead ancestors who said the child should be named "Cheng," which is derived from the Red Zao word "tsheej," meaning; for sure or real! Perhaps her name suggested simple coincidental irony when, before the ritual that morning, the girl came up missing while five Red Zao females, unsure if she was lost or hiding, looked for the girl in the jungle's undergrowth near the ceremony's "magic waterfall!"

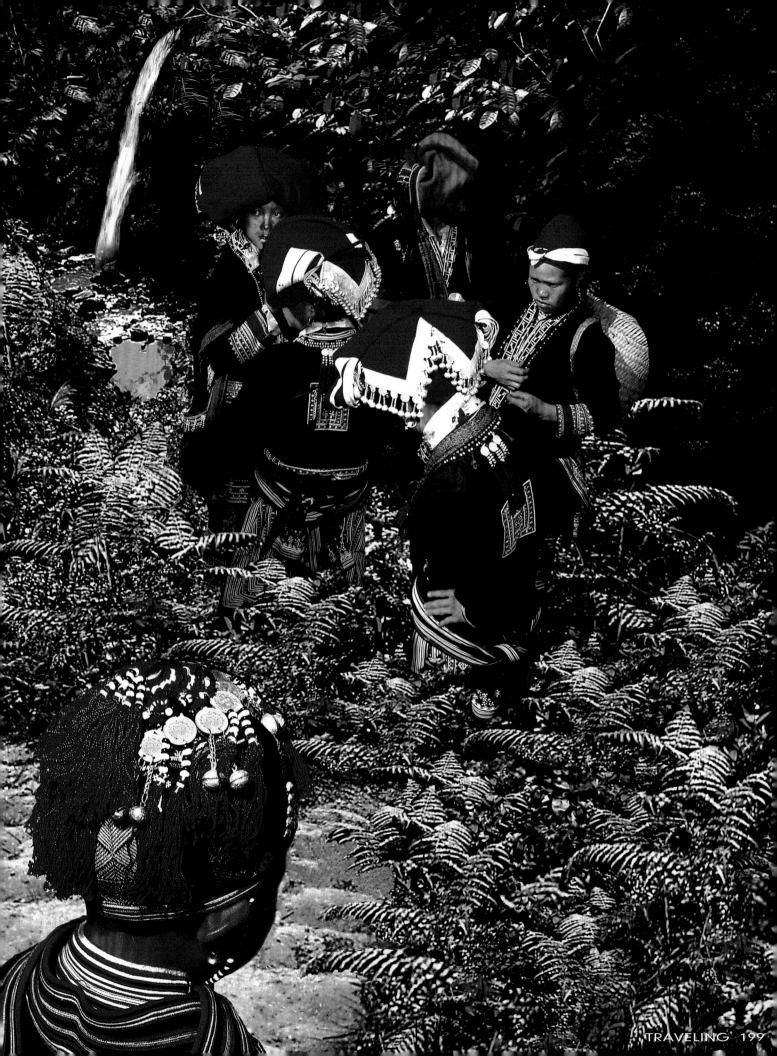

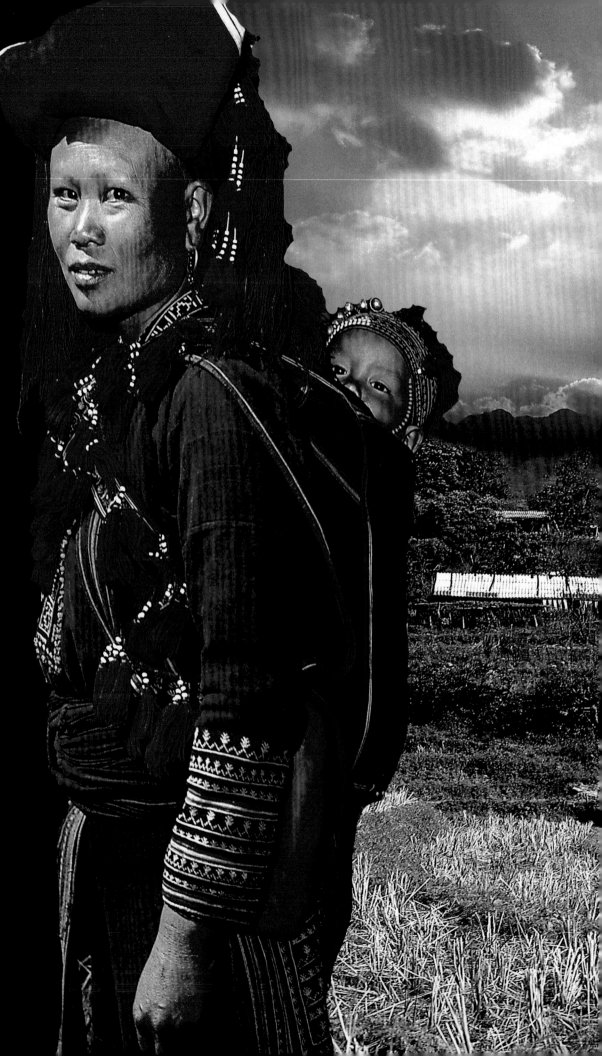

Fan Rao Phin and Seo La May both attended the Red Zao baby-naming ritual with their unnamed infant strapped on May's back. After waiting through a three-hour search the ceremony's centerpiece was finally found shyly hiding in jungle undergrowth. When the ritual was almost concluded, the child was forever dubbed "Cheng." The day waned as we celebrated in the sunset before we went back to Phin's village. While we walked through dry, spent farm land it grew dark before Phin requested a detour to examine a multitude of his spring loaded quarry traps. Perhaps we could look forward to a meal full of fresh meat? As day turned to night, disappointing examinations revealed six empty traps were sprung! Phin struggled, in darkness, to re-set the antiquated devices but when he carefully opened the last set of rusting jaws I knew the spring had slipped, after hearing metal scrapping metal, as the trap's brown teeth slit through his right thumb. When he walked away laughing I admired his innate ability to overcome the challenges to life that we had experienced together!

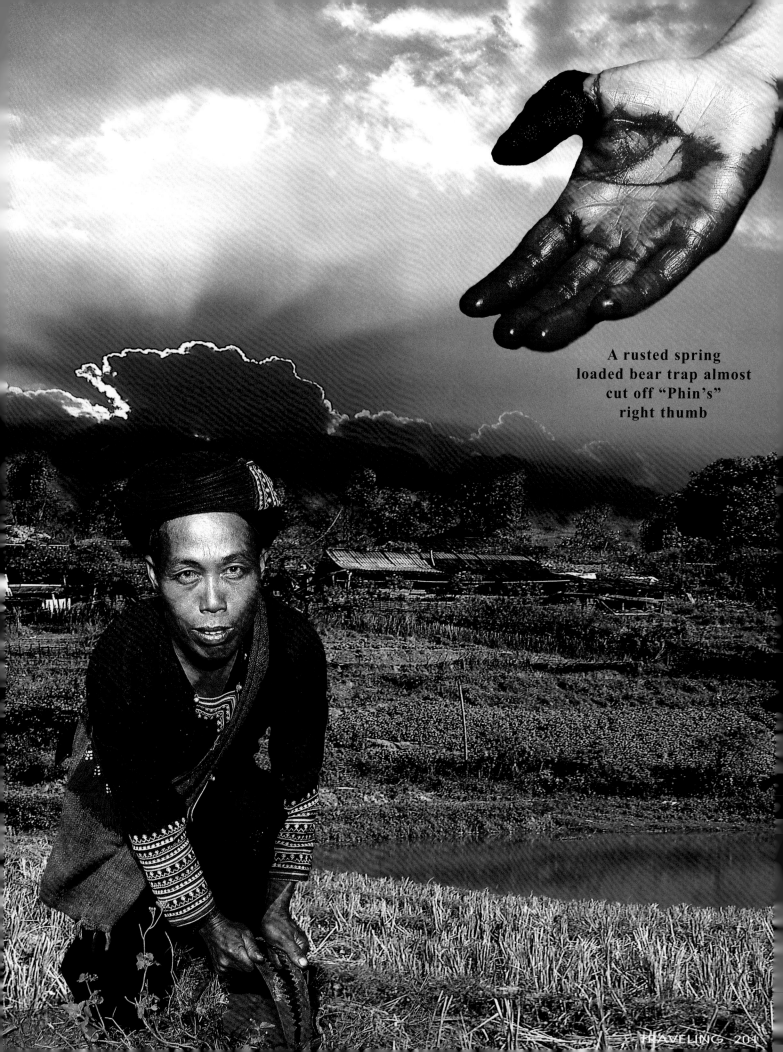

A rusted spring loaded bear trap almost cut off "Phin's" right thumb

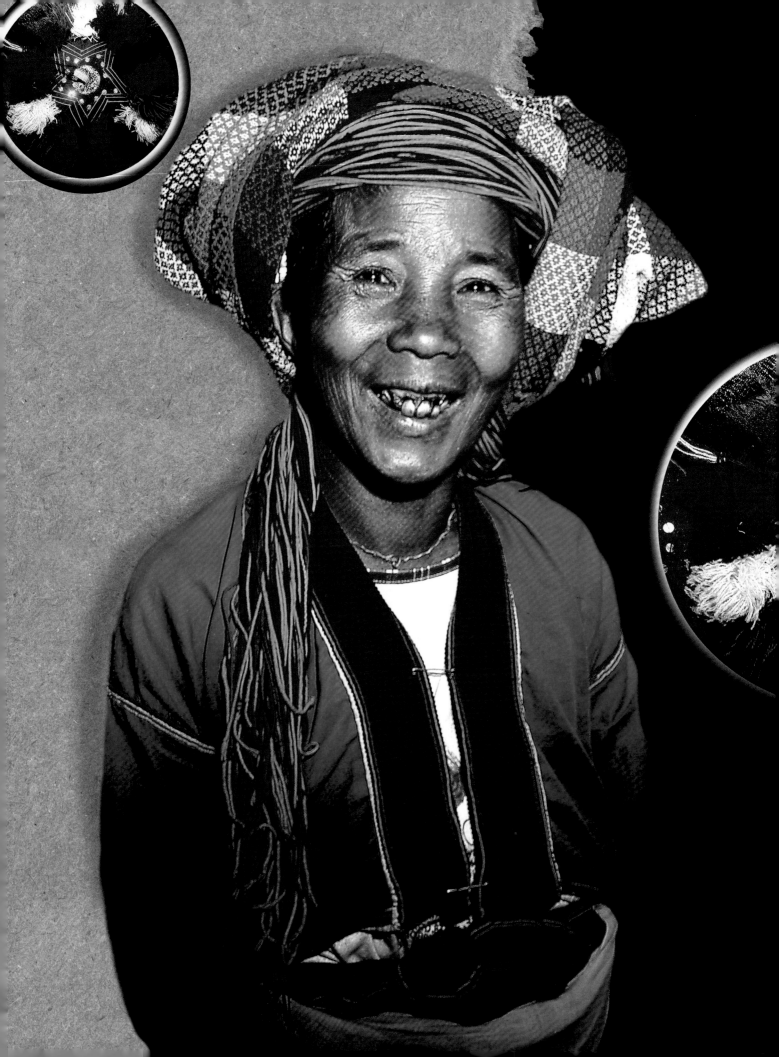

# PALAUNG

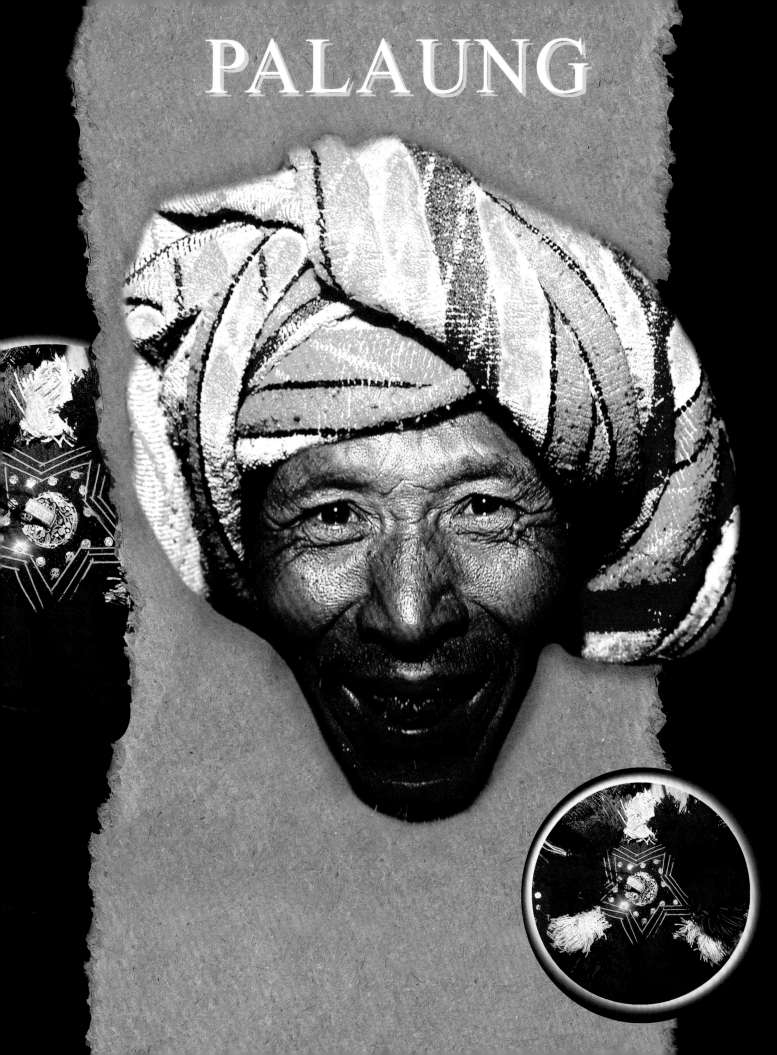

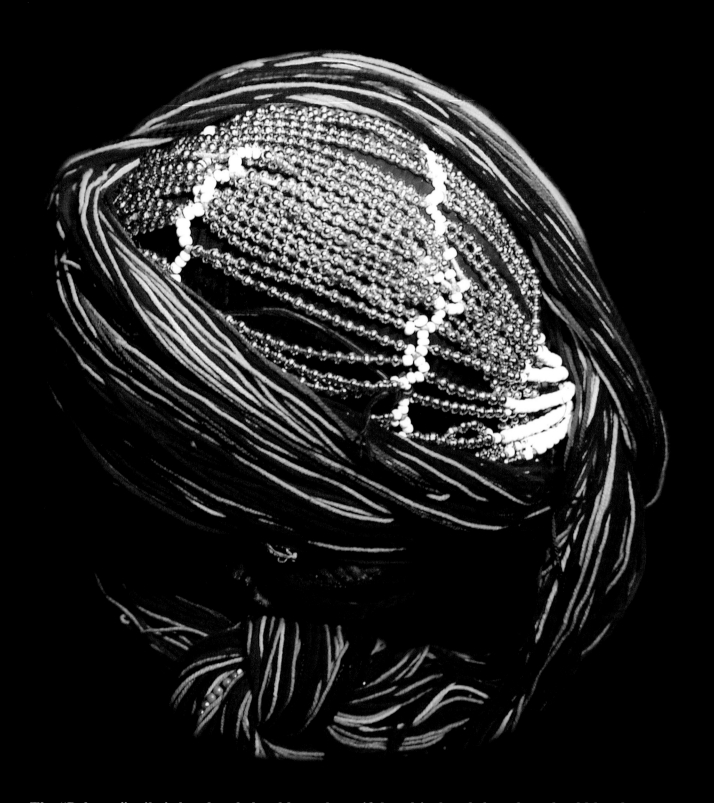

**The "Palaung" tribe's handmade headdress: beautiful multicolored threads and gold beads**

I left the remote mountains of North Vietnam, after surveying the hospitable Black Hmong, Red Zao, and Flower Hmong tribes. Certain of surely satisfying all desire for dog-meat soup in my lifetime, I reluctantly stepped onto a night flight from Hanoi to Rangoon Burma. When my sixteen-seater prop jet disappeared into a dark, starless, overcast sky I looked back on my unforgettable experiences with those three Vietnamese tribes. My heart pained as I tore myself from those truly gracious, primitive, and loving people. It was like leaving a lover when love ran the coarse, a mixture of remorse and satisfaction in knowing; after abandoning failed relationships new beginnings are just around the corner.

I was compelled to attend the Palaung tribe's full moon "Tabaung" bonfire ritual in the village, "Tar Yaw," after hearing an Englishman speak of the small Burmese town, "Kalaw." While eating a "special" airplane meal on a foldout tray table, "Alex" told extraordinary tales of a tribe, who venerate dead ancestors' skulls displayed on python snakeskin pedestals while wearing a headdress made of beautiful red threads and gold beads. Before the half empty jet touched down I found Alex to be as informative as he is trustworthy, and so agreed to split cab fare with him to downtown Rangoon. He spoke about this trip being his only chance to see the "strangest and most extraordinary sites on the planet" before being "chained to a desk" for the rest of his life. We arrived at our rickety three story walk up,

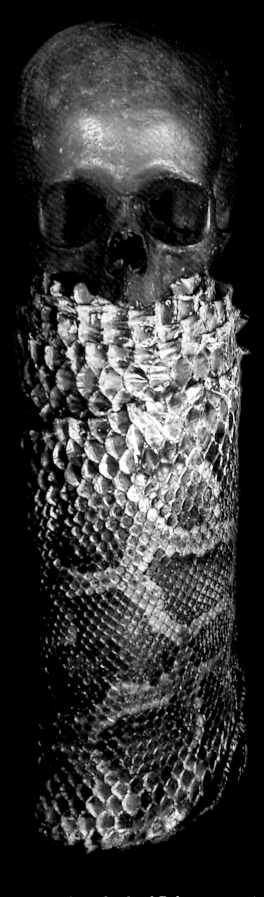

"Mahabandoola" guesthouse, that shakes each time a mac truck passes on the busy street below. We soon went our separate ways, but before leaving his sight forever, he reinforced my desire to investigate distant Palaung villages, when he suggested I look for venerated ancestor skulls and transvestite gay "Nat" mediums that surely could be found in and around Kalaw. A mixture of Buddhism and Animism, Nat worship is based in a religion practiced by the Palaung tribe that is similar to the Hmong, Zao, and Yao concepts and tribal beliefs but has two fundamental differences. The Nat shamans, once old women, have been replaced by androgynous gay men, who while considered neither male nor female, act as "Nat Kadaw," mediums between the living and a pantheon of thirty seven Nat Gods.

**Tribal veneration of a dead Palaung ancestor:**
**a human skull displayed on a python snakeskin pedestal**

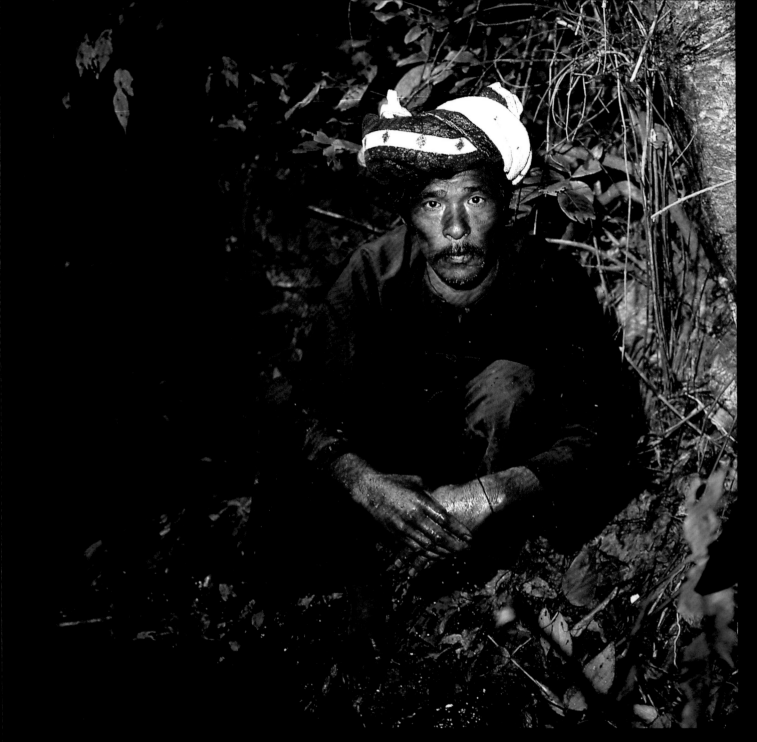

**"Kyan Nwane:" "headman" in the Palaung village: "Tar Yaw" washes his hands in a mountain stream**

When I checked into the dilapidated "Golden Kalaw" two-dollar-a-day guesthouse, the Burmese proprietor, "Eddie," greeted me with an inviting smile when I voiced a desire to locate the Palaung tribe: "Do ya' know anyone who can take me up the mountain to see the tribes?" Eddie was savvy, and while not wanting to tread on turf of more popular local Kalaw guides said, "I can take you trekking but I only go to one place. It's the Palaung village of "Tar Yaw." I know the "Headman, Kyan Nwane." He welcomes me, and my people, because I bring medicines and help em' with the village's water supply." I had only been in this small town, "Kalaw," for a few minutes, but was convinced: Eddie is my "man" for this "job," as I quickly replied, "All right! When can we leave?" The following morning, with unbearable midday heat dancing mirages on the horizon and Eddie's prompting, I headed up a narrow mountain dirt road. After we began the trek, Eddie sheepishly offered a small, recycled, half empty plastic water bottle that I gluttonously consumed before realizing I drank all the water we had. Hallucinations kicked in! After dehydration

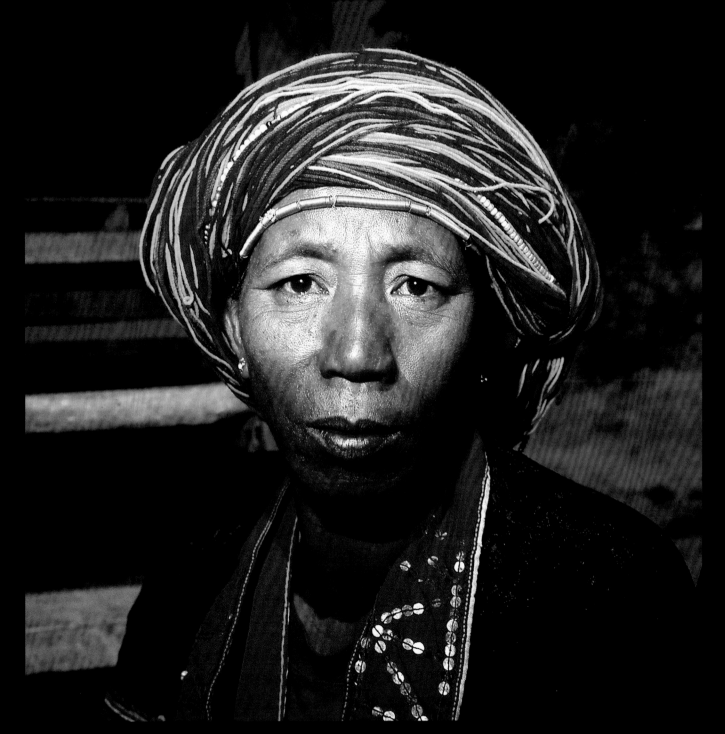

**The headman's wife: "Mahlahing" helped us after a young girl had an extremely bloody miscarriage**

took a toll I heard a "classic" 30's dump truck thump through the first of thousands of potholes. The sound was deafening each time it slammed into a poorly graded spot. The vehicle was not completely attached to its chaise, and when the truck hit holes the bed shook with such great force it produced a sound that made my ears ring. Eddie suggested we hop a ride up the mountain, in the back of the antique, after he saw I was too thirsty to enjoy the walk. I was delighted with the opportunity, particularly after I discovered an attractive young Burmese women already riding in the truck's bed. But it was necessary to stand and hold, over our heads, the canvas-covered aluminum framework, as the bumpy ride made it impossible to comfortably sit. With spread legs, and arms over head, our bodies contorted into "X" shapes! After crashing through countless potholes, the shaking unstable cargo bed triggered extraordinary adnominal pain in the young woman. She cried out when we stopped the truck, but it was too late. We looked down into a small crimson viscous pool between her legs, and saw what was once life, as she suffered through a dreadful, extremely bloody miscarriage

Tar Yaw is only an arid hillside spotted in gnarled, dying, almost barren shrubs and a few rice terraces. The village's "longhouse," build at an angle on a steep mountain ledge, houses more than fifteen families, where no plant lives on dry, brown, infertile earth. "Eddie, Eddie! Hello! Hello! Hello! HI EDDIE!" the wife of the headman, "Mahlahing," hollered from across a steep revine that separated us from the sloped entrance to Tar Yaw. "Can ya' gimme' water? We're thirsty from climbin' the mountain. My friend drank all our water 'bout three hours ago!" Eddie screamed over constant calls of circling birds. While seeing red threads and gold beads I remembered Alex mentioning the existence of this Palaung-styled headdress. After Mahlahing gave us more than water, she fried unrecognizable vegetables on a hearth in her hut's wood floor. While eating rice and vegetables with hands from Chinese bowls we praised her. When Mahlahing served the simple, but nutritious, meal I realized: Eddie provided only water, since dawn, and that was just a few ounces at best!

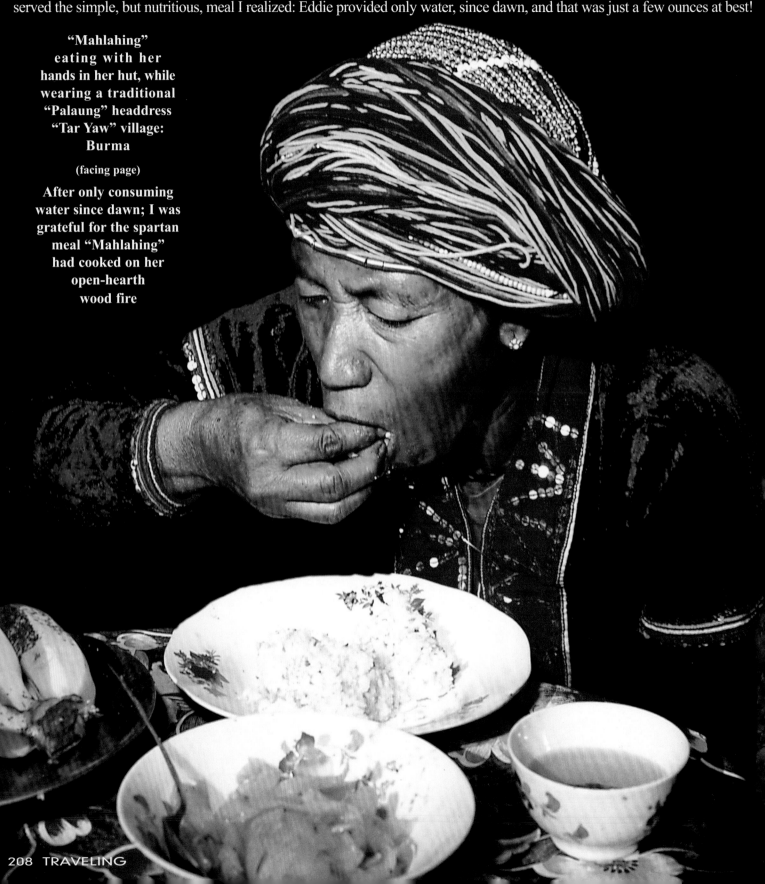

**"Mahlahing" eating with her hands in her hut, while wearing a traditional "Palaung" headdress "Tar Yaw" village: Burma**

(facing page)

After only consuming water since dawn; I was grateful for the spartan meal "Mahlahing" had cooked on her open-hearth wood fire

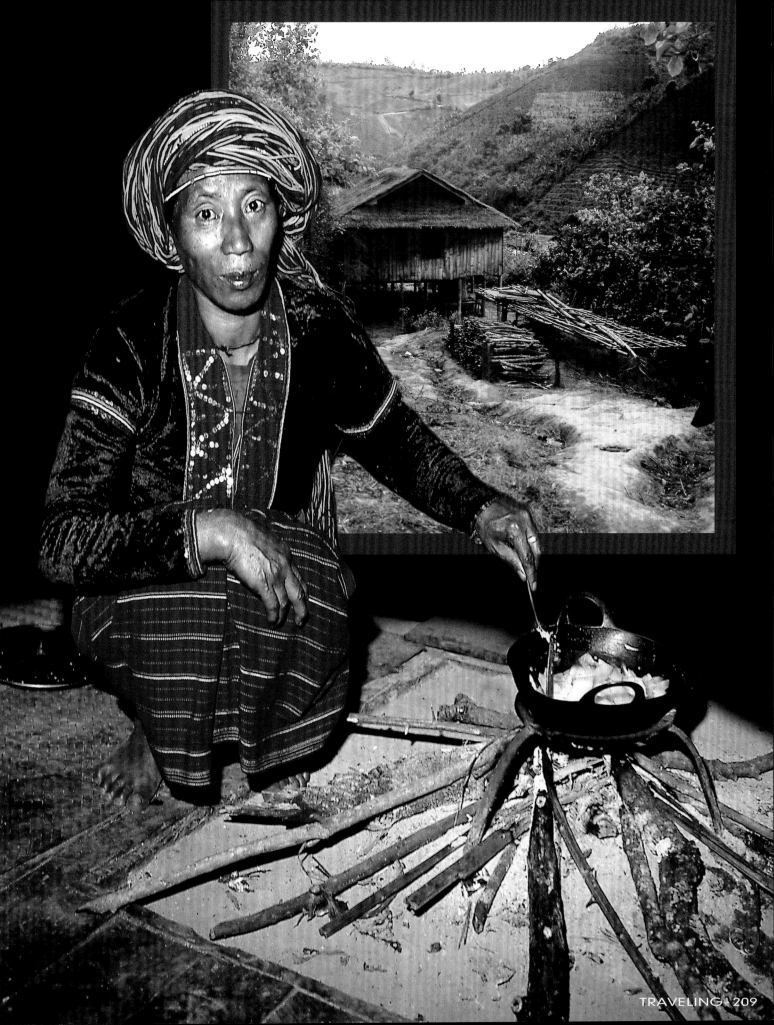

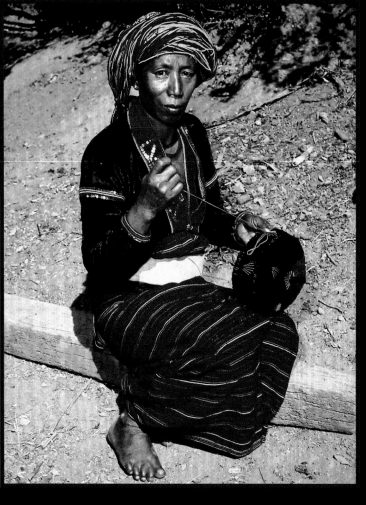
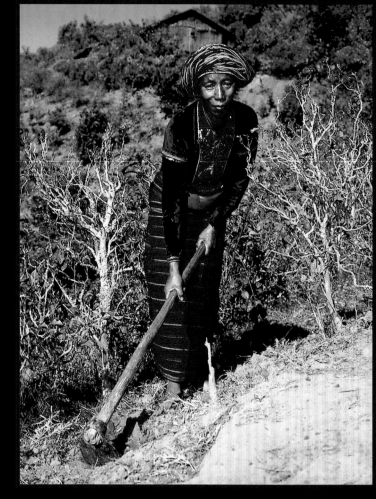
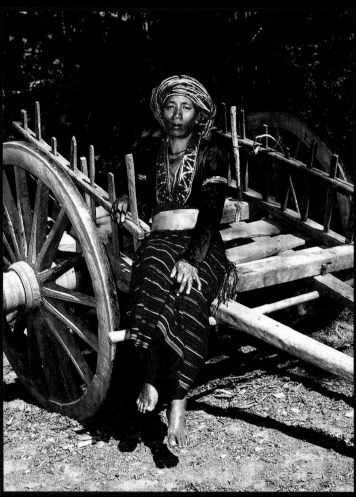
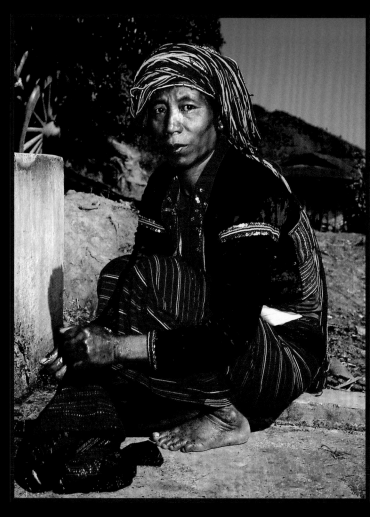

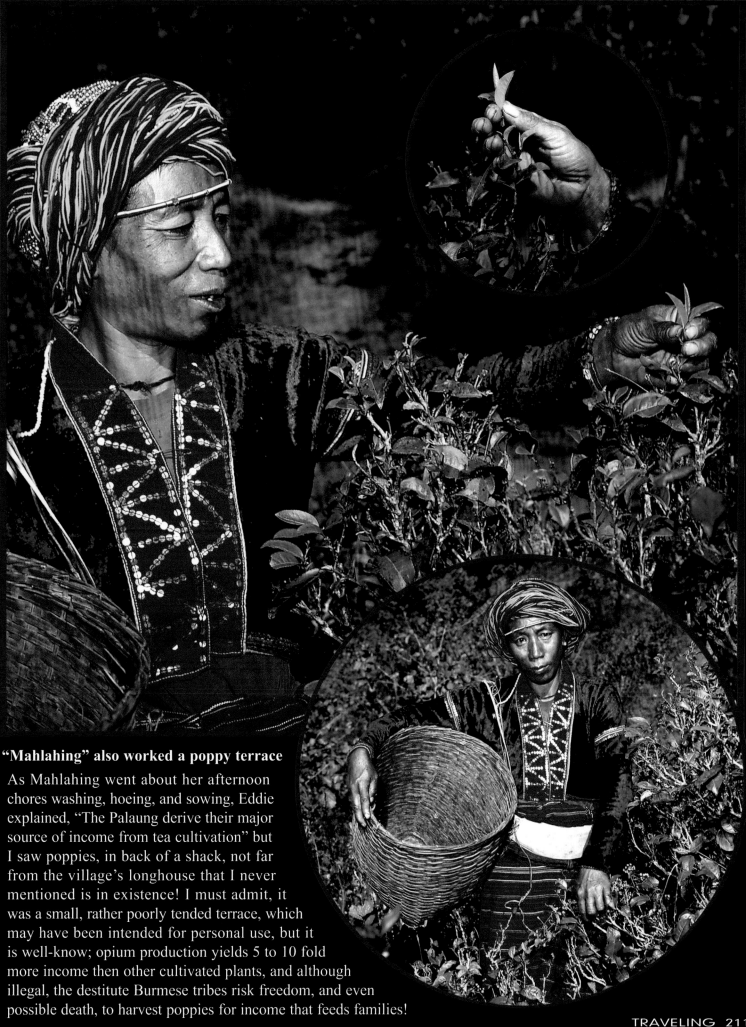

## "Mahlahing" also worked a poppy terrace

As Mahlahing went about her afternoon chores washing, hoeing, and sowing, Eddie explained, "The Palaung derive their major source of income from tea cultivation" but I saw poppies, in back of a shack, not far from the village's longhouse that I never mentioned is in existence! I must admit, it was a small, rather poorly tended terrace, which may have been intended for personal use, but it is well-know; opium production yields 5 to 10 fold more income then other cultivated plants, and although illegal, the destitute Burmese tribes risk freedom, and even possible death, to harvest poppies for income that feeds families!

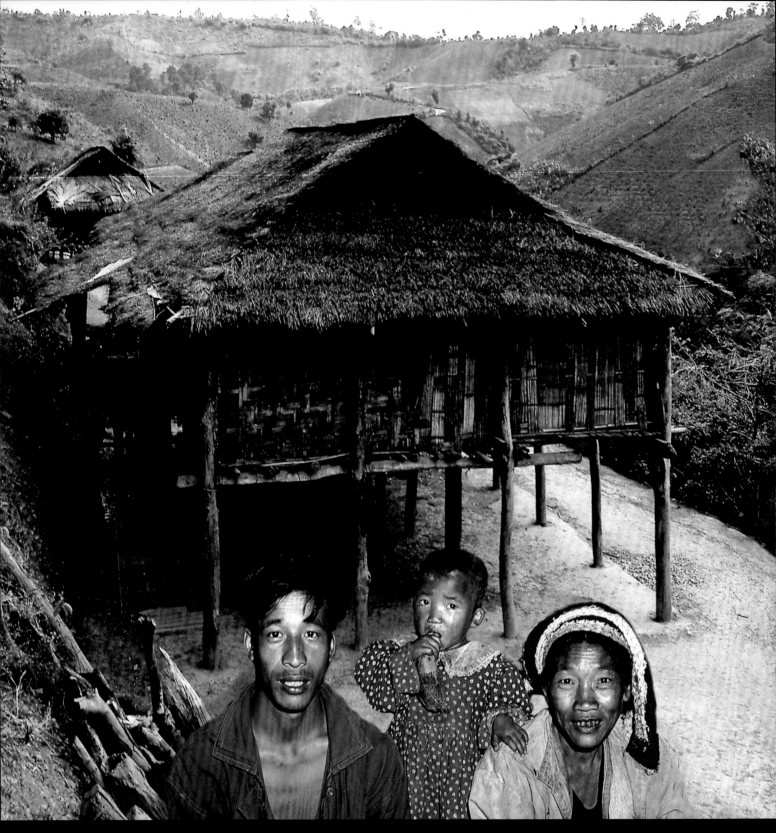

**"Witches" whisper ancient "folk tales" of lost civilizations, caves full of treasures, and a huge "Golden Egg!"**

I stopped looking for transvestite and gay Nat mediums when I wandered from Mahlahing's longhouse to a neighbor's hut, where I was told, by a family of four, "Nat shamans only appear near Tar Yaw village during Palaung festivals." After losing all hope of seeing those respected "gender-less" priests of the Burmese religion, "Nat Worship," I was invited into that informative family's shack, where a young girl, with a shaved head, ate a green banana. While chewing beetle nut with rotting teeth, the child's grandmother spoke of spectacular Burmese sites: "Bagan," "Inle," "Pindaya" and "Kyaikto" that she had visited with her now deceased father. I recognize fantastic subjective stories, clouded by selective memory when I hear them, but her tall tales rang true with sincere innocent intent as the old witch described ancient temples, caves full of Buddha statues, and a huge "Golden Egg," impossibly balanced on a cliff!

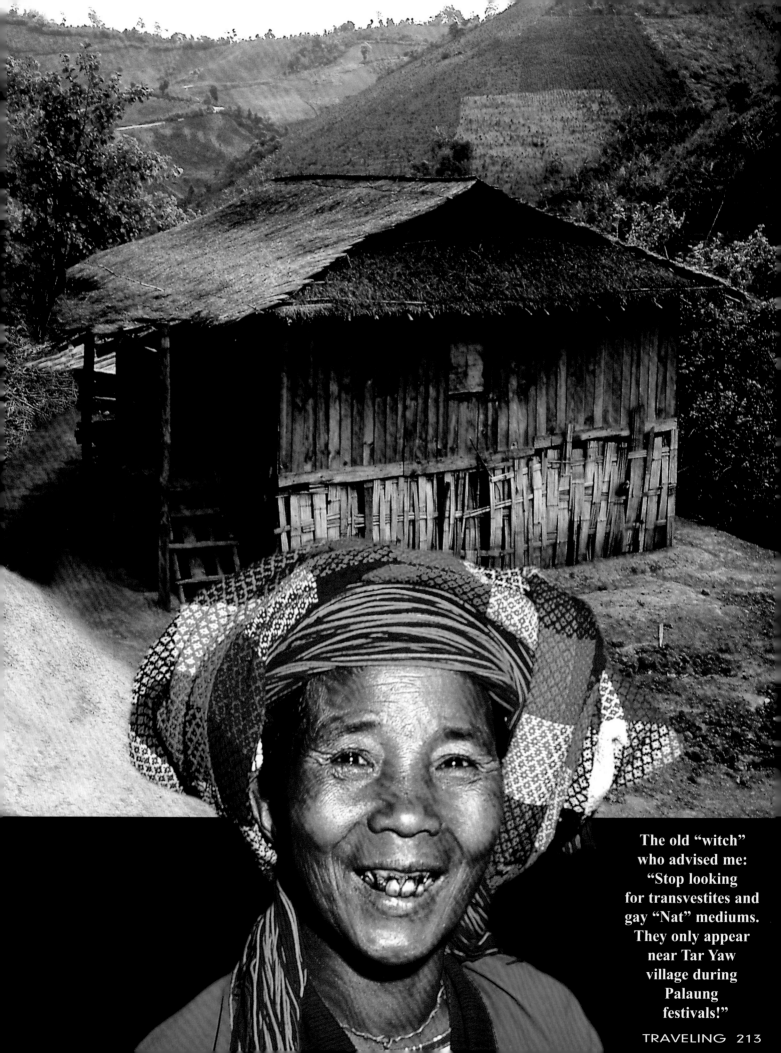

The old "witch" who advised me: "Stop looking for transvestites and gay "Nat" mediums. They only appear near Tar Yaw village during Palaung festivals!"

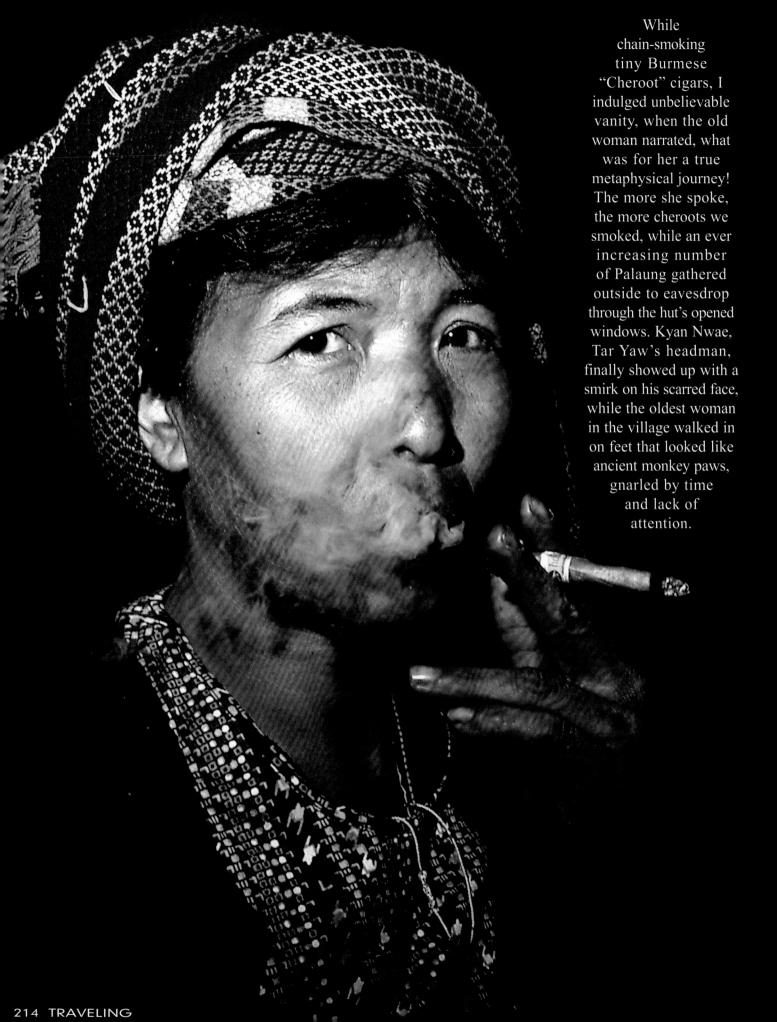

While chain-smoking tiny Burmese "Cheroot" cigars, I indulged unbelievable vanity, when the old woman narrated, what was for her a true metaphysical journey! The more she spoke, the more cheroots we smoked, while an ever increasing number of Palaung gathered outside to eavesdrop through the hut's opened windows. Kyan Nwae, Tar Yaw's headman, finally showed up with a smirk on his scarred face, while the oldest woman in the village walked in on feet that looked like ancient monkey paws, gnarled by time and lack of attention.

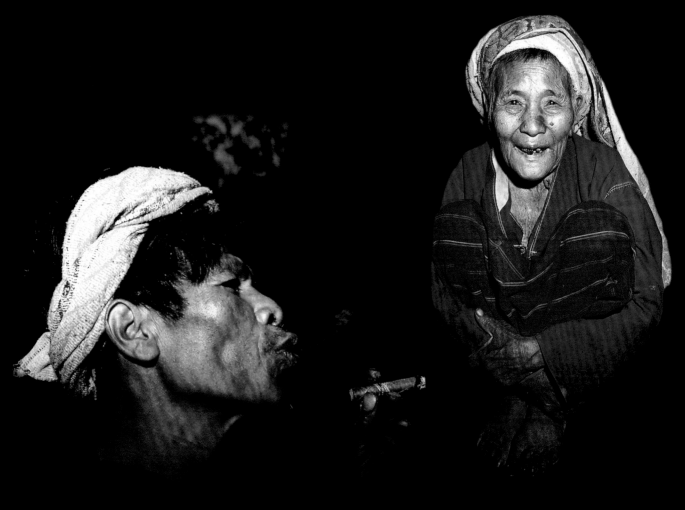

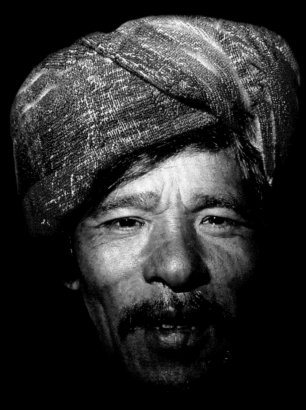

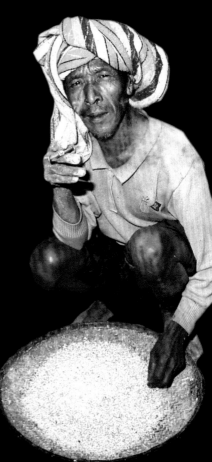

While chain-smoking small Burmese "Cheroot" cigars "wizards" spun mythic tales of metaphysical journeys to "Bagan," "Pindaya," "Inle," and "Kyaikto," where caves, temples, treasures, and an enormous "Golden Egg" could be found!

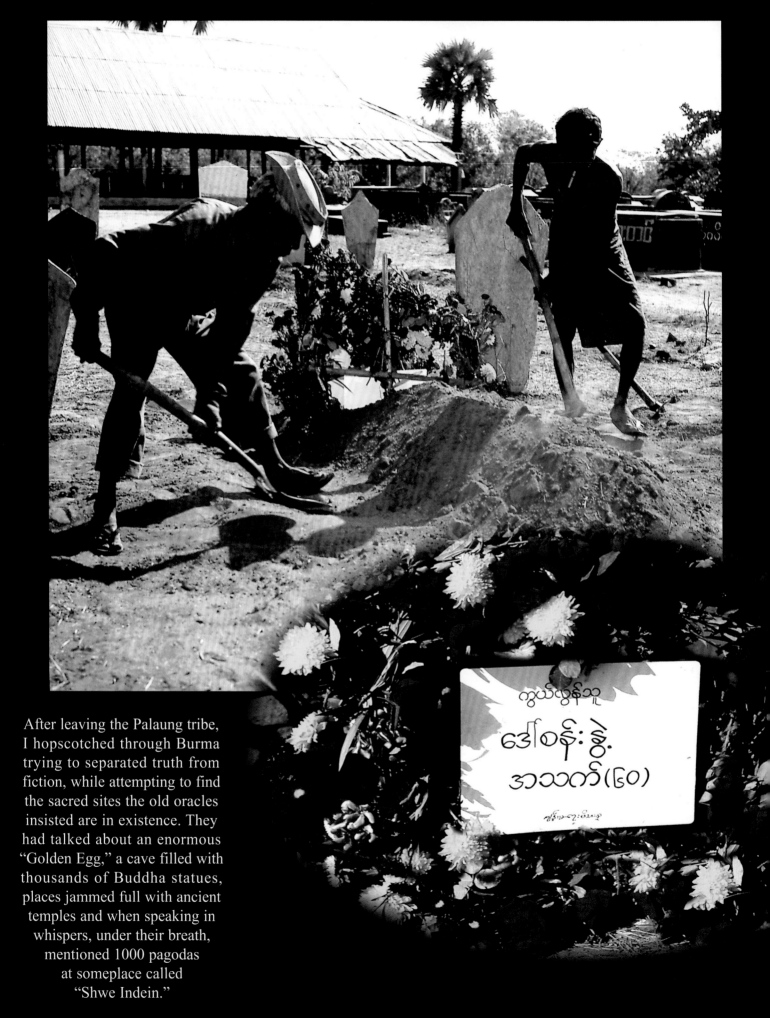

After leaving the Palaung tribe, I hopscotched through Burma trying to separated truth from fiction, while attempting to find the sacred sites the old oracles insisted are in existence. They had talked about an enormous "Golden Egg," a cave filled with thousands of Buddha statues, places jammed full with ancient temples and when speaking in whispers, under their breath, mentioned 1000 pagodas at someplace called "Shwe Indein."

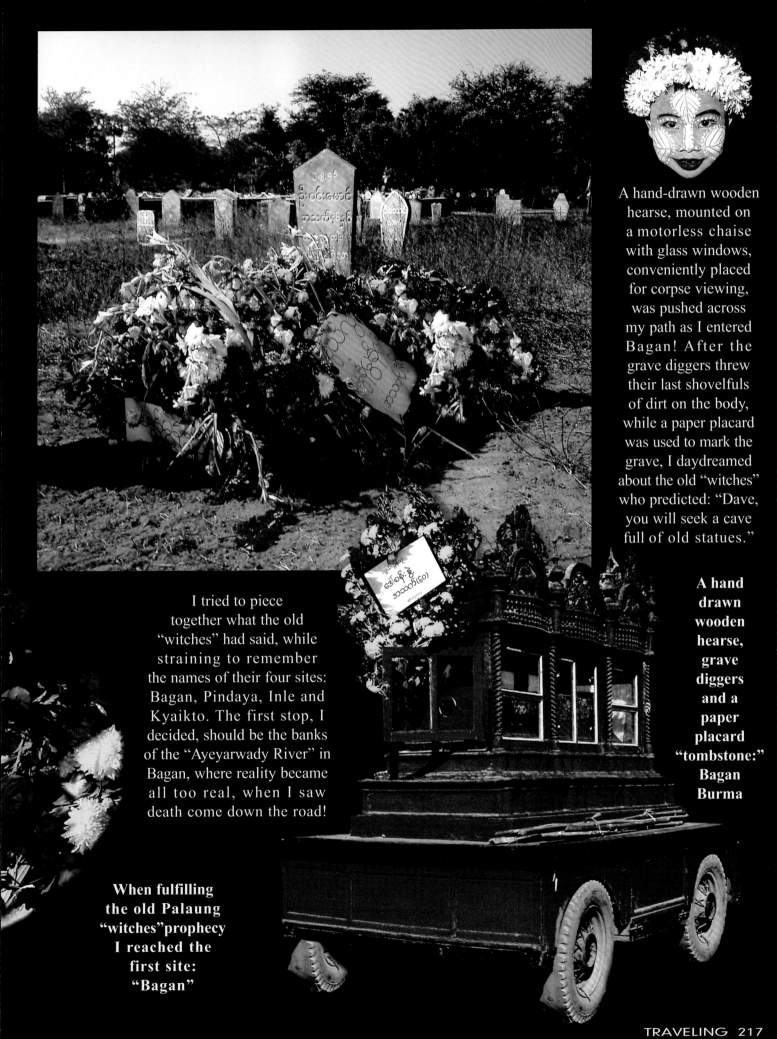

A hand-drawn wooden hearse, mounted on a motorless chaise with glass windows, conveniently placed for corpse viewing, was pushed across my path as I entered Bagan! After the grave diggers threw their last shovelfuls of dirt on the body, while a paper placard was used to mark the grave, I daydreamed about the old "witches" who predicted: "Dave, you will seek a cave full of old statues."

**A hand drawn wooden hearse, grave diggers and a paper placard "tombstone:" Bagan Burma**

I tried to piece together what the old "witches" had said, while straining to remember the names of their four sites: Bagan, Pindaya, Inle and Kyaikto. The first stop, I decided, should be the banks of the "Ayeyarwady River" in Bagan, where reality became all too real, when I saw death come down the road!

**When fulfilling the old Palaung "witches"prophecy I reached the first site: "Bagan"**

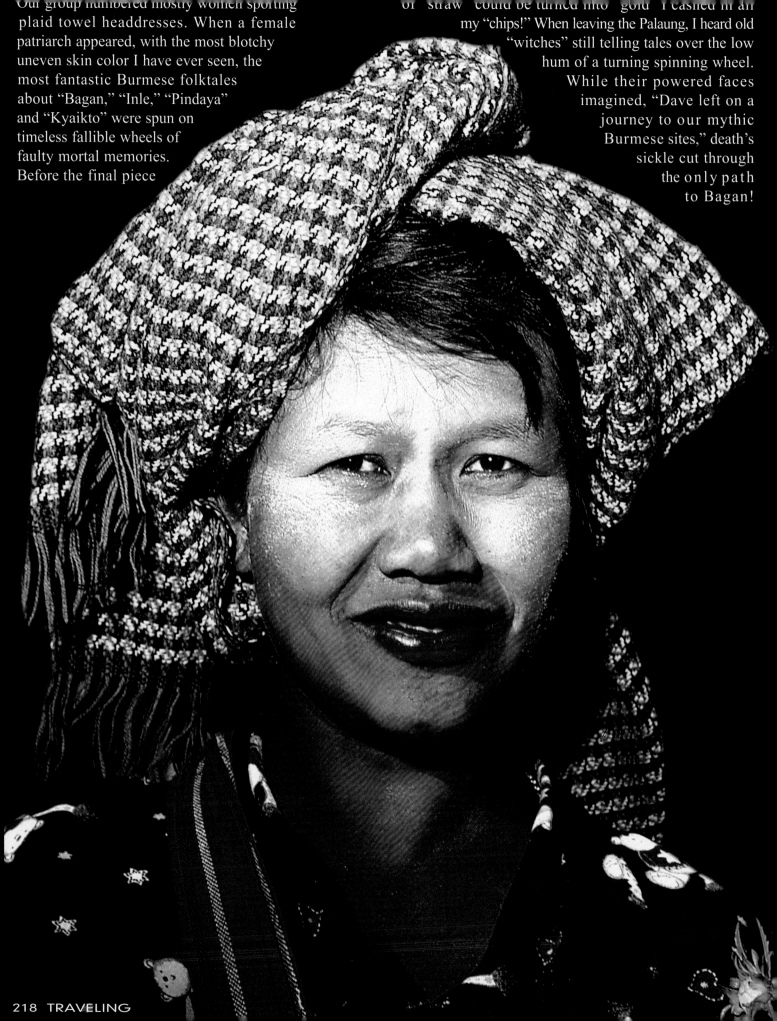

Our group numbered mostly women sporting plaid towel headdresses. When a female patriarch appeared, with the most blotchy uneven skin color I have ever seen, the most fantastic Burmese folktales about "Bagan," "Inle," "Pindaya" and "Kyaikto" were spun on timeless fallible wheels of faulty mortal memories. Before the final piece

of "straw" could be turned into "gold" I cashed in all my "chips!" When leaving the Palaung, I heard old "witches" still telling tales over the low hum of a turning spinning wheel. While their powered faces imagined, "Dave left on a journey to our mythic Burmese sites," death's sickle cut through the only path to Bagan!

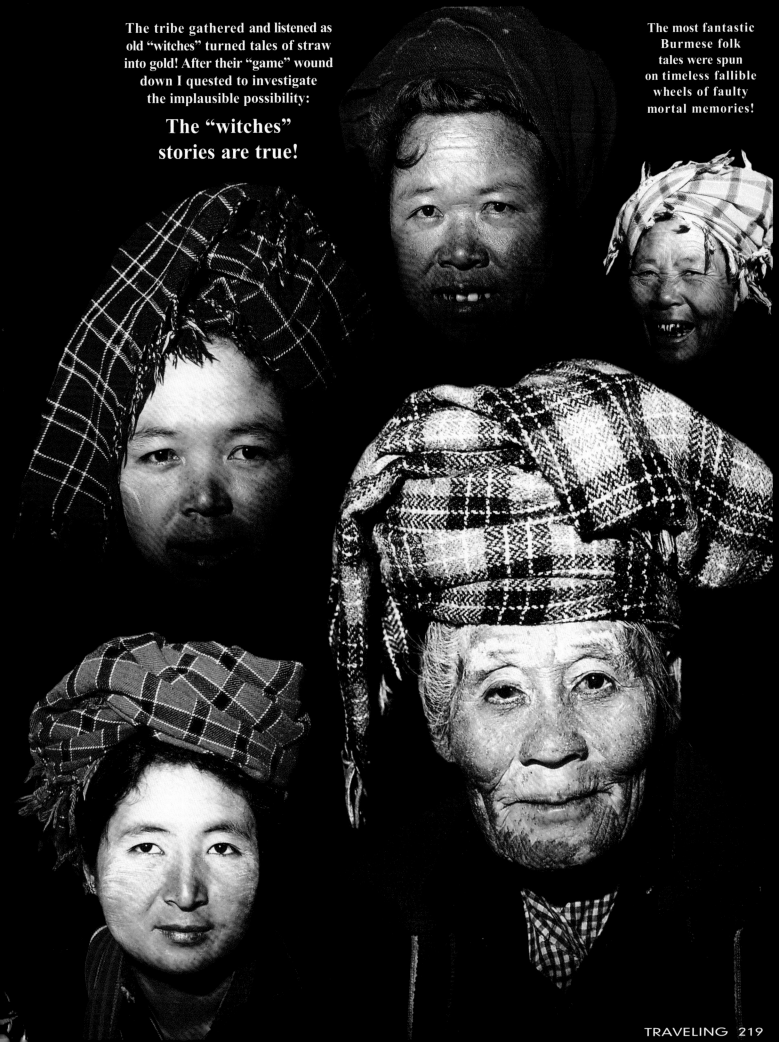

The tribe gathered and listened as old "witches" turned tales of straw into gold! After their "game" wound down I quested to investigate the implausible possibility:

**The "witches" stories are true!**

The most fantastic Burmese folk tales were spun on timeless fallible wheels of faulty mortal memories!

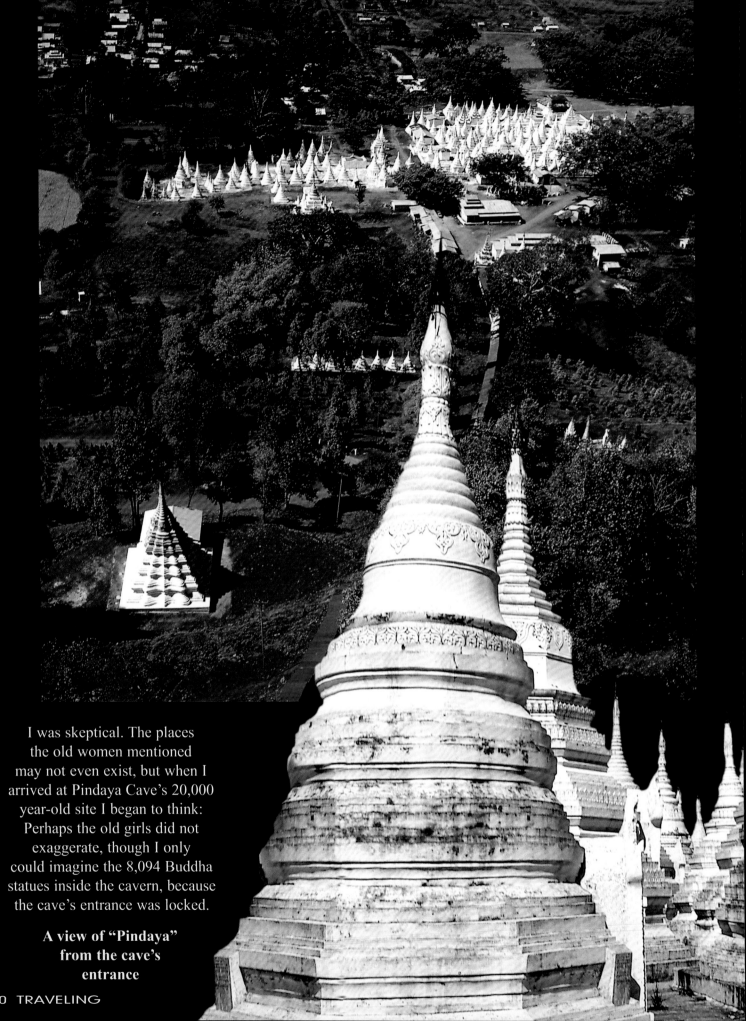

I was skeptical. The places the old women mentioned may not even exist, but when I arrived at Pindaya Cave's 20,000 year-old site I began to think: Perhaps the old girls did not exaggerate, though I only could imagine the 8,094 Buddha statues inside the cavern, because the cave's entrance was locked.

**A view of "Pindaya" from the cave's entrance**

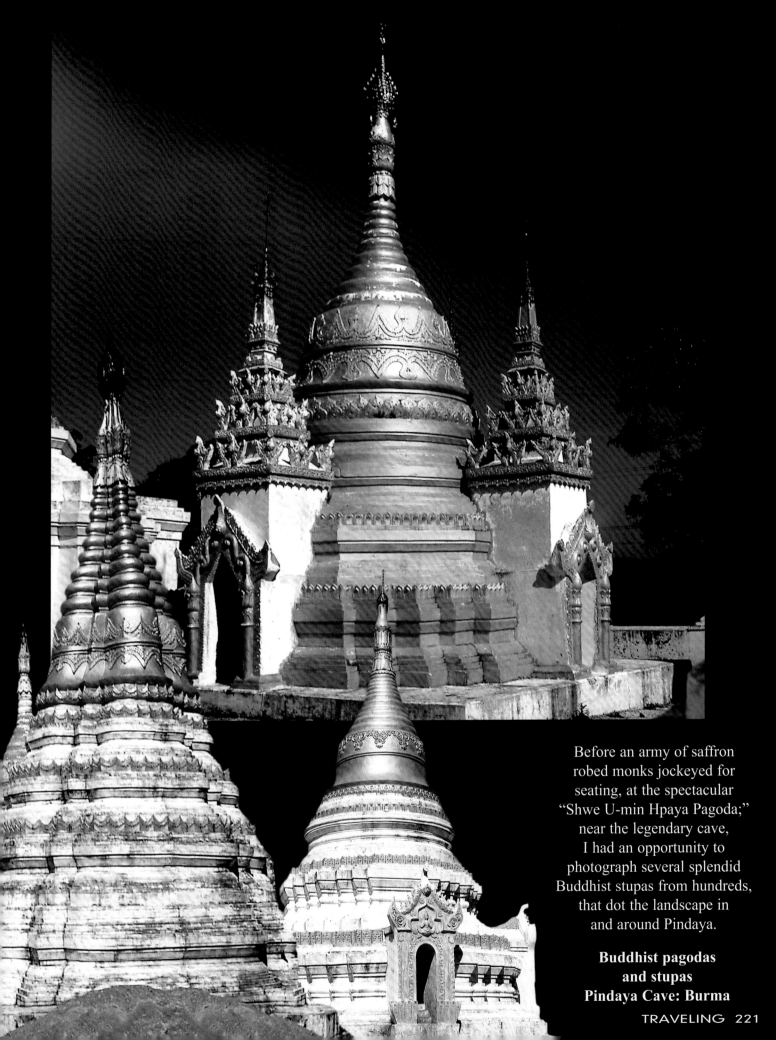

Before an army of saffron robed monks jockeyed for seating, at the spectacular "Shwe U-min Hpaya Pagoda;" near the legendary cave, I had an opportunity to photograph several splendid Buddhist stupas from hundreds, that dot the landscape in and around Pindaya.

**Buddhist pagodas and stupas Pindaya Cave: Burma**

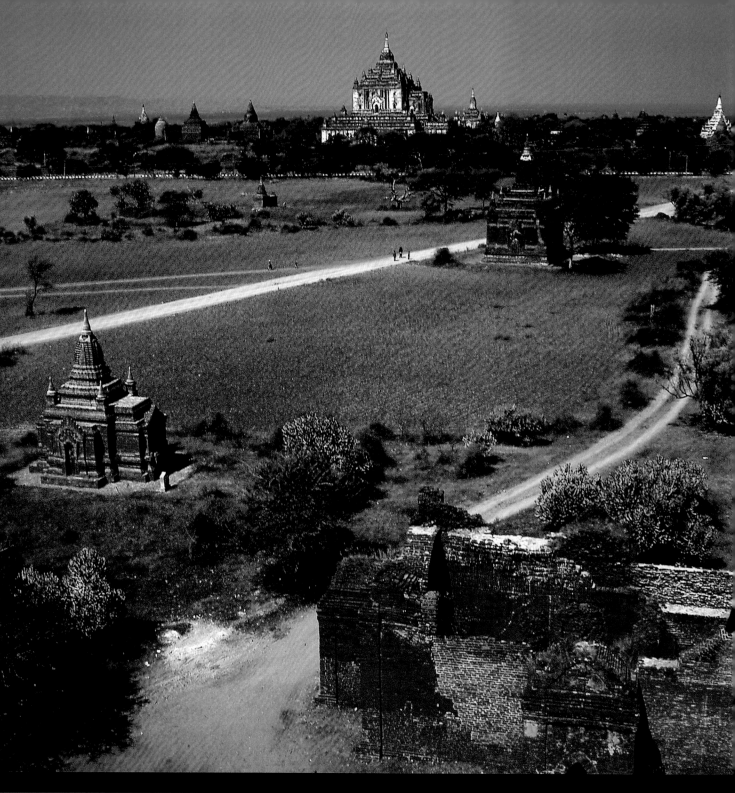

### Bagan's 5000 temples are more than a 1000 years old

I was disappointed missing Pindaya Cave, and so decided to explore, at least, a few of the 5000 temples in Bagan that Kublai Khan sacked in 1287. Burma's "glory days" lasted almost two hundred years, from the 11th thru the 13th century, and during that ancient golden era the fantastic city of Bagan was constructed. After Khan's invasion the site's original grandeur was never restored, but you do not have to tell me: The place was destroyed! That was obvious when I stumbled over countless red bricks at sunset, looking for the city's three most magnificent temples: "Gawdawpalin," "Ananda," and "Thatbyinnyu," while thinking about the old Palaung oracle witches, back in Tar Yaw, who predicted "Dave you'll see an enormous "Golden Egg!" A Golden Egg? An enormous Golden Egg? Did they forget to mention? "Keep your eyes open for an enormous Goose!"

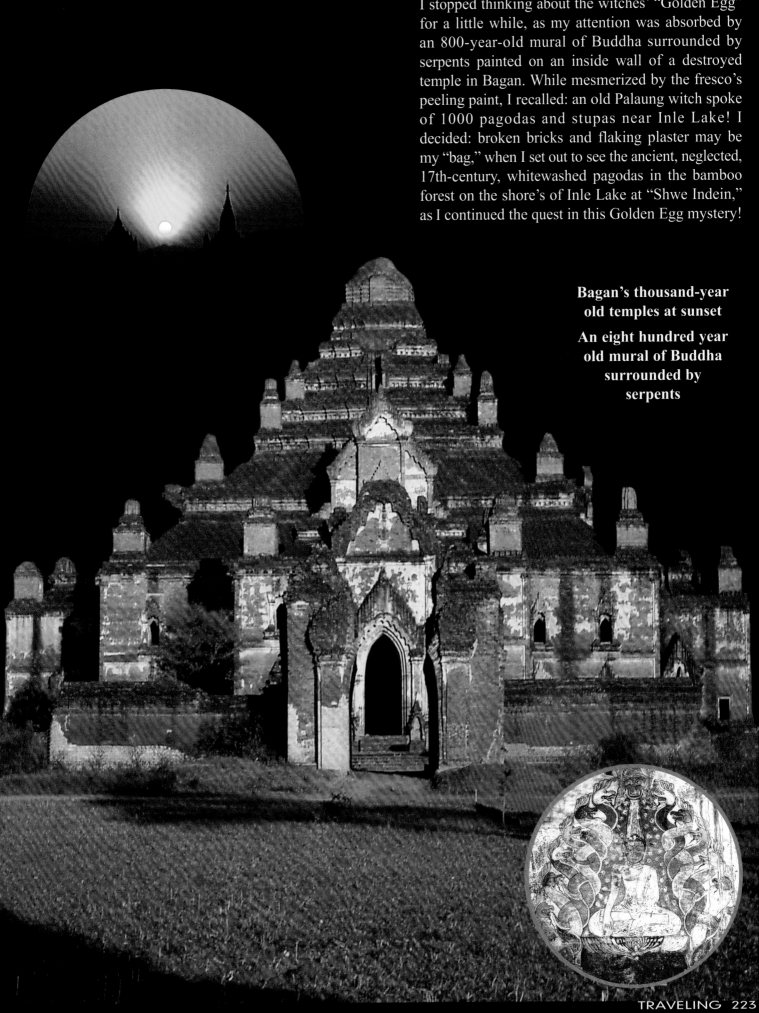

I stopped thinking about the witches' "Golden Egg" for a little while, as my attention was absorbed by an 800-year-old mural of Buddha surrounded by serpents painted on an inside wall of a destroyed temple in Bagan. While mesmerized by the fresco's peeling paint, I recalled: an old Palaung witch spoke of 1000 pagodas and stupas near Inle Lake! I decided: broken bricks and flaking plaster may be my "bag," when I set out to see the ancient, neglected, 17th-century, whitewashed pagodas in the bamboo forest on the shore's of Inle Lake at "Shwe Indein," as I continued the quest in this Golden Egg mystery!

**Bagan's thousand-year old temples at sunset**

**An eight hundred year old mural of Buddha surrounded by serpents**

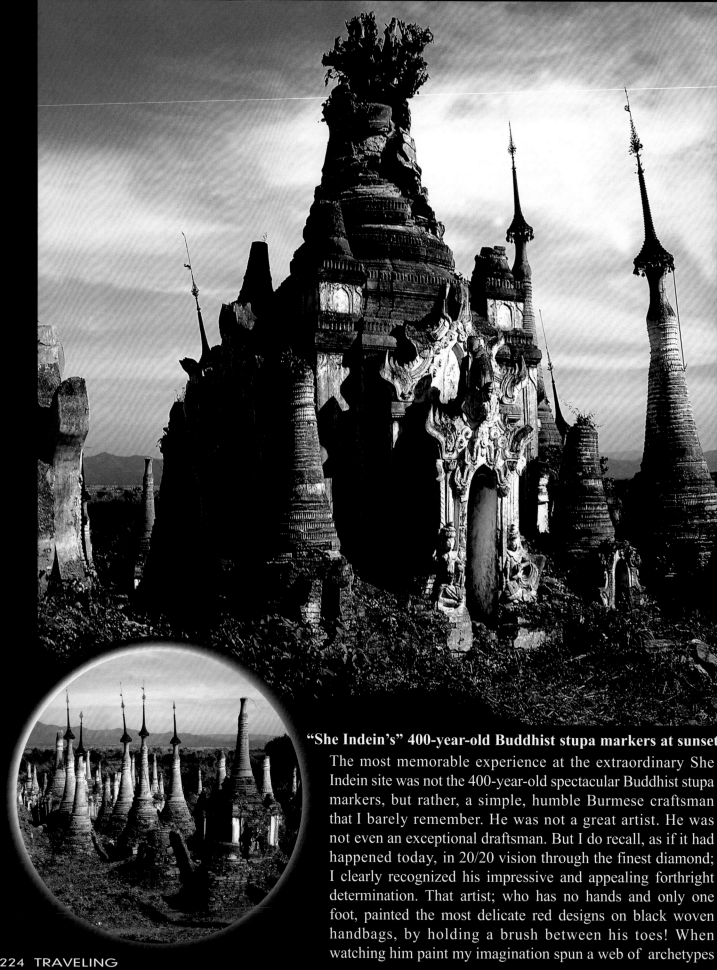

**"She Indein's" 400-year-old Buddhist stupa markers at sunset**

The most memorable experience at the extraordinary She Indein site was not the 400-year-old spectacular Buddhist stupa markers, but rather, a simple, humble Burmese craftsman that I barely remember. He was not a great artist. He was not even an exceptional draftsman. But I do recall, as if it had happened today, in 20/20 vision through the finest diamond; I clearly recognized his impressive and appealing forthright determination. That artist; who has no hands and only one foot, painted the most delicate red designs on black woven handbags, by holding a brush between his toes! When watching him paint my imagination spun a web of archetypes

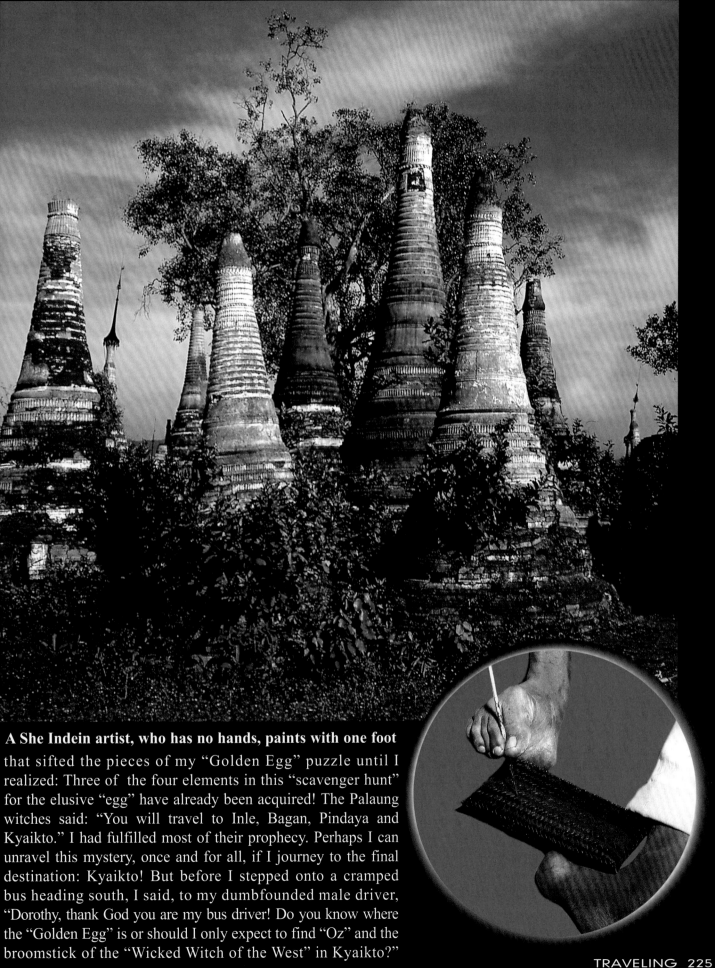

**A She Indein artist, who has no hands, paints with one foot**

that sifted the pieces of my "Golden Egg" puzzle until I realized: Three of the four elements in this "scavenger hunt" for the elusive "egg" have already been acquired! The Palaung witches said: "You will travel to Inle, Bagan, Pindaya and Kyaikto." I had fulfilled most of their prophecy. Perhaps I can unravel this mystery, once and for all, if I journey to the final destination: Kyaikto! But before I stepped onto a cramped bus heading south, I said, to my dumbfounded male driver, "Dorothy, thank God you are my bus driver! Do you know where the "Golden Egg" is or should I only expect to find "Oz" and the broomstick of the "Wicked Witch of the West" in Kyaikto?"

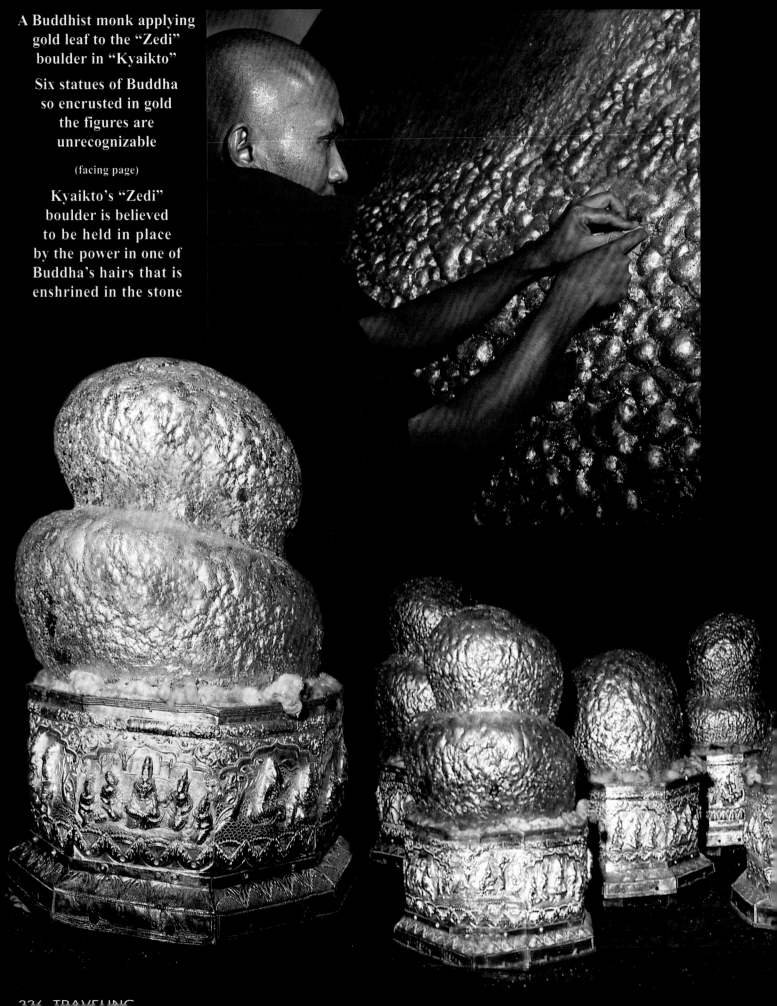

A Buddhist monk applying gold leaf to the "Zedi" boulder in "Kyaikto"

Six statues of Buddha so encrusted in gold the figures are unrecognizable

(facing page)

Kyaikto's "Zedi" boulder is believed to be held in place by the power in one of Buddha's hairs that is enshrined in the stone

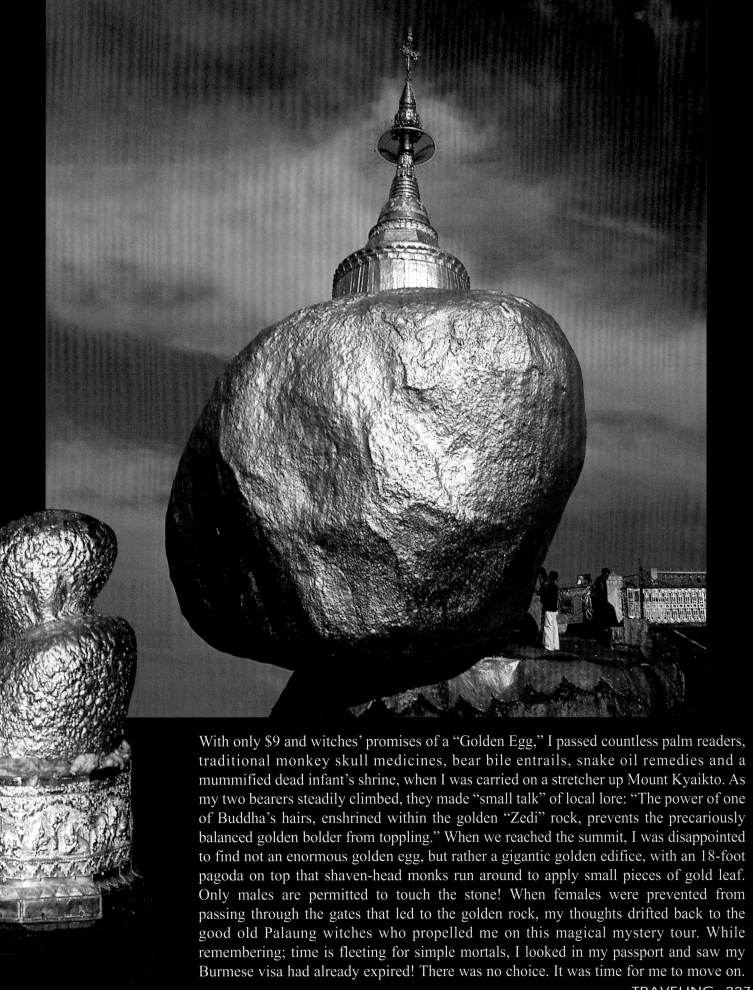

With only $9 and witches' promises of a "Golden Egg," I passed countless palm readers, traditional monkey skull medicines, bear bile entrails, snake oil remedies and a mummified dead infant's shrine, when I was carried on a stretcher up Mount Kyaikto. As my two bearers steadily climbed, they made "small talk" of local lore: "The power of one of Buddha's hairs, enshrined within the golden "Zedi" rock, prevents the precariously balanced golden bolder from toppling." When we reached the summit, I was disappointed to find not an enormous golden egg, but rather a gigantic golden edifice, with an 18-foot pagoda on top that shaven-head monks run around to apply small pieces of gold leaf. Only males are permitted to touch the stone! When females were prevented from passing through the gates that led to the golden rock, my thoughts drifted back to the good old Palaung witches who propelled me on this magical mystery tour. While remembering; time is fleeting for simple mortals, I looked in my passport and saw my Burmese visa had already expired! There was no choice. It was time for me to move on.

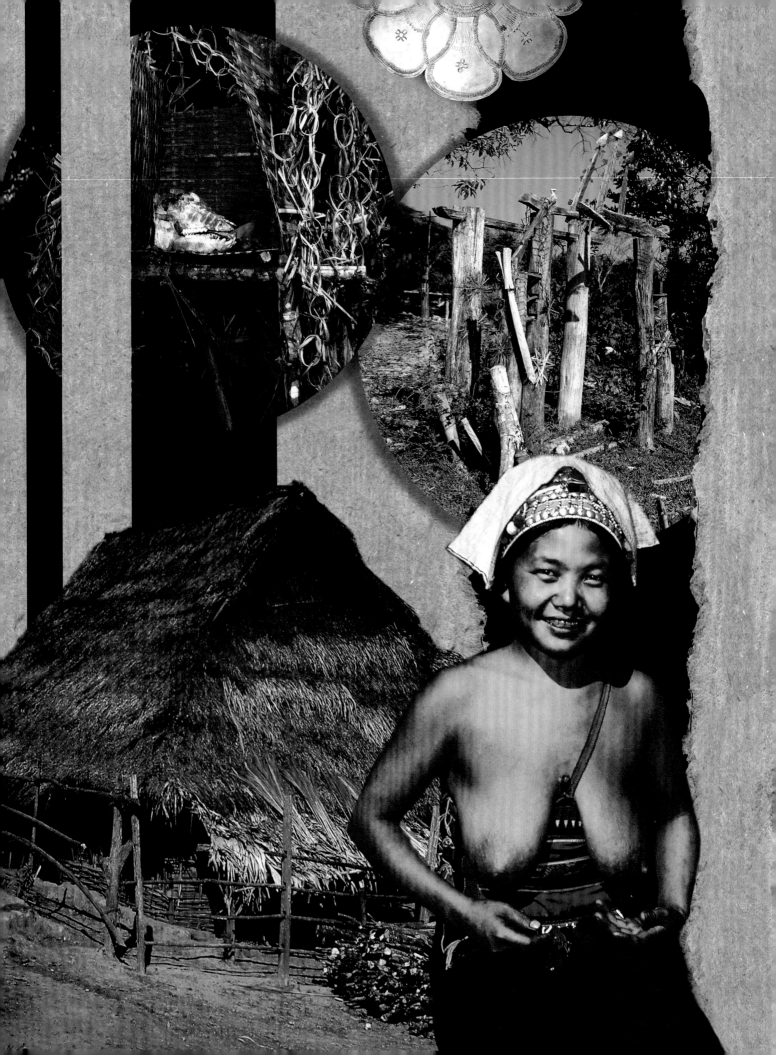

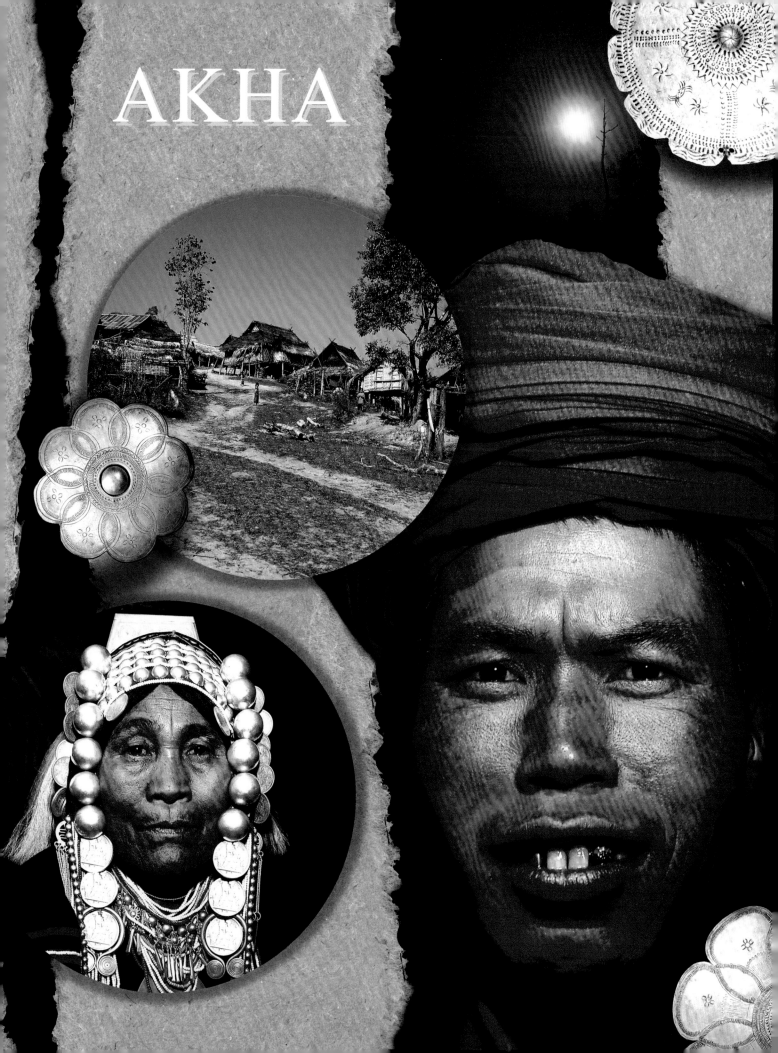

# AKHA

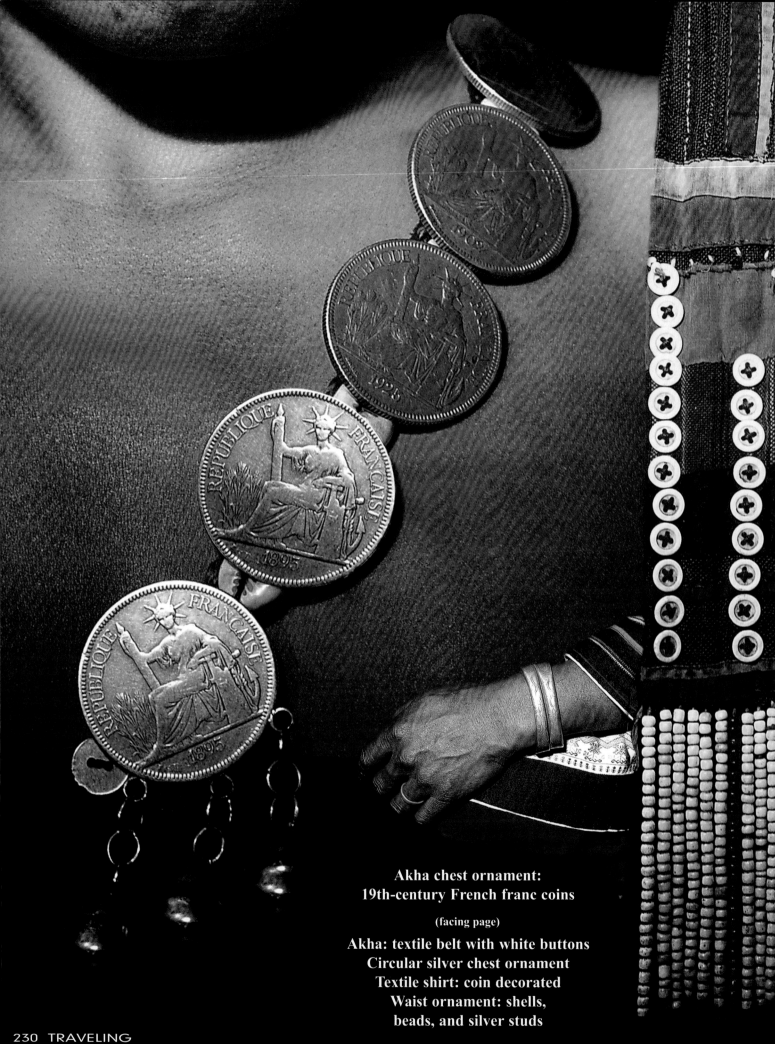

**Akha chest ornament:
19th-century French franc coins**

(facing page)

**Akha: textile belt with white buttons
Circular silver chest ornament
Textile shirt: coin decorated
Waist ornament: shells,
beads, and silver studs**

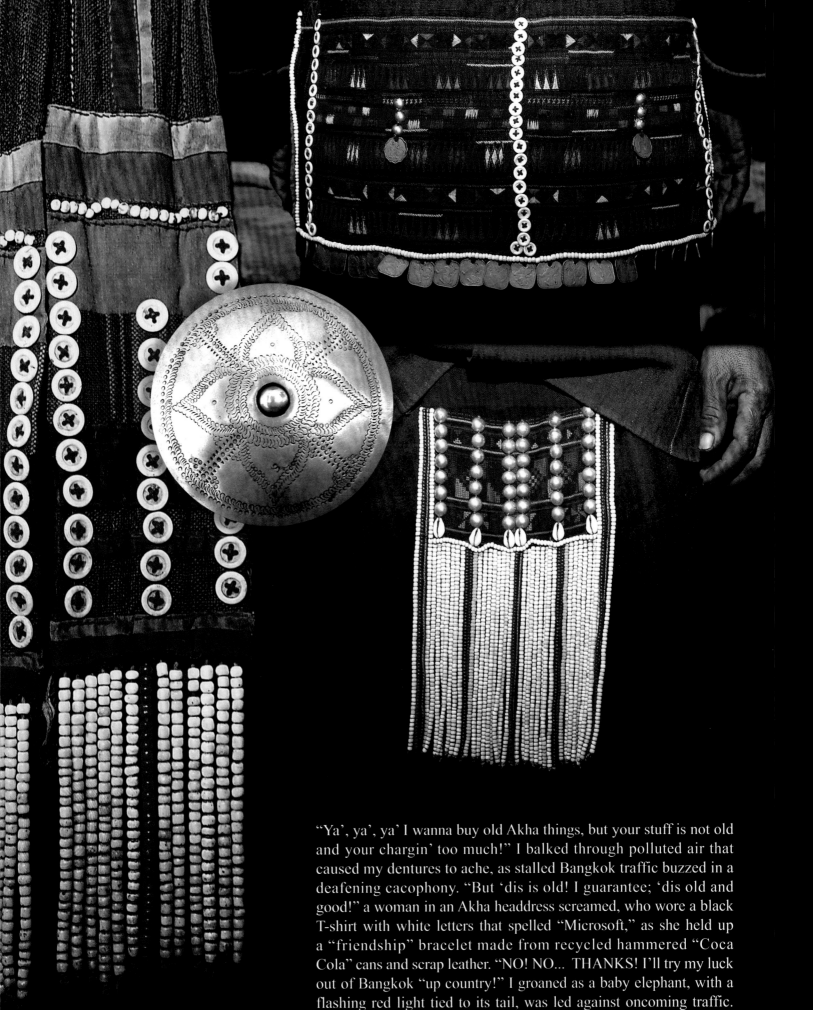

"Ya', ya', ya' I wanna buy old Akha things, but your stuff is not old and your chargin' too much!" I balked through polluted air that caused my dentures to ache, as stalled Bangkok traffic buzzed in a deafening cacophony. "But 'dis is old! I guarantee; 'dis old and good!" a woman in an Akha headdress screamed, who wore a black T-shirt with white letters that spelled "Microsoft," as she held up a "friendship" bracelet made from recycled hammered "Coca Cola" cans and scrap leather. "NO! NO... THANKS! I'll try my luck out of Bangkok "up country!" I groaned as a baby elephant, with a flashing red light tied to its tail, was led against oncoming traffic.

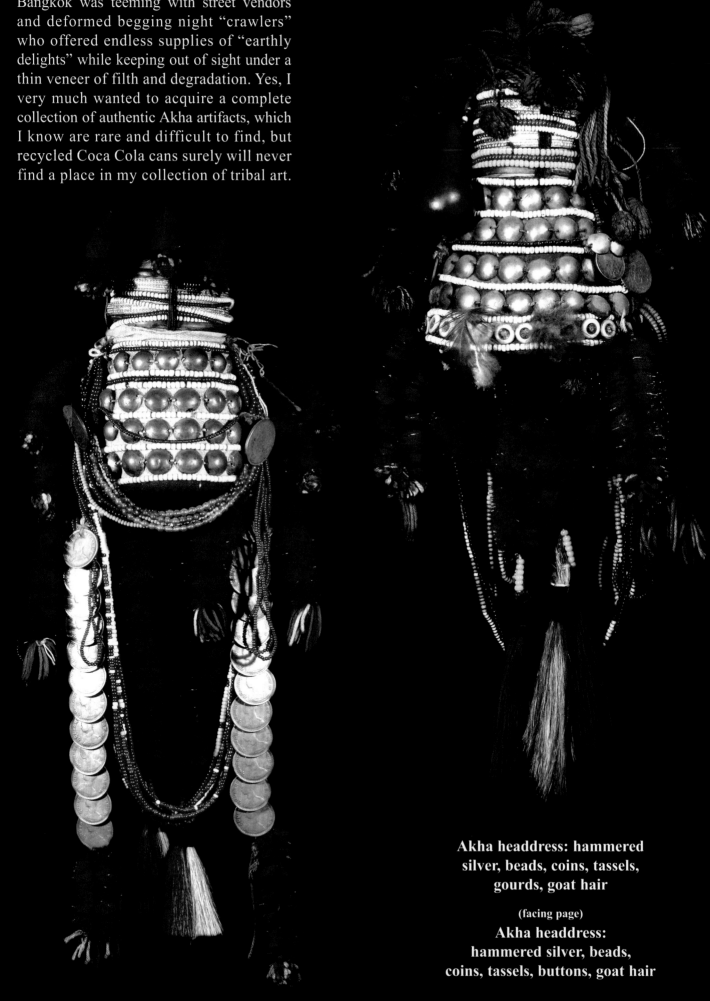

Bangkok was teeming with street vendors and deformed begging night "crawlers" who offered endless supplies of "earthly delights" while keeping out of sight under a thin veneer of filth and degradation. Yes, I very much wanted to acquire a complete collection of authentic Akha artifacts, which I know are rare and difficult to find, but recycled Coca Cola cans surely will never find a place in my collection of tribal art.

**Akha headdress: hammered silver, beads, coins, tassels, gourds, goat hair**

(facing page)
**Akha headdress: hammered silver, beads, coins, tassels, buttons, goat hair**

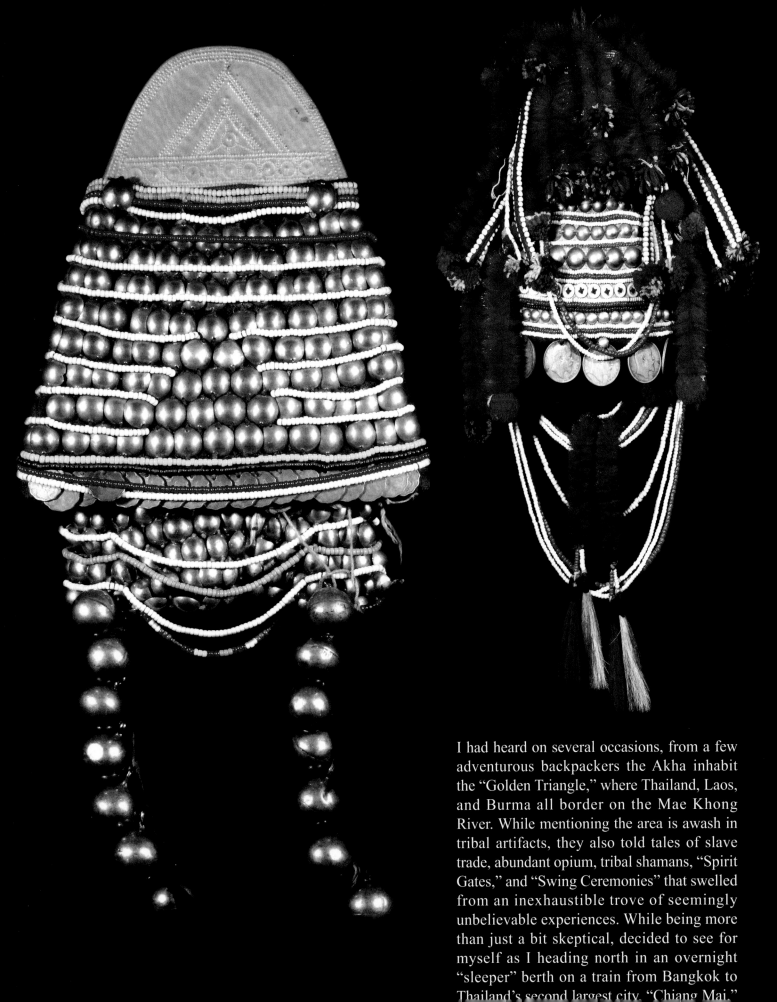

I had heard on several occasions, from a few adventurous backpackers the Akha inhabit the "Golden Triangle," where Thailand, Laos, and Burma all border on the Mae Khong River. While mentioning the area is awash in tribal artifacts, they also told tales of slave trade, abundant opium, tribal shamans, "Spirit Gates," and "Swing Ceremonies" that swelled from an inexhaustible trove of seemingly unbelievable experiences. While being more than just a bit skeptical, decided to see for myself as I heading north in an overnight "sleeper" berth on a train from Bangkok to Thailand's second largest city, "Chiang Mai,"

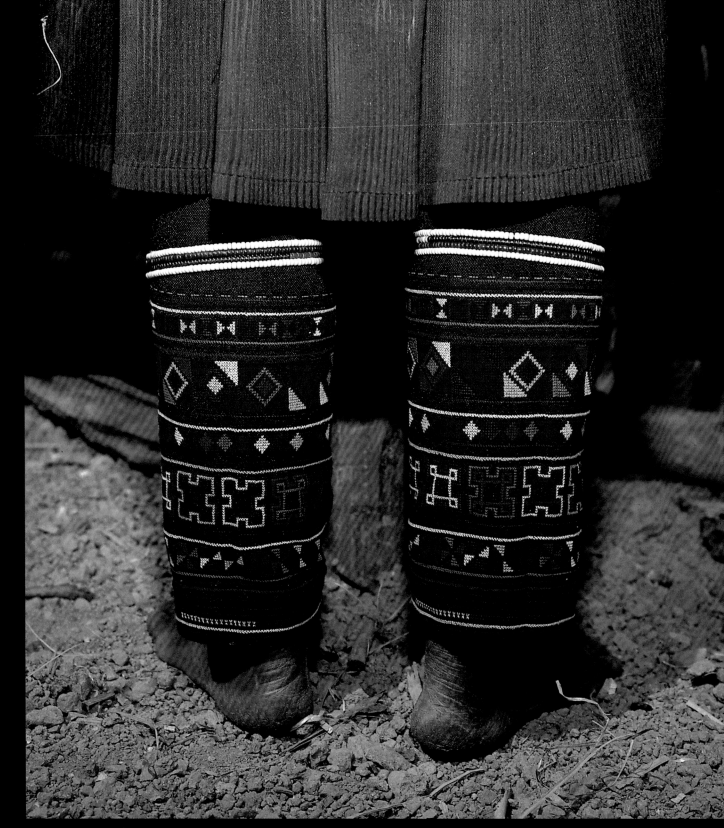

**Akha female's textile-embroidered leggings: "Muang Sing, Laos"**

I saved the Akha for last, not because they are the most intelligent or the most friendly tribe but rather, because they are dear to my heart. I first encountered the Akha, more than two decades ago, in "Mai Sai" Thailand on the Burmese border and, though devious at times, I still harbor a kinship with this prolific tribe. As "survivors;" this semi-nomadic "gypsy" tribe's history was traced back to an origin in the Tibetan highlands. They first migrated from China to Thailand a century ago and arrived in greater numbers in the 50's and 60's. It is difficult to determine the exact number, but it is estimated 70,000 Akha inhabit approximately 450 villages in Thailand. Most Akha lack Thai citizenship and therefore can not own land, which exacerbates an endless

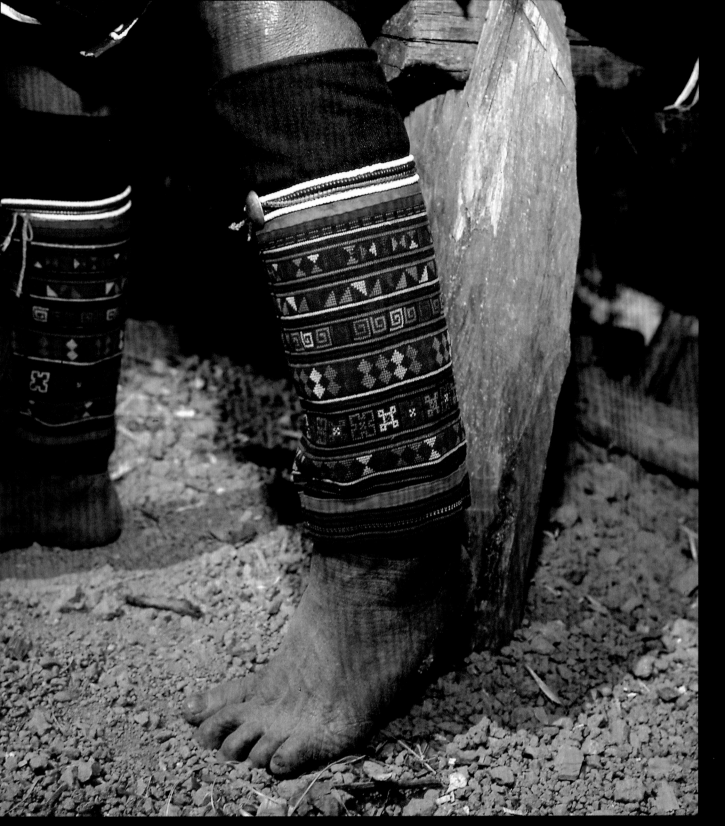

**The Akha wear traditional tribal clothing at all times even while sleeping and working**

cycle of chronic poverty. The tribe has since turned to opium cultivation and other "tricks in all trades," when necessary, to feed loved ones. The Akha, unlike many other tribes, wear traditional clothing at all times, even when working. To avoid losing a highly prized status symbol, Akha females keep their headdress on while sleeping. A headdress is an Akha's greatest asset. Containing currency and silver, it symbolizes and embodies all that is precious, while remaining the only valuable commodity in an arsenal of poverty. A headdress is a symbolic tribal icon that evolves over generations into an heirloom! When added to or changed by Akha women as they age, it communicates specific traits, such as marital status. I was seeking those old Akha artifacts:

headdress, silver chest medallions, colorful embroidery, beautifully crafted coin-studded headbands, and of course, the tribe's extraordinary hand made clothing, when I arrived in Chiang Mai, but decided the best pieces could only be found farther north, on the Burmese border, in Mai Sai. I immediately headed for the secluded "Mai Sai Guest House," ideally situated on the meandering "Mai Sai River," and from there, about only one hundred feet away, on the opposite bank I saw Burma. Exhausted by the journey from Bangkok, I rested for three days on the Mai Sai River bank, where I first met the beautiful young Akha girl, "Mee Taw." Each evening at dusk she waded across the river that separates Thailand from her home in Burma to avoid a border guard's identity check at the usual bridge crossing.

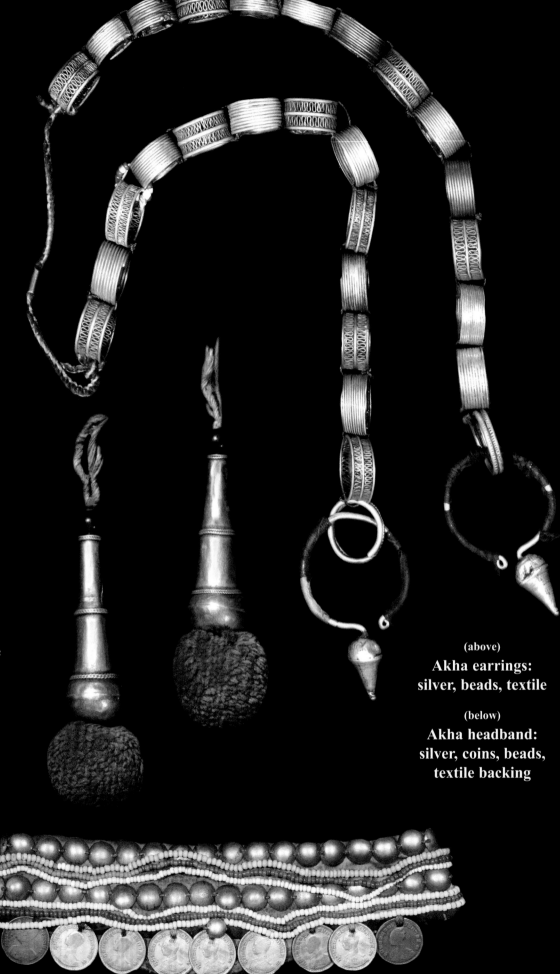

(above)
**Akha earrings:
silver, beads, textile**

(below)
**Akha headband:
silver, coins, beads,
textile backing**

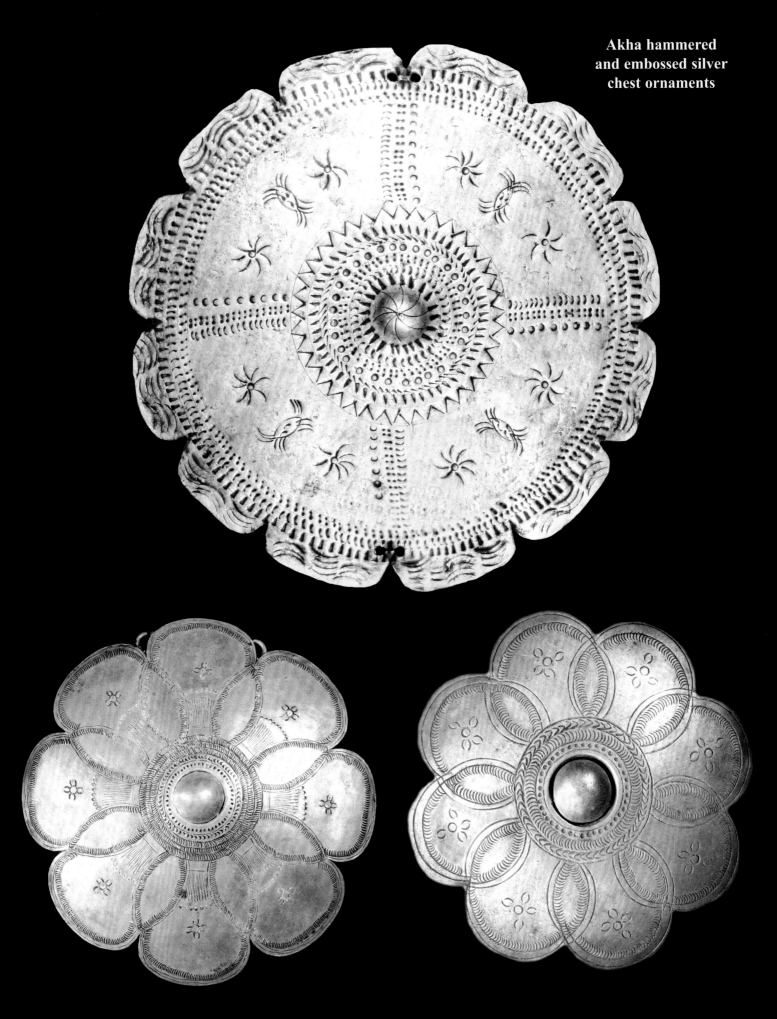

**Akha hammered and embossed silver chest ornaments**

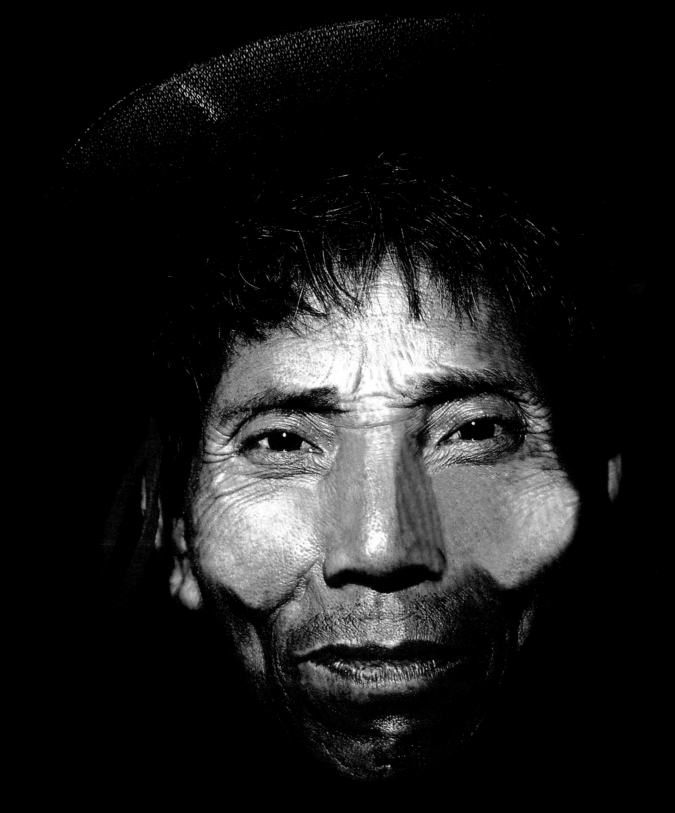

**"Bu Yuen:" Akha tribesman and father of my beautiful Burmese girlfriend: "Mee Taw"**

Even though I saw only her shadow reflect in a rush of ink-black river water that was backlit in a glaring setting sun, I still knew she was more beautiful than any vision in my finest fantasy of the Akha. Because "Mee Taw" worked in the "Mai Sai" Guesthouse, I was familiar with her exotic countenance and extraordinary personality, as we flirted while she served meals. Without fail, each day after work, when crossing knee deep in river water, she would turn back and siren in the softest, most suggestive, sultry tone, "Come... come follow!" I knew if I pursued her, without an official Burmese visa, I faced indefinite jail time in a filthy Asian prison, but an uncontrollable urge to go with her was stronger than any rational thought. By the time we set foot on the Burmese side of the river the sun had already set. Grateful for that cover of darkness we silently crept west, undetected, through the bank's undergrowth. We tried to be quiet, but uncontrollable laughter

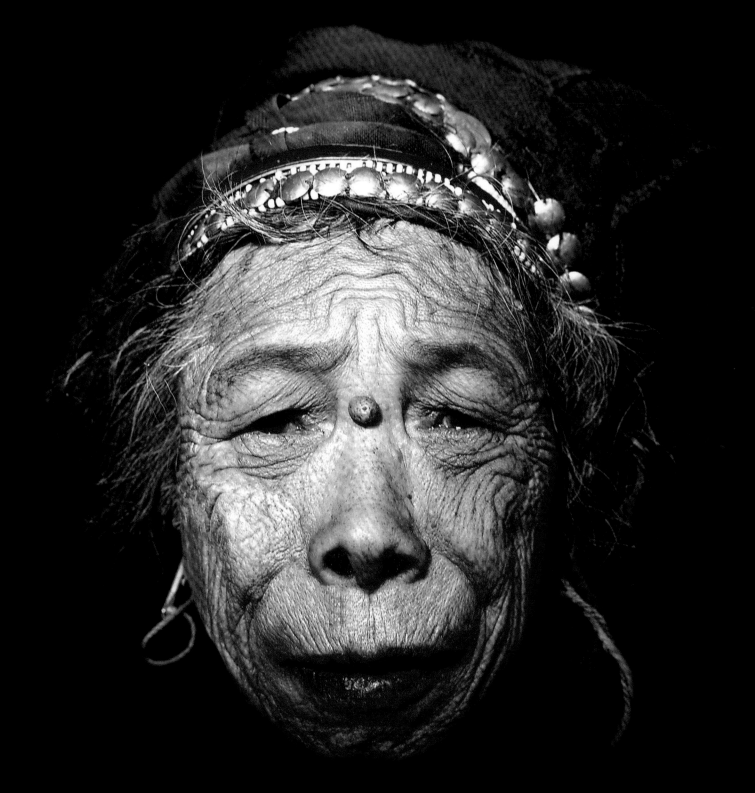

**"Ah Naung:" mother of my Akha girlfriend: "Mee Taw"**

overtook us when we became giddy. In the near distance, I heard voices speaking in languages I did not understand, as the jungle came alive with the sound of buzzing insects and animals crying in the night. After the river crossing, I was relieved to reach Mee's home in a matter of minutes but, when her family came to greet us, they were astonished to discover a "farang" foreigner was in their midst. But after a formal introduction to Mee's father, "Bu Yuen," and mother, "Ah Naung," they accepted me when we sat in a circle around an open fire for an evening meal. I was disturbed! Mee received less than Thailand's daily minimum wage of $4 (U.S.) dollars for a full day's labor, but when she handed the cash to her mother the smile on the old lady's face made Mee's efforts seem more than worthwhile! We celebrated by eating with our hands, from a single pot that hung over a fire, while splashing wet meat and vegetables from a dangling metal caldron into bowls filled with rice.

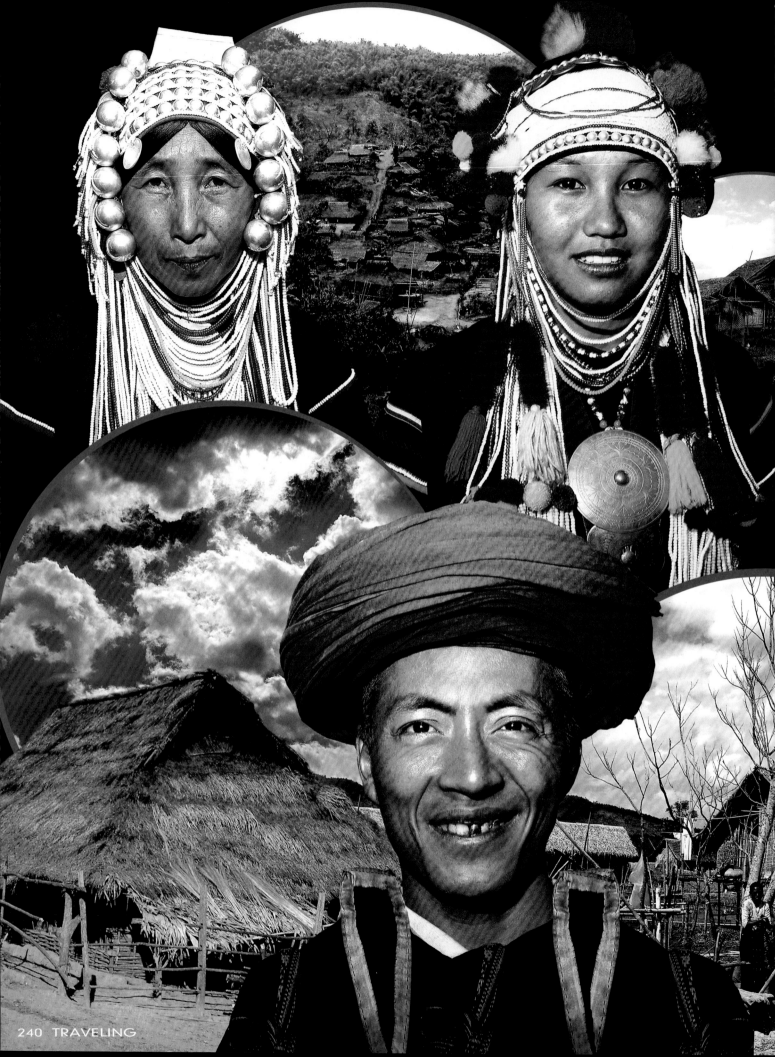

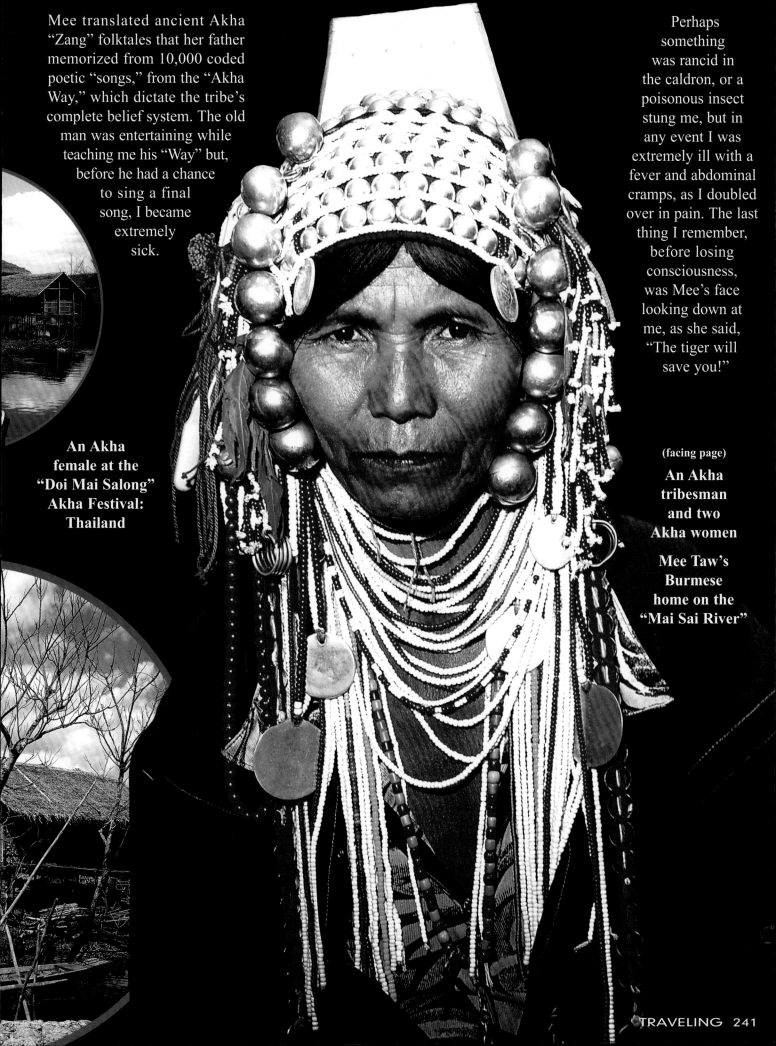

Mee translated ancient Akha "Zang" folktales that her father memorized from 10,000 coded poetic "songs," from the "Akha Way," which dictate the tribe's complete belief system. The old man was entertaining while teaching me his "Way" but, before he had a chance to sing a final song, I became extremely sick.

**An Akha female at the "Doi Mai Salong" Akha Festival: Thailand**

Perhaps something was rancid in the caldron, or a poisonous insect stung me, but in any event I was extremely ill with a fever and abdominal cramps, as I doubled over in pain. The last thing I remember, before losing consciousness, was Mee's face looking down at me, as she said, "The tiger will save you!"

(facing page)
**An Akha tribesman and two Akha women**

**Mee Taw's Burmese home on the "Mai Sai River"**

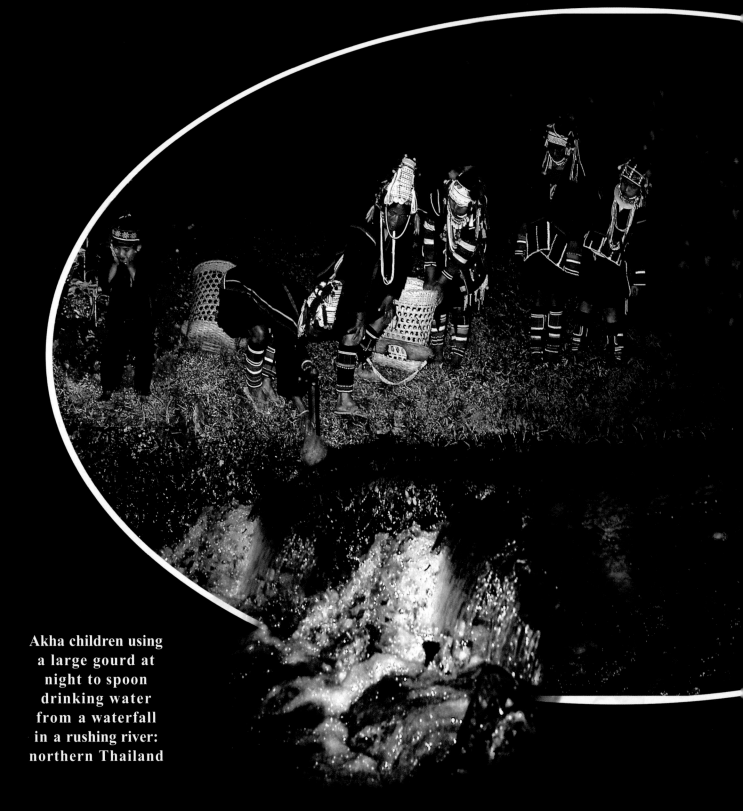

**Akha children using a large gourd at night to spoon drinking water from a waterfall in a rushing river: northern Thailand**

I remained in Burma, unconscious on the floor in Mee's hut for four days. After regaining consciousness I discovered, on a makeshift table made from an old wooden crate, a partially broken tiger tooth in a small pile of fine white powder. While Mee held my head in one hand, she nursed me with her other, as she administered a questionable combination of powered tiger teeth, lime, and green leaves distilled in boiling water. When I unwillingly drank the hot substance she assured me, "Drinking this can cure you!" I was too weak to illegally wade to Thailand, across the Mai Sai River, so after dark on my fifth night in Burma, Ah Naung, Mee's old mother, who was anxious to rid herself of me, decided to carry me back. In only light of a pitch-black starless night, with a head strap attached to a wooden "stock" fitted around her neck, the old woman hoisted two ropes that lashed me to her back. With bare feet and an Akha headdress, Ah Naung struggled to keep her footing while she crossed the rushing river in darkness. It did not take long to reach the other side, as she had made the crossing countless times before. When she set me down on the Thai bank my thoughts did not look to the "Golden Egg" any longer but rather to "The Golden Triangle!"

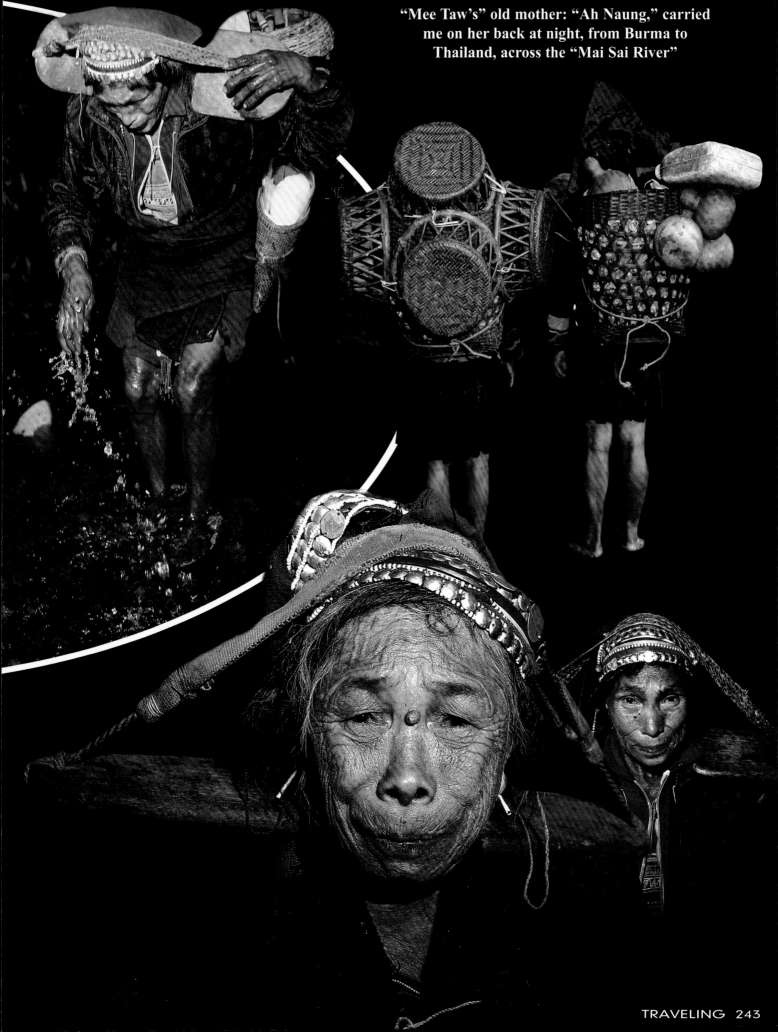

"Mee Taw's" old mother: "Ah Naung," carried me on her back at night, from Burma to Thailand, across the "Mai Sai River"

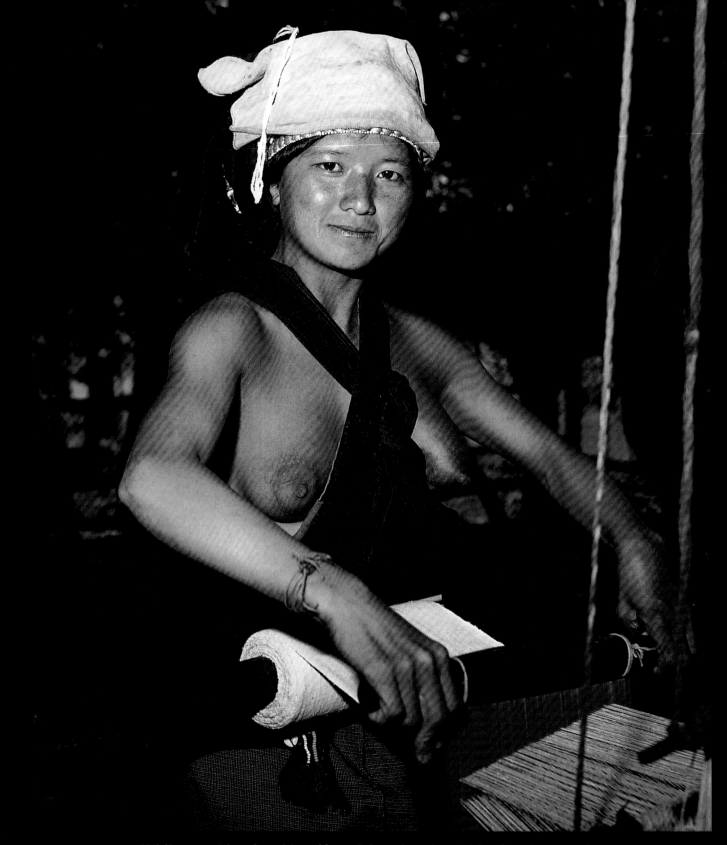

**While searching for old artifacts I found topless Akha females weaving**

I assumed the tiger tooth potion had worked as I was on my feet, heading east, on a bus to a small town on the mighty "Mae Khong River" known as "Chiang Saen." Before setting sight on the river's far bank, I was assured: "You're in the Triangle!" As I stood in Thailand, Laos and Burma were within "spitting distance." I had reached the "promised land:" the "Golden Triangle!" I celebrated by drinking 4 baht (10 U.S.cent) shots of dark brown, homemade whiskey spooned from large glass jars, on makeshift tables, that were displayed on every street corner. Before long I was drunk and singing, "Holly-wood, Akha da' ka', Akha da' ka', Holly-wood!" While I danced back and forth in front of the spirit vendors a disheveled Thai boy cried out, "You sing about Akha? I guide you to the Akha!"

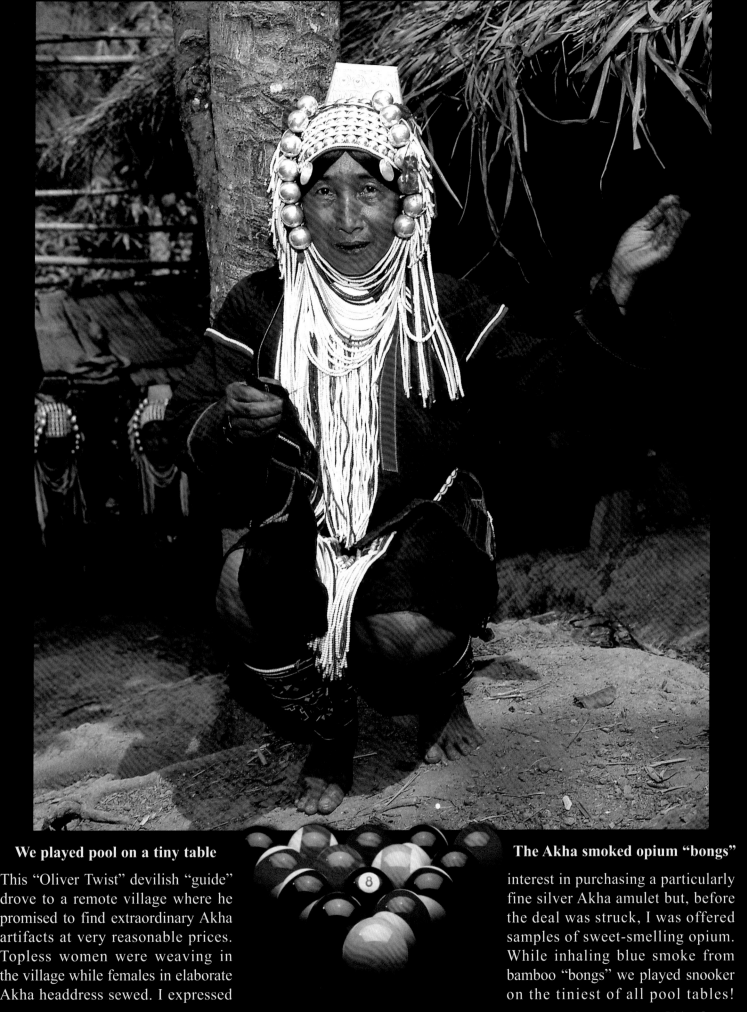

## We played pool on a tiny table

This "Oliver Twist" devilish "guide" drove to a remote village where he promised to find extraordinary Akha artifacts at very reasonable prices. Topless women were weaving in the village while females in elaborate Akha headdress sewed. I expressed

## The Akha smoked opium "bongs"

interest in purchasing a particularly fine silver Akha amulet but, before the deal was struck, I was offered samples of sweet-smelling opium. While inhaling blue smoke from bamboo "bongs" we played snooker on the tiniest of all pool tables!

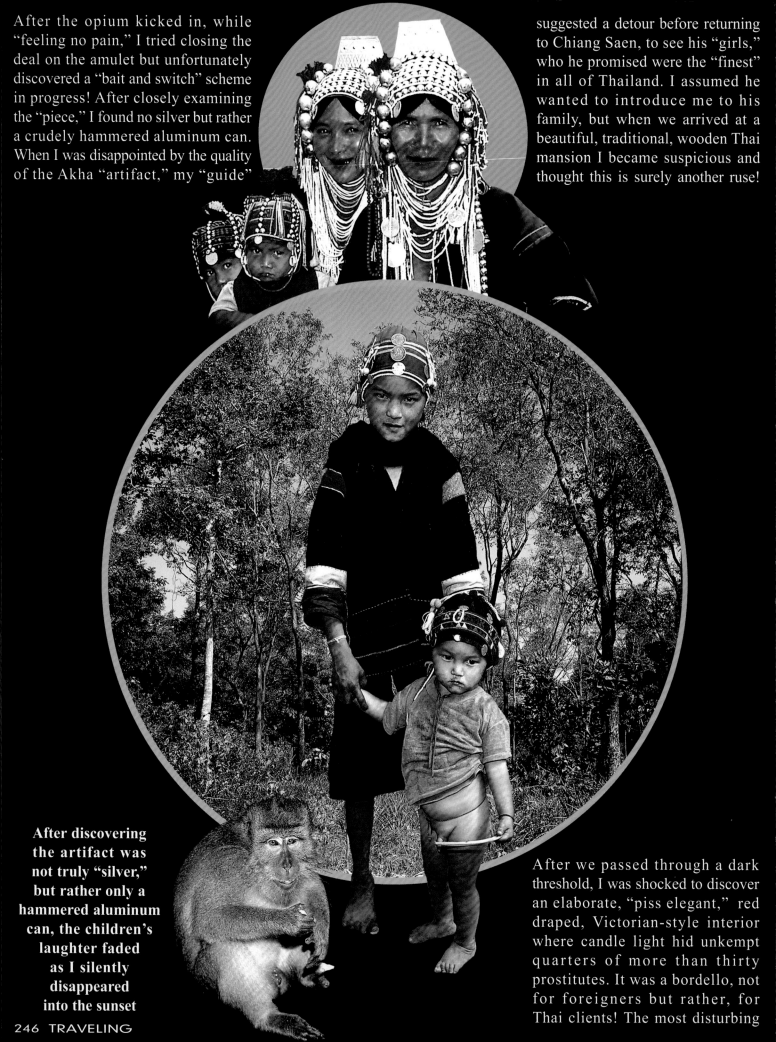

After the opium kicked in, while "feeling no pain," I tried closing the deal on the amulet but unfortunately discovered a "bait and switch" scheme in progress! After closely examining the "piece," I found no silver but rather a crudely hammered aluminum can. When I was disappointed by the quality of the Akha "artifact," my "guide"

suggested a detour before returning to Chiang Saen, to see his "girls," who he promised were the "finest" in all of Thailand. I assumed he wanted to introduce me to his family, but when we arrived at a beautiful, traditional, wooden Thai mansion I became suspicious and thought this is surely another ruse!

**After discovering the artifact was not truly "silver," but rather only a hammered aluminum can, the children's laughter faded as I silently disappeared into the sunset**

After we passed through a dark threshold, I was shocked to discover an elaborate, "piss elegant," red draped, Victorian-style interior where candle light hid unkempt quarters of more than thirty prostitutes. It was a bordello, not for foreigners but rather, for Thai clients! The most disturbing

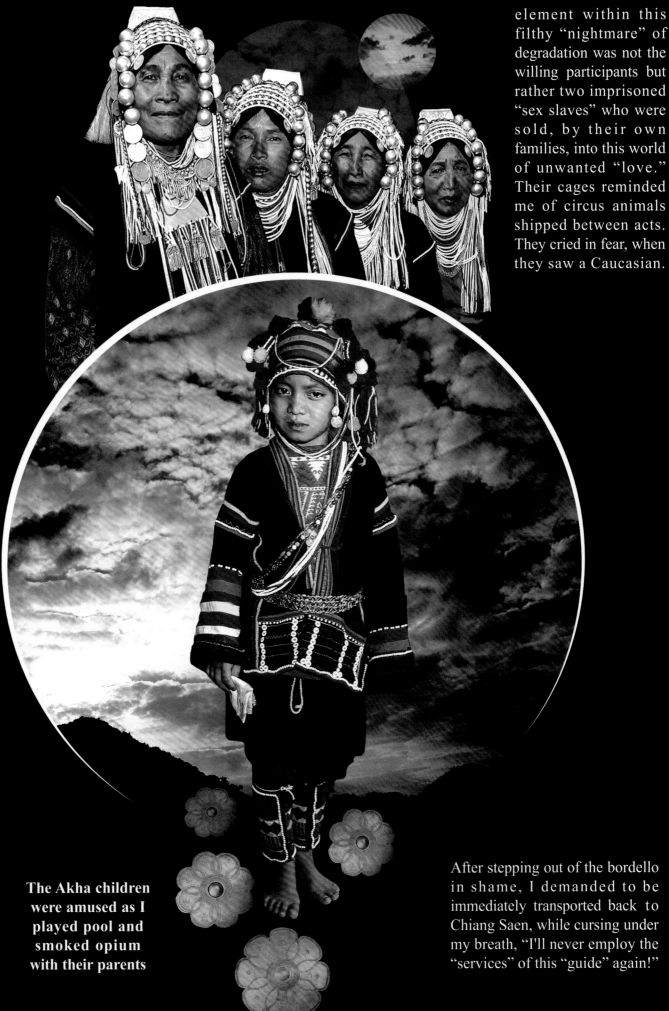

element within this filthy "nightmare" of degradation was not the willing participants but rather two imprisoned "sex slaves" who were sold, by their own families, into this world of unwanted "love." Their cages reminded me of circus animals shipped between acts. They cried in fear, when they saw a Caucasian.

**The Akha children were amused as I played pool and smoked opium with their parents**

After stepping out of the bordello in shame, I demanded to be immediately transported back to Chiang Saen, while cursing under my breath, "I'll never employ the "services" of this "guide" again!"

Hoping for a deeper, more spiritual experience; I left Thailand and ventured across the Mae Khong River into Laos. I recalled stories of "Lokon Spirit Gates" that are on the front and back of Akha villages, as I headed north in a "long tail" speedboat to the remote enclave, "Bouakou." As the "banana boat's" loud motor drowned all sound in its roar I remembered: A " Spirit Gate's" function is to repel evil while admitting positive energy. My "powered canoe" trip up the Mae Khong into northern Laos was uneventful, but after arriving in Bouakou, while attempting to enter a Lokon Gate at the front of an Akha enclave, my adventure heated up, when a naked, rice-sifting Akha woman challenged me when she screamed, "No, No, No... you must go around the gate, not through it."

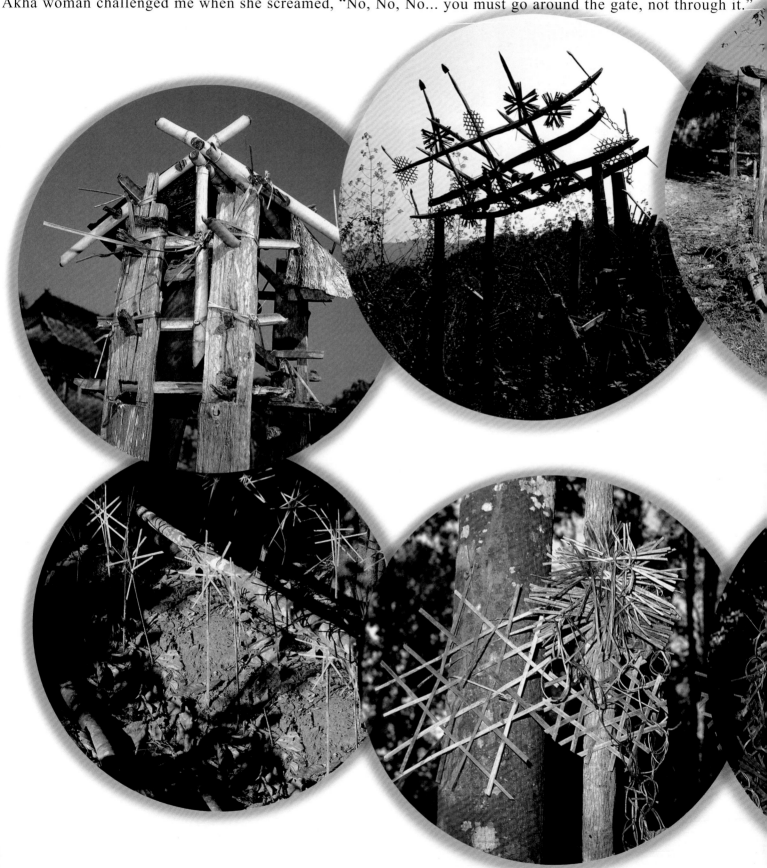

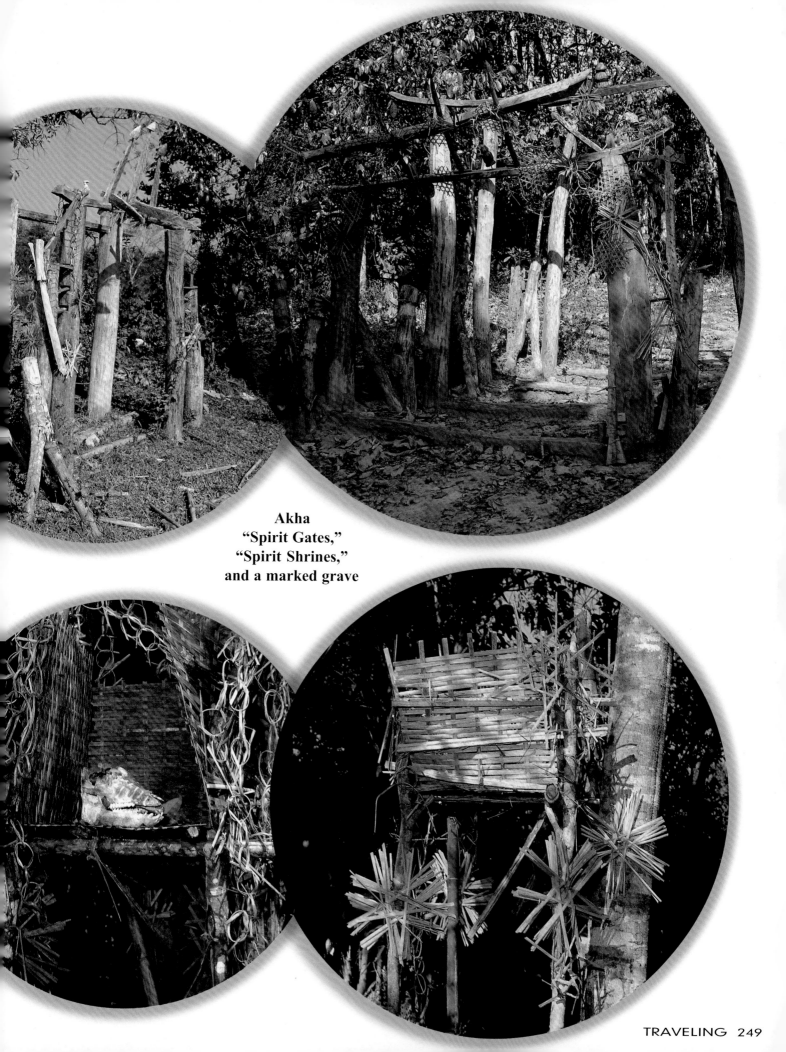

Akha
"Spirit Gates,"
"Spirit Shrines,"
and a marked grave

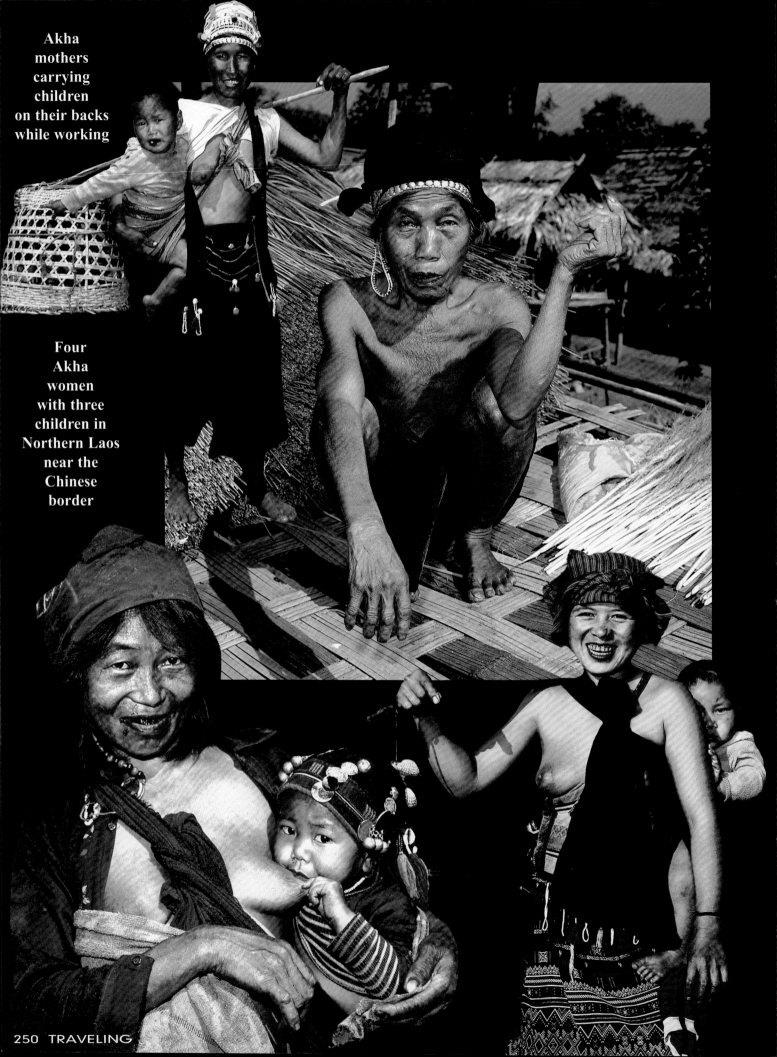

Akha
mothers
carrying
children
on their backs
while working

Four
Akha
women
with three
children in
Northern Laos
near the
Chinese
border

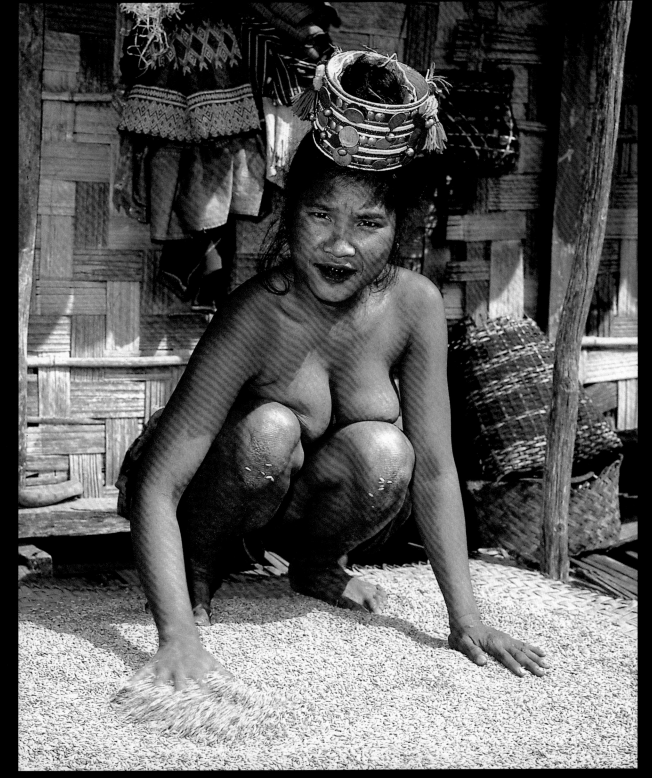

**A nude Akha woman, who wore only a headdress, challenged me at a sacred "Spirit Gate"**

But I had already inadvertently passed through the rickety "Gate" that had a vast assortment of broken wooden arrows and daggers mounted on top. The nude woman, who wore only an Akha headdress, sheepishly smiled and said ever so softly, "If evil spirits ever come to Bouakou I'll know you brought them!" I could only be certain she toyed with me, after we made eye contact, when she reassured me, "Don't worry. I see no evil in your heart or pocket, and because you have come at the right time, our "Dzoe Ma" priest, "The Father of this Village," welcomes you!" When I turned to leave, I only then realized, a decrepit Akha patriarch, who stood directly behind me, gave a "high sign" to the nude woman that allowed me to pass unmolested through the gate into the village. I understood the topless woman's words: "You have come at the right time" only after I found a raging Akha festival inside the village just past the front " Gate."

Red chickens, rice wine, ginger root and tea were being sacrificed to dead Akha ancestors. While an old Dzoe Ma shaman dug holes in the earth, young muscle-bound tribesmen inserted freshly cut tree trunks into the soil's cavities. I had fortunately stumbled on the tribe's most infamous rite of passage: "The Akha Swing Ceremony." Little time was lost in assembling the "centerpiece" of that ritual, as a mammoth wooden swing rose from a cloud of dust. This was the day girls became women! When adolescent females throw away their play things, they are crowned for the first time; adults, with a full Akha headdress! As topless women danced to the beat of a single drum, they honored dead ancestors with straw effigies.

**Three Akha women dancing while honoring dead ancestors with a straw "Spirit" shrine**

**A lone drummer kept the beat as Akha dancers played percussion instruments**

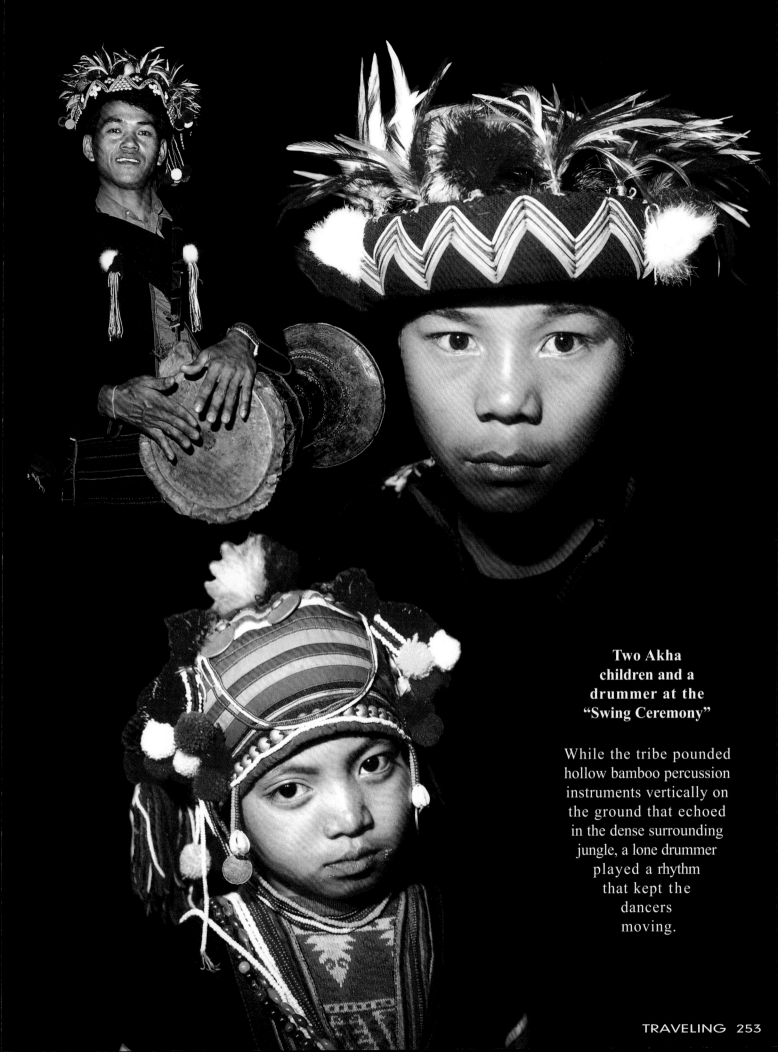

**Two Akha
children and a
drummer at the
"Swing Ceremony"**

While the tribe pounded
hollow bamboo percussion
instruments vertically on
the ground that echoed
in the dense surrounding
jungle, a lone drummer
played a rhythm
that kept the
dancers
moving.

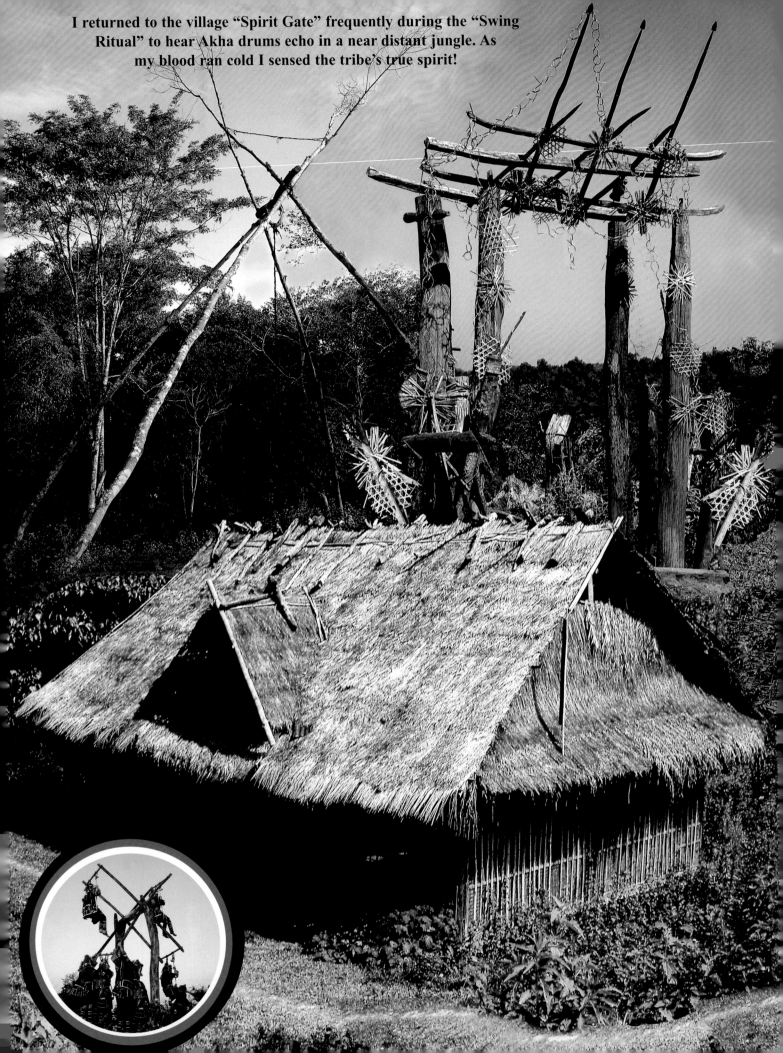

I returned to the village "Spirit Gate" frequently during the "Swing Ritual" to hear Akha drums echo in a near distant jungle. As my blood ran cold I sensed the tribe's true spirit!

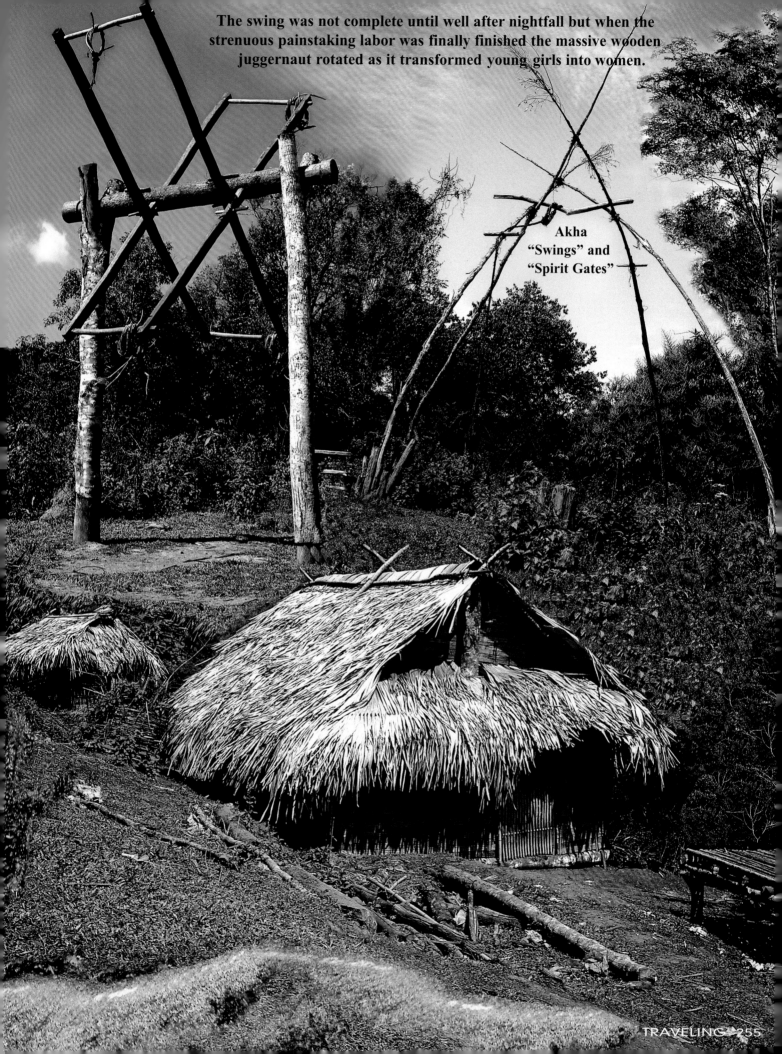

The swing was not complete until well after nightfall but when the strenuous painstaking labor was finally finished the massive wooden juggernaut rotated as it transformed young girls into women.

Akha
"Swings" and
"Spirit Gates"

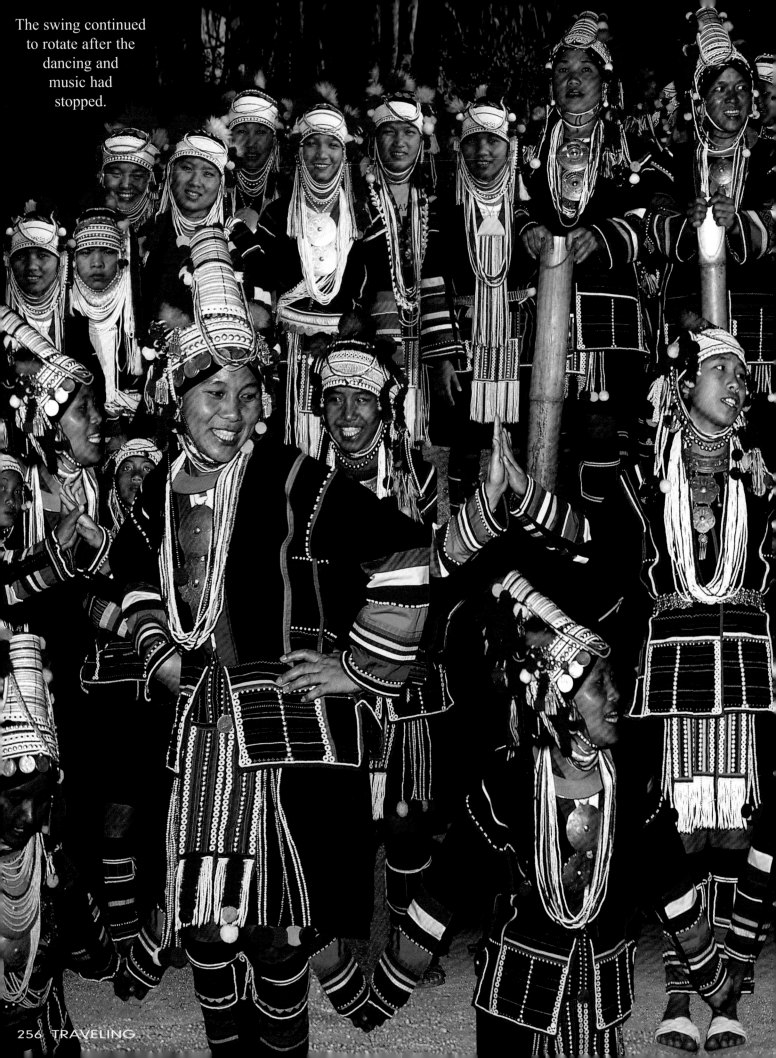

The swing continued to rotate after the dancing and music had stopped.

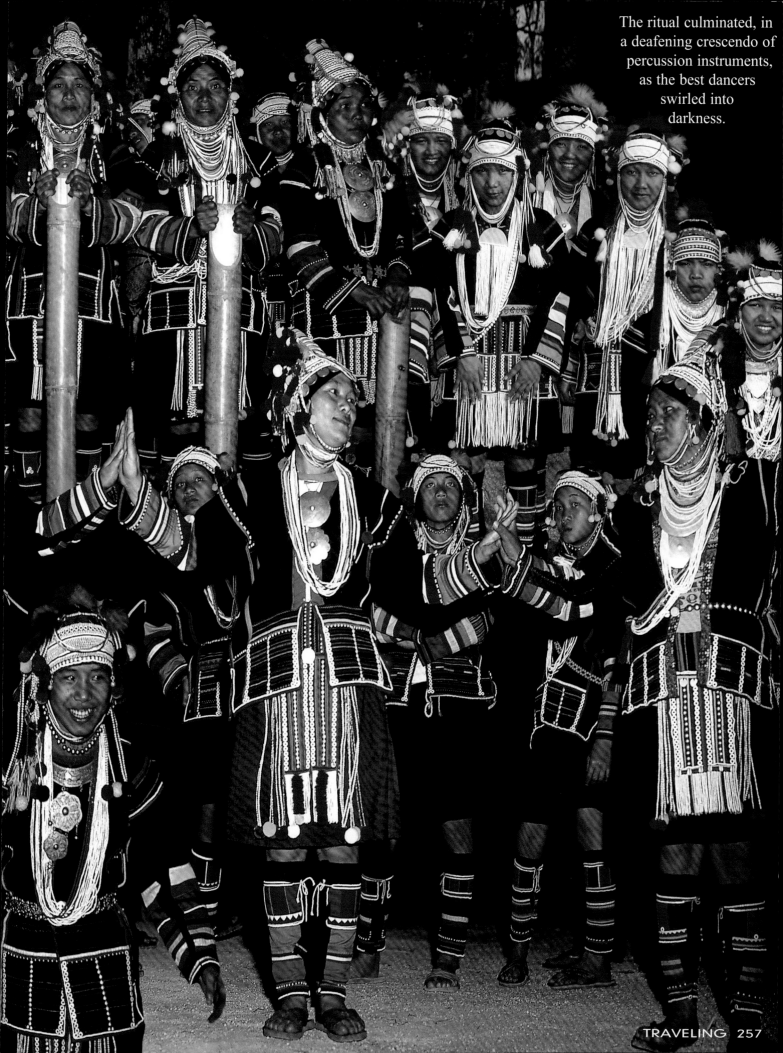

The ritual culminated, in
a deafening crescendo of
percussion instruments,
as the best dancers
swirled into
darkness.

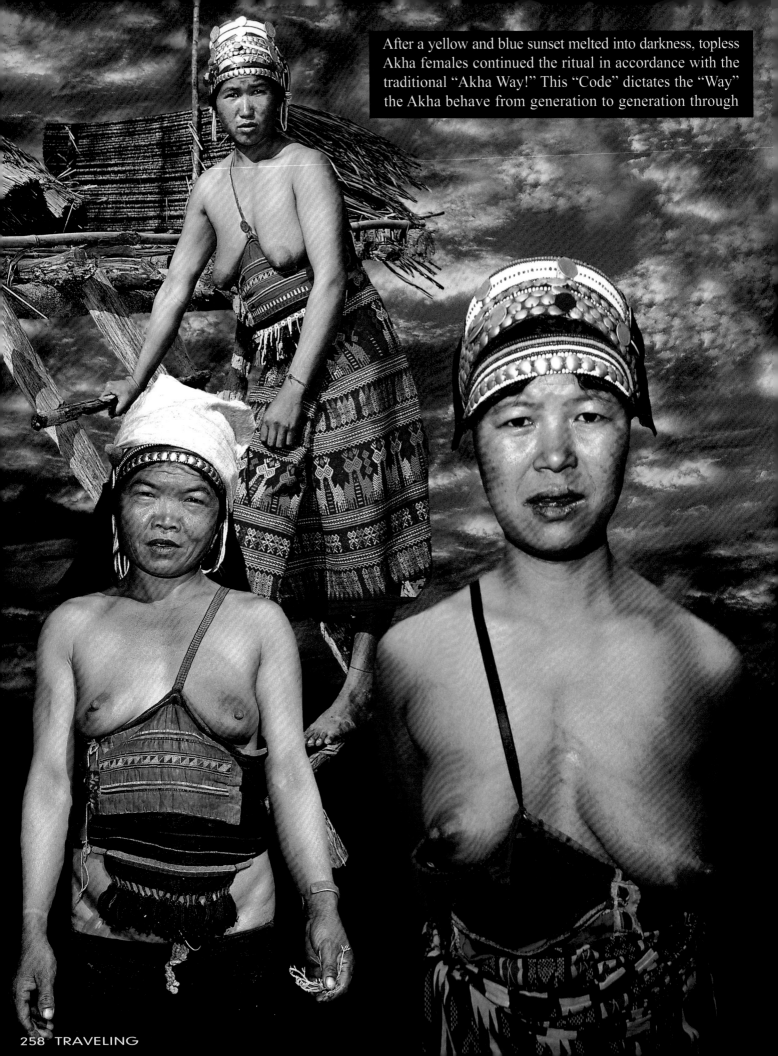

After a yellow and blue sunset melted into darkness, topless Akha females continued the ritual in accordance with the traditional "Akha Way!" This "Code" dictates the "Way" the Akha behave from generation to generation through

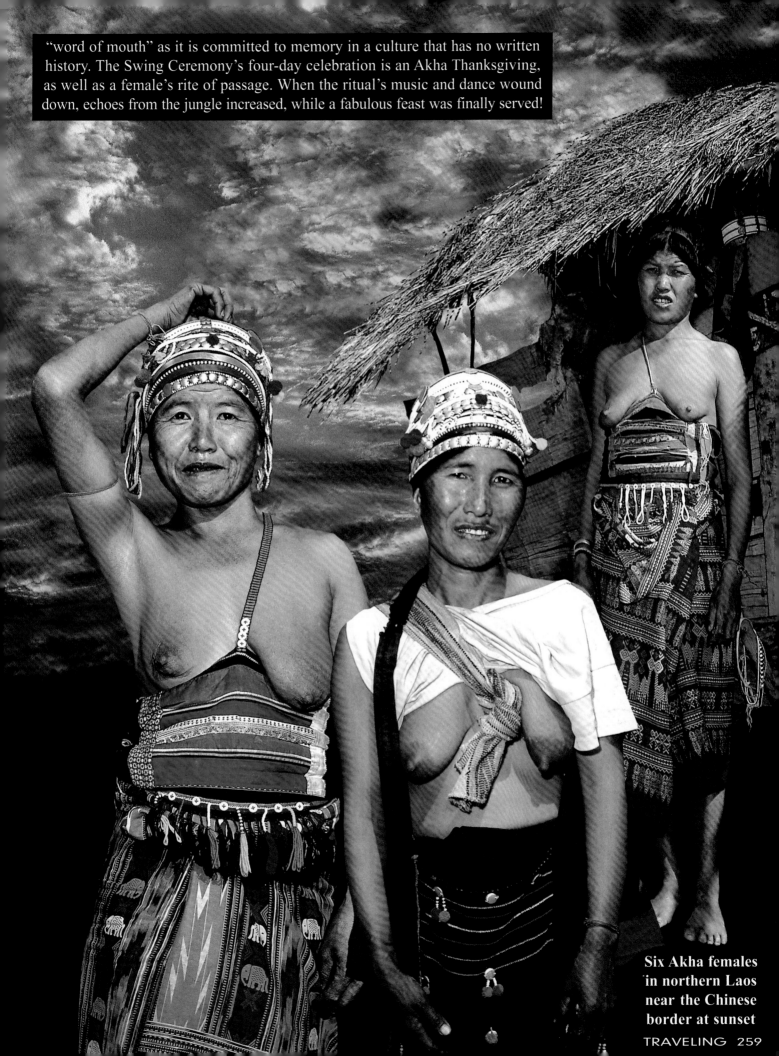

"word of mouth" as it is committed to memory in a culture that has no written history. The Swing Ceremony's four-day celebration is an Akha Thanksgiving, as well as a female's rite of passage. When the ritual's music and dance wound down, echoes from the jungle increased, while a fabulous feast was finally served!

**Six Akha females in northern Laos near the Chinese border at sunset**

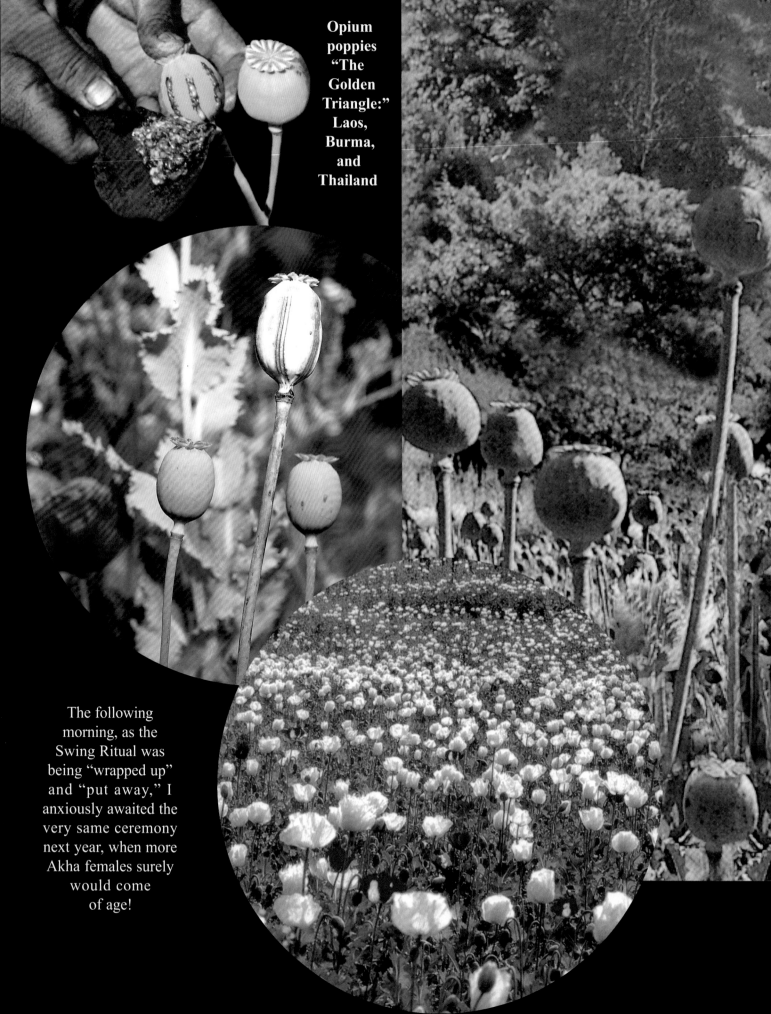

**Opium poppies "The Golden Triangle:" Laos, Burma, and Thailand**

The following morning, as the Swing Ritual was being "wrapped up" and "put away," I anxiously awaited the very same ceremony next year, when more Akha females surely would come of age!

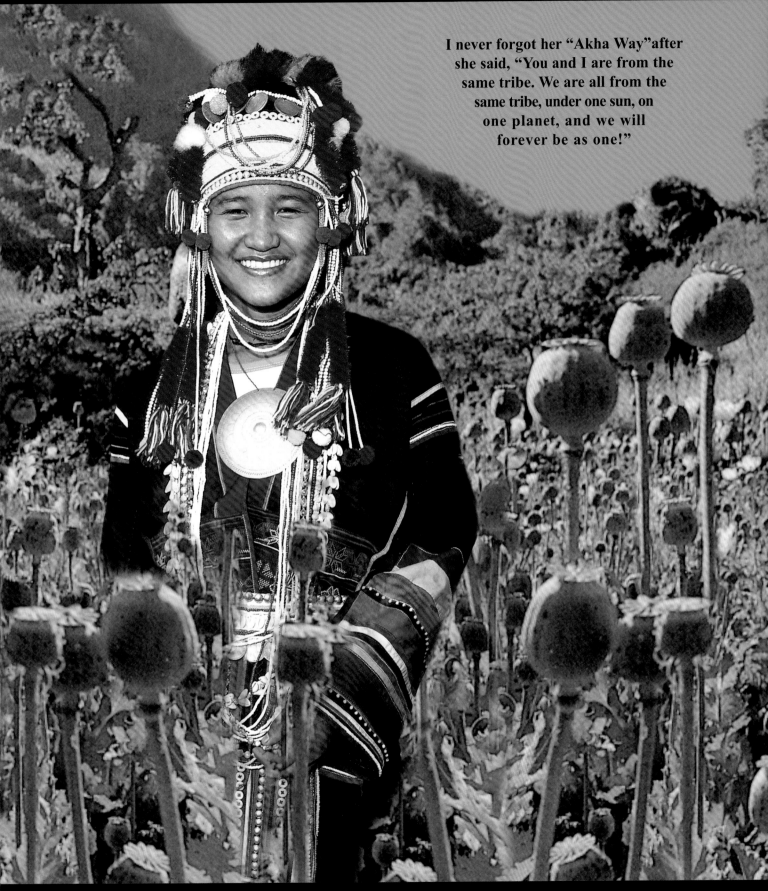

I never forgot her "Akha Way" after she said, "You and I are from the same tribe. We are all from the same tribe, under one sun, on one planet, and we will forever be as one!"

**My lover woke and said, "We are all from the same tribe and will forever be as one!"**

After rising and reluctantly stepping into the blinding morning sunlight with a splitting headache from the festival's poorly distilled homemade rice wine, I clearly remember smelling tasty black opium curling from smoldering bamboo bongs when I was greeted with a large cup of black coffee handed to me by an Akha woman who only yesterday was a girl! I did not realize at the time this fine woman would soon be my lawful wedded wife, but as I put the cup down I noticed she held my hand when she said, "My "Akha Way" can be your path to peace! Always remember: You and I are from the same tribe. We are all from the same tribe, under one sun, on one planet and we will forever be as one!"

# TRIBES

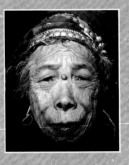

"AH NAUNG," THE MOTHER OF MY "AKHA" GIRLFRIEND, WHO CARRIED ME ON HER BACK AT NIGHT ILLEGALLY ACROSS A RIVER FROM BURMA TO THAILAND

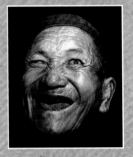

THE TOOTHLESS "BLACK HMONG" TRIBESMAN WHO CORRECTLY PREDICTED THE FUTURE BY THROWING TWO RED STICKS

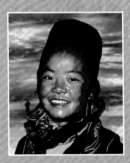

"SO WHOO," THE BEAUTIFUL, YOUNG, "BLACK HMONG" WHO TAUGHT ME HOW TO RETURN, AFTER DEATH, TO MY ORIGINAL PLACE OF BIRTH

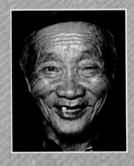

THE DISHEVELED, DEFORMED, SINGLE-TOOTHED, DWARFED "FLOWER HMONG" TRIBESMAN WHO RELUCTANTLY SOLD ME A SACRIFICIAL GOAT

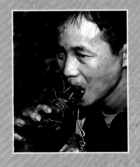

"LEEA" WAS SICK AND NEAR DEATH BECAUSE THE "BLACK HMONG" ASSUMED HE HAD COME IN CONTACT WITH "SPIRITS" IN THE FOREST, BUT AFTER EATING CANNABIS SEEDS AND STALKS HE FULLY RECOVERED

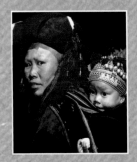

I WAS SECRETLY TOLD "SEO LA MAY" WAS INSEMINATED WITH A SYRINGE BY HER HUSBAND BECAUSE SHE IS H.I.V. POSITIVE, AND NOW HAS A CHILD

# PEOPLE

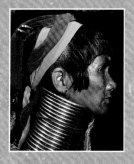

"DAW MU THEEN," THE PADAUNG "LONG NECK" TRIBESWOMAN, WHO RITUALLY COILED TWELVE BRASS RINGS AROUND A YOUNG GIRL'S NECK

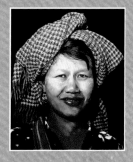

THE "YAO" TRIBESMAN WHO GAVE ME OPIUM FROM A SMOLDERING, BLACKENED, BAMBOO PIPE WHILE HE CARRIED A BABY ON HIS BACK

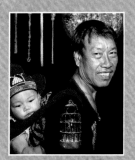

"FAN RAO PHIN," THE "RED ZAO" TRIBESMAN, WHO AFTER SAVING MY LIFE IN A BURNING HUT, ACCIDENTALLY SHOT A RIFLE WHICH CAUSED A JUNGLE FIRE

THE PALAUNG "WITCH" WHO PROPHESIED I WOULD FIND "BUDDHA'S CAVE," 1000 PAGODAS, COUNTLESS ANCIENT TEMPLES, AND A HUGE "GOLDEN EGG"

"LOAJANG," THE "LANTIEN" TRIBESMAN, WHO TAUGHT ME "THE WAY," "THE STEAM," AND ABOUT "LIFE WITHIN ALL THINGS!"

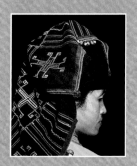

"BON CHEN," THE "THAI LU" TRIBESWOMAN WHO, WHILE PREGNANT, UNEXPECTEDLY DIED FROM A RUPTURED FALLOPIAN TUBE AND WAS CREMATED AS HER MOURNERS MOANED IN UNISON

# PADAUNG VILLAGE PRIEST

*During a Padaung tribal celebration I watched villagers sacrifice a boar so its liver could be inspected by a priest as a portent of the happiness and favorable prospects for fertility of a Padaung marriage. The boar was killed with a foot-long piece of bamboo inserted into the heart. After the animal was killed and the liver had been scrutinized by the village priest, I spoke with him about the purpose and meaning of the sacrifice.*

D: What role does a sacrifice of a pig have in a wedding ritual? I don't see the connection...

P: I cut the liver out of the animal's body. It tells me if the marriage will be successful and if the bride will bear children. The healthy color of the liver predicts the man and woman will be happy together. It's very simple!

D: But do you know whether a marriage will be successful? What does a liver tell you about the man and woman?

P: After I remove the liver, I look at it very carefully for signs of disease. I make sure to look at it from all angles. If the liver is healthy, the wedding may proceed. If it is unhealthy, we sacrifice another boar. If the liver of the second boar is unhealthy, we kill a third boar. If all three boars have livers that are sick or discolored, the wedding must be cancelled because the union will not be blessed by the spirits. Then we can feast on the carcass of the sacrificed animals.

# CONVERSATIONS
## LANTIEN SHAMAN

*In the village of Ban Nam Dy, Laos, I was fortunate to have the opportunity to speak to "Sip Mien Mien," the village shaman, about the most important Lantien rituals. I found him carving Lantien Taoist masks while he explained Lantien philosophy and religion to me.*

D: Please tell me why your people are sometimes referred to as "The Stream."

S: "The Stream" is the place where my tribe set up camp by a river when we migrated from China in the 17th century. But it is also the "Way," the river of life passes through us.

D: Can you describe your religious philosophy to me, please? What do you believe?

S: We believe in our ancestors as gods, and that there is life within all things. That is our "Way."

D: What are the shaman's tools and in what ways do you use them in your Taoist rituals to generate power that can effect change in the present or will at least enable you to see into the future?

S: We use rituals that include charms and magic to cure sickness. When we wish to predict the future, we throw joss sticks but we believe each person must find their own way.

# BLACK HMONG WOMAN

*Soon after dawn one morning, in Vietnam's
"Sapa" town market, I had an opportunity to
speak with a young Black Hmong woman
named "So Whoo" about the significance
of the striking dark-blue color clothing,
oversized silver hoop earrings and
large Elizabethan-style chain
metal necklace that she wore.*

D. Tell me about that blue color all over
your hands. Where does it come from?

SW: The dye is made from hemp grass. We weave
all our clothing from hemp. This skirt is all hemp.
My tribe believes that our God who made the
sky carries an umbrella, so our skirts are
symbols of that God's great umbrella.

D: So the hemp plant is important to you?

SW: Yes. It's very important! We use hemp for all our
clothing. Even in death, we are dressed in hemp
clothes and shoes. The shoes help a person's
spirit cross difficult mountain paths back
"home" to their original birthplace
after they die!

D: What about the embroidery on the skirts you
wear? What do those patterns represent?

SW: We use symbols to tell important stories about
our tribe -- the history of our ancestors, where
their homes were located, whether they
lived in mountains or along rivers.

D: So your tribe believes you will journey
back to the place you were
born after you die?

SW: Yes. We pay a toll by burning money at the funerals of our dead so that they can travel through the Spirit World and find their way back to their birthplace. When this trip into the after life is successful, they can live again.

# AKHA TRIBESMAN

*Commonly built on elevated wooden posts, Akha huts generally have similar floor plans that exploit a sort of "feng shui" tribal logic. "Bu Yuen," an Akha tribesman who I met in Laos, explained the spiritual rationale behind the layout of his hut.*

D: Please tell me how your house design came about.

BY: The most important thing is to keep our ancestral altars in the correct place in our homes. All of our important ceremonies take place around the altar. So when we build the house everything that has to do with the altar is taken in first.

D: Most Akha huts are built up onto posts. Why?

BY: We shelter our animals and store things under our huts.

D: Do the Akha build separate sections in their houses for men and women?

BY: Yes. The women's section is where we place the ancestral altar. It is our custom that guests who are male do not enter the women's section unless the head of the household invites them. Women are allowed to visit the men's section with others. Another of our customs is that when a guest comes into the house by one door, he should not leave by another door unless he first accepts the offer of food and drink. Otherwise, he is not seen as a guest, but rather as an intruder.

# *TRIBAL*

Despite the presence of strong Buddhist, Taoist and even Christian religious influence, most of the tribes adhere to earlier, more primitive belief systems dating back to the dawn of time. Animism and a cherished belief in the role of spirits in daily life continues as a way of life for the Akha, Hmong, Yao, Thai Lu, Palawan, and the Palaung. The power of the village shamans to commune with these spirits and cure sickness is a widely accepted tenet. The use of objects of power is also readily accepted, as is the sacrifice of animals to appease or placate the spirits that populate the minds and bodies of the villagers. All of these tribal communities embrace the power of ritual and incorporate it into the very fabric of their existence. These rituals serve to unite the community and keep the members tightly bound together. There is no doubt that their rituals and beliefs, so alien to our Western system of organized religion, have played a major role in preserving and promoting their cultural survival.

There is no single religious paradigm for Asian tribes, but all of these peoples believe that supernatural beings are involved in every aspect of human life. Spirits protect the villagers' souls and the well-being of their crops, livestock and money, so that each household may be healthy and prosperous.

# RELIGION

The spirits also direct human affairs. The door spirit, for example, gives the soul of a dead Hmong permission to leave the house. It is no exaggeration to say the spirits inhabit an alternative, co-existent world alongside the mundane world of the tribespeople, communicating with them, guiding, protecting and punishing them when ordinary human law does not suffice.

In the case of illness, the tribal shaman, a sort of religious specialist who is often a diviner and medicine man, identifies spirits, speaks to them and communicates their demands and laws. The shaman may go into a trance to heal the sick, conduct a ceremony to send an evil spirit away, and uses amulets and incantations in the healing work. (Lebar, Hickey, & Musgrave, 1964)

To some extent, all these tribes believe humans have their ancestral souls residing within their bodies and around their homeland, and that there are numerous nature-based animist spirits present in this world with whom orderly relations must be kept.

In addition to the long-established spiritual traditions and rituals, the tribes also have simple systems of law and order and tenuous but authoritative links to the regional and national governments of their particular nation. As a rule, tribespeople take a dim view of conflict, and in most cases village elders have the responsibility for settling disputes. Matters of a spiritual, superstitious or personal nature are deferred to tribal shamans. The villages function as integrated, unified groups rather than isolated individuals; all the members of the village community rely on one another for assistance in emergencies and have a responsibility to the clans or families, in addition to meeting the basic needs of their own households. The common system of governance within villages includes the exercise of power by headmen, or shamans, and councils of elders. These societies are patriarchal, and the women are expected to be subservient, although clearly they play crucial roles in child rearing, agriculture and creation of tribal artifacts. Depending upon social cohesion and integrity, each village has some variant on this traditional tribal model of self-rule. Although largely apolitical in the modern sense, the tribes deal with the national government on their own terms and through their own leaders. For example, the Thai government

Filipino head-taking ax

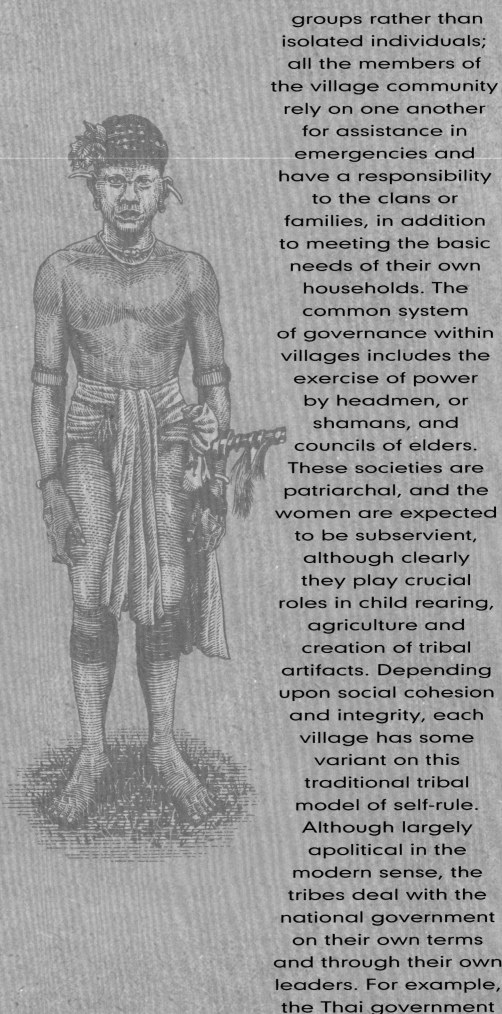

# TRIBAL LAW

recognizes a single village headman, who represents each village in all dealings with authorities. The headman also arbitrates disputes among villagers, but the shaman is the primary spiritual leader; however the counsel of village elders may appoint a priest or a headman (Lewis & Lewis, 1984). Spiritual matters are concerns of the priest, shaman, and each and every member of the tribe, male or female. The tribes are, of course, all subject to the laws of their national governments, and tribespeople are keenly aware that when they travel outside the bounds of their village and homeland they come under a different legal regime. Tribal law is not legislated or policed in the manner of state or national law, a reality which

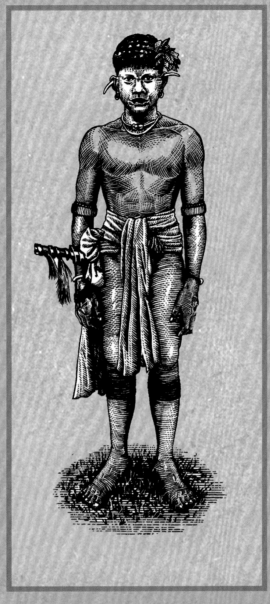

underscores the significance of the village gates and tribal territories. Tribespeople live under their own law and government within their rural enclaves, and survive despite unwanted interference from federal politicians who are usually disguised in some form of "judicial assistance" or labeled "for your own protection." But for everyone, who actually lives or has truly experienced life in a real village, they surely can prove their local governments are not really interested in enforcing the strictures of civilized life or imposing the legal dictates of the state upon people who have little economic or political influence beyond their homelands.

The tribes depicted in this book are individual and distinct, having migrated over time, mostly from China to Vietnam, Thailand, Laos, Burma and the Philippines. In some cases the migration was due to attempts at subjugation by unfriendly governments. The warfare of the 1960s and 1970s drove waves of emigration from one country to another,

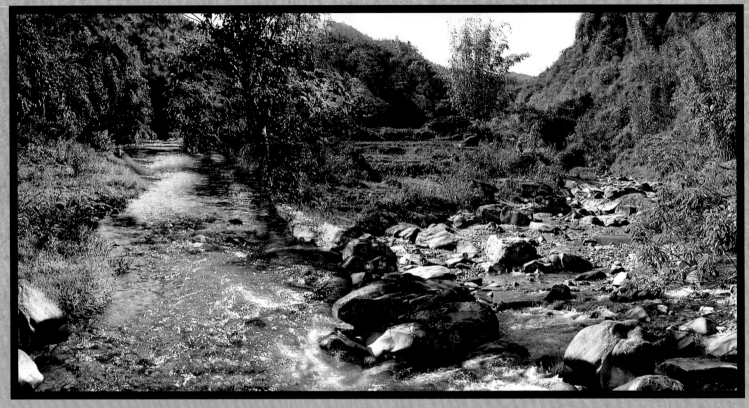

Palawan Island: The Philippines

resulting in population shifts that tended to stabilize over time when the conflicts died down in the mid-1970s. Exhausted resources, economic hardship and seasons of

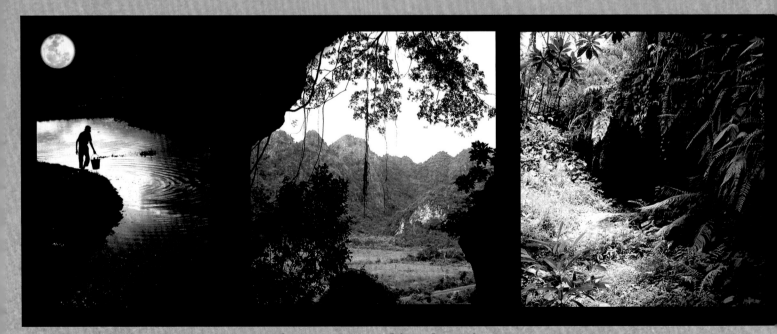

Rice terraces and jungles: Vietnam

# CONCLUSION

drought have also forced migration at times, so that people with common origins who wound up in different parts of Southeast Asia

Rice terraces: Vietnam

evolved separately into the tribes found in rural areas today. But these tribes are alike in many ways, as emigrants, outsiders and "primitive" people who live on the edge of "civilization."

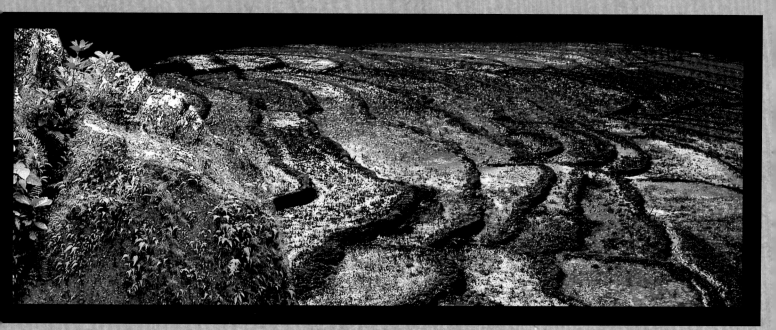

Rice terraces: Vietnam

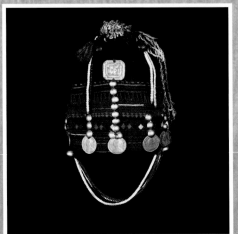

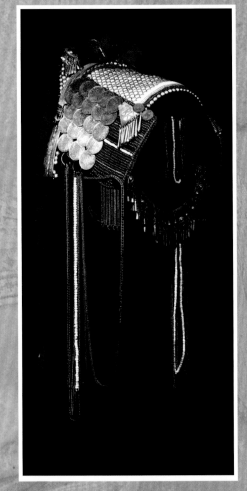

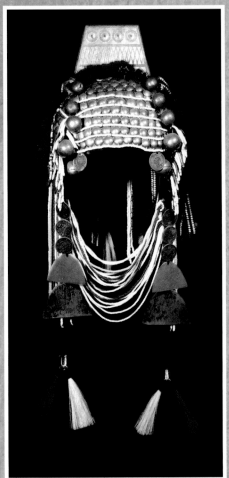

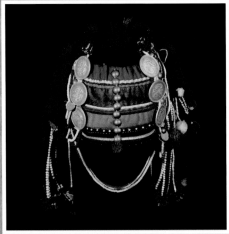

Akha child's headdress:
top and bottom

left and right:
Thai Akha female's
heirloom headdress:
hammered silver and
19th-century coins

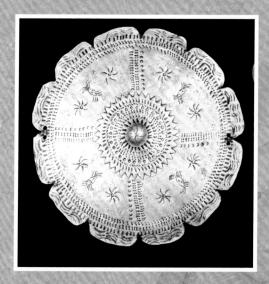

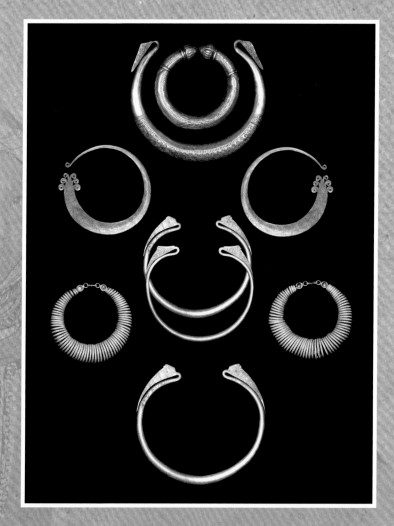

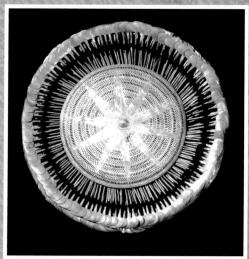

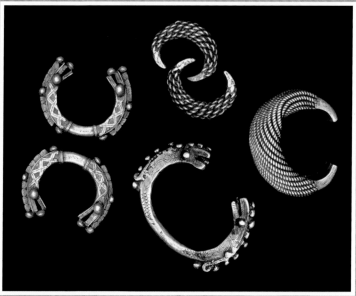

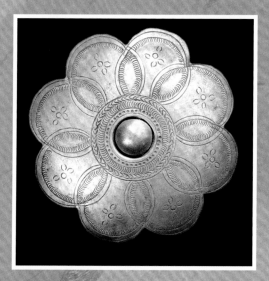

Akha silver chest ornaments: (left top and bottom). Lantien ceremonial "Celestial Crown": silver in a web of human hair: (left middle)   Hmong and Lantien necklaces, earrings and bracelets

Perhaps the most striking cultural characteristic common to all these Asian tribes is the breathtaking beauty of their art, in their clothes, headdress and jewelry. The women create stunning embroidered clothing, and the girls begin to learn the skill at an early age. Silver jewelry is ubiquitous in the form of earrings, pendants, bracelets, anklets, neck rings, hair ornaments and crowns.

Crop cultures differ but most tribes are agrarian. The Yao and Hmong live at the high elevations where opium thrives, so the highland tribes favor opium as a cash crop. Relatively few Akha engage in poppy cultivation but the rewards of opium are hard to resist.
(Lewis & Lewis, 1984)

The risks of opium production are outweighed in many circumstances by the need to escape abject poverty. Outside traders will come into the villages to collect the opium at harvest. While this arrangement saves the farmers from having to market their own crops, it also leaves tribes at the mercy of the traders, who set prices and intimidate all growers who try to act independently. The tribes are now attracting more attention from the governments of countries where they reside because of the political issues of opium production, the environmental destruction caused by slash and burn agricultural practices, and the strategic positions the tribes hold by virtue of the fact they live in remote mountain regions along borders that are difficult to defend. As a result, governments in the region are intervening to mitigate the economic hardships of the tribes and to secure their country's borders.

Arable land is scarce, and funds to purchase new cropland are few. Farmland for tribal use is shrinking as soil erosion and deforestation spread. The need to diversify into alternative crops and cottage industries requires capital that is, for the most part, lacking. Civilization is encroaching on mountain villages. As more valley dwellers move farther up into the hills the political status of the tribes becomes more uncertain!

The old ways die hard. As modern medicine becomes more available, ritual healing is practiced less often, a consequence is tribal religious beliefs are viewed as less important. Formal education is providing explanations of the cosmos that do not depend on an animistic, Taoist, or Buddhist view of the world. The chain of tribal religious practitioners is being disrupted. Newly constructed roads make remote regions accessible. The result is easier commerce, but local tribal customs are frequently ignored or disrespected by visitors.

These clashes cause
tensions to develop as
the roads bring modern
ideas and perspectives that

further erode the tribes' culture,
but publicity and protection
seem to be the only means
to preserve these peoples'
unique way of life.

For these Asian tribes life as it has
been carried on for centuries is now
changing. Encroaching civilizations
offer stable economies and modern
medicines, but in exchange for these
benefits the belief structures of tribal
cultures are without a doubt irrevocably
altered. The greatest challenge,
therefore, is a dichotomy for tribes
attempting to maintain a unique
cultural identity; by preserving
independence from the
modern world, they write their
own invitation to isolation when
hoping for only eternal endurance!

Abbott, Gerry  *"The Traveler's History of Burma"*  Bangkok Thailand, Orchid Press (1998)

Babinski, G *"Methodological Problems of Cultural differences in Ethnic Groups"* Ethnic Forum (1985)

Banks, D.J. *"Changing Identities in Modern Southeast Asia"*  The Hague: Mouton (1976)

Bastin, John and Harry Benda *"A History of Modern Southeast Asia"* New Jersey: Prentice-Hall (1968)

Cohen, R. *"Ethnicity: Problem and Focus in Anthropology"* Annual Review of Anthropology (1978)

Conklin, Harold  *"Field Work on the Islands of Mindoro and Palawan: Philippines"*  (1949)

Diran, Richard K. *"The Vanishing Tribes of Burma"* Amphoto (1997)

Dorman, J.H. *"Ethnic groups and "ethnicity": Theoretical Considerations"* Ethnic Studies  (1980)

Dzoedang, Phima Aghaw  *"Akha Death Rituals"*  East Asian Institute, Copenhagen  (1979)

Ellis, Geroge R. *"Arts and Peoples of the Northern Philippines"* U.C.L.A. Fowler Museum  (1981)

Evans, G. *"Laos: Culture and Society"* Chiang Mai: Silkworms Books (2000)

Friedman, Jonathan *"Tribe, Chiefdom, State"* Ph.D. thesis: Uppsala University, Ann Arbour (1971)

Garnier, Francis *"Travels in Cambodia and Parts of Laos"* (1866-1868) reprinted White Lotus (1994)

Girard-Geslan, Maud *"Art of Southeast Asia"* Harry N. Abrams  (1998)

Goldman, Ann Yarwood  *"Lao Mien Embroidery: Miration and Change"*  Bangkok: White Lotus (1995)

Goodman, J. *"Meet the Akha"*  Bangkok: White Lotus (1996)

Grunfeld, F. V.  *"Wayfarers of the Thai Forest: The Akha"* Amsterdam: Time-Life Books  (1982)

Hanks, Lucien and Jane *"Reflections on Ban Akha Mae Salong"* Journal of Siam Society  p. 63  (1975)

Hanks, Jane *"Recitation of Patrilineages among the Akha"* Cornell University Press pp 114-127 (1974)

Hansson, Inga Lill *"Akha Shaman's Trance"* East Asian Institute, University of Copenhagen  (1983)

Hansson, Inga Lill *"Akha Sickness Rituals"*  East Asian Institute, University of Copenhagen  (1984)

Halliday, Simon *"Preliminary Research on the Yao in Chiang Rai"* Journal of the Siam Society  (1978)

Hesselt van Dinter, Maarten  *"The World of Tattoo: an illustrated History"*  Amsterdam : KIT  (2005)

Higham, Charles  *"The Archeology of Mainland Southeast Asia"*  Cambridge (1989)

Jacobs, Julian *"The Nagas: Hill Peoples of Northeast India"* London Thames and Hudson Ltd.  (1990)

Kayes, Charles *"The Golden Peninsula: Cultural Adaptation in Southeast Asia"* MacMillan  (1977)

Kunstadter, P. *"Southeast Asian Tribes, Minorities and Nations"* Princeton University Press  (1967)

Kahn, J.S. *"Southeast Asian Identities"* London: Tauris (1998)

Lee,Y.L. *"Ethnic differences and state-minority relationship in Southeast Asia"* Ethnic Studies (1983)

Lemoine, Jacques *"Yao Ceremonial Paintings"* Bangkok, Thailand : White Lotus (1982)

Lewis, Paul and Elaine *"Peoples of the Golden Triangle"* London Thames and Hudson (1984)

Lewis, Paul and Elaine *"The Fourth Dimension in Thailand"* American Baptist Mission Studies (1973)

Lewis, Paul *"Ethnographic notes on the Akhas of Burma"* HRAFlex New Haven (1969-1970)

Litzinger, Ralph *"Other Chinas: Yao and the Politics of National Belonging"* Duke University (2000)

# BIBLIOGRAPHY

Majul, C.A. **"Cultural diversity and national identity in the Philippines"** Hong Kong: Southeast  (1972)

Maran, LaRaw **"Towards a Basis for Understanding the Minorities of Burma"** Princeton Press  (1967)

Masferre, Eduardo  **"People of the Philippine Cordillera"**  Manila, Philippines:  Devcon  (1988)

Nash, June C.  **"Living with Nats: An Analysis of Animism in Burma"**  New Haven  (1966)

Pourret, Jess G. **"The Yao: Mien and Mun in China, Vietnam, Laos and Thailand"** Art Media  (2002)

R. Cushman **"Rebel Haunts and Lotus Huts: Problems in the Ethnohistory of the Yao"** Cornell (1970)

R.F. Fortune **"Yao Society: A Study of a Group of Primitives in China"** Lingnan Journal 18  (1939)

Shiratori, Yoshiro **"Ethnic Configurations in Southern China' Culture in South-East Asia"** Tokyo (1966)

Suryadinata, Leo **"Ethnic Chinese as Southeast Asians"**  Institute of Southeasts Asian Studies   (1997)

Tanabe, Shigeharu **"Religious Traditions among Tai Ethnic Groups"**  Ayutthaya Study Centre   (1991)

Tambiah, Stanley **"Galactic Polity: The Structure of Traditional Kingdoms in Southeast Asia"**  (1977)

Tapp, N.C.T. **"Change and Continuity among the White Hmong of Northern Thailand"** London  (1985)

Tarling, Nicholas **"The Cambridge History of Southeast Asia"** Cambridge University Press  (1992)

Taylor, Eric **"Musical Instruments of South-East Asia"**  Singapore:  Oxford University Press  (1989)

Taylor, Keith Weller **"The Birth of Vietnam"**  Berkeley:  University of California Press  (1983)

Telford, James **"Animism in Kengtung State"** Journal of Burma Research Society, 27(2),  pp.86  (1937)

Terwiel, B.J. **"Tai Funeral Customs: a Reconstruction of Archaic-Tai Ceremonies"**  Anthropos  (1979)

Tilman, Robert **"Man, State, and Society in Contemporary Southeast Asia"** New York: Praeger  (1969)

Tooker, D. **"Inside and Outside: Schematic Replication Akha Village North Thailand"**  Harvard  (1988)

Tooker, D. **"Identity Systems of Highland Burma"** Man 27/4: 799-819  (1992)

Tribal Research Institute **"The Hilltribes of Thailand"** 30th Anniversary of Tribal Research Institute (1995)

Truong Thanh-Dam **"The Dynamics of Sex Tourism: The Case of Southeast Asia"**  Dev Change (1983)

Vambery, Armin **"Travels in Central Asia"** New York: Harper & Brothers (1865)

Van Cutsem, Anne **"A World of Bracelets"** Milano Italy : Skira (2002)

Van Ham, Peter and Stirn, Aglaja **"The Hidden World of the Naga"** Prestel  (2003)

Von der Mehden, Fred R. **"Religion and Modernization in Southeast Asia"**  Syracuse Press (1986)

Wain, Barry  **"The Refused"**  New York: Simon & Schuster  (1981)

Watson, C.W. and Roy Ellen **"Understanding Witchcraft + Sorcery in Southeast Asia"** Hawaii (1993)

Wijeyewardene, G. **"Ethnic Groups across Boundaries in Mainland Southeast Asia"**  ISEAS  (1990)

Wolters, O.W. **"History, Culture, and Region in Southeast Asian Perspectives"** Asian Studies  (1982)

Ten Southeast Asian Tribes from Five Countries:
Thailand, Burma, Vietnam, Laos, Philippines

Photography, text, concept, layout, and design
by David Howard

More information contact David Howard:
www.tribalartasia.com

Published by Last Gasp of San Francisco
777 Florida Street
San Francisco, CA 94110
www.lastgasp.com

ISBN: 0-86719-704-8
ISBN-13: 978-0-86719-704-4

First printing October 2008.

08 09 10 11 12  5 4 3 2 1

Printed in China.